Ultimate Diving Adventures
100 Extraordinary Experiences Under Water

Len Deeley and Karen Gargani

ULTIMATE

Diving Adventures

100 Extraordinary Experiences Under Water

Len Deeley and Karen Gargani

WILEY ⊕ NAUTICAL

A catalogue record for this book is available from the British Library.

ISBN: 978-0-470-74492-5

Set in 8.2/9.8 ITC Garamond by Laserwords Private Ltd. Chennai, India
Printed in China by SNP Leefung Printers Ltd

Tropical Reefs

Contents

Temperate Waters

Wreck Dives

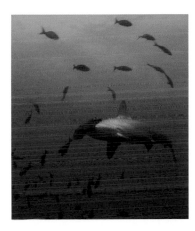

Shark Inhabited Reefs

Whales and other Mammals

Exotic Species

Conversions

For clarity, throughout the book all measurements, distances, etc., are given in metric only. Please refer to the following conversion information to obtain the imperial equivalent.

To convert *to* metric, multiply by the factor shown.

To convert *from* metric, divide by the factor.

Length

miles: kilometres	1.6093
feet: metres	0.3048
inches: millimetres	25.4
inches: centimetres	2.54

Area

square miles: square kilometres	2.59
square feet: square metres	0.0929
square feet: square centimetres	929.03
square inches: square millimetres	645.16
square inches: square centimetres	6.4516

Weight

tons: kilograms	1016.05
tons: tonnes	1.0160
pounds: kilograms	0.4536

Temperature

Multiply	by	to get
°F Fahrenheit	$- 32 \times 5 \div 9$	°C Celsius
°C Celsius	$\times 9 \div 5 + 32$	°F Fahrenheit

Introduction

Man is blessed with the ability to explore all corners of the earth, the skies and beyond. Throughout time, the hidden secrets of the underwater world have captured the human imagination. Within these pages we encounter the richness of life beneath the seas.

Our recollections and acquired knowledge of amazing dive locations, whether close to home or across the globe are described throughout this book. Diving offers extraordinary recreation - a chance to sink into your own thoughts and be at one with the sea. For some, it pushes the boundaries of one's spirit of adventure. Others crave the thrill of a close encounter with mysterious marine creatures great and small. No matter what the motivation, diving has something for everyone.

Our oceans are precious. To ensure their survival and preserve this unique underwater paradise for many generations to come, respect for the environment and the myriad creatures dwelling within our waters is essential.

We hope you enjoy reading about and diving these sites and are inspired to discover many more for yourselves.

Len Deeley and Karen Gargani

We admire the way dive guides and dedicated groups across the world unite as a virtual team with one clear aim - to protect the environment. As visitors to the underwater world, we seek out healthy and pristine reefs and wrecks that are conserved as artificial reefs and historical remains. It is our hope that they remain this way by effective conservation and good diving practices.

Often, a diver will witness a dive guide picking up fishing line lying across a reef or clearing up debris left by thoughtless tourists.

These people, together with conservation groups, make an enormous contribution to safeguard the ocean's jewels.

Our book features many dive sites which are part of official marine parks, protected by a government body. We support these groups and encourage people to dive in such places. Let us all help to preserve the seas for future generations.

SHARK AND YOLANDA REEFS, RAS MOHAMMED

The first and most famous dive site in the Red Sea

Situated at the southernmost tip of the Sinai Peninsula, Shark and Yolanda Reefs are part of the Ras Mohammed National Park, which has been a protected area since 1983. Situated within easy reach of the earliest dive resorts in Sharm el Sheikh, this has been a magnet for sport divers from the earliest days of the sport.

maximum depth:
8m

minimum depth:
3m

access
Day boat from Sharm el Sheikh resorts or liveaboard. Liveaboard from Hurghada.

average visibility
30m–40m

water temperature
Summer 28°C, winter 21°C

dive type
Reef and drift

currents
Variable to strong

experience
** to ****

in the area
Shark Observatory, Fishermans Bank, The Eel Garden, Jackson Reef, Gordon Reef, Ras Nasrani, The Thistlegorm

WHAT WILL I SEE?

Where the southernmost tip of the Gulf of Suez converges with the deeper waters of the Gulf of Aqaba, lies the Ras Mohammed peninsula. Over 1,000 species of fish and 150 species of corals have been recorded in this national park. There are numerous famous dive sites in the immediate area but the most famous are Shark and Yolanda Reefs. These are formed by two pinnacles that rise from the depths to the surface at their southern side, with a shallower lagoon between them and to the north. Strong currents bring nutrients that attract large shoals of jacks and snappers, especially during the summer months, and these in turn can attract larger visitors such as sharks.

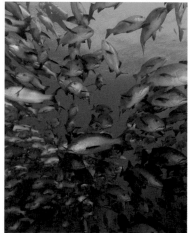

While it is clear why Shark Reef got its name, Yolanda Reef is less evident. In fact, this reef is named after a Cypriot freighter that ran aground in 1980. Most of the wreck has now succumbed to the battering of storms and currents and has disappeared into the depths beyond the reach of sport divers. Technical divers have located the remains at around 145m. What remains, however– mainly a consignment of household toilets, baths and piping–makes an interesting addition to a dive, and is home to many small fish and invertebrates.

THE DIVES

You may start your dive in the lagoon between the two pinnacles, where it is about 8-10m to the seabed. From there you can swim to the north of Shark Reef and circle it clockwise, which will take you to the outer drop off that disappears to the depths a thousand metres down. You may encounter large shoals of jacks and snappers, especially in the summer months when they come in to mate, as well as emperors and spadefish. Shoals of barracuda are also a common sight. An alternative detour before you circumnavigate Shark Reef will take you to Anemone City. This rock shelf has many sea anemones with their accompanying anemonefish, as well as coral heads and gorgonian sea fans.

Swim round Shark Reef, where most of the shoaling action will be taking place, and you can find yourself out in the blue amongst the shoals. From there you head for Yolanda Reef and make your way along the south side drop off and around the western side into the shallower waters, where you will eventually come upon the remains of the Yolanda wreck littering the seabed.

Given its name and the propensity of shoaling fishes, it is not surprising that sharks are a common at this dive site.

Hard and soft corals make this a very attractive dive and you can encounter an enormous variety of marine life. Shoals of masked puffers may be seen. Resident Napoleon wrasse are used to divers and will come very close. Unicornfish, groupers, emperors, spadefish, scorpionfish, lionfish, blue spotted rays, sergeant majors, trigger fish, Tuna, wrasses, yellow goatfish and moray eels are seen, and of course the inevitable endless shoals of anthiases ebbing and flowing along the reef walls.

ON DRY LAND
While it may look barren, the Ras Mohammed National Park has an abundance of marine life and is well worth a visit. Sand dunes are interspersed with outcroppings of Miocene limestone, created by uplifting of coral reefs, where a variety of marine fossils will be found. Excursions to desert locations such as the Feiran wadi, Kid wadi and Isla wadi can reveal interested pockets of colour. There is a mixture of granite and sandstone mountains and alluvial plains. Fauna such as desert foxes, Nubian ibex, hyrax (a species of guinea pig) and gazelles are found in the area as well as reptiles and many birds. Dating back to 527AD, St Catherine's Monastery can be visited at the foot of Mount Moses. Other trips can be arranged to such places as the Blue Desert

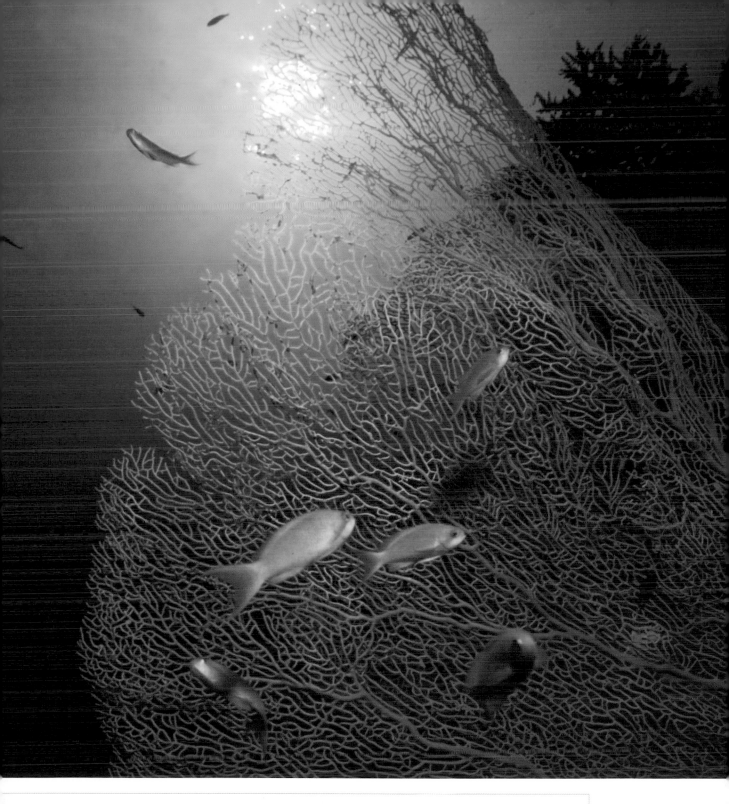

with its blue coloured boulders and the Coloured Canyon with its breathtaking canyon walls. Both are near St Catherine's Monastery and can be incorporated into one trip together with the town of Nuweiba.

HOW DO I GET THERE

Flights to Sharm el Sheikh and Hurghada, and then day boats from the local resorts or via liveaboard. Sharm el Sheikh is more suitable for day boats.

BIG BROTHER ISLAND

Spectacular drift dive

Big Brother Island, known locally as El Akhawein, is the larger of two isolated coral islands that have risen up in the middle of the sea, some 53km from El Quesir. Each side of the wall offers spectacular and exhilarating diving.

maximum depth:
30m or to your qualification

minimum depth:
10m

access
This location is too remote for a visit by day boat, as it is eight hours from the mainland. Access is via liveaboard. Book on a seven-day liveaboard trip out of Hurghada, Safaga, El Quseir or Marsa Alam ports.

average visibility
20m–40m

water temperature
25˚C–28˚C

dive type
Drift and wreck dives

currents
Medium to strong

experience

in the area
Little Brother Island, Elphinstone Reef, Safaga.

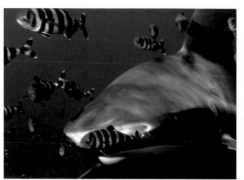

WHAT WILL I SEE?

Big Brother Island is 400m in length, with a lighthouse built by the British at the end of the last century to ensure safe passage through these waters.

The majority of dives are drift and sometimes the currents can be very strong. This creates opportunities for large pelagics, and sightings of shark and large tuna, thresher and scalloped hammerhead sharks are possible here. If you are lucky, you might encounter long distance travellers such as oceanic whitetips and mantas.

Every dive on this island provides an endless mass of amphias, surgeon fish, trevally and more; it is teeming with fish and marine life. There are no empty spaces on the reef wall, with every patch packed with chunky, colourful soft coral. Hard coral is also in pristine condition, a good reminder of how a healthy reef should be.

THE DIVES

The island is surrounded by a fringing reef that plunges to great depths all the way round. The north-east wall slopes more gradually, and makes a good dive to save for the third or fourth of the day.

There are two wrecks on the reef. The first, on the northern side, is an old English freighter. The Numidia struck Big Brother on 20 July 1901 when the ship hit the reef after the watch officer most likely fell asleep at the wheel. The bows are scattered over 10m. The Numidia lies on a very steep slope, plummeting off the plateau to the depths. Strong currents sweep through, but you can shelter within the wreck and observe patrolling sharks. The companionways, adorned with soft corals, offer an entry point on the starboard side. Corals have been growing on her since she sank at the beginning of the century, and

now cover her broken wreckage like a carpet.

Further north, the Aida, an Egyptian steamer that once carried army troops in the 1950s struck the reef while attempting to dock on 15 September 1957. She lies at a very steep angle on the reef with gorgeous corals and superb fish life. The back of the hull is the only remaining intact section, with the rest scattered over the reef for around 35m. Here there is an opening where thousands of glassfish move in unison, brightening this darker area of the artificial reef and providing protection from the often strong current. The steel framework of the wreckage is covered with soft corals even at the deeper sections, and you have to look hard to distinguish true reef from wreckage.

Drift away from the wreckage along the south side, relax and enjoy the ride. The huge gorgonian forest gives a surreal atmosphere; these sea fans are very photogenic as they hang out far from the reef wall, the sun penetrating from above. Keep a look out in the blue for large creatures cruising by.

As you move into shallower waters, the reef life is busy as the fish dart about and carry on with their day. Redtooth triggerfish gather in great numbers.

A nice contrast to the wall diving is an area under the pier to the lighthouse. Here, shoals of bream pack together in the warm, shallow water, and it is a great alternative to the drift diving experienced on most points of the island. Spend time here and watch the sun's rays break through the surface, lighting up the colours under the pier.

This island's reef is astounding, and well worth the visit.

ON DRY LAND From the dive boat, by special arrangement, it is possible to get permission to go onto the island, escorted by military personnel. Surrounded by desert, bare mountains rise to 2,000m high along from the shoreline. Some spots on the southern coast have mangroves with a rich habitat of fauna and flora. Many species of birds, gazelles, snakes and foxes live here. A visit by coach can include a visit to a Bedouin camp.

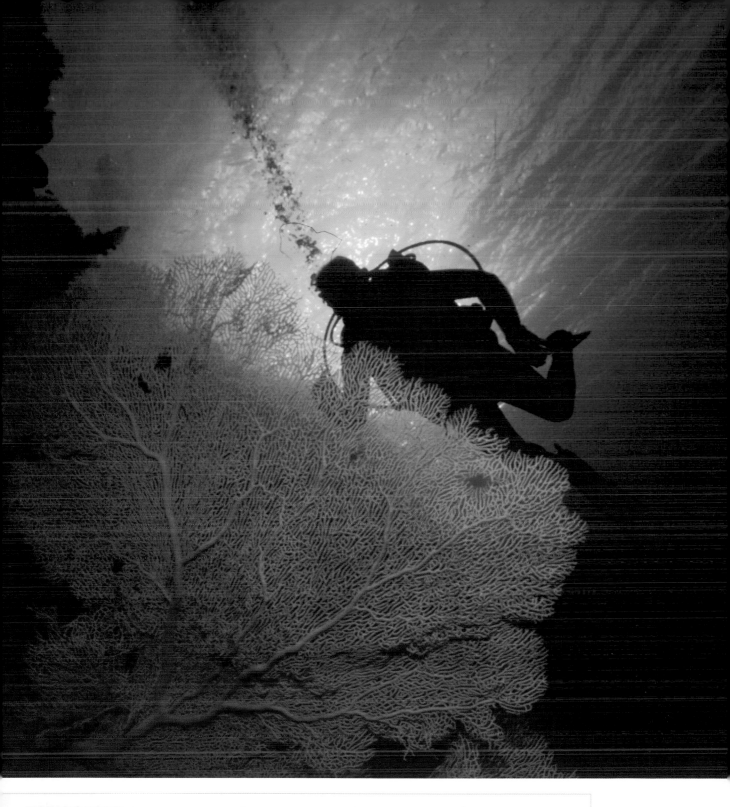

HOW DO I GET THERE
Fly to Hurghada or Marsa Alam airport.

SANGANEB REEF, SUDAN

The jewel in the crown of Red Sea diving

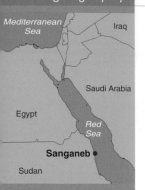

maximum depth:
40m

minimum depth:
25m

access
Via liveaboard either from Port Sudan or from Egyptian ports.

average visibility
30m–40m

water temperature
*Winter: 24°C,
Summer: 28°C*

dive type
Liveaboard

currents
Light to variable

experience
*** to **** Depth dependent*

in the area
This dive is normally just one part of a dive trip that takes in the reefs of the northern Sudanese Red Sea, all of which have a great reputation, from Wingate Reef with the wreck of the Umbria, north to Abington Reef and beyond. Or you can include Sanganeb in a trip that travels down to the Suakin Peninsular with its wonderful reefs that are dived even less than those of the northern Sudanese Red Sea. All in all, a dive trip to Sudan is an unforgettable experience and well worth the effort.

Sailing north-east for 23km from Port Sudan will take you to the wonderful atoll of Sanganeb Reef. This is in fact the only true atoll in the Red Sea. The first site you reach is the 50m lighthouse that was built by the British after conquering Sudan in the 1890s. This was and remains a vital safeguard for ships heading to and from the port of Sudan.

WHAT WILL I SEE?

The lighthouse is located on the south of the reef, with its long catwalk leading to it. It is manned, and the lighthouse keepers normally welcome visitors and allow them to climb to the top to view the wonderful vista of the atoll with its turquoise shallows and the deep blue of the deeper waters.

The north plateau is a dive for advanced divers. It is normally approached by inflatable while the main dive boat moors in the sheltered waters to the south. Grey sharks, blacktail sharks and hammerheads can be found here if the current action is right but this makes for an energetic dive and most shark action will be found at 45-50m.

The south-west plateau is the most famous dive at Sanganeb, with its sheer walls dropping down to 800m, and it is on this site that we will concentrate.

THE DIVES

The dive would normally start on the western side, where you can drop down to the plateau at 25m. If you are prepared for it, you may wish first to drop down to 40m with the chance of encountering scalloped hammerheads. From there, head back up to the plateau. This sandy area is interspersed by coral pinnacles decorated with beautiful soft corals in various colours from red to pink to purple, whip corals, gorgonians,

ON DRY LAND
As mentioned, there is the opportunity to visit the lighthouse and a climb to the top to see the wonderful view across the atoll is well worth the effort. The lighthouse keepers welcome visitors from dive boats and usually have a good rapport with the crews of the dive boats that serve these waters.

If your journey takes you via Port Sudan, it is possible to arrange visits to markets in the town as well as escorted trips to the ruins of Suakin Harbour, founded in 600AD.

Some 44km from Port Sudan is Marsa Fijab, a natural harbour where many birds shelter and nest, including ospreys, little egrets, kites and spoonbills. There is also

Marsa Inkelfal, a sheltered coastal area that offers opportunities for walks to take in the desert vistas and the white beaches that contrast with the blue waters.

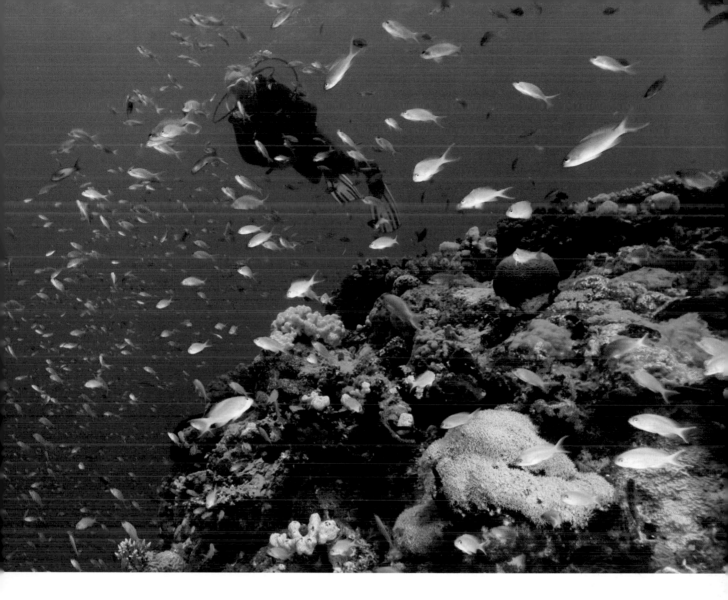

sponges, bryozoans and clams. The reef is rich with marine life, including scorpionfish, red hind groupers, grunts, parrotfish, triggerfish, sweetlips, bluefin and bigeye trevallies, squirrelfish, jacks, bluespotted stingrays, freckled, pixie and longnose hawkfish, pufferfish, butterflyfish, anemonefish and damsels with their adopted anemones. Glassfish will be found on some of the pinnacles and there are large shoals of anthiases all over the reef. A large stingray may be found resting on the sandy bottom and you may hear before you see a shoal of resident bumphead parrotfish charging across the reef in a cloud of coral dust like a herd of underwater buffalo, as they feed by taking bites out of the corals and secreting the calcium carbinate as sand.

Shoals of blackfin barracuda are frequently seen, as well as great barracuda. Although the north plateau is the main dive site for sharks it is well worth keeping an eye out toward the blue water as it is not unusual to spot grey reef sharks, blackfin sharks and even hammerheads prowling off the reef. Manta rays and turtles are also seen occasionally. As you work your way up the wall towards the end of the dive, you are sure to find surgeonfish darting to and fro in the shallows.

This dive site deserves its reputation as one of the greatest dive sites in the Red Sea.

HOW DO I GET THERE

Flights to Cairo and onward flights from Cairo to Port Sudan. From there by liveaboard. Alternatively, liveaboards from southern Egyptian Red Sea ports such as Marsa Alam. This option has been somewhat intermittent in the past, due to the changing attitudes of the Sudan authorities in giving approval for these boats to enter their waters. (At the time of writing this seems to be available, with the boat needing to visit Port Sudan to obtain necessary paperwork. A departure tax is charged by the Sudanese authorities.) Some international flights serve Marsa Alam but it may be necessary to fly via Cairo, depending on the outgoing location.

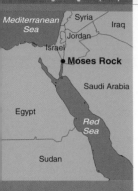

Mediterranean Sea
Syria
Iraq
Jordan
Israel
Moses Rock
Saudi Arabia
Egypt
Red Sea
Sudan

maximum depth:
9m

minimum depth:
0m from shore

access
Shore dive. Approx 400m swim from beach.

average visibility
20–30m

water temperature
Always above 20°C (68°F)

dive type
Reef dive

currents
Normal

experience
* to ***

in the area
The Japanese Gardens are south of Moses Rock and are normally accessed by dive boat. The depth varies from 12–47m. Dives are restricted each day by the authorities but is well worth the effort as it is a stunning site with an abundance of marine life.
Dolphin Reef offers an opportunity to dive with the resident dolphins in this vast enclosure.
Other local dive sites include the Eel Garden, Satil Wreck, Yatush Wreck, Paradise Reef, The University (where marine biologists are experimenting in ways to enhance the growth of corals), The Caves, Lighthouse Reef, and Neptune's Tables. Dive safaris can be arranged all the way down the Sinai coast,

MOSES ROCK

Holy Moses! Paradise in 9m of water

Eilat is probably one of the earliest established dive sites in the Red Sea area. Located at the northern tip of the Gulf of Aqaba, it has easy, shallow diving but that is deceptive. It attracts thousands of divers each year, but is well managed and still offers fantastic dive opportunities, including the beautiful Japanese Gardens and Dolphin Reef. Moses Rock is world famous and deservedly so.

WHAT WILL I SEE?

Eilat is a vibrant, lively and cosmopolitan resort and has been an established dive location for many years. It is particularly popular with novice divers who can take well-organised basic courses there to learn to dive. It has shallow sites for easy diving, but don't be deceived by that. The abundance of marine life and beautiful coral gardens make it very popular with more experienced divers too, as well as underwater photographers, who can spend long, relaxed dives with plenty of time to get the shots they are after.

THE DIVES

There are numerous dive centres along the beach and, with directions from the local guides, Moses Rock is easy to find. The closer you get to the area, the shorter the swim time to the site. From the nearest entry point, Moses Rock is reached by a swim of about 400m. This is in shallow water and there is plenty to see on the way, so there is no need to rush. The beach area that offers the shortest distance is within the Coral Reef Nature Reserve, which runs from the Ambassador Hotel to the Underwater Observatory. It is no problem if you are

ON DRY LAND
Eilat has a large variety of international restaurants as well as many bars, cafés, shopping malls, boutiques and nightclubs. A visit to

the Coral World Underwater Observatory will give you an opportunity to view the reef without getting wet. Apart from being able to see the marine life, you may also

find a diver or two looking back at you! You can take a guided tour of the reef in the Coral 2000 semi submersible.
Water sports such as water

skiing are available, as well as jet ski hire. A visit to the Marine Museum will offer plenty to entertain and interest.
Guided tours into the desert

by jeep safari, camel trek or quad bike are available, as well as many all-day trips to places such as Jerusalem, Massada and the Dead Sea.
There are also escorted

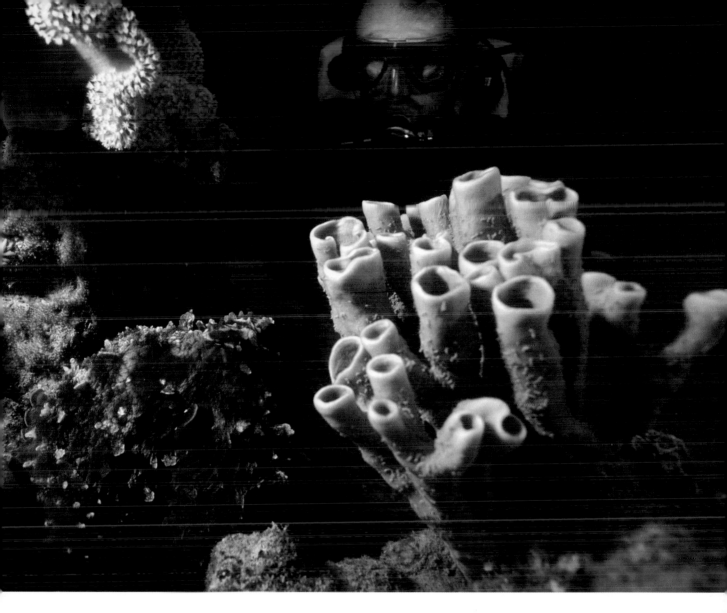

outside this area, however; simply swim down to 8–9m then turn south and follow the contour until you reach Moses Rock and, nearby, its sister, Joshua Rock. Be sure to begin your return journey with enough air, as you may well be swimming against a current on the way back.

Moses Rock is the largest coral head and from the seabed it rises to just beneath the surface. Joshua Rock is made up of three coral heads. Both sites can be achieved in one dive, although both deserve repeat dives.

Moses Rock is covered with hard, beautifully coloured soft corals. A shoal of glassfish is resident on the rock, normally accompanied by lionfish that feed on them. Being so close to the surface, it offers amazing photographic opportunities and the rays of the sun can add drama to your pictures.

You will find all sorts of fish among the corals, such as scorpionfish, groupers, shoals of anthiases and sergeant majors, morays, clownfish and goatfish. Keep your eyes open through the dives and you may well come across broomtail wrasse, blue spotted ray, humphead wrasse, stingray, octopus, barracuda, crocodilefish and much more.

tours to Egypt (for example, to St Katherine's Monastery) or Jordan, where you can visit Petra, as well as cruises in the Gulf of Aqaba.

Dolphin Reef is a massive enclosure where you are able to watch the dolphins, and swim, snorkel and dive with them.

HOW DO I GET THERE
Domestic and international flights to Ovda (Eilat) Airport. Car rental, limousine and bus services from airport or transfer by hotel services.

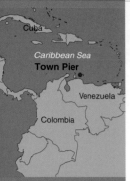

Caribbean Sea
Town Pier

Cuba

Venezuela

Colombia

maximum depth:
0m

minimum depth:
12m

access
Shore dive

average visibility
Can exceed 30m but
depends on activity

Water Temperature
25.6°C–28.9°C

dive type
Shore dive

currents
Little current

experience
** to *** with night
dive experience.
Novice for day dives
but good buoyancy
control essential.

in the area
There are more than
60 moored sites all
along the west coast
of Bonaire so you
are spoilt for choice
for dive sites. The
fringing reef system
makes for easy diving
whether you go from
a dive boat or hire a
vehicle. Just to the
west of Kralendijk,
a small island called
Klein Bonaire also has
dive sites all round it
within easy reach of
the local dive boats.
To the south is a major
wreck called the Hilma
Hooker. As well as the
Town Pier, the Salt Pier
is another major pier
that offers great day
and night diving.
The World Wildlife
Fund provided a grant
in 1949 that made
it possible for the
Bonaire Marine Park
to be created. Now
the entire coral reef
system around Bonaire
and Klein Bonaire is
protected, making it
a great success story
in conservation.

TOWN PIER

Forget a night on the town. Make it a night under the town pier!

Town Pier at Kralendijk in Bonaire is one of the best known dive sites in Bonaire and it is especially regarded as a night dive.

WHAT WILL I SEE?

Town Pier is a working pier and, as such, the seabed around it is littered with the detritus of mankind–old tyres and other debris. (When I visited Bonaire I recall a motor car falling off the pier into the water–it was recovered!) Nature does not waste opportunities and the large pillars of the pier and the debris are all encrusted with marine life, now providing a home for many creatures. If you are a photographer, this is a macro paradise. At any one time, the wonderful colours of the sponges, corals and soft corals combine to create a painting from nature's palette. These also provide a home for many exotic creatures.

THE DIVES

Because of the restrictions on diving the pier, it is important that you plan the dive carefully with the local dive guide who will be able to arrange access. All of the dive resorts in the area can do this but with a little extra care you can ensure that you get the best out of the dive. You do not want to dive with a large number of people. A group of just two or three people is ideal for you to find it a most relaxing night dive. Your dive resort will arrange transport to the pier and no doubt you will find yourself kitting up with tourists around. Parking is available by the pier. There, you enter the water from the beach. You will meander between the

ON DRY LAND
Vehicles can be rented and are an ideal way to travel round Bonaire. The island is 39km long and between 5km and 11km wide. The capital, Kralendijk, is a very quaint, picturesque town with a mixture of architecture reflecting the Dutch and English influences. Here you will find plenty of nightlife, restaurants, hotels and shops. Salt is produced in the flat, southern part of Bonaire, in evaporation pools that create an amazing contrast of colour against the beautiful turquoise waters of the sea. Here you are likely to find flocks of flamingos. Pyramids of salt wait to be loaded onto ships for export. The remains of slave huts can be found along this part of the coast and are a sobering sight. In the north is the Washington/Slagbaai National Park, which covers

pillars of the pier, which are encrusted with sponges, soft corals, anemones and gorgonians. Among these and around the pier you will find an enormous variety of marine life and wonderful macro opportunities. It is an extensive pier, reaching out about 100m from the shore and then extending north for about another 76m. The marine life is found at all depths and you can reach a maximum of 12m at the outer limit of the pier.

There are several varieties of moray eel, such as the spotted moray, chain moray, and goldtail moray, and some special treats such as frogfish and seahorses. But there is so much more. Arrowhead crabs, sponge crabs, banded coral shrimps, lobsters and octopuses

may be seen. There are spotted and smooth trunkfish, porcupinefish and blennies. If you do your dive before sundown, you may find many other species on the 'day shift' such as trumpet fish, tobaccofish, bar jacks, squirrelfish, French and queen angelfish, shoals of French grunts, butterflyfish, pufferfish, damselfish, jawfish, snappers, and the list goes on. Orange tubastrea corals extend their polyps to feed at night, creating a wonderful display of colour. So consider a day dive with a wide angle lens here as well, as the shallow water and the sun's rays, particularly in the early morning or late afternoon, can create beautiful effects as a backdrop to this spectacular display.

some 13,500 acres. This is a wildlife preserve and in excess of 100 species of birds can be found here, including flamingos. The north is a mountainous region, with the highest point being Mount Brandaris at 240m. Just outside the reserve is the tiny village of Rincon, which is the oldest settlement in Bonaire.

As Bonaire is located to the south of the hurricane belt, it is a pleasant place to visit and dive any time with temperatures that average 28°C.

HOW DO I GET THERE
International flights to Bonaire via Curacao and Aruba or direct flights from some locations. Dive resorts

normally collect guests from the airport.

MANTA REEF

Mozambique

Zimbabwe

Manta Reef

Indian Ocean

maximum depth:
35m

minimum depth:
17m

access
Rigid hull inflatable.

average visibility
10m–30m

water temperature
23°C–29°C

dive type
Reef and drift dive

currents
Drift dive. Normally light drift.

experience
**** to *****
Advanced diver

in the area
There are in excess of 17 dive sites in the area, from Amazon in the north to Manta Reef in the south. With depths ranging from 10m to 37m, these cater for various levels of experience. New dive sites are being discovered, so there is always the chance of diving somewhere that has only recently been discovered.

It's showtime on Manta Reef!

You will often hear this dive site called a showcase dive, and it really does offer something special.

WHAT WILL I SEE?

Many of the dives in the Inhambane Peninsula can start before you even reach your destination. Be prepared to drop overboard on the way, should a whale shark happen to pass by, which is not unusual. There are dive sites to suit all dive standards here, but most of the offshore sites are more suited to advanced divers; currents may be encountered at these reefs, and negative buoyancy entries are often the order of the day to get the group onto the dive site.

Manta Reef is so named as there are three cleaning stations here. But it offers much more than this, not least the wonderful shoals of fish that are not panicked by close encounters with divers.

THE DIVES

Manta Reef is the most southerly of those marked on the peninsula and, depending which resort you are with, it can be a 20km boat ride on rigid hull inflatables.

Once you arrive at the Manta Reef site, the group will enter with negative buoyancy to get down to the reef at about 26m. The dive guides have a well established procedure to ensure groups keep together within visibility. These are offshore reefs and there are currents, so good dive practice is absolutely essential. You will normally

ON DRY LAND
The Inhambane peninsula has some of the finest beaches in Mozambique. Inhambane itself is an historic town founded by

Vasco da Gama in 1534. It is the third biggest port in Mozambique, has some interesting architecture and is very atmospheric, with friendly people.

Safari packages are available into South Africa to visit the Kruger National Park or other private safari parks. Maputo is the capital of Mozambique and, although

it has suffered in recent wars, it is interesting to explore the shops, restaurants and many places of interest.

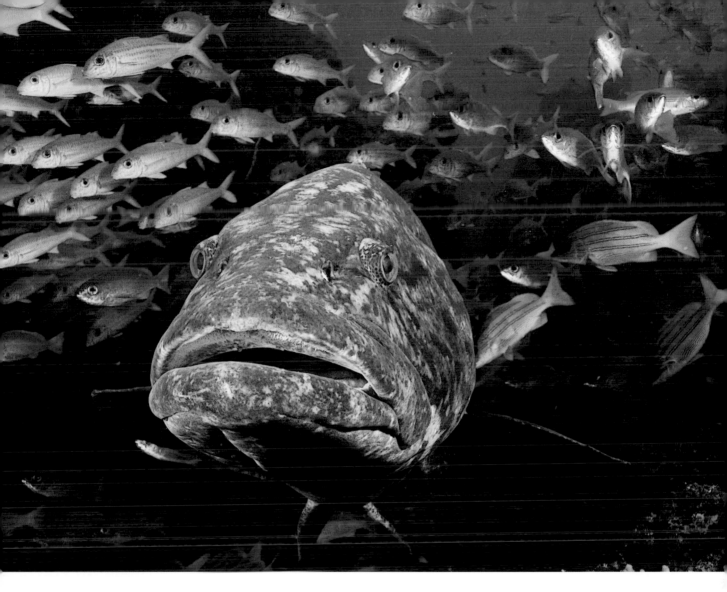

drop into a small amphitheatre, where you get your first understanding of why this site is so special as it is teeming with life. The outer edge of the reef drops to 35m (17m at its shallowest). This is a large reef and you are limited by bottom time, as there is no wall to make your way slowly to the surface. So repeat dives are the best way to take full advantage of all this site has to offer.

The reef has a series of pinnacles, many walls, overhangs and small caverns. Large schools of yellow snapper, goatfish, barracuda, fusiliers, triggerfish, trevally, goldies and fairy basslets can be found here, and shoals of bigeye fish. Large potato groupers, normally accompany schools of snapper or goatfish, which they no doubt prey upon.

There are endless species to find here, including trumpetfish, frogfish, flying gurnards, sea moths, long horned box cowfish, longnosed hawkfish, numerous species of eels such as giant moray, honeycombe, geometric, and whitemouth moray, banded sweetlips, pufferfish, scorpionfish, clownfish and crocodilefish.

The reef has beautiful soft corals and many invertebrates, including up to 13 species of nudibranchs, including Spanish dancers, bonded and emperor shrimps, cowries, and crayfish.

Devil rays are also regularly seen on the reef, and occasionally whale sharks, whitetip sharks and eagle rays.

HOW DO I GET THERE

Flights via Maputo or Johannesburg to the small airport at Inhambane. Buses also run from Maputo, and you can travel by car from Johannesburg. Some dive organisations provide two-centre arrangements to dive South Africa and Mozambique.

PALANCAR REEF

Experience a dive through the deep ravines, tunnels, caves and canyons of this giant coral mountain

Palancar Reef was first discovered by Jacques Cousteau in 1954. It covers an area of 5.6km with depths ranging from 10m to 25m, after which it drops off at the edge of the continental shelf into the abyss. The diving is off shore to the south-west of Cozumel Island, the most famous dive site in Cozumel.

United States

Atlantic Ocean

Gulf of Mexico

Cuba

Palancar Reef

Caribbean Sea

Colombia

maximum depth:
40m

minimum depth:
5m

access
By dive boat from any of the dive centres on the island. Liveaboard dive boats also visit the island.

average visibility
30–60m

water temperature
Winter: 25°C
Summer: 29°C

dive type
Reef dive

currents
Mild to strong

experience
** to **** Depth dependant

in the area
The highest concentration of dive sites, including Palancar Reef, are in the south west, so that is the ideal place to be located and there are a good selection of hotels there. If you want to stay closer to the main town, the dive operators will provide transport to the various dive sites around the island.

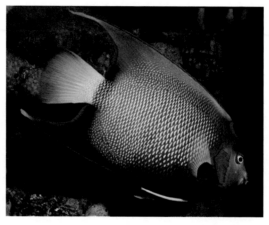

WHAT WILL I SEE?

With 5.6km of reef to cover, you are not going to do it in one dive but you will surely want to go back again and again. In fact, there are 40 different dive locations you can start from on Palancar Reef (at Palancar Caves, Palancar Deep, Little Horseshoe, Big Horseshoe, Palancar Gardens and La Francesca) so make time to do justice to this vast coral mountain. You will journey through deep ravines, tunnels, caves, canyons and arches in this wonderful three dimensional world, covered with corals, soft corals and sponges of many varieties, making it very scenic and colourful. Add the variety of other marine life that you are likely to see there and you will soon begin to understand why Jacques Cousteau returned many times to dive this reef.

THE DIVES

The first thing you are likely to notice is the wonderfully clear water. Visibility is normally 30-60m and the turquoise water is usually warm enough for just a shorty wetsuit! Depths can range from 5m to 40m depending on the area you dive. As you explore the wonderfully rugged and varied reef, you are likely to encounter many species of fish, including angelfish (French, grey and queen), goatfish, snappers, parrotfish, porkfish, grunts, damselfish and large grouper, including tiger grouper. Look out also for guitarfish and reef sharks, sea turtles, eagle rays and yellow spotted stingrays. If you are lucky, you may encounter a manta ray or nurse sharks. Crayfish may also be seen under the rocky crevices. On the outer edge of the continental shelf, you may find black corals at the deeper parts. There is a variety of sponges and some, like the elephant ear sponge, can grow to up to 3.6m across. You will also find barrel sponges, stovepipe sponges and yellow tube sponges, all of which add colour to the reef.

Another treat is to dive on a bronze figure of Christ that has been erected underwater. It stands in 17m of water and rises to just beneath the surface.

ON DRY LAND
Cozumel is the largest and most densely populated island in Mexico. There are some Mayan ruins to explore in both the north and the south of the island; you need to go to the Yucatán Peninsula on the mainland for the famous sites. The Spanish invasion affected Cozumel as it did the rest of Mexico but it is now a pleasant and peaceful place.

Measuring 53km long by 14km wide, and situated about 20km off the east coast of the Yucatán Peninsula, the island is the shape of a teardrop. Its only town is San Miguel de Cozumel, and it is here that you will find the most nightlife, with bars, restaurants, clubs and shops. San Miguel de Cozumel is located to the north-west of the island and the airport is close by. There are beautiful beaches to the south-west

and along the east coast. San Miguel de Cozumel has a small but excellent museum, where you can learn about the island's fauna and flora as well as its history. For golfing enthusiasts, there is a golf course designed by Jack Nicklaus. For non-divers, Atlantis Submarines offer an excursion to take tourists to glimpse this underwater world without getting wet. Boats can be chartered to go deep sea fishing. There are also facilities on the island for many water sports, such as sailing, kayaking and para-sailing.

HOW DO I GET THERE

Flights to Cozumel International Airport or via cruise ship.

Pacific Ocean

Philippines

Manado

Indonesia

Banda Sea

Papua New Guinea

DEPAN KAMPUNG

Indonesian reef diving at its best

Literally meaning 'in front of the village', Depan Kampung offers quite a variety in underwater Bunaken diving terrains.

maximum depth:
30m

minimum depth:
5m

access
The reef is 18km north of Manado Bay, a 40-minute journey by day boat. Liveaboards are also available. Diveable all year round, but can be rough from January to March. May to November has the best visibility.

average visibility
10m–50m

water temperature
25°C–30°C

dive type
Vertical reef wall drift

currents
Medium to strong

experience

in the area
Tanjung Kopi
Bunaken Timur
Tanjung Parigi
Alung Banua
Fukui Point
Mandolin Point
Raymond's Point
Sachiko's Point
Mike's Point

WHAT WILL I SEE?

Depan Kampung is located at the southern tip of Bunaken Island.

Indonesia has become well known for its rare and endangered species, and in particular for its muck diving in dark sand and rubble. This area also boasts beautiful tropical reefs and walls, and Manado is a good example of a great reef. Much reef life can be found here. As expected, Manado adds its own twist of magic with new endemic species often being discovered. Scorpionfish seem more colourful and varied here, and include the white leafed scorpionfish, and many rare species of ornate ghost

pipefish can also be seen here on the reef. Frogfish have their place away from the rubble and are equally hard to spot on sponge and coral; ribbon eels, in black or striking blue and yellow, may be seen sticking their heads out of their coral holes.

If you still need a reason to come to Manado, new dive sites are discovered here every year by local divers, and you might explore a virgin reef with them. The waters of the Bunaken National Marine Park offer some of the greatest levels of biodiversity on the planet, and world class diving. Mandarin fish are an amazing sight, particularly at night. Cockatoo waspfish, brown dottybacks and Picasso tobies have grand names and are bizarre looking; they, too, have their home here.

You are likely to encounter marine life here that you have not come across elsewhere.

THE DIVE

Starting your dive on the wall to the west, you can drift along at a healthy pace admiring the vast numbers of pretty pyramid butterflyfish, black damsels, and juvenile redtooth triggerfish in their hundreds. Many neon and yellow dash fusiliers are scattered everywhere, reflecting light near the surface and showing as dots of silhouettes when viewed from beneath.

About halfway through the dive, the wall gives way to a steep slope dominated by branching green cup corals and pink hydroids. You may see plenty of yellow margin triggerfish, gilded triggerfish and angelfish along the way. The blue gilded angelfish has luminous orange markings and is quite distinctive. Weird creatures share the habitat of reef and muck, small spiny devil fish and many species of scorpionfish blend into the reef or seabed. Broadclub cuttlefish and long, elegant bigfin reef squid propel themselves along the reef, looking psychedelic at night. The cuttlefish also change colour rapidly, responding to their surrounding environment and predators. Too much pressure and they are gone in a puff of ink.

The wall contains many vertical crevices and canyons, and there is much to explore. Beyond the coral are sea grass meadows; here, the mimic octopus or even rarer wonderpus octopus may be observed. There is an immense crinoid community in these waters, and a diver not used to discovering such things will need a dive guide to show them the shrimps, crabs and gobies that hide within the crinoid's body and arms.

Both ornate ghost pipefish and robust ghost pipefish look like coral or sea grass, hanging vertically to fool predators. The shy, retiring pygmy seahorse is ever so tiny and may be found at around 30m on a particular coral patch.

ON DRY LAND
Trips can be booked along the Tondano River, and even the journey there is very scenic. Go on a tour of the Tangkoko Nature Reserve, where you can observe unique animals and plants. Exotic birds and small primates live in the beach forest.

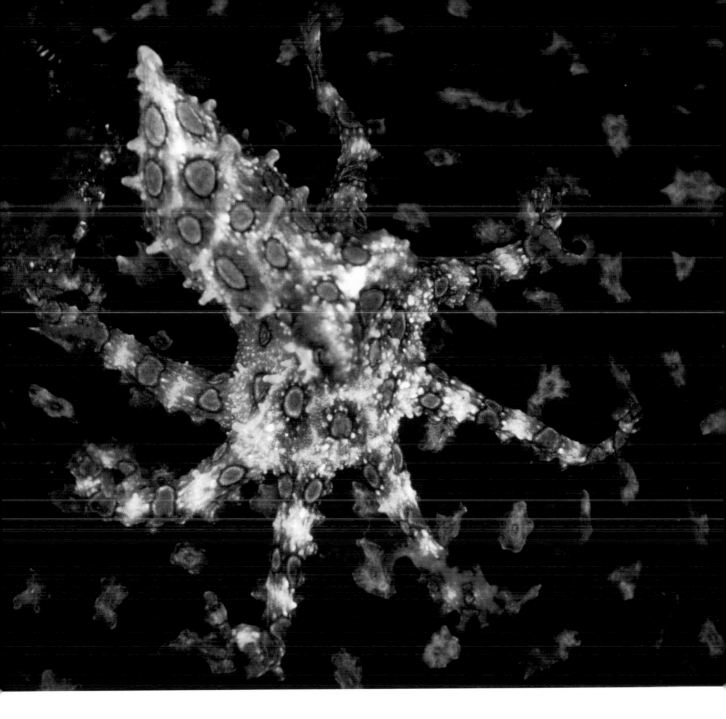

Many poisonous creatures dwell here too: weedy scorpionfish, blue eyed stingfish, waspfish and leaf scorpionfish. The strange looking stargazer shows only an ugly face above the sand.

Lose yourself in the amazing variety of species, with the bonus of a beautiful coral reef.

HOW DO I GET THERE
Fly to Manado, three hours from Singapore and accessible from most international airports.

maximum depth:
35m

minimum depth:
10m

access
Best times are between March and October but the area is diveable all year round. Several operators have daily boats to these sites but it might be worth hiring a liveaboard if you wish to explore further. Access is best from either Puerto Galera or Ani-lao on Luzon. Verde Island diving is a banca trip of about 45 to 60 minutes from either.

average visibility
12m–40m

water temperature
23°C–30°C

dive type
Reef and some drift

currents
Slight

experience

in the area
Verde Island–The Washing Machine Many dive locations around Mindoro Island, accessed via Puerta Galera

THE PINNACLE

Rainforest of the sea

Volcanic bubbles rise through the table coral, providing changes in the sea's alkalinity (pH) and temperature and encouraging different species to visit the area. Corals are perfectly preserved and the marine life is prolific.

WHAT WILL I SEE?

Verde Island diving is pretty unique. There aren't many places in the world where you can not only enjoy fantastic scuba diving but also, above water during your surface interval, sometimes come across pieces of porcelain from a Spanish galleon that was shipwrecked centuries before. It offers varied diving, stunning walls and a good, lively reef.

THE DIVES

Verde Island has two excellent dive sites consisting of one magnificent wall and a very quick drift dive. It lies between Mindoro Island and the main island of Luzon. The actual passageway is called Verde Island Passage.

The pinnacle of this dive site is a huge underwater reef rising to the surface on the eastern side of Verde Island. Its deepest point is around 60m, and it narrows as it gets to the surface.

Take your time exploring the reef; there are some really healthy gorgonian fans and on occasion you may see sea snakes sleeping amongst the coral.

Begin the dive with a slow descent, taking time to admire the myriad of soft corals, fish and small creatures around you. The nudibranch or slug species look like the lettuce the sponge and algae graze on. The reef looks as lush as rainforests on land. Many trumpetfish or cornetfish hang around with their long faces, often hanging vertically or upside down to appear like the fronds of coral that grow here.

You have to watch the conditions, as the currents can be fierce at times. The dive meanders along the wall, where you can explore the fantastic corals and marine life that inhabit the pinnacle. If you look out into the blue you may be rewarded with schools of pelagic fish, which are always a bonus.

Blue spotted ray can be seen here, and a particular treat is the stargazer with its strange appearance, just visible through the sand where it buries itself to hide. Massive orange frogfish look like the sponge they hang around. Only their lure or eyes give them away. Cockatiel leaf fish sway in the swell, lying awkwardly on one side. Snake eels bury themselves deep in the sand, and colourful ribbon eels sway gently from side to side. The creatures and lush reef life provide a touch of the exotic, like an underwater rainforest.

This is a world-class dive with brilliant visibility. If you are diving in Puerto Galera, make sure you also request a day trip to dive at Verde Island.

ON DRY LAND
Your surface interval can be enjoyed on the beach with a picnic or beach barbeque. This pretty, white sandy beach has a tropical feel, with a backdrop of luscious palm and coconut trees. Here, there is something special to see: the remnants of a Spanish galleon, which can be explored. In 1620, the galleon hit the reefs on the southern side of the island in Verde Island Passage, where she sank. She was heavily salvaged in the 1960s and, while there is not much left of her now, the remnants of her passing still show up on the beach in the form of broken Chinese porcelain dating back to the late 1500s and early 1600s. While beachcombing, you will regularly stumble across pieces of broken porcelain and after major storms you may even be lucky enough to find intact plates or bowls.

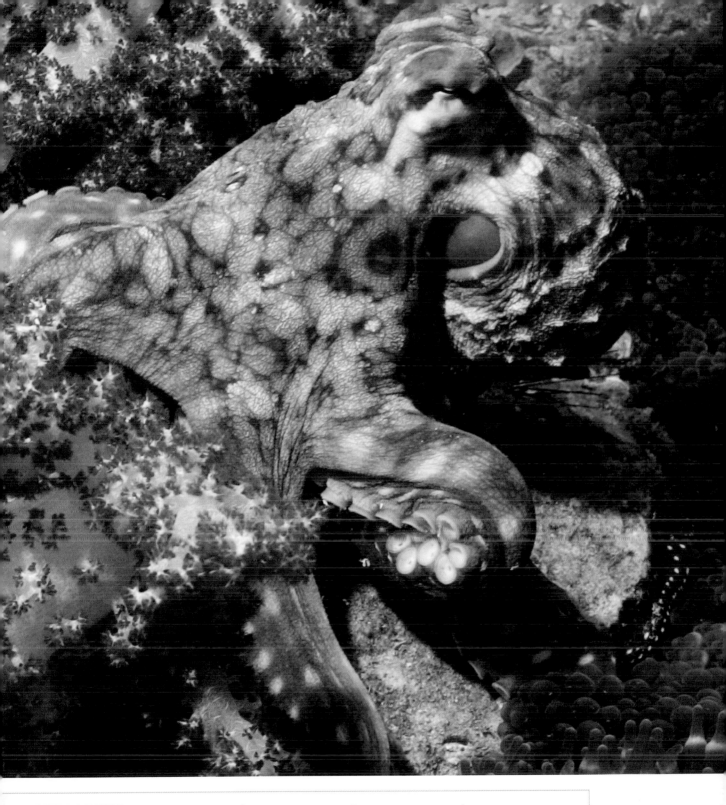

HOW DO I GET THERE

Flights via Singapore to Manila, then boat to Mindoro.

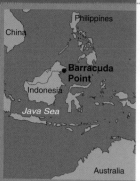

BARRACUDA POINT

The massive shoals of barracuda will set your pulses racing

Vast shoals of chevron and blacktail barracuda cruise back and forth with the current and are an awesome spectacle, sometimes several thousand strong.

maximum depth:
40m

minimum depth:
5m

access
By dive boat from neighbouring islands or liveaboard.

average visibility
20m–30m

water temperature
26°C–30°C

dive type
Drift and Reef dive

currents
Mild to strong

experience
*** to ****

in the area
There are famous dive sites all around Sipadan Island, such as Barracuda Point, Coral Gardens, Drop Off, Hanging Garden, Lobster Lair, South Point, Crest, West Ridge and White-tip Avenue. In reality, the whole reef system that surrounds the island offers great diving.
The nearby island of Mabul is larger than Sipadan and tourists stay at the water village resort. Mabul offers great diving of its own and is a famous 'muck diving' location. Similarly, Kalapai, which is basically a water village atop a reef, also offers excellent 'muck diving'. Both Mabul and Kalapai are paradise for macro photographers.

WHAT WILL I SEE?

There is no secret about the main attraction of this dive site, but even without the barracuda it is a fantastic dive experience with a great variety of marine life. Sipadan Island is located in the Celebes Sea off the east coast of Borneo. Formed by an extinct volcano, it rises 600m from the seabed. The island itself is small and you can walk all the way round it in less than an hour. but beyond the shore is a massive reef system, which is home to over 3,000 species of fish and hundreds of species of coral. Lying just five degrees north of the equator, the island has a wonderfully rich ecosystem.

Barracuda Point is at the northern tip of the reef that surrounds Sipadan. Strong currents pass through here, which is the reason for the presence of the vast shoals of barracuda and other current-dwelling predators.

THE DIVE

For you to have the best advantage in seeing and photographing the barracuda, your dive boat needs to position your entry so that you are up-water from them. You may simply be dropped in at the edge of the sheer wall in about 5m of water. Chance encounters with the barracuda mean that you may have to work hard to get close to them as they swim effortlessly along the reef. With good positioning, you can experience the exhilaration of swimming close to them and even amongst them, normally causing them to swirl like a maelstrom. Sometimes they will be accompanied by a massive shoal of jacks and together they can form a breathtaking wall of fish.

The sheer wall at the edge of the reef merges into a ledge at about 22m. You will often find whitetip sharks resting on the bottom. Reef sharks, devil rays and eagle rays may be seen, and a large group of bumphead wrasse might charge across the reef like a herd of buffalo.

Green and hawksbill turtles are a common sight and breed on the island so it is rare not to see them. They are so used to divers that you can often get right up close to them. Go deeper down into an underwater valley at 40m and you may encounter leopard sharks. It is likely that you will be able to get close to them before they casually turn and swim away.

A dive where you do not see the barracuda in vast numbers is not the end of the world. There is so much else you are likely to see; shoals of batfish and bannerfish, triggerfish, Napoleon wrasse and tuna. You may see grey reef sharks patrolling the reef and, if you are lucky, a giant barracuda, manta ray or scalloped hammerhead shark may come into view.

Among the beautiful corals, soft corals, sponges and hydroids, there are clownfish in their host anemones, parrotfish, anthiases, butterflyfish, moray eels, groupers, lionfish, sweetlips, nudibranchs, octopus, garden eels and much more.

Sipadan deserves its reputation as one of the greatest dive locations in the world and Barracuda Point plays a great part in putting it there.

ON DRY LAND Borneo offers a wide choice of activities, including exploring its jungles and rainforest or enjoying its dazzling white sand beaches. Mount Kinabalu is the highest point in Borneo, and treks can be arranged. Kinabalu National Park was designated as a World Heritage Site in 2000.

Wildlife safaris in Borneo include opportunities to explore the riparian forest along the Kinabatangan River. The river and surrounding rainforest wetlands comprise one of the richest ecosystems on earth. Ten species of primate are found here, including orangutan, proboscis monkey, maroon langur and Bornean gibbon.

The Sepilok Sanctuary offers the chance to get close to orangutan.

Although all divers who currently dive Sipadan have to go ashore to sign paperwork,

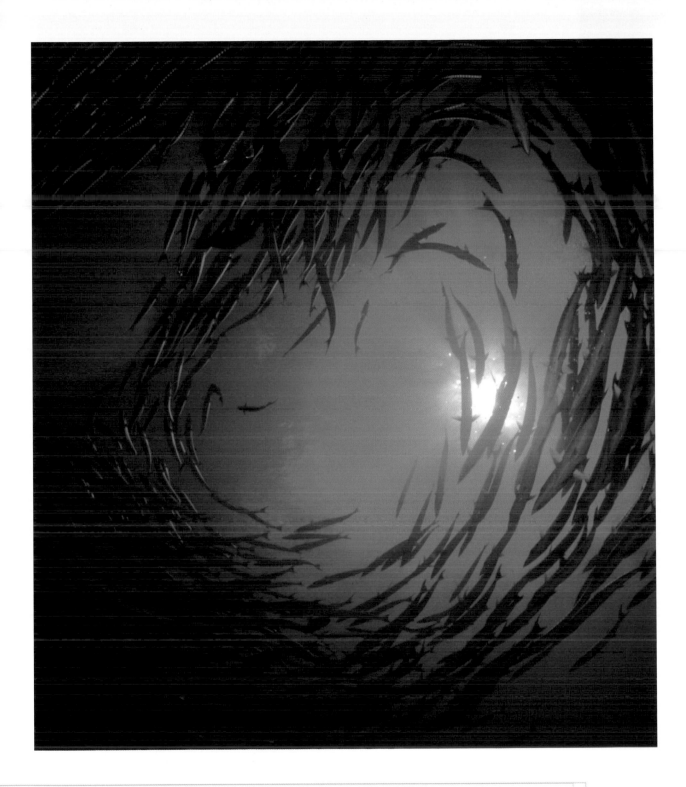

they are not free to wander around the island.

It is possible to visit Mabul Island from the water village resort.

HOW DO I GET THERE

Until 2004, there were several dive resorts on the island but the Malaysian government closed these as a conservation measure. At the time of writing, to dive Sipadan it is necessary to fly to Kota Kinabalu, travel overland to Semporna and transfer to a neighbouring island (the nearest are Mabul and Kapalai) by boat. With the closure of dive resorts, some major liveaboards now visit the island. The number of divers allowed to dive in Sipadan per day is restricted, So ensure that any booking at Mabul, Kalapai or on a liveaboard include Sipadan.

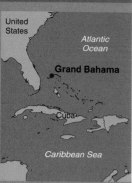

United States
Atlantic Ocean
Grand Bahama
Cuba
Caribbean Sea

minimum depth:
9m

maximum depth:
15m

access
Good climate all year round. Book a liveaboard out of Florida.

average visibility
15m–25m

water temperature
27°C–29°C

dive type
Reef

currents
Slight

experience

in the area
*Playground
Orange Cay
Last Chance Reef
Elbow Cay
Victoria Reef*

DAMAS CAYS

Enter the black abyss

The most fascinating thing about this dive is the blue hole, with its deep darkness and the anticipation of what creature may emerge from the depths.

WHAT WILL I SEE?

Situated just 50km north of Cuba, Cay Sal Bank is the most remote area of the Bahamas. With one of the highest concentrations of blue holes in the world and spectacular vertical walls, Cay Sal Bank offers exciting and exotic diving for more experienced divers.

Cay Sal Bank is a shallow plateau surrounded by the deepest, bluest water imaginable. It is separated from the rest of The Bahamas by Santaren Channel, from Cuba by Nicholas Channel and from the US by the Straits of Florida. This unique geography offers a dive with a difference.

Bahamian legend tells the tale of a mythical beast, Lusca. Half shark, half octopus, she was believed to inhabit the blue hole. The tidal currents are said to be the breath of Lusca. As she breathes in, water pours in strongly enough in some caverns to form a whirlpool, and when she exhales, cold, clear water boils to the surface. Luckily, it is pretty certain you will not meet Lusca, but you should see the real dwellers of the dark blue holes. Each cycle of the tidal flow brings enough food to nourish different species of shark, grouper, lobster and many silverside fish. Conch shells, with their strange tube like eyes, shuffle on the sandy ledge, careful not to fall into the abyss. Colourful tropical fish dart in and out of the coral. Octopus and huge basket stars come out after dark. Tons of fish spiral around the perimeter of the hole and a plethora of reef sharks call this home as well, making this blue hole dive an exciting experience.

THE DIVES

On approach from the boat, the dive site looms, a huge black circle of ocean a quarter of a mile in diameter,

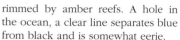

rimmed by amber reefs. A hole in the ocean, a clear line separates blue from black and is somewhat eerie.

The blue hole at Cay Sal Bank may have been formed during the ice age when the area was dry land. As the earth collapsed forming a sinkhole, a limestone substrate was exposed. Millions of years later, as water began to cover the bank, these narrow ridges of limestone became a perfect base for corals and sponges to attach themselves to. This in turn attracted many marine species.

Thanks to years gone by, divers can now enjoy the vibrant virgin coral gardens around the perimeter of the blue hole. From great depths, the rock thrusts up into a seamount reaching 9m, a mariner's nightmare. Many Spanish galleons perished here, unaware of the sudden shallowing of the waters.

Anchoring in a depth of 9m of water in a pretty coral reef, at first this appears like any other dive. Parrotfish crunch on the coral without a care in world, ignoring the huge chasm that lies just around the corner. The ridge is coated with soft coral and fans; swimming over them is beautiful, and a whole dive could be spent here. Continue across the ridge and with just a few fin strokes you suddenly find yourself in mid water with nothing beneath you. The world dramatically plunges straight down to over 1800m, although there is no definite record of its depth.

Long white strands of wire coral give the underside of the rim a ghostly appearance. Silverside fish school around the perimeter. At about the same depth, but slightly farther around the circumference of the hole, a mysterious looking white soft coral sprouts from the limestone like a gnarly beard.

Keep your buoyancy steady and slowly descend into the warm, inky water, looking up to see the amber reef

ON DRY LAND
Trips are available to island hop; there are 700 islands in the chain, 30 of which are inhabited. Wildlife habitats, including pine forests and wetlands, give the Bahamas an exotic paradise feel.

disappear and the last few lobsters watching you retreat into the darkness. Other divers above you will be silhouetted against the daylight; an awesome sight. Like a skydiver in freefall, enjoy the moment but watch your depth gauge.

Some dive centres encourage Caribbean sharks out of the depth, by weighing a tag line on the large sand ledge inside the hole. It seems that there is little life in the abyss. Perhaps strange creatures lurk below, which have adapted to the deep, and life without light.

Looking up during your ascent, the atmosphere is both fascinating and haunting. Incredible structures of stalagmites and stalactites appear before you, attesting to its history of once being on dry land. The blue hole is spectacular viewed from beneath the waves, a bright circle framed in black, decorated with chandeliers of bubbles. Ascend with the expanding bubbles and the colourful reef comes into view before your very eyes.

HOW DO I GET THERE
Flights via the US, typically Miami or Freeport. The main airport in Bermuda is Nassau

STEPPING STONES

Rare beauty concentrated on the Barrier Reef

Known as the heart of the Great Barrier Reef, this area is less frequented by sport divers than others, resulting in dive sites with better variety, less crowds and more pristine diving.

maximum depth:
40m

minimum depth:
12m

access
Day cruises aboard fast, comfortable catamarans and specialist dive/snorkel boats include Hardy and Bait reefs in their dive itineraries.

average visibility
30m–40m

water temperature
24˚C–26˚C

dive type
Tropical reef

currents
Slight

experience

in the area
Blue Pearl Bay
Maureen's Cove
Hayman Island
Hooks Island
Fairy Reef
Hardy Reef
The Maze
The Looking Glass

WHAT WILL I SEE?

The 74 breathtaking islands of the Whitsundays offer countless dive sites both among the islands and on the Outer Great Barrier Reef.

The Great Barrier Reef is the largest structure on Earth made by living organisms. It extends more than 2,000km from just south of the Tropic of Capricorn off Queensland's central coast, north to the coastal waters of Papua New Guinea. It has the world's largest collection of coral reefs, with some 3,400 types of coral.

Situated on Bait Reef, the Stepping Stones dive site is a great place to see massive grouper and potato cod. Coral trout, hawkfish and lionfish are but some of the species that make up the population of typical reef fish.

This great area of reef is protected, as it is home to many rare and endangered marine creatures. Divers will be amazed by the sheer volume of species here. Recorded animals living in the reef include 30 species of dolphin, porpoise and whale, six species of sea turtle and an abundance of dugongs. Then there are 15 species of seagrass, over 200 species of bird, and 4,000 species of mollusk, including the many varieties of nudibranch. Amazingly there are 17 species of sea snake, more than 1500 species of fish and 400 species of both soft and hard corals. Almost too much to take in, there are also 500 species of seaweed and marine algae, and the strange irukandji jellyfish. Certainly more than enough to occupy one dive.

Depending on the time of year, you may find yourself face to face with anything from a turtle to a humpback whale.

THE DIVE

Whitsundays Reef reveals something new and beautiful to see with every changing season. Stepping Stones is on the outer reef and conveniently is the closest reef to the mainland. This diverse dive site is made up of a series of 17 flat-topped bommies, or giant coral heads which are exposed at low tide, while seven more are submerged.

These coral topped pinnacles form stepping stones that provide many interesting channels and caves to explore. Large areas of plate coral are stacked in layers, interwoven with a terrain of blue staghorn. The vertical columns represent millions of years of coral growth that has slowly ascended almost to the surface over time. The soft and hard corals provide a structure of hiding places for marine life and many macro creatures of the underworld.

Photographers will find the grandeur of the pillar corals, myriad of colours and light patterns very interesting. Spend time spiralling around the pinnacles, some covered with glassfish, others with fans protruding far and wide. The pillars attract fish and tend to concentrate them in one area, rather than spreading them along a horizontal reef. Small lifeforms cling to the safety of the columns, attracting larger fish that dramatically dive bomb the stepping stones for a tasty meal.

The seabed's grassy area provides a soft platform for crocodilefish, spotted stingray and burrowing eels. Sea snakes forage for food, swimming to the surface for air. Coral trout open their mouths for shrimps to clean inside, hermit crabs shuffle along the coral bases,

ON DRY LAND
Soft white sandy beaches and pristine blue water invite you to relax and enjoy life on land. Many water sports activities are available, but it is worth hiking through the local rainforest or visiting Cedar Creek Falls. The wildlife is wonderful with special birds, fauna and flora. Kangaroo and koala can still be seen in the wild.

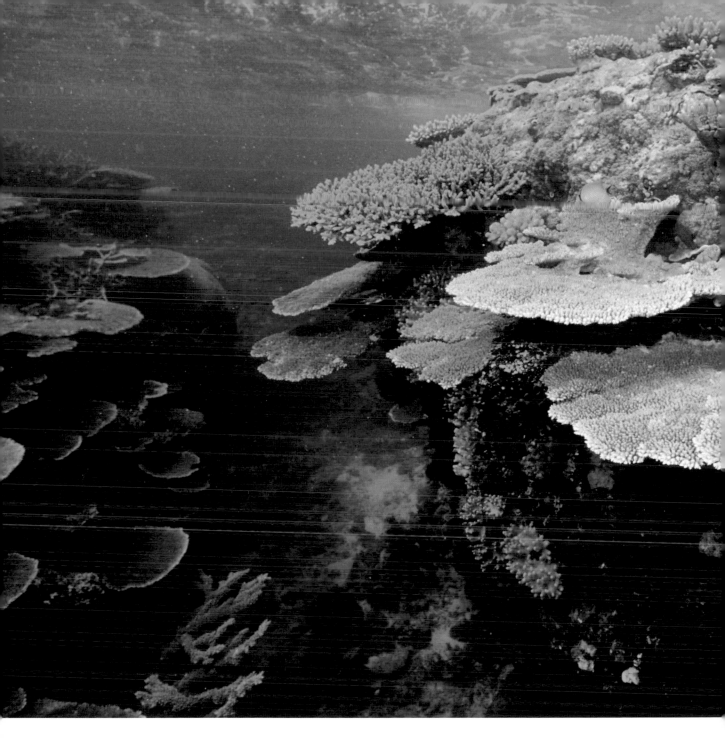

retreating into their shell when disturbed. There is enough marine life to spend all day watching it, so it is with reluctance the diver leaves this underwater paradise to return to the surface. The stepping stones make this dive an excellent choice that can be enjoyed by novice and advanced divers alike.

HOW DO I GET THERE

The Whitsundays are located approximately 1,160km north of Brisbane and 737km south of Cairns.

Fly to Hamilton Island from Cairns, Brisbane, Sydney or Melbourne. A ferry or plane can be booked to the Whitsunday Islands. Transfer to Airlie Beach, where your resort and dive centre await.

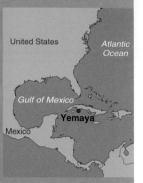

United States

Atlantic Ocean

Gulf of Mexico

Yemaya

Mexico

YEMAYA
Goddess of the sea

Maria La Gorda boasts dramatic underwater scenery, with steep drop-offs embroiled with colourful sponges and teeming with life. Yemaya is the elusive Goddess of the Sea; this stunning dive site is named after her.

maximum depth:
30m or as deep as your qualification allows

minimum depth:
9m

access
Dives are easily reached via a short boat ride from a local dive centre. Maria la Gorda has a resort on the beach within a stroll from the pier where the dive boat leaves three times a day.

average visibility
In excess of 30m

water temperature
A constant temperature of 24°C in winter and up to 28°C during the summer months. Cuba can be dived all year round, but avoid the hurricane season.

dive type
Reef and drift diving

currents
Some current, mainly gentle drifts

experience

in the area
*El Salon de Maria (Maria's Lounge)
Paraiso Perdido (Lost Paradise)
Encanto (Enchanted)*

WHAT WILL I SEE?

Maria La Gorda is a remote area on the west coast, 300 kilometres west of Havana, accessible to all divers. The island's warm, clear waters are blessed with a diversity of marine life. A chain of tall coral hillocks has formed here, cut with channels and passages. Sheer walls plunge down to depths beyond the limit of sports divers; a steady 30–35m is a good starting point to see the enormity of the reef wall and large barrel sponges typical of this area. Tube sponges in red, lilac and yellow add colour to the wall. The sea around Cuba is home to 50 species of coral and 200 species of sponge. Spectacular gorgonians, sea fans and plume worms are all there to be seen, as are sea urchins, spiny lobsters, coral shrimp and crabs on the seabed, ensuring a fascinating variety.

Turtles can also be seen in this area, sedately making their way past the more abundant species, including yellow tail snappers, groupers and angelfish; resting under ledges, you may find some nurse sharks.

Maria La Gorda is particularly noted for its brightly coloured coral formations. The underwater scenery is varied, often dramatic, with plummeting and vibrant walls, wide plateaus, channels and pinnacles.

THE DIVES

Yemaya is a diverse dive site. At 9–14m, you descend through a hole, or chimney, in the reef. The rock walls surround you, then it quickly opens up into a colourful canyon. Like a parachutist you glide down, admiring

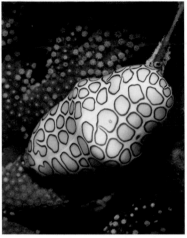

the views around you. At about 30m you can level off and swim along the wall. The largest barrel sponges are around 32–36m, a phenomenal sight as they hang out from the wall. Tube and vase sponges bulge out of the reef wall; they have a built-in filtering mechanism, which takes bacteria from seawater, contributing to the excellent visibility. The sponges offer a home to various small animals including gobies, blennies, brittle starts and shrimps.

Hanging out from the wall to feed in the current are different types of sea fan at various depths, growing between one and five feet tall: sea rod gorgonian, common sea fans and deep water gorgonians with their skeletal like pink stalks. Colour continues on the wall all the way up to the shallows. This site has many small caverns, tunnels and swim-throughs encrusted with feathery coral; shoals of small fish dart about, enhancing the view further. It is hard to look away from the awe of the scenery and concentrate on the macro life; there are nudibranchs and Christmas tree worms, and flamingo tongue snails can be found resting on small fans or whip coral. These small animals have a beautiful mantle–actually tissue–covering their shell to protect it.

Bigger shoals of fish, grunt and snapper are found on the shallow dives; here the scene changes, with lovely white sand and dappled sunlight providing a nursery for fish, ray and macro life. Each dive site in the area continues to delight the visiting diver as each one brings vibrant energy and colour.

ON DRY LAND
Cuba's people remain warm and friendly, and are very welcoming to tourists. The country has an intricate political history. Old Havana reveals the capital's rich past with its historic buildings and musical cafes. You can't pass a busy street in Cuba without seeing a car from the 1940s or 1950s, perhaps an old Cadillac, a Chevy or other American cars imported before the US embargo. It is rumoured that, because of economic shortages, the old cars' brake fluid is made from shampoo, alcohol and brown sugar. The area surrounding Maria la Gorda is a national park with wonderful views and exotic wildlife.

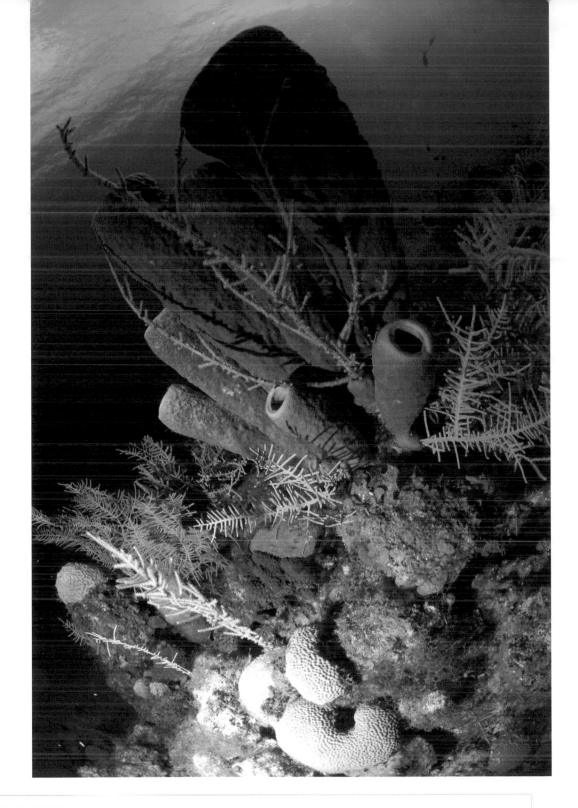

HOW DO I GET THERE

Havana's Jose Marti airport is a five-hour drive from Maria la Gorda, organised through a travel operator.

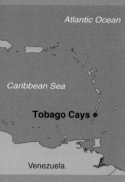

Atlantic Ocean

Caribbean Sea

Tobago Cays •

Venezuela

maximum depth:
23m

minimum depth:
6m

access
Land based access by day boat from Tobago and Grenada, or a week's liveaboard trip. There are two approaches to Tobago Cays by sailboat from Mayreau, from where total travel time is about 45 minutes. Speed boats can pick you up and transfer you to the dive spot in minutes. Local dive boats will come and collect divers from their sailing boats–a good service if you are not land-based and can combine a sailing holiday with diving. Once moored, you can radio the local dive boat from your mooring in Tobago Cays. You will be picked up and delivered back to your yacht, and the dive centres will also bring hired kit on the dive boat if you need it.

average visibility
15m–30m

water temperature
26°C–30°C

dive type
Reef and drift

currents
Some currents, usually light

experience
*

in the area
Horseshoe Reef
Ends Reef
Petit Tabac

SAIL ROCK
Dreamcatcher

The Tobago Cays are a cluster of small, undeveloped islands guarded by an extensive shallow reef, called Horseshoe Reef. This Caribbean paradise is a place to relax and enjoy fantastic views, including a myriad of fish life.

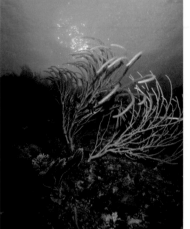

WHAT WILL I SEE?

The five cays are uninhabited and form a national park that is protected by the government, in an effort to ensure that the Tobago Cays continue to offer an unrivalled marine experience with spectacularly clear waters and shallow reefs.

Located just off the Tobago Cays, Sail Rock is the peak of an underwater mountain that barely protrudes from the ocean and is a good location to view coral and deep-water marine life. Trumpetfish whizz around, manoeuvring their bodies back and forth; shoals of yellow goatfish gather together and turtles may be seen foraging for food in the area.

Sleeping blacktip sharks, spotted eagle rays and large barracuda are usually seen at Sail Rock.

THE DIVES

Sail Rock is an exposed pinnacle, which means you will need fair weather to be able to dive the area. There can be strong currents but this also brings the advantage of more fish life.

The pinnacle has vertical walls. Start the dive by descending down the wall and exploring the various caverns and ledges, all thickly covered with coral. There is a small cave that adds to the atmosphere; you can swim through it as there are a couple of separate exits.

An old cannon lies near the cave, its background unknown. Pufferfish seem to hang out here, perhaps using the cave as cover. They can grow quite large and really have the cute factor.

Shoals of fish, stingray and other bottom dwellers may be observed. Drift along the wall, observing the sponges and whip coral protruding from the reef. Much life is present here, with a slightly greener hue to the water at depth, where it is full of nutrients.

Shoals of tuna and barracuda can be observed in open water, buzzing the reef. French angelfish majestically swim by.

As you move into the shallow water, you will find this is the best area to hang in the water and admire the life around you. The reef has a magical feel, the colours of the coral seeming more vibrant than ever. The sea fans appear more strident in colour with a strong purple hue; brain corals appear greener and the reef fish appear brighter. Large branches of elkhorn and antler coral provide a superb backdrop for the enchanting scenery. Small tropical fish swirl around the coral in a huge moving mass, the sunlight glinting off their bodies to produce a dappled light effect on the white sandy seabed.

Tobago Cays offers a crystal clear paradise where there is less hustle and bustle than on the main islands.

ON DRY LAND The Windward Islands are the south-eastern islands of the Caribbean and include Martinique, St Lucia, St Vincent, the Grenadines and Grenada. They're called the Windward Islands because they're exposed to the north-east trade winds. Hikers, birdwatchers, mountain bikers and kayak enthusiasts travel to Grenada to revel in the nation's natural beauty and resources.

Tobago has an abundance of bird and wildlife, and is known as Robinson Crusoe Island. It has the oldest protected rainforest in the western hemisphere.

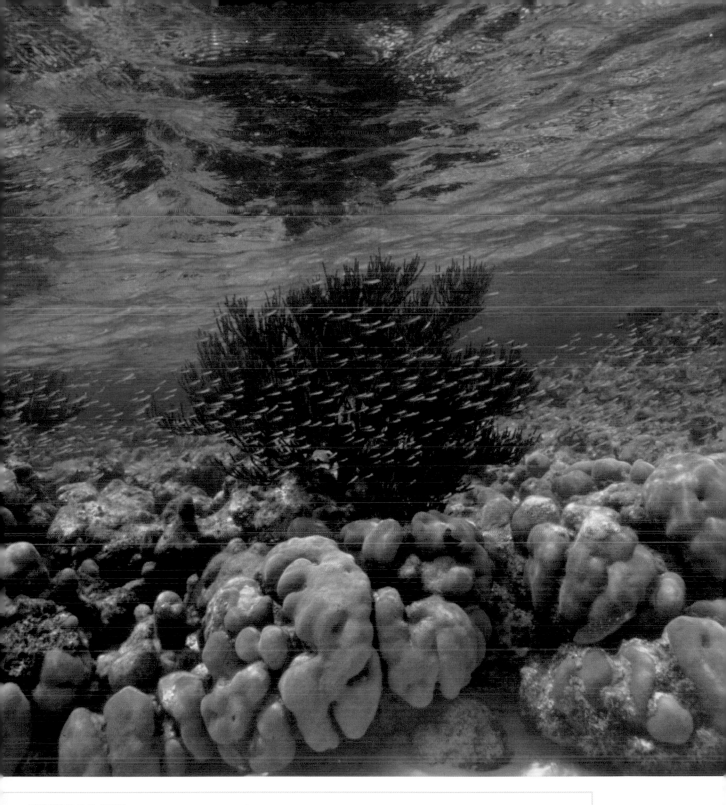

HOW DO I GET THERE
Via Grenada or Tobago.
Flights are available direct
from America and Europe.

CARL'S ULTIMATE, EASTERN FIELDS

A dive on the wild side

There can be few places in the world that offer such exciting, wild and wonderful diving as Eastern Fields, Papua New Guinea.

maximum depth:
40m

minimum depth:
18m

access
By liveaboard. The season operates from November to December, and from April to May, which is the most suitable time to dive Eastern Fields.

average visibility
40m–70m

water temperature
24°C–29°C

dive type
Reef dive, wall dive

currents
Strong currents frequently encountered

experience
*** to *****

in the area
Eastern Fields provides ample opportunities to dive sites of this vast atoll. There are about 30 dive sites accessable from Port Moresby, including the wrecks of Pacific Gas and Pai II. To the south, Milne Bay Province has in excess of 400 islands and a great variety of dive sites including renowned muck diving sites. On the east coast is Tufi, where deep channel fjords have an abundance of corals and soft corals as well as fish life and invertebrates. Further afield, there are many Papua New Guinea islands in the Bismark Sea, Solomon Sea, South Pacific Ocean and Coral Sea, including many WWII wrecks.

WHAT WILL I SEE?

You need a spirit of adventure to dive Eastern Fields. Papua New Guinea lies off the north-eastern tip of Australia and has a diverse tribal culture in which some 700 different languages are spoken. The mainland is largely covered by rainforest, and it also has more than 600 islands. Lying in an area renowned for the richness of its marine diversity, it has over 24,000 square kilometers of coral reefs, much of which is still to be explored, and is estimated to have more than 800 species of reef fish and over 350 species of coral. Eastern Fields lies some 177 kilometers to the south-west of Papua New Guinea's capital city, Port Moresby. It is a submerged atoll covering an area of approximately 155 square kilometers, and can only be accessed by liveaboard. At the time of writing, only one liveaboard, MV Golden Dawn, regularly visits Eastern Fields. But for those who seek adventurous diving, you can be certain that Eastern Fields will not disappoint.

THE DIVES

The Eastern Fields reef is formed by an ancient volcanic island, which has now been reclaimed by the sea. Being so far from land there are no river run-offs, and the reef is outside the main cyclone zone, which means visibility can reach 70m. Drop-offs plunge thousands of feet into the

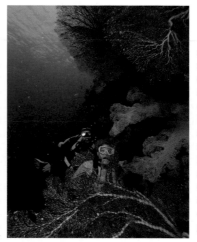

abyssal depths. Because it covers such a vast area there are many dive sites to choose from. Probably the best-known site is Carl's Ultimate. With its strong currents, the reef channel at Carl's Ultimate can attract many pelagic fish such as sharks and barracuda. You may encounter shoals of scalloped hammerheads and great hammerhead shark have also been seen there. A drift dive will take you over caverns and overhangs abundant with soft corals, barrel sponges, sea whips, gorgonian sea fans and crinoids.

Among the creatures you can expect to encounter are whitetip, grey reef, silvertip, epaulette and leopard sharks, tasselled wobbegongs, vast shoals of jacks and barracuda, groupers, Napoleon wrasses, massive shoals of bumphead wrasses, manta rays, eagle rays, fusiliers in huge numbers, horse eye jacks, big eyes, dogtooth, bluefin and yellowfin tuna, trevallies, Spanish mackerel, wahoo, potato groupers, goliath groupers, anthiases and turtles.

If, There is much macro life to see as well – nudibranchs, shrimp gobies, blennies and much more.

Other named sites at Eastern Fields are Neptune's Garden, Eastern Passage, Northern Passage, Point P, Condor Reef, Shaw Thing and No Women's Reef. However, a journey to this amazing dive location is a great opportunity to dive sites that are as yet unnamed and largely unexplored. Could any diver ask for more?

ON DRY LAND
Port Moresby is not a place that naturally attracts tourists. The town has a lot of social problems, which make some areas unsafe to visit. There are, however, some very scenic locations. There is the National Museum and some excellent art and craft shops, which make for a good half-day exploration of the town as part of an organised tour.
Out of town, high up on the mountains is Varirata National Park, an excellent place to see Papua New Guinea's birdlife and dense rainforest. The famous Kokoda Trail, which is popular with hikers, ends here. Further afield, there are opportunities for some exciting cultural tours, trekking opportunities and cruises, but these must be organised through an established travel agency. There are also numerous established

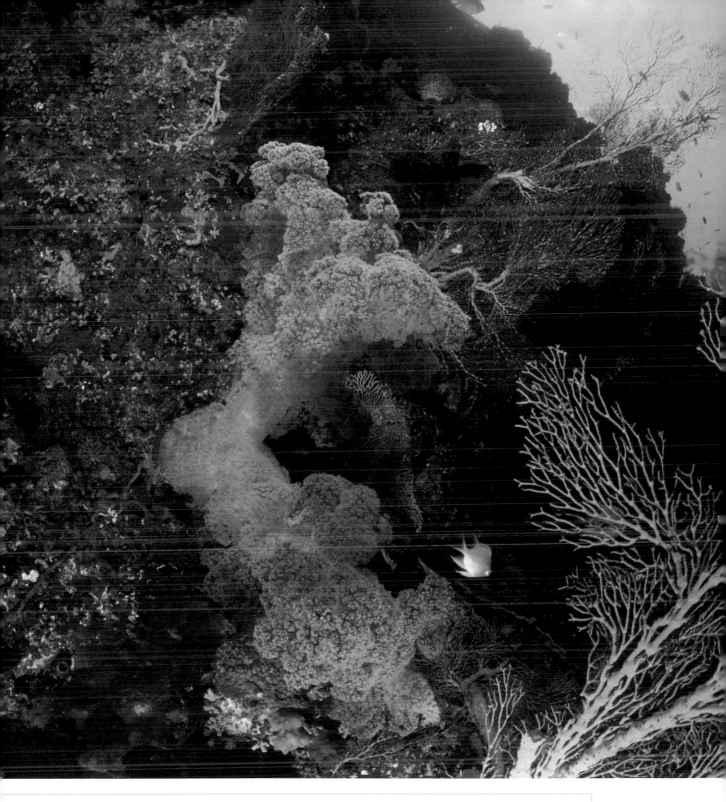

resorts such as Medang
Resort, Kalibobo Village and
Malagan Beach Resort.

**HOW DO I GET
THERE**
Flights to Port Moresby's
Jackson International Air-
port. Visas are required and
can be obtained on arrival.

The liveaboard departs from
Port Moresby.

India

Arabian Sea

Sri Lanka

● Maa Kandu
Thila

Indian Ocean

Maldives

MAA KANDU THILA

Idyllic views, as if painted on canvas

The word 'maldive' translates as 'realm of a thousand islands'. A fabulous panorama stretches out before your eyes; islands can be seen dotted around for miles, surrounded by clear, turquoise waters.

maximum depth:
35m

minimum depth:
5m

access
Accessible by liveaboard, booked through a tour operator for a seven-day dive trip. November to April is the best time, but diving is accessible most of the year.

average visibility
10–30m

water temperature
27°C–29°C

dive type
Reef and drift diving

currents
Moderate to strong currents

experience

in the area
*Dhekanan Faru
Orimas Thila
Many dive sites in the Lhaviyani Atoll
Many dive sites in the Noonu Atoll*

WHAT WILL I SEE?

A great variety of turtles can be found here in the Shaviyani Atoll. You may come across hawksbill, green, loggerhead, olive ridley and leatherback turtles in these waters, representing five of the seven known species of turtle in the world.

This site is not well known, but the local dive guides keep it as a great surprise. A huge and stunning reef, this dive offers massive shoals of fish life and endless scenery.

A wealth of soft corals to view will take your breath away. There is a good chance to see something extra special, and you may spot a sailfish or marlin swimming in the blue. Grey reef shark and large tuna also hang out here, and whale sharks and manta rays gather when conditions are right.

THE DIVES

This beautiful reef shows off is an impressive colourful wall, with huge soft corals and sea fans growing out, lit by the overhead sun. It is ideal to dive first to around 25m, checking out the largest fans and overhangs. Take time to look up towards the surface and enjoy the enormity of the outlook and scenery around you. Ascend slowly to around 14–18m, where smaller caves and overhangs reveal pretty archways. Whip coral growing out of the seabed in and around the caves provides a home to tiny blennies. Nudibranchs and gobies hide in the sponges, covering every inch of available space.

As the wall flattens, the current picks up and there are fish of all sizes jostling for space and food. Large

shoals of oriental sweetlips and blue lined snapper hang around. Honeycomb morays compete for space with the more common brown moray.

Massive shoals of red toothed triggerfish fill the reef. Black surgeonfish dart about in a massive cluster. Jacks rush in and eat the smaller fish, with barracuda and tuna also on the prowl for a meal. Large oysters and clams show off their mantles, feeding on the passing plankton as the current flows.

The resident turtles are very relaxed around divers. Periodically, the turtle will swim to the surface for a refreshing gulp of air, only to return again to its sanctuary in a small cave or overhang.

In the shallows from around 8m and less, you are greeted by the perfect scene. Even an artist would struggle to illustrate such an idyllic picture. First, blue bubble anemones lie on the coral beds. Clownfish nestled deep within its tentacles, the anemone's skirts are blown up by the current, revealing dynamic colours. Next, huge, perfectly formed table coral with mushroom heads and coral pinnacles, are scattered around the seabed. In between there is endless fish activity and colour. Shoals of juvenile fish, surgeonfish stuffed into holes: a perfectly framed picture of a beautiful coral reef. Hundreds of anthias buzz around like dots of coloured paint to complete the canvas. Lionfish, with their spines up, circle slowly on the hunt for little fish. As the night draws in, dappled light effects from the surface can be seen in the shallows. It is magical.

ON DRY LAND
The seaplane journey is a highlight, offering a great view of many of the islands and atolls in the Maldives. Kuredu is the nearest island location for watersports and relaxation. Snorkelling, canoeing, sailing and windsurfing are available. The beaches are breathtaking and accommodation excellent.

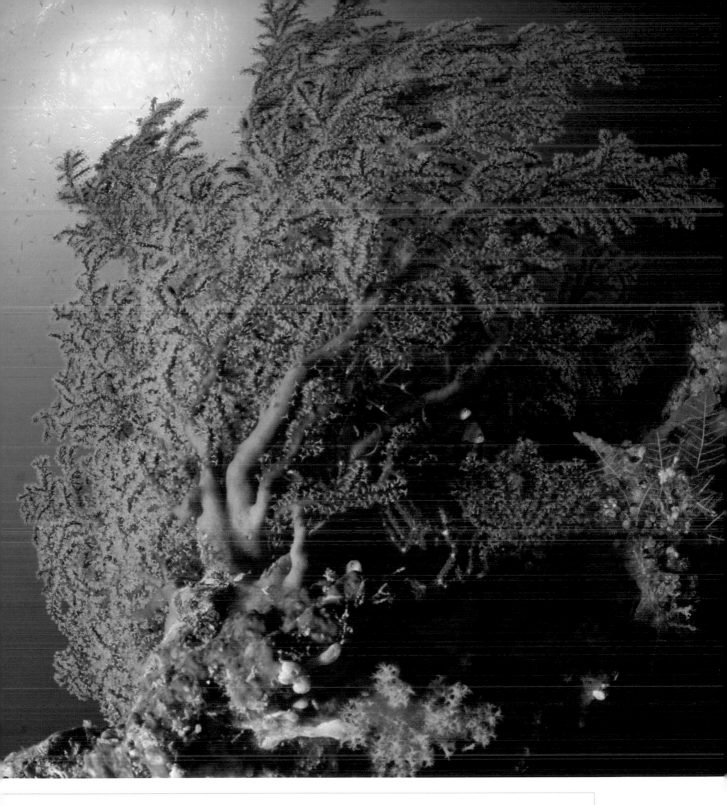

HOW DO I GET THERE

Fly via Dubai or Singapore, or there are flights direct to Male from many countries . A taxi takes you to the local seaplane terminal for transfer to Kuredu Island.

UEPI POINT

Expect the unexpected on this fabulous drop-off dive

There are few dive locations in the world where you will find as much diversity as Uepi Island. Fish galore, beautiful coral gardens, dramatic vertical drop-offs plunging down into the abyss, and big stuff too. Sharks, including hammerheads in season, rays and even orcas have been seen here. Drop-offs plunge to depths of 2000m and the waters are warm all year round, so you can dive unencumbered by wet suits as a Lycra skin is all that is needed.

maximum depth:
30m

minimum depth:
6m

access
By local dive boat from resort.

average visibility
20m–40m

water temperature
26°C–28°C

dive type
Reef dive with vertical wall

currents
light to moderate

experience
** to ***

in the area
There are plenty of dive sites around Uepi Island to keep the most ardent diver satisfied, such as Charapoana Drift, Inside Point, Uepi Pier, The Elbow, Elbow Caves, North Log and South Log, Langara Gardens, Manta Lagoon, Landoro Gardens and Monggo Passage. There is a plane wreck (USA P38), as well as two US landing craft. There was a lot of action in the area during World War II, so there are many other wrecks that can be reached.

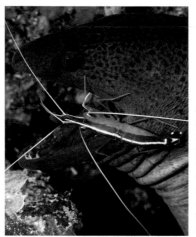

WHAT WILL I SEE?

Uepi Island is one of an archipelago of some 990 volcanic islands and atolls that make up The Solomon Islands, spread over 1,000 miles in the Pacific Ocean. This strip of land is 2.5km long and only 600m wide. Located on Marovo Lagoon, one of the longest lagoons in the world, it is a barrier reef island and the interior is largely covered by rainforest. The nutrient-rich waters are ideal for attracting an enormous amount of marine life of all sorts, and the various sites provide plenty of variety, from its world renowned walls to coral gardens, caverns and bommies.

Uepi Point is the site we have chosen to feature as it exemplifies the dramatic drop-offs to be found here. It is easy to reach, being only 100m from the island's resort. It is a site of endless surprises, whether you have your head down checking out the macro life or are looking out into the blue where pelagics can be found in vast numbers.

THE DIVES

It is best to begin the dive by descending to the point, at about 30m, and waiting in the current for sightings of large pelagics. This is where you will find the drop-off jutting out into blue water before it plunges into the depths. Here you can find large schools of barracuda, blacktip and whitetip sharks, giant travelly, schools of mackerel, tuna, big-eye jacks, fusiliers, rainbow runners and much more, both predators and prey in their relentless battle for survival. Hammerheads are often seen, as well as mantas, eagle rays and turtles. Dolphins may make an appearance and even an orca whale, sailfish and marlin have been reported, but these are bonuses and not to be expected. Once you have spent some time on the point, it is time to work your way back up and along the wall toward Uepi Pier, and you will find plenty of interest along the way. The anemones, hard and soft corals and gorgonian sea fans form coral gardens that are full of photographic opportunities. Mantis and coral shrimps, nudibranchs, including Spanish Dancers, and enormous numbers of tropical fish will delight you. At Uepi, 55 species of nudibranch have been recorded as well as 1400 species of fish and 450 species of coral. Queensland groupers and Maori wrasse are found here, as are large crayfish, cuttlefish and moray eel specimens. There are sandy areas in the shallows where fields of garden eels appear from their holes, disappearing like ballet dancers as you swim near them. Colourful gobies also inhabit the sandy areas, keeping watch and diving into their holes when they feel threatened. You can end your dive in no more than 6m, giving you plenty of time to enjoy it while decompressing.

ON DRY LAND
Diving is the main attraction at this remote island but there are beautiful sandy beaches to enjoy and interesting rain forest to explore with plenty of wildlife. Snorkelling is very rewarding and kayaking is available, including instruction in the sea, on the Chachole River and in the Marovo Lagoon, which is the largest saltwater lagoon in the world. Line fishing is available but it is very low key.

Visits can be arranged to other islands such as Chubikopi, where you can visit the local village and witness the handicraft skills of the local villagers. On New Georgia Island, you can also take a short journey up the Ohne River, which cuts through the jungle, and then walk to see a small waterfall and a natural swimming pool where you can cool off.

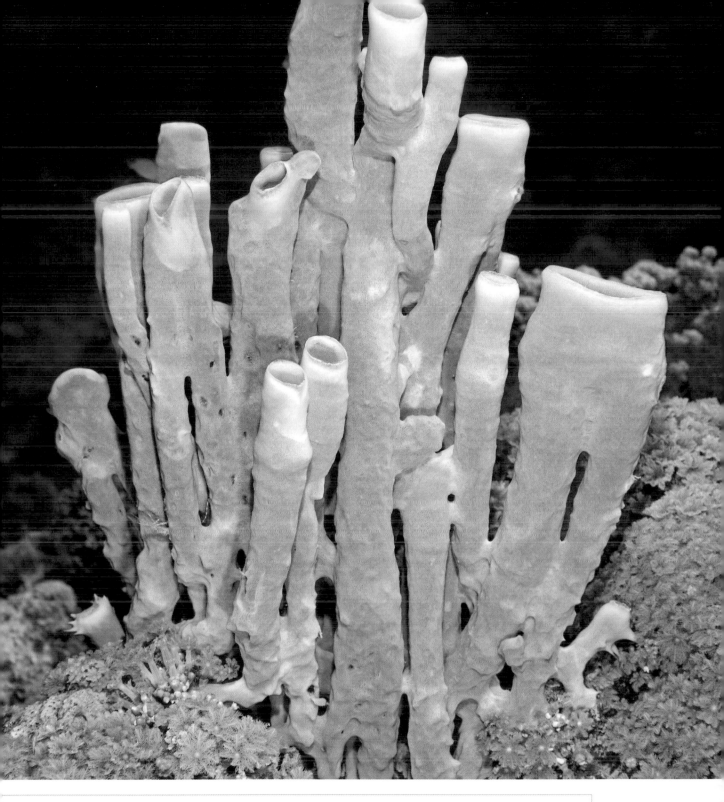

Ohne Village is very unspoilt and natural and the people very friendly and welcoming. You can visit the beautiful church in Vakabo Village and join the locals for a Sunday Service if the mood takes you.

HOW DO I GET THERE

International flights to Honiara, the capital of the Solomon Islands, and then a 60-minute flight by light plane to Seghe on the south-east tip of New Georgia. From there, you will be ferried the 12km across the lagoon to Uepi.

GOTHAM CITY

Batfish guard the secrets of the deep

Gotham City in Fiji has become a well-known and favourite dive site. Famed for providing the unusual, Gotham City never disappoints.

Pacific Ocean

Gotham

Australia

New Zealand

maximum depth:
26m

minimum depth:
18m

access
Access by a 20-minute boat ride off Mana Island, three times a day, booked through your resort. Full and half-day dive trips are available.

average visibility
20m–50m

water temperature
24°C–30°C

dive type
Reef diving and drift

currents
Medium to strong

Experience

In the area
Namotu Wall
The Big W's
Barrel Heads
Castaway Passage
Namotu Reef
The Big Blue
Wilky Wall
Wilkes Passage
Magic Mushroom

WHAT WILL I SEE?

Over 300 islands make up the Fijian group of islands, renowned for their wonderful beaches, sunny skies, and relaxing lifestyle.

Jean-Michel Cousteau called Fiji the soft coral capital of the world. It has a huge range of quality dive sites with around a thousand species of fish, several hundred types of corals and sponges and an infinite variety of macro life living in the shallow coral gardens or on deep sloping shelves. The amazing, diverse marine life includes large pelagic species such as sharks, tuna, turtles and fish of all hues and sizes. Fiji is home to the pilot whale and many other whale species, including the humpback and sperm whales, which pass through Fijian waters.

Pelagics such as blue fin trevally, Spanish mackerel, barracuda and scad mackerels are popular visitors to the dive site. The soft corals are every colour of the rainbow.

Divers blessed with good fortune may see a marlin or whale pass by in the blue.

THE DIVES

Gotham City spans the outer edge of the Malolo Reef not far from Mana Island. An underwater wonderworld, this should ideally be dived at slack water as it is often subject to quite strong currents.

The dive is characterised by two main coral heads, handy barriers if the current is a little strong. This lee provides a leisurely view of dense schools of blue striped snappers, bump head wrasses and large groupers. Giant

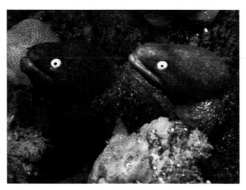

moray eels appear, the lower half of their body wound into the coral holes, the upper half looking fearsome as it wafts in the water to sense potential food in the area. The area is flushed with nutrients attracting those plants and animals that thrive on them. Fans, crinoids and small creatures start off the food chain. Larger fish then move in, creating a fantastic coral reef, bursting with life. Branches of soft coral burst out of the reef, reaching out for the passing planktonic food.

As the title suggests, Gotham City awaits your arrival with schools of batfish, which often approach the mooring as you descend. Regal in appearance, batfish swim in what appears to be a flying formation.

Sergeant major fish and the infamous triggerfish seem to dive bomb the human visitors, having become accustomed to regular diving activity.

Along the slopes of both pinnacles, expect to find hard and soft corals, and all around the reef there are schooling goatfish and brightly coloured tang. Look out for humphead wrasse and maybe a Napoleon. This is also a good place to find smaller species, including arrow crabs, tiny anemone shrimps, flatworms and a variety of colourful nudibranchs.

The nutrient-rich water often attracts cruising reef sharks, rainbow runners and eagle rays. Rare in this part of the world, the elusive guitar shark has also been seen on this site. Silvertip sharks have also been seen in the deeper areas of the reef.

Watch a beautiful sunset, and wait for the night dive.

ON DRY LAND

Sailing, windsurfing, waterskiing, canoeing, kayaking and parasailing are all popular activities across the islands. This is a good area for catching a wave, and the Cloud Breaker, the incredible six-metre wave found offshore at Tavarua, draws surfers from around the world. For land tours, there are a network of marked natural trails where you may see fruit bats, parrots and many rare orchids and flowering plants. You can also swim in numerous waterfalls found in the forests, coastal parks and reserves. If you fancy some dancing, you can watch, and even participate, as the local men perform warrior dances while the women sing, all in national costume.

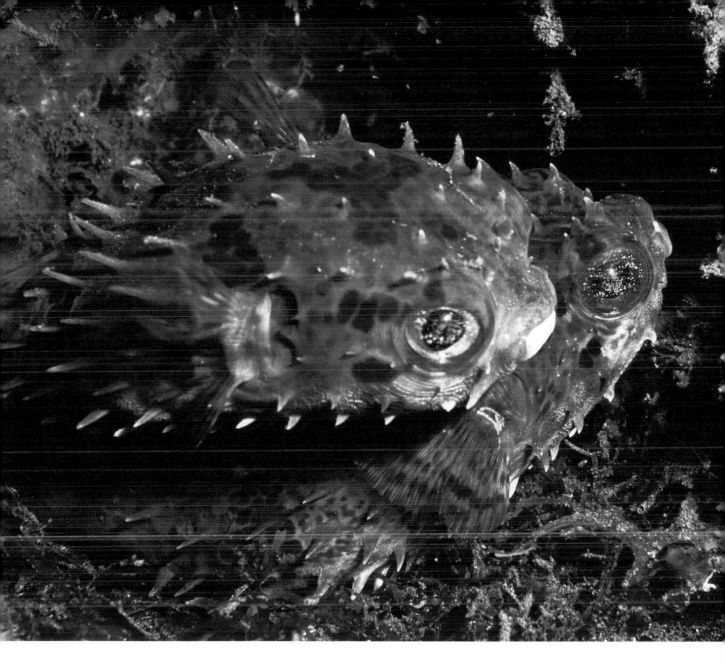

HOW DO I GET THERE

Fly from all international airports via LA, Singapore or New Zealand to Nadi airport in Fiji. Your resort on Mana Island will be a short distance away, 90 minutes by ferry, or 20 minutes by air.

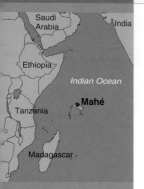

SHARK BANK

Enchanting scenery and atmosphere, above and below the water

The Seychelles form part of the world's longest coral reef system. Shark Bank is a terrific dive location attracting many pelagics to its current-enriched reef, with lots to offer all levels of diver.

maximum depth:
45m

minimum depth:
19m

access
Daily resort boats take divers out to the dive site, a short boat trip from the shores at Mahé. Many of the Seychelles island dive centres will visit this location. Diving is possible all year round but best conditions are from March to May and October to November.

average visibility
2m–40m

water temperature
21°C–29°C

dive type
Tropical reef

currents
Medium

experience
**

in the area
*North Point Rocks
L'Ilot Island
Turtle Rock
Pinnacle Point
Brissaire Rock
Vista Bay Rocks
Fishermans Cove
Reef
Dredger Wreck*

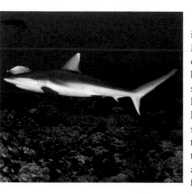

WHAT WILL I SEE?

Plantations of coconut palms and cinnamon rise to forested peaks. Surrounded by coral reefs, the clear, calm waters are inviting to divers and snorkellers alike. Mahé provides a haven for many fish species, including many types of butterflyfish and angelfish. Large numbers of batfish congregate in groups and are a pretty sight. Like a collage, the combination of bright yellows, reds, blues, greens and purples ensures the diving scenery is spectacular. Soldierfish and squirrelfish lurk in overhangs and shoals of sweepers are common on most dives, not forgetting the wide variety of invertebrates, crabs and spiny lobsters that flourish here. Larger fish species may include the Napoleon wrasse and barracuda. Small gobies and blennies are but a few of the many smaller creatures that also find a home here in the shallow sections of the dive site. Christmas tree worms in all colours are dotted around the coral heads, with their pretty and delicate looking plumage.

You may have lucky encounters here from October through to January, when migrating whale sharks visit the area, providing you with a fantastic opportunity to swim with them.

Turtles are plentiful and always a welcome sight on any dive. More secluded island beaches in the Seychelles provide them with a breeding ground to lay their eggs and hatch their young.

THE DIVES

Fast moving water enhances the dramatic, adventurous atmosphere during your dive. Shark Bank is situated in the middle of the ocean between Mahé and Silhouette, bringing current, and it is often strong. Granite boulders rise up from the sandy seabed at around 19m, and there are lots of marine animals to view at all levels of the rock formations; on the seabed, Shark Bank is renowned for the large numbers of grey stingrays that populate it. Continue weaving around the boulders and you will find a massive plateau at 30m, which provides a cleaning station for whitetip reef sharks; over the edge, the granite rocks drop further still, to around 45m. Huge eagle rays have regularly been spotted around the plateau.

Obvious by its name, Shark Bank is popular for its big fish encounters. Strong currents attract large shoals of forster's Barracuda and giant barracuda. Both eagle ray and stingray are frequent visitors. Jack fish and trevally rush in and out of the current, adding excitement to the dive.

Most notable are the incredible number of colours; yellow snappers, grunts and brightly coloured surgeonfish dash about the reef. Bigeye fish cruise around the rocks, stable against the current as you fin like crazy to keep up. Masses of soft coral colonies cover every rock, making this a very attractive dive site. The current flows also support colourful tree coral formations and fan corals. Look out for colourful nudibranchs, with their external lungs wafting in the water. Spanish dancers appear on the site, flat and colourful during the day but coming alive at night when you may be entertained by their movement through the water.

Forage under ledges to find sleeping reef sharks and ribbon tailed stingray. Try the dive again at night—it is worth the effort.

ON DRY LAND
Island hopping is a fun way to see a few of the other islands in the Seychelles chain; there are more than 150 of them. On land, there are well marked nature trails and guided walks are available. An interesting variety of animals can be viewed, including fruit bat, gecko, skink and tenrec (a hedgehog-like creature, originally from Madagascar), and the island of Aldabra has more than 100,000 rare giant tortoises. A number of watersports can be booked on the beach. Whale shark conservation trips can be booked for sighting and tagging sharks; dives are provided whilst searching for them.

HOW DO I GET THERE

The international airport at the capital, Victoria, can be reached by most international airports.

Major European airports fly direct; international visitors can transfer to Mahé from Singapore, Dubai and Mumbai.

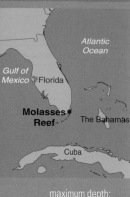

MOLASSES REEF

Roll out the barrel!

Molasses Reef got its name from a barge carrying molasses barrels that ran aground here many years ago. It is a wonderful site, with a series of buoys marking a range of depths from 1m to 14m.

maximum depth:
14m

minimum depth:
1m

access
Boat dive

average visibility
20–30m

water temperature
Approx 21°C–31°C

dive type
Reef and wreck dive

currents
Normally nil to light. Occasionally moderate and rarely strong.

experience
** to ****

in the area
There are dive facilities the length of the Florida Keys. From Key Largo, you are in easy reach of some impressive wreck dives such as Daune and Bibb (both 99m US Coast Guard Cutters), and the 155m USS Spiegel Grove. These were all sunk as artificial reefs. In addition, there are more historic wrecks such as a Norwegian freighter called the Benwood that sank during World War II, and the City of Washington, a 90m passenger cargo steamer that sank in 1917. Further south are wrecks such as the Eagle, Thunderbolt, Adolphus Busch Sr., the Tug, Alexander's Wreck and the Cayman Salvor. The world famous underwater statue of Christ of the Abyss stands in 8m of water at Dry Rocks Reef.

WHAT WILL I SEE?

A 10m steel constructed light tower is the main identifying feature of this reef, which is set at the southern end of the Key Largo National Marine Sanctuary. This reef has 33 mooring buoys, each one marking a specific dive area and, as these range from extremely shallow to 14m, it is ideal for both snorkelling and diving. Coral channels lead from shallow to deeper water and there is an abundance of marine life. Molasses is probably the most visited dive site in Florida; in fact, due to its 33 moorings, it is a complex site. The different areas of the reef have their own distinct names, clearly indicating their special interest. These include Spanish Anchor, where an 2m anchor of unknown origin can be found in the shallows at mooring M3; Fire Coral Caves; and Windless Wreck at mooring M8. The main feature here is a winch from a wooden Schooner called the Sobodana that ran aground in 1887, its remains now much scattered in the shallows. A spur and groove system leads down from the shallows to about 9m, where coral outcrops reach up from the sandy bottom, rich in hard and soft corals, sponges and many species of fish.

THE DIVES

Dives can start from any of the mooring buoys. Moorings M1 to M25 are entry points suitable for shallow diving or snorkelling. You should plan to repeat dive the area

ON DRY LAND There are parks such as Dagny Johnson Key Largo Hammock Botanical State Park and, of course, the Everglades National Park. There are also man-made beaches. John Pennekamp Coral Reef State Park offers plenty of alternatives to diving, including glass bottom boat tours, kayaking, canoeing, camping and fishing. Here is also the Coral Reef Theatre, which is a reconstruction of a living reef in a 30,000 gallon aquarium. You can visit the original African Queen from the film of the same name, and arrange a ride in it. The whole of the Florida Keys has everything: hotels, motels, condo rentals, pubs, restaurants, marinas, art galleries, theatres, wildlife tours, golf courses and much more.

as there is much to see as you work your way from the shallows to the deeper water. There are impressive coral structures such as large brain corals, elkhorn corals, sea fans, and star corals. Invertebrates such as lobsters and crabs make their homes in the caves and on the ledges, and you will find vase and rope sponges in the shallower areas, making the reef very colourful. Large barrel and tube sponges can be found in deeper water. There is a great variety of fish life such as angelfish, parrotfish, sergeant majors, filefish, grouper, snappers, jawfish, blue tang, moray eels, and chubb. You will find massive shoals of fish everywhere on the reef, including jacks, goatfish and grunts. Great barracuda are not uncommon and you may encounter turtles that feed on the sponges. Nurse sharks and spotted eagle rays have also been recorded on the reef.

Make a point of inspecting the Spanish Anchor at mooring M3, you are likely to encounter barracuda here. At M8 is The Windless Wreck, the remains of the boat that gave Molasses Reef its name, and is a good start for a dive.

The nearby Gulf Stream normally makes for excellent visibility.

This is a designated sanctuary preservation area so fishing is strictly prohibited, which helps keep the dive area in tip-top condition.

HOW DO I GET THERE

Flights to Key West Airport or Marathon Airport. From the airports, you need either car hire or organised transport. Alternatively, Greyhound Key Shuttles serve the Keys from both airports. Or arrive by sea, docking at one of the many marinas.

Belize

Bay Islands

Guatemala

Honduras

VALLEY OF THE KINGS
Majestic coral pillars reach up to the shallows

The Honduran Bay Islands are comprised of eight islands and more than 60 cays surrounded by a large reef. This reef system is one of the most species-rich in the Caribbean.

maximum depth:
38m

minimum depth:
6m

access
The dive site is around ten minutes away by day boat.

average visibility
18m–30m Reduced during winter due to rain runoff

water temperature
26°C–28°C

dive type
Reef

currents
Slight

experience

in the area
Bear Den
Peter's Place
Eagle's Nest
Fish Den
Blue Channel
West End Beach
West End Wall
Herbie's Place
Enchanted Forest
Insidious Reef
Mary's Place

WHAT WILL I SEE?

Grouper may be seen in their favourite spot, basking in the soft current. This site has good growth of black coral, and black gorgonians can be seen up and down the wall. Blue chromis and creole wrasse chase each other across the vast reef.

Cute spotted trunkfish with their clumsy swimming action bumble along the reef.

Tunicates of purple, white and yellow glow like light bulbs, illuminating the reef. Lettuce coral and elkhorn are in good supply. Clusters of Spanish, white and French grunts linger in the dips and hollows created by the hard corals.

THE DIVES

Shallow to deep, this dive provides scenery of great variety. A shallow ledge 20–30m from the surface leads to a wall with abundant shallow water fans and reef fish.

Several large pillars of coral grow along the ledge. A fascinating scene of grandeur, the slow growing coral will have taken hundreds of years to form such structures. Some have toppled from their position, new growth reaching for the sunlight in shallow waters, altering the line of symmetry. This pillar coral is rare in the Caribbean, and provides a signature for the bay islands.

As you zigzag around the pillars, you can follow the wall with a gentle drift. By swimming to the base of the peaks you can investigate the bottom life. Azure vase sponges and red and pink rope sponges fit into every ledge or crevice, surrounded by shoals of fish. Surgeonfish weave in and out of the tube like protusions. The massive barrel sponges can be found at

around 25m. Appearing dull at first, they seem to come to life as, merely by shining a torch on them, they glow a brilliant red, orange or pink.

Further round, following an S-curve, the wall plunges down to the depths, standing out like a colossal mountain. It reveals a spectacular and overgrown crevice that cuts into the wall. The entrance is jammed full of thousands of glassfish and snappers, jostling for space. This hole in the coral structure opens out onto another wall into the blue, and is a good place to see passing eagle rays.

Back along and up the wall to the shallow ledge, and you may see butterflyfish winding through the maze of marine growth, picking algae off the coral. Sand patches with large brain coral heads provide shallow sanctuary for moral eels and turtles. Currents and wave swells cause sea fans to sway, soft coral to pulsate.

At night, tiny creatures that usually go unnoticed move to the surface of sponges and coral, and coral polyps open to feed. Arrow crab and banded shrimp may scuttle away when you shine your torch on them. Thousands of minute pink worms may also swarm towards your light beam; there may be so many that they affect your visibility.

Each month, especially after a full moon, microscopic pelagis shrimps glow in the dark. Turn off your dive torch and you should see the trails of phosphorescence left behind by these micro subjects. Like shooting stars, they move and fade in and out, forming a string of light. Other night creatures such as basket star, tigertail, sea cucumber, brittle star and lobster are plentiful. So make sure you save enough energy for the night dive.

ON DRY LAND
On these beautiful islands, palm lined beaches and mountain ridges covered with pine and grass provide magnificent views, or visit the Roatan Butterfly Garden and Carambola Gardens. Many endangered birds and parrots can be viewed in the wild. Horse back riding, deep sea fishing, sailing and other watersports can be booked through your resort. A tour through the mangrove canal is not to be missed. The canal was dug to link harbours and bays in the area and now tourists can travel through its tunnels by dory, for a rare glance into a unique ecosystem only accessible by boat.

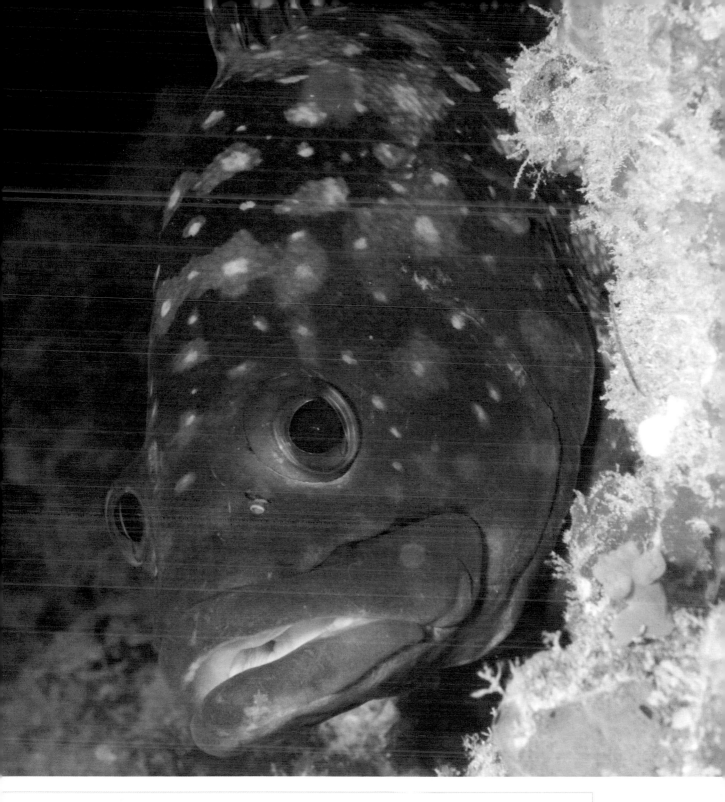

HOW DO I GET THERE
Flights to Roatan are available via Miami, Houston, Atlanta, LA and New York.

TUPITIPITI

Dive a pearl of the South Pacific

maximum depth:
60m

minimum depth:
10m

access
*By local dive resort
dive boat.*

average visibility
10m–30m

water temperature
26°C–29°C

dive type
*Sheer wall dive and
drift*

currents
*Moderate but can
reach up to 2 knots*

experience
****to **** depend-
ing on depth, water
conditions and expe-
rience with sheer
wall drop offs*

in the area
*There are many dive
sites to suit begin-
ners to advanced
divers, including:
Leopard Rays Trench
White Valley
Fafa Piti
Toopua Iti
Teavanui Pass
Manta Ray Lagoon
Outer Reef Aquarium
Toopua Coral Wall
Fai Manu Rai Channel
Te Ava Coral Wall
Toopua Iti Canyons
Oe Hiro
Opupu
Manta Rays' Dance*

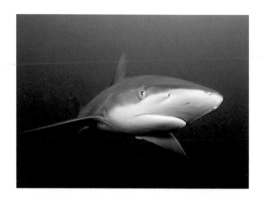

French Polynesia conjures up images of beautiful palm fringed beaches, heavenly blue lagoons and staggeringly impressive land-scapes. Bora Bora is one of these islands. It was described by Captain Cook, who first discovered it, as 'The Pearl Of The Pacific' and the author James Michener called it the most beautiful place on earth. One of his stories was the inspiration for the film South Pacific.

WHAT WILL I SEE?

The island of Bora Bora was formed more than four million years ago and is the remains of vast volcanic activity. It has a land area of only 44 square kilometres, with two towering volcanic peaks. It is encircled by a wide lagoon and a string of outlying islands and barrier reef system, which create a necklace beyond the lagoon. With its blend of relaxed Polynesian culture and French influence, it has a lot to offer the visitor, not least the diver, and there is a wide choice and variety of dive sites from which to choose. These range from manta ray and leopard ray encounters inside the lagoon to more adventurous diving beyond the barrier reef.

On the south-eastern tip of one of the outlying islands, Motu Piti Aau, is the dive site of Tupitipiti, which is considered by many to be the best dive in Bora Bora. It is not a dive that can always be guaranteed, however. Being very exposed to the ocean currents and with no protection if the seas are rough, it is one of those dives that you head for when the conditions come together. This is a wall dive *par excellence*, as the coral reef drops vertically 600m into the depths, enabling divers to choose their depth, even down to 60m with instructor agreement. It is often done as a drift dive along the reef. Occasionally, humpbacks are seen here between August and September.

ON DRY LAND
The unique beauty of this place makes it a honey-mooner's paradise and there is a wide range of accommodation from luxuri-ous hotels to more modest pensions and even camping sites. There is a good choice of restaurants and excellent opportunities for shopping, including boutiques located in most hotels. Activities include walking, biking and lagoon tours. For the really energetic, a hike up Mount Pahia will reward you with breathtaking views. A less vigorous option is to take a helicopter tour of the island. Snorkelling is very rewarding here as there is plenty to see in ideal calm conditions in the lagoon. Other activities include game fishing, horseback riding, 4x4 safaris, kite surfing, jet skiing, parasail-ing and mountain biking. Dotted around the island are

THE DIVES

Sometimes just called The Wall or The Labrynth, this is an advanced dive where you dive on a sheer wall with nothing but eternal blue below you and the open ocean at the surface. Depending on the strength of the currents, it may necessitate a drift dive. Drifting with the current can be effortless and it is a dive not to be missed; it will probably leaving you wanting to experience the exhilaration of it more than once, if possible. The wall is covered in hard corals, branching corals and colourful sponges and is festooned with all kinds of fish such as butterflyfish, snappers and sweetlips. Sea fans are rare in most of French Polynesia but you will find them on

this reef. Continue around the wall at a constant depth, enjoying your dive. As you descend, you will see caves and gullies for you to explore. Swim throughs can be explored, enabling you to duck out of the current and also providing nooks and crannies for some of the inhabitants of the reef. As you drop into the deeper waters, there are large schools of golden and bluefin jacks and snappers. Here you may encounter mantas and spotted eagle rays, blacktip and whitetip sharks and grey sharks, and even nurse sharks are occasionally seen. Some of the other larger species you may find include marbled groupers, parrotfish, large morays and Napoleon wrasses.

temples of archaeological interest from ancient Poly-nesian culture. More recent sites of interest include old army bunkers and cannons dating back to the American army presence during World War II.

HOW DO I GET THERE
International flights to Tahiti and connecting flight from there to the island of Motu Mute where Bora

Bora's airport is situated. From there, a launch takes you to Vaitape on the main island and you are trans-ported from there to your accommodation.

Kenya
Nairobi
Tsavo National Park
● **Watamu**
Tanzania
Indian Ocean

THE CANYON
Sea safari

Watamu Marine National Park is situated on the north coast and offers one of the best diving locations on the Kenyan coastline. The coral gardens are just metres from the shore and are home to a vast number of fish and other weird and wonderful sea creatures.

maximum depth:
28m

minimum depth:
10m

access
Watamu Marine Park is located 23km south of Malindi. Local dive boats take you a short distance from the shore. November to January is the best time for better visibility; no diving is available in June, July and August due to adverse weather conditions.

average visibility
10m–15m

water temperature
Varies from 20°C–25°C depending on the season. It is coldest from June–October and warmest from December–May.

dive type
Reef dive by day boat

currents
Slight

experience

in the area
*The Chakwe wreck
The Canyon
Black Coral
Moray Reef
The Marine National Reserve encompasses the parks from south of Malindi town to Watamu, and many dive sites can be found in the areas close by.*

WHAT WILL I SEE?

Several coral reefs stretch out in front of Watamu. The water is fairly clear and shallow, with a sandy and sometimes weedy bottom, surrounded by coral. At Watamu Marine Park, the small coral gardens lie parallel to the shore, and are not exposed during low tide. Fishing is not allowed so the Marine Park has become a safe haven and productive breeding ground for numerous species of fish, coral and eel. There are approximately 600 species of fish in the area, over 100 species of stony coral and countless invertebrates, crustacea and molluscs.

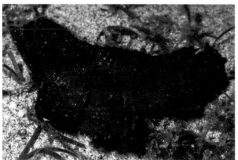

THE DIVES

The dives start at a depth of around 12m along the coral reef, at the edge of the drop-off. The abundant and varied marine life includes colourful Indian Ocean reef fish such as butterflyfish, angelfish, damselfish, surgeonfish, snapper and coral grouper.

The Canyon dive site reveals a sandy channel with sloping walls rising on both sides from around 20m to around 28m. You may experience some current in the channel, and are likely to find stingrays and small reef sharks congregating here. At the edge of the channel, the coral tends to grow in large spires, separated by stretches of sand and weed. Navigating away from the sandy channel, you will come across a series of overhangs, soft corals and an arch jammed with glassfish, mantis shrimps and colourful soft corals.

Amongst the weedy areas, leaf fish can be found. These remarkable fish look like leaves swaying with the motion of the water. On closer inspection, they are very much alive and doing a good job of looking like a leaf. They are usually pale in colour, white, yellow or brown.

It can be possible to encounter larger marine life such as several different species of ray, including the common or whip ray, as well as barracuda, blacktip reef shark and occasionally whale shark and manta ray.

On top of the reef is a prolific coral garden and it is often possible to see turtles in this area. Spend the latter part of the dive here and look at the miniature fans of white coral, like window frost. Yellowback fusiliers swim around the coral heads in shoals. Then there are the tiny creatures such as nudibranchs and soft coral, appearing like flowers in your garden. Frogfish are also known to live in this area and hide almost as well as the local scorpionfish, which flash a lovely red if you approach too near. This area of Kenya is known for the large brain corals resting on the seabed. Sea anemones, which cover the top of the coral, and clownfish are plentiful here.

The topography of the north differs from the southern views, with great underwater rock formations and channels. The visibility can be disturbed during the rainy season, and the sea temperature is a noticeable 3-4°C lower than other areas in Africa.

ON DRY LAND
A wild animal safari in Tsavo National Park is a must if you have the time. In both Tsavo East and Tsavo West you can see elephant, giraffe, hippo and many other big game up close. Amboseli National Park is also a short drive away. Satao Camp is a short flight away and nearer to base at Watamu is Crocodile Farm. Sailing or relaxing on the beautiful beaches are enjoyable, and many day trips to islands or dolphin spotting are also on offer.

HOW DO I GET THERE

Take a flight direct to Mombasa or via Nairobi from most international airports.

It can also be reached from Malindi airport.

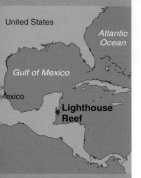

HALF MOON CAY

Sponges galore

The Belize barrier reef is said to be the second largest on the planet. Lighthouse Reef is the most easterly of Belize's three Caribbean atolls, roughly oval-shaped and surrounded by a nearly enclosed ring of coral reefs, with a shallow emerald lagoon on the inside. Half Moon Cay lies within a section of it and is known as one of the best dive spots in the area.

maximum depth:
30m or your chosen depth

minimum depth:
6m

access
*Half Moon can be reached from Belize City or San Pedro and visited as a day-trip. Other accommodation options are a liveaboard or stay at a resort at the Northern Two Cay, at the extreme north of Lighthouse Reef. This gives daily access by boat.
The best time to go is January to July, with the calmest weather around May; July to November is hurricane season.*

average visibility
15m–60m

water temperature
25°C–27°C

dive type
Reef and some drift

currents
Slight

experience

in the area
*There are more than 50 miles of wilderness reefs and walls, and hundreds of dive sites. Lighthouse Reef also houses the Blue Hole, a dive spot that was made famous by Jacques Cousteau.
Long Cay
Glovers Reef*

WHAT WILL I SEE?

The island is a coral sand cay, providing shallow reefs with gardens of hard and soft corals harbouring many species of reef fish. Amongst them, grazing parrotfish can be heard crunching the coral, which they will digest and later deposit as fine sand.

Some of the Caribbean's healthiest sponges and sea fans provide much colour: brilliant reds, greens, yellows and vibrant purples. Turtles nest on the cay and can often be seen on dives.

Most of the world's atolls are in the Pacific Ocean, beginning as fringing reefs around volcanic islands; atolls are rare in the Caribbean and were created on the top of offshore fault blocks.

THE DIVES

Half Moon Wall is incredible. The top of the wall is ablaze with fish life with large angelfish in groups of four or five and many varieties of butterfly fish hanging around in perfect pairs. Filefish, grunt, Nassau groupers and unusually large cowfish thrive here. The garden eels in the shallow areas sway back and forth, ducking into the sandy bed at the approach of any intruder. The shallow regions are punctuated by patch reef and channels offering views of lobsters and stingray on the sand.

The wall is the only sheltered dive site on the eastern side of any of the three atoll reefs and divers can expect

to see pelagic life on this side. There is a chance to see oceanic whitetip, lemon, blacktip and bull sharks. At a depth of around 15m to 18m, an entrance to a small cave and overhang can be found; nurse sharks may rest here in the soft sand.

This wall is at times vertical, cutting back in on itself, displaying many interesting features. Sponges protrude at right angles to the reef, competing for space with the hard elkhorn and other corals. Tube sponges can extend several feet, and barrel sponges can reach over three feet in diameter – they look lovely against the backdrop of deep blue water.

Spanish mackerel and wahoo hang around the shallow water, and wahoo is often served up on the island for supper. Spanish mackerel sift the water for fine particles, their mouths open wide. They do this in unison, making for interesting viewing. Blue chromis add variety to the colour and movement near the surface as they cling together like synchronised swimmers.

Half moon cay is worth diving a few times with the sun in different positions, lighting the reef in different sections. At night, sharptail eels leave the reef to forage for food. Parrotfish secrete mucous cocoons for protection against nocturnal predators and hogfish change colour from a vibrant orange during daylight, to a pale sandy colour to blend with the dark.

ON DRY LAND
Dense mangrove thickets grow along Belize's shore and the rain forest is home to many animals. Bird watchers will enjoy this island.

Its most famous inhabitants are the red-footed boobies that nest in thickets at the western end of the cay. Other varieties include nesting magnificent frigatebirds,

identifiable from their fishy smell and piercing screeches and squawks. A platform on a spectacular site in the heart of the colony allows you to see the birds up close.

For reptile enthusiasts, there are many species of lizard and gecko, and on boat trips there is also the chance to see Atlantic bottlenose dolphins.

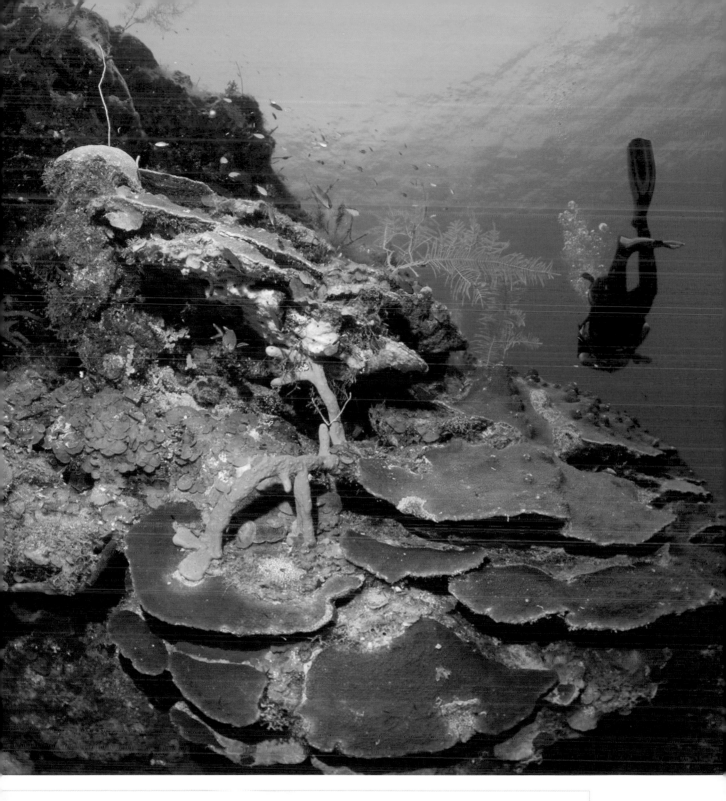

HOW DO I GET THERE
Flights via Miami, Los Angeles, New Orleans or Houston. Internal flights to Belize international airport, then by boat or car to the resort.

Atlantic Ocean

Caribbean Sea
St Lucia

Venezuela

maximum depth:
43m

minimum depth:
3m

access
*Travel time by boat
is five to ten minutes
from the dive centre,
making the dive sites
at the north end of
the island quickly
accessible.*

average visibility
20m–35m

water temperature
26°C–29°C

dive type
Reef dive

currents
Medium to strong

experience

in the area
*La Roche
Smugglers Cove
Pigeon Island
Dinasour Reef
Anse Chastanet*

THE PINNACLES

King Neptune's underwater rainforest

St Lucia's two famous volcanic mountains, The Pitons, rise like two giant sentinels from the sea to over 700m. Idyllic white beaches rest at their feet, giving way to lush underwater scenery. Located midway down the Eastern Caribbean chain, amongst the Windward Islands, St Lucia is an island to dream about.

WHAT WILL I SEE?

The island is at the tip of an underwater volcano where both beginner and experienced divers will enjoy the stunning variety of coral, sponge and marine life.

Resident turtles are a common sight on most dives. Less frequently, you might see the rare pink frogfish or seahorses. The seabed here consists of sand and red algae-covered rocks, with some coral and sponge developing as you dive deeper.

Creole wrasse are here in large numbers and buzz around the tops of the pinnacles.

Yellow-spotted snake eels forage in the sandy bottom for food scraps. Well camouflaged lizard fish and blue spotted flounder remain still until you approach and at the last moment bolt for safety. Feisty blue and yellow damselfish dart about, patrolling their territory.

An array of colourful gobies and blennies, nudibranchs and darting juvenile drums may be seen.

There are many other fish species here, including long-spined squirrelfish with their bright red and orange markings, big brown porcupinefish and tiny green and speckled moray eels.

THE DIVES

Situated across Soufriere Bay from The Pitons, four spectacular natural monuments rise from the deep to within several feet of the surface. Known as the pinnacles, they stand on the edge of a steep slope, stretching towards but not quite reaching the surface.

Take your time to weave around them, to view the myriad of life before you. Investigate the proliferation of sea life that dwells on different sides of the peaks, in or out of the sunlit reef area. Most divers find it fun to spiral around each pinnacle where the rock formations are closest together, separated by a gap of little more than a metre. This provides entertainment and good buoyancy control practice. There is an abundance of coral, including black coral, and as many fish and invertebrates as you have time to see in one dive.

Each time you complete this dive, you may see something new. Perhaps because of the strong water movement, the water visibility can sometimes start off cloudy, but submerge a couple more metres and the water is clear. The pinnacles loom towards you and provide dramatic scenery.

The steep slope of the reef falls away to the south. Healthy pencil coral and elkhorn hang from every crag and corner of rock face. The place to spot colourful nudibranchs is at around 15m around one of the pinnacles, where you should find a patch of green grape algae, often their favourite haunt.

You will need to swim west to find the third pinnacle, as breathtaking as the first two, encrusted with sponges

ON DRY LAND
This is a great place to see exotic trees and magnificent tropical birds and marine life. Tours can be arranged through the mountainous rainforest or to see the birds of the mangroves. There are endless banana and cocoa plantations, and the crater of a dormant volcano with bubbling sulphur springs is a sight to see. You can bathe in a mineral spring, or take a sailing boat out to view the magnificent scenery from the sea.

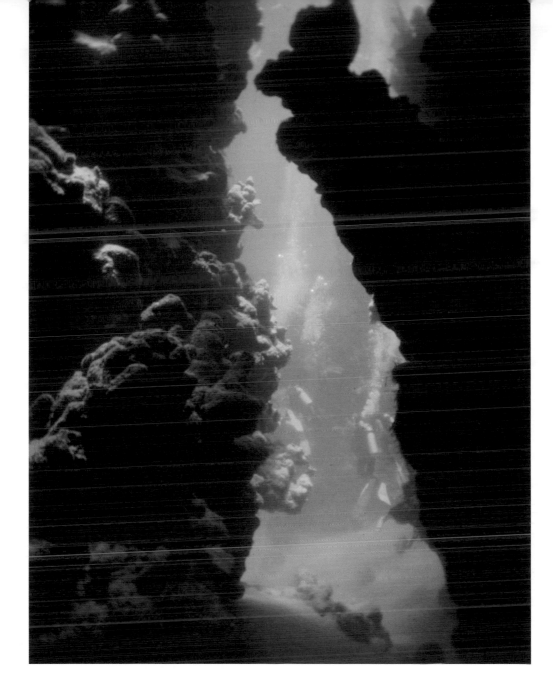

and sea fans. Vase sponges on the face of the pinnacles house enterprising cleaner shrimps.

There is still one more pinnacle to complete the set; further west and it emerges from the blue. This pinnacle is the most interesting and worth the wait. A large crack in the rock is wide enough to enter, its walls entirely encrusted in yellow and orange sponges.

Bright fish buzz around together inside the fissure walls, creating a mosaic of colour. Tiny purple and yellow fairy basslets contrast beautifully with butterflyfish and rock beauties elegantly swimming by.

Use the remaining air to enjoy the final part of the dive in calmer waters, in a large sandy area with small coral heads.

HOW DO I GET THERE

Flights to St Lucia are available from many international airports direct and via Miami, New York, Toronto, London and Paris. Transfers between Caribbean islands include Martinique, Antigua, Barbados, Dominica, Martinique, St Vincent and Trinidad.

CANNIBAL ROCK

Under the dragon's lair

Discover this unique wilderness and its astonishing marine life. Known as one of the best macro sites on the planet, it is not uncommon to discover a new species here. Komodo's richest treasures lie beneath the sea.

maximum depth:
40m

minimum depth:
6m

access
Komodo is not the easiest resort to get to but it is worth the effort. The only access is by liveaboard. Some liveaboards operate year-round but the best season is April–January. The wet monsoon ends around April and the dry monsoon in November, when you find the best visibility and warmest water.

average visibility
5m–30m

water temperature
18°C–29°C

dive type
Reef and muck diving

currents
There are often strong currents in the area

experience

in the area
*The Yellow Wall of Texas
Grandma Bangs
Bommies
Banana Reef
Torpedo Alley
Horseshoe Bay*

WHAT WILL I SEE?

While Komodo dragons bask in the sunshine on the beach, the marine waters provide habitats in the form of coral reefs, sea grass beds, mangrove and semi-enclosed bays.

Komodo's waters harbour more than 1,000 species of fish, some 260 species of reef-building coral, and 70 species of sponge. Dugong, shark, manta ray and up to 14 species of whale and dolphin make Komodo National Park their home, while there are rare and unusual nudibranchs in literally every colour and design imaginable.

Small but deadly, the blue ringed octopus is hard to spot as its colour appears dull until a predator approaches, then the blue rings emerge. Similarly, the flamboyant cuttlefish appears a dull colour brown. If disturbed, it puts on a very colourful and puffed up display.

Many species in Komodo are rare or endemic to the area; yellow-ribbon sweetlips, tiny Coleman shrimps that live only on one species of fire urchin, sometimes accompanied by zebra crabs may be observed.

THE DIVES

Cannibal Rock lies in the channel just to the south of Rinca Island and 1km off the northern coast of nearby Nusa Kode.

Cannibal Rock is a wide ridge of coral that rises from 35–40m to just below the surface on low spring tides. As you approach you can make out the top of the pinnacle, marked by breaking waves.

A rich kaleidoscope of life, the shallow dive areas are full of colours from yellow, black and orange featherstars and blue and ultraviolet tunicates, with small crustaceans and shrimp to coordinate the palette.

Incredible numbers of rare nudibranchs fight for space on the sponges and rock face–and look out for the strange looking painted or clown frogfish.

Komodo delivers strange, inhospitable forces. Strong currents and cold water thermoclines often surprise the visiting diver. This oddity is partly responsible for Komodo's extraordinary abundance of marine life. The low water temperatures in particular have very interesting biological implications because Komodo's cool waters draw in organisms usually restricted to temperate seas well outside the park's tropical boundaries.

Descend to the south to the deepest diving section, to observe dozens of huge carpet anemones in brilliant purples, green and blues, draped on the top of the reef ledges and small walls. Up to eight different species of clownfish make their homes here. In amongst them, tiny porcelain crabs, shrimps and gobies blend with the colour of their host.

Going deeper still, you find a mixture of steep coral slopes and drop-offs before you reach a gently shelving seabed at the base of the reef. The density of the coral and invertebrate cover is overwhelming. There will be no need to remind you how amazing this place is as you find yourself staring at alien beings; leaf scorpionfish, electric blue ribbon eels and the hairy frogfish.

ON DRY LAND
Komodo National Park provides refuge for 277 animal species including the orange-footed scrub fowl, an endemic rat and the Timor deer. It is also home to a wild population of more than 5,000 Komodo dragons, so a walking tour is an experience like none other. You are allowed to get close to the Komodo dragons and photograph these remarkable and frightening looking creatures.

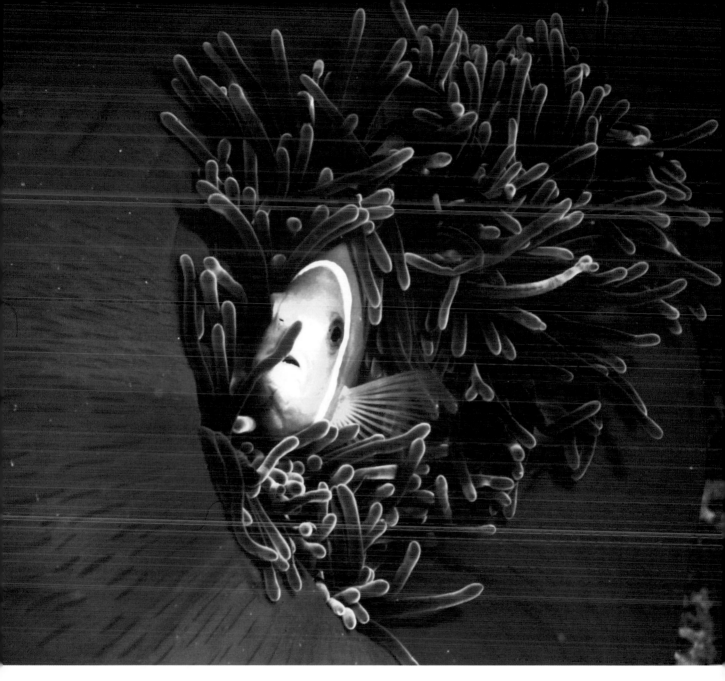

Making your way east and north, you will be astounded by the sizes of the purple gorgonian fans, some over two metres tall. Something of an enigma, the pygmy seahorse may be discovered on these seafans, but even when your guide points one out it can be difficult to see and requires a lot of concentration. Its shy character, tiny size and ability to look life soft coral make it a rare find.

You will need no encouragement to repeat dive this area as there is a phenomenal diversity of marine life. It is truly a world-class dive site.

HOW DO I GET THERE

Fly to Bali, Indonesia via Kuala Lumpur, Singapore and Jakarta, or fly to Flores for a trip to Komodo National Park.

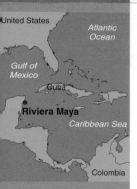

United States

Atlantic Ocean

Gulf of Mexico

Cuba

Riviera Maya

Caribbean Sea

Colombia

CENOTE CHIKIN-HA

Entrance to the underworld

This natural wonder of the world offers a great opportunity for a unique diving experience and adventurous underwater exploration. Underground caverns are known for their crystal clear water, which gives you the illusion of floating in air.

maximum depth:
40m

minimum depth:
8m

access
One-week excursions can be booked at the renowned Villas DeRosa or local dive centres. There are now three registered centres in the Yucatan where you can train in cave and cavern diving. This very specialised course comprises over 12 hours of lectures and a minimum of 14 cave dives with double tanks.

average visibility
100m–300m

water temperature
24°C–28°C

dive type
Cave dive

currents
None

experience

in the area
Cristalino Cenote
Taj Mahal Cenote
Azul Cenote
Temple of Doom

WHAT WILL I SEE?

The underwater labyrinths of Mexico's Yucatan Peninsula are breathtaking. The area known as Riviera Maya is south of Cancun and stretches south as far as Belize. The landscape here is flat, allowing rainforest water to seep through the ground rather than enter the river system. It passes through rotting vegetation, absorbing carbon dioxide to produce carbolic acid, which over the years creates cenotes, or underground caves, by gradually eating away the limestone and forming underground rivers and caverns. In places where the water eats away the stone close to the surface, this eventually collapses, giving access to underground water.

Cenotes are the fresh water pools that connect the submerged caves and caverns. When diving these, it is essential to do so with a knowledgeable local dive guide.

At the bottom of the water pool are large rocks covered by mosses and plants. This area is home to a variety of fish including fresh water eels and abundant aquatic plant life. Here, saltwater and freshwater meet, providing a mixture of freshwater tropical fish and saltwater marine fish found nowhere else.

THE DIVE

Diving underground and drifting through the flooded rock tunnels and caverns takes you to another diving dimension.

Located approximately 25km from Playa del Carmen, Chikin-Ha is the first cenote in a system that connects several holes through more than 10km of underwater passages. You descend in a brilliant pool, where light is plentiful, to a depth of about 10m. These underground lakes are breathtaking, particularly where saltwater and freshwater meet, creating a halocline. You can see the clear divide between the two, as classroom physics take over. You experience strange visual affects as you descend a few metres and view it as a milky cloud, then your buoyancy changes dramatically and the water appears thicker and much warmer as you leave the freshwater behind and move into a new domain of salt water.

As you swim deeper into the cavern, you will notice the plant roots from the jungle above, reaching into the depths below for nourishment. On the bottom, marine plants grow through the rock and microscopic animals and tiny fish swarm around them, protected in their nursery.

Look back towards the entrance and, on particularly sunny days, you may see fascinating light effects. Divers can turn back here, as there is a clear way back to the surface. More experienced divers may continue to the next cenote, entering a wide room underneath an air filled cave where shafts of light penetrate through holes like laser beams. Bats live in the cave, and you can pop your head above water to see them. Continue the dive,

ON DRY LAND
Yucatan is a fascinating area covered by dense jungle and swamps and scattered with ruins from the Mayan civilisation, including the famous pyramids of Chichén-Itzá, which are over 1500 years old and worth a visit. You can see many exotic birds on jungle tours. There are plenty of opportunities for watersports or a relaxing stay on the superb beaches.

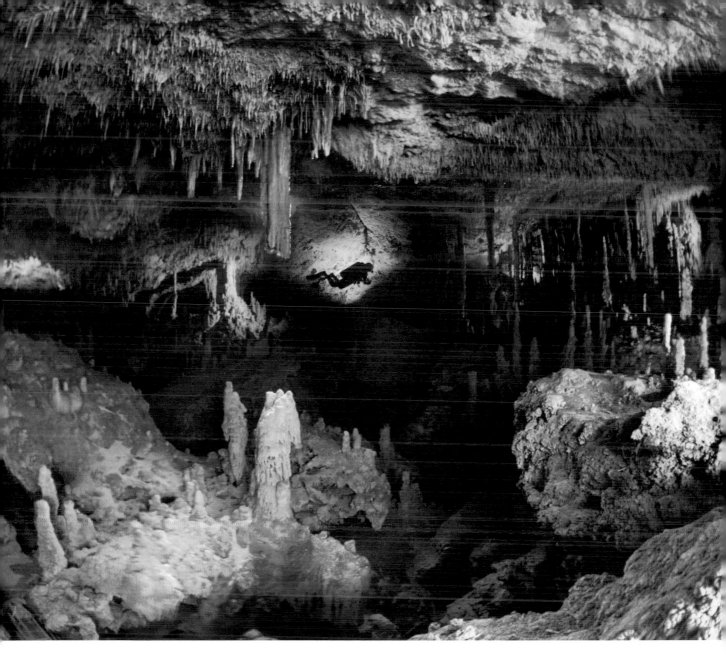

gliding gently around immense limestone stalagmites and stalactites, and feeling as if you have left Earth and travelled to an alien planet. You may also discover fossils lying in the sediment.

Frozen in time, these wondrous geological formations date back to the last ice age. View the columns from floor to ceiling, and admire its grand architecture.

The water that gathers in these subterranean cenotes is crystal clear, turquoise and mystical. Perhaps more surprising is the mix of fish life, both freshwater and saltwater fish living here side by side.

Cenote means sacred well. There are hundreds of cenotes spread over Caribbean Mexico, and many are remote, hidden by the dense, lush growth of the jungle.

It is a magical experience to dive in a place that nature took millions of years to create.

HOW DO I GET THERE

Fly direct to Cancun, Mexico from most international airports. Transfer from there to your resort.

North Sea

Cathedral Rock

United Kingdom

maximum depth:
50m

minimum depth:
0m

access
Dive boat or shore dive.

average visibility
2m–8m

water temperature
Winter: 7.5°C
Summer: 18°C

dive type
Reef dive

currents
Can be fairly strong depending on tides. Slack water diving recommended.

experience
*** to *** For divers who are familiar with temperate water diving.*

in the area
The dive sites between Petticowick and Eymouth are too numerous to name; all are within easy reach of St Abbs harbour by boat. The wreck of the Glanmire is located just north of St Abbs Harbour beneath the lighthouse and lies in 110ft (34m) of water. South of the border, the Farne Islands are an ideal location for diving with seals, as well as being enormously rich in marine life. Dive sites are abundant all along this coast, from Newcastle to Dunbar and the Firth of Forth, including an impressive array of wrecks, and all are well recorded.

CATHEDRAL ROCK

A cathedral to answer the prayers of those looking to dive in British waters

One of the best-known dive sites in the UK, Cathedral Rock is in an area where there are plenty of other sites to keep you occupied, so it is ideal for an extended visit.

WHAT WILL I SEE?

St Abbs is a most attractive Scottish coastal village. Located on the east coast of Scotland about 12 kilometres from the border with England. The predominantly westerly winds have little impact on diving as the waters are protected by the high cliffs, so you can normally dive unless the winds turn easterly and become strong.

In 1984, eight kilometres of coastline stretching from Petticowick in the north to Eyemouth in the south were designated as a marine reserve.

There are endless dive sites to choose from here, all of which can be reached quickly by the dive boats. Petticowick can be dived from the shore, if you are prepared for a long walk in full kit down many steps to the beach. A similar option is available at Weasel Loch in Eyemouth.

Cathedral Rock can also be reached by a shore dive from the harbour wall and a clamber down over rocks to the water. Cathedral Rock does not break surface, even at low tide, and careful navigation is necessary for a shore dive, requiring a swim of some 45m. However, dive boat is by far the easiest way to dive Cathedral Rock and all the other dive sites in the reserve, and there are numerous well established in St Abbs and Eyemouth.

THE DIVES

Cathedral Rock derives its name from an impressive arch festooned with dead man's fingers and plumose anemones. Above the arch is a smaller one called the Keyhole. The maximum depth is some 15m and the seabed is made up of boulders and rocky outcrops.

Its shallow parts are covered with kelp forest, which is typical of these nutrient rich waters. There are abundant anemones, soft corals, sponges and hydroids, and you are likely to be escorted on your dive by one or more ballan wrasse, no doubt hoping you will disturb something that will reveal a meal. Simply running your fingers through the sand and gravel on the seabed will often bring wrasse up close in anticipation of food. You may well see a large shoal of pollock, which are usually in the area, and sometimes impressive cod that predate on them. Shoals of herring may also make an appearance. Many invertebrates can be found in the area including edible crabs, lobsters, spider crabs, velvet crabs, mussels, nudibranchs, octopus, hermit crabs, sea urchins, sun starfish, common starfish and brittle stars. Squat lobsters, prawns and shrimps can be found in the cracks and crevices of the reef and, in addition to the dead man's fingers and plumose anemones, dahlia anemones are common in a variety of colours. The arctic anemone is found in the area, at the southern extremities of its range, as is the Devonshire cup coral.

Another creature at the southernmost extremity of its range is the wolf fish, which you may find in its lair. Other fish include the various blennies and gobies, scorpionfish, anglerfish, ling, butterfish, dogfish, pipefish, and lumpsucker. Flatfish such as plaice may be found on the sandy areas of the seabed. Keep an eye on the water column and you may find jellyfish such as the common jellyfish and lion's mane jellyfish.

ON DRY LAND
Just outside St Abbs is the town of Coldingham, which has several pubs and shops. Eyemouth is much larger and has a wider range of pubs, restaurants and shops. Nearby are numerous other village communities, such as Reston and Auchencrow, with pubs and restaurants of their own. South of the border is the town of Berwick-upon-Tweed with its impressive battlements from a bygone age. South of Berwick is the famous Holy Island.

Edinburgh is only 30 miles (48 kilometres) away and offers everything from restaurants, pubs, shopping centres, museums and theatres, to the magnificent castle. (The Edinburgh Festival, which takes place in August, is a must.)
Not far from Edinburgh is the famous Rosslyn Chapel, which attracts tourists from

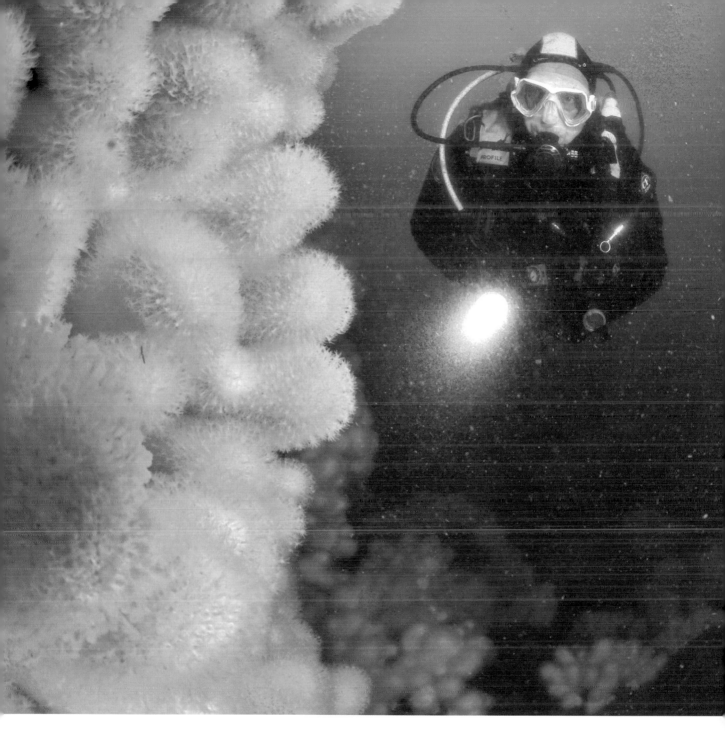

Grey seals might make an appearance here. In recent years, perhaps due to rising water temperatures, crayfish and bottlenose, risso and white-beaked dolphins have been seen in the St Abbs area, as well as minke, killer whales and sunfish (*Mola mola*).

all over the world. Further south down the A1 is Aln-wick Castle, now famous as the setting for the Harry Potter adventures. In fact, if you have time between your dives, there are end-less opportunities to take in the beautiful countryside, famous landmarks and quaint towns and villages in Scotland's borders.

HOW DO I GET THERE
Nearest airport is Edinburgh International Airport, which is 30 miles (50 kilometres) from St Abbs. Bus services are available.

Ireland

United Kingdom

Gannet Rock

Atlantic Ocean

France

GANNET ROCK

Jewels and seals on one dive

Lundy Island is situated in the Bristol Channel, where the west coast feels the full force of the Atlantic Ocean from the prevailing westerlies. This impressive hunk of granite and shale is a dominant feature, with most of it over 100m above sea level. Separated from the mainland of north Devon by 18km of sea, it is one of the richest marine habitats around the British coast.

maximum depth:
30m+

minimum depth:
0m

access
By dive boat. The island is now owned by the National Trust and most of the buildings on the island, including the lighthouse, have been converted into visitor accommodation, which needs to be booked in advance. There is also a facility for camping.

average visibility
5m–15m

water temperature
8°C–20°C

dive type
Temperate wall and reef

currents
None at slack water to strong

experience
to ** depending on depth, and experience with temperate water diving

in the area
Dive sites include:
Hen and Chickens
North Coast
Seals Rock
Brazen Ward
Knoll Pins
Robert Wreck
Gull Rock
HMS Montague
Wreck Landing
Bay area
Rat Island
Surf Point
Rattles Anchorage
Black Rock
Jenny's Cove
Devil's Slide
Long Roost

WHAT WILL I SEE?

The island is 4.8km long and 0.8km wide, with a north/south orientation. The west of the island is battered by the force of the Atlantic Ocean while the east side affords protection from the seas that roll in from the west. The unique nature of the waters around Lundy were recognised in 1973 when Lundy became a voluntary marine nature reserve. In 1986 it was then established as a statutory marine nature reserve.

Although battered by the Atlantic Ocean, the island is in fact washed by the waters of the Atlantic Gulf Stream and the Mediterranean. With its remoteness from the mainland, visibility can be 15m, although this can be reduced by water and weather conditions. Lundy also has one of the greatest tidal ranges in the world, up to 9m during spring tides, creating strong currents.

The accommodation on Lundy is limited and most divers make the 40km journey from Ilfracombe on the North Devon coast to the island by dive boat. Most of the diving is done on the east side of the island but there are also great dives on the west side when water and weather conditions permit. The main diving season is between late April and end September. The marine life, both fish and invertebrates of all types, is exceptional. Basking sharks also make an appearance around Lundy, especially in July and August, and harbour porpoises are sometimes seen. The island has its own seal population and there are also many wrecks to choose from. We have chosen a dive site that is high on the list of favourites

of those who dive the island: Gannet Rock.

THE DIVES

Gannet Rock juts out of the waters to the north-east of Lundy Island, with Gannet's Bay behind it. The outside of Gannet Rock drops down to about 30m and beyond. There are areas of the rock that are covered with jewel anemones. Yellow Sunset cup corals, at the most northerly end of their range, are also found here. Look out also for Devonshire cup corals, with their own delicate beauty. The less common red species of dead man's fingers add an extra splash of colour and fan corals make a rare appearance. You will find plenty of fish, especially wrasses such as ballan and cuckoo wrasses. Look out, too, for tompot blennies and conger eels.

There are many crustaceans, such as edible, velvet swimming and spider crabs. Squat lobsters and shrimps can be found tucked into the nooks and crannies, as well as lobsters and even crayfish. Starfish and sea urchins are all plentiful and octopuses are not uncommon.

As you get shallow, the kelp forest terrain takes over. Here, you can find nudibranchs and blue rayed limpets on the kelp fronds. Barrel jellyfish lumber around—they do not have the typical long string of tentacles and are very robust looking.

You may want to make your way round to the west side of the rock to end your dive by looking out for the resident seals, or you may prefer to treat the bay area as a separate shallow dive especially for the seal

ON DRY LAND
Lundy is famous for having the biggest seabird colony in the south of England, including puffins. In addition, migratory birds stop over on Lundy. On the island are wild ponies, Soay sheep and goats. The flora includes the Lundy cabbage, which is unique to the island. There is only one landing point on Lundy and a small beach leads to a steep road to the top of the island and the village. This is only suitable for 4x4 vehicles. Tourists gather here to see the flora, fauna and the wild landscape. There are few trees on the island due to the violent Atlantic winds, so most flora is low lying and resilient.

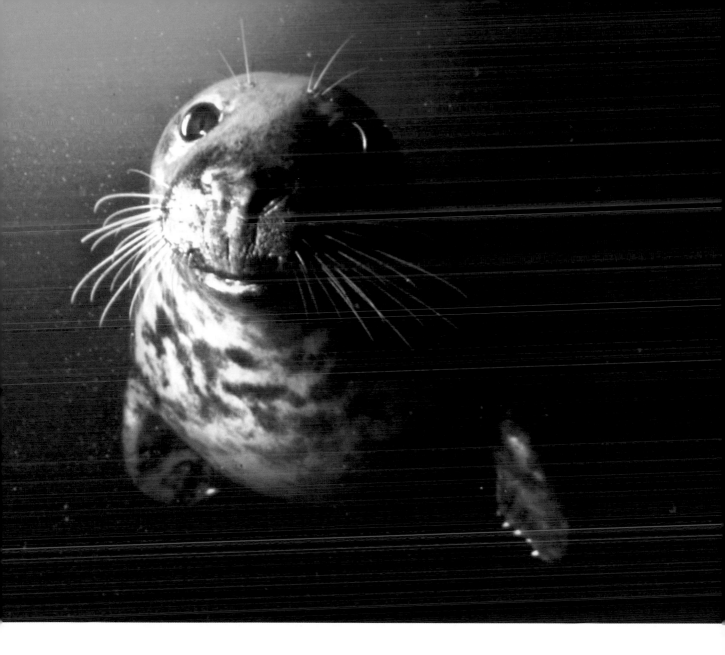

encounter. You have more chance of them coming to inspect you if you settle down and wait, although they are often there, just at the limits of your view. From time to time, take a swift look behind or beneath you, as you can sometimes catch them creeping up behind you and nibbling your fins. They may fly past to inspect you and if you are lucky will return for a closer encounter. When the young pups are out and about, they are at their most curious and playful. In the water column, keep an eye out for compass jellyfish, which can be there in great numbers.

HOW DO I GET THERE

Bristol is the nearest international airport, with bus or coach transfer to Ilfracombe, which is the most typical area to book dive charters, which should be booked in advance. This involves daily trips to Lundy. Accommodation can be arranged in advance on Lundy but it is limited. A ferry service is available during summer months from Ilfracombe or Bideford, depending on tides.

EDDYSTONE LIGHTHOUSE

Let the light shine on a great UK dive site

There is a sea shanty called The Keeper of the Eddystone Light, with a chorus that goes, 'With a yo-ho-ho, let the wind blow free, It's all for the life on the rolling sea!'. Try to avoid rolling seas, as the lighthouse is approximately nine miles from Penlee Point, which you will pass to the west as you leave Plymouth harbour and the Plymouth Breakwater. But on a good day, visibility can be unbelievable for UK waters.

maximum depth:
40m or deeper

minimum depth:
8m

access
Dive charter boat

average visibility
Generally 10m–12m but can reach 30m

water temperature
Winter: 5°C
Summer: 18°C

dive type
Reef and wreck dive

currents
Can be strong. Carefully planned dives within slack water periods essential.

experience
**** to *** ***

in the area
Many dive sites in the area, such as Hands Deeps, Mewstone and Mewstone Ledges, Hilsea Point, Fairylands, Drake's Island Drift. Many wrecks, including James Egan Layne and Scylla, Le Poulmic, Glen Strathallen, HMS Abelard. Altogether, there are some 50 dive sites that are available for all standards within the area. On the first weekend in July, the British Society of Underwater Photographers (BSoUP) normally have a 'Splash-in' underwater photographic competition in Plymouth.

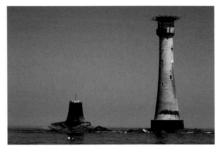

WHAT WILL I SEE?

Most dive boats heading to dive the Eddystone Light leave from Plymouth. In fact, there are two lighthouses sitting atop the Eddystone Rocks. The current one, known as Douglass's Lighthouse, was lit in 1882 and is still in use today, while only a stump remains of the previous one, known as Smeaton's Lighthouse. Douglass's Lighthouse is the fourth to be erected on the Eddystone Rocks, the first being lit in 1698.

Running from east to west, the jagged rocks break surface. Kelp forest ranges down to 15m. The skippers will invariably know the terrain very well and will be able to determine the best time and place to start and finish the dive, depending on the water conditions, slack water, currents and visibility.

THE DIVES

The surface conditions will determine where to start the dive. If the water is rough, it is better to enter beyond the shallow rocks to get below any surge. On a calm day you can drop in at shallow depth and then make your way into deeper water while inspecting the kelp forest. There, you may find nudibranchs, blue rayed limpets, urchins and crustaceans. Although extremely variable, visibility can reach 30m on rare occasions and

be exceptionally clear for British waters. It is the clarity of the water and the fact that the site is well away from the mainland run-offs that you need to go deeper than usual to get below the kelp forest.

You will find beautiful vistas of plumose anemones in a variety of colours from orange to pale green, and vast areas of dead man's fingers. Then there are the areas of rock simply covered with jewel anemones in Sea fans (*Eunicella verrucosa*) are quite rare in British waters but are plentiful here. You will also find ross corals (in fact a bryozoan) and hydroids. The rocky crevices may reveal lobsters and edible crabs and there are plenty of fish too. These include Pollack, bib, wrasses, such as ballan and cuckoo wrasse, dogfish, and conger eels. Mackerel may be seen in large numbers.

There is some scattered steel wreckage from wrecks, but the lighthouses on Eddystone Rocks have served their purpose well over the years, generally keeping ships clear of this hazard. The remains of one wreck, the Hioga, is 14m of water and is not very well known as she is hidden by the thick kelp forest in the summer months. She sank in 1867 and, having settled in shallow water, she has now completely broken up, although her boiler still remains.

This dive site will bring home to divers the delights that British water diving can offer.

ON DRY LAND
Plymouth is the regional capital of Devon and Cornwall, and is a vibrant, thriving, modern city as well as an historic seafaring port and holiday centre. There are endless things to do and see, such as the Plymouth Dome, a high tech interactive visitor centre on the Hoe, the National Marine Aquarium, Preston house (the oldest house in Plymouth), and the Barbican Maritime Village, with its historical associations with Sir Francis Drake and Sir Walter Raleigh. This is also the place from which the founding fathers of America sailed in the Mayflower. The area is full of beautiful countryside, walks and many historical attractions such as Buckland Abbey, once home to Sir Francis Drake, and other stately homes such as Saltram House. Shops, restaurants, pubs, shopping

centres, entertainment: you will find everything you need in and around Plymouth.

HOW DO I GET THERE

International Flights to UK International airports. Connecting domestic flights to Plymouth City Airport from London Gatwick, Glasgow, Newcastle, Manchester, Leeds and Bristol. Alternatively, train or coach services or hire car to Plymouth. It should be remembered that divers in UK invariably have their own dive equipment, including tanks. Therefore, if you plan to hire dive gear it is important to contact dive centres beforehand to ensure they can supply your requirements.

Charter dive boats are plentiful in the Plymouth area, including rigid inflatable

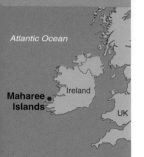

GURRIG REEF

The land of Guinness, green mountains and underwater jewels

In a landscape of exceptional beauty, the Atlantic Ocean meets the Brandon Mountains. Here, beneath the Irish water, there is an abundance of marine life.

maximum depth:
28m

minimum depth:
21m

access
Easy access by rib or hardboat throughout the day, dependent on tides. The pier/harbour is a few minutes' walk from Harbour House, from where ribs and hardboats take you a short distance to reefs or further afield to more scenic drop-offs and caves.

average visibility
7m–30m

water temperature
12°C–21°C

dive type
Reef

currents
Slight

experience

in the area
*Blasket islands
Many other dive sites around the islands*

WHAT WILL I SEE?

Maharees means 'seven pigs', and there is actually a cluster of islands here. Spiny crayfish, lobster, crawfish and edible, velvet swimming and spider crabs cruise the rocky bottom. Many starfish and urchin can be found all over the reef and are often taken for granted, though their colours can be lovely. Sponges and anenomes light up the reef, white Devonshire cup corals, plumose anenomes and white and orange dead man's fingers coat the walls.

Many special encounters can be experienced here on fortunate days. Playful seals, dolphins, minke and long finned pilot whales are known to be in the area. Rare sightings of orcas and white sided dolphins have been reported in recent years.

Basking sharks are becoming more common when conditions are right, and the odd sighting of the very large fin whale makes this region all the more enticing to visit.

THE DIVES

Stone carved into twisting gullies, overhangs and caves are fun to explore. This site reveals a special home to friendly seals; be aware that you may feel a tug on your fin and find it is a playful seal.

Located off Gurrig Island, the reef is a kelp-covered top with a few small walls falling away to a larger ravine dropping down to the sand. Shoals of mackerel and Pollack move in a mass.

Try moving slowly in amongst them—it feels as if you are part of the pack.

The diving is a soft drift, helping you cover more area of the walls and gullies. The rock is obscured by a cov-

ering of pretty jewel anenomes and bright seasquirts.

King scallops snap along the seabed when disturbed, exhausting their energy on movement for which they are not very well designed. They prefer to sift the water and feed, encased in their protective shell. Because the Gulf Stream washes this coastal region, it brings different species to view.

Barrel and moon jellyfish pulsate, displaying their transparent bodies and trailing stinging filaments.

Bright purple nudibranch, tiny seahare and candy stripe flatworm can be seen creeping along kelp and sponges on the ledges and walls.

Pretty wafting worms (actually marine animals rather than plants) include clusters of peacock worms and the pinkish fan worm. Even hard ross coral and pink sea fan can be found in this region of nutrient rich waters. A vast variety of anenomes is on display: on the sea floor, the burrowing anemones with their long, reaching tentacles; the chunkier parasite anemones that often find themselves on the back of large hermit crabs; snakelock anemones, a rich green with purple tips, often with tiny spider crabs hiding at their base; and rich red and purple beadlet anemones, adding to the beauty of the crowded wall.

At night, as most divers sleep, the reef comes alive. Scorpion fish, stickleback and plaice are just a few of the creatures you can find on the night shift. In particular, tiny cuttlefish, known as 'little cuttle', dance tantalisingly in front of your lens and, just as you focus on them, bury themselves in the sand. The moment they emerge

ON DRY LAND

Beach activities on offer include pony trekking, surfing, windsurfing, canoeing and waterskiing. Equipment and instruction are avail-

able locally.

On summer evenings, traditional music can be heard at several pubs in the village. This area has plenty to explore, with beautiful scen-

ery and countless lakes surrounded by mountains. The famous Connor Pass joins Castlegregory, Stradbally, Cloghane and Brandon, with Dingle to the West. A drive

through these roads is an experience in itself and well worth the trip.

they are off again, with a knack of being able to change colour from dark to pale to fool you. It's worth waiting until midnight to dive, to see the best nocturnal display.

You may disturb a sleeping thornback ray or dogfish, but many creatures are awake. Catch a few hours sleep before the morning dive.

HOW DO I GET THERE
From the UK and Europe, fly to Cork (or get a ferry from Swansea in the Wales). Distant travellers can get to Swansea via London or US Miami International airport. Once in Cork, hire a car or get a bus past Tralee and Castle Gregory to this remote and beautiful south-western point in Ireland

Ligurian Sea

Italy

Secca del Papa

Tyrrhenian Sea

African

SECCA DEL PAPA

Mediterranean magic

Few dive sites in the Mediterranean can be described as having such prolific fish life as this one. Huge rock formations give it a prehistoric aura, redolent of the beginning of time.

maximum depth:
45m

minimum depth:
8m

access
By day boat. Access to La Maddalena Marine Park and the Tavolara/Coda Cavallo marine reserve is restricted, with only licensed operators allowed to work or dive in these special areas. Diving is possible year round, but conditions get cooler in winter. The best time to dive is September to October.

average visibility
15–30m

water temperature
Shallow temperatures range from 12°C–20°C. In summer, there is a thermocline at around 12m where temperatures drop to 15°C or so. In winter, temperatures are round 13°C.

dive type
Reef dive.

currents
More current at depth, and in between the huge reef sections. More sheltered around the shallower sides of the pinnacles or rock face.

experience

in the area
*La Maddalena
Capo Figuri
Motoriotto
Site of the seven wrecks
Angelica wreck
K12*

WHAT WILL I SEE?

Sardinia's topography under the sea is as dramatic and rugged as it appears on land, the seabed presenting an imposing granite structure. Where the rock is interrupted by cracks, soft corals, sponges and anemones provide a home for small blennies, gobies and juvenile fish. Visibility can be up to 40m, giving a real perspective on the dive and a feeling of space.

Sea bream are a common sight and are always seen in shoals passing by. The clear waters help a diver see far into the distance to spot a turtle or eagle ray on the move. The sandy bottom hides flatfish, rockfish and smaller crustaceans crawling on the seabed.

Protected by a marine reserve authority, the sea area of Tavolara has been allowed to flourish. Surprisingly, this marine park has a large population of anthias and damselfish. Looking up during your dive, you can see them fluttering around the top of the reef in their thousands.

THE DIVES

Two impressive granite monoliths rise up from the bottom from 40m to around 8m, nearly to the surface, where clouds of small fish swim close to their highest points. Below 25m, on the lower pinnacle vertical wall, red sea fans flourish, showing off their wonderful yellow streaks.

There is often current between the two pinnacles, and a strong swim may be required if you wish to cover both

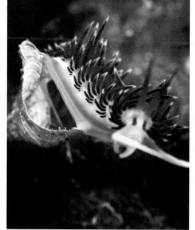

during one dive. Swimming around these huge structures is a humbling experience; a diver is dwarfed beside the enormous boulders, formed over 200 million years ago. Barracuda and small tuna can be seen around the pinnacles; snappers and jacks are common here too.

Secca del Papa boasts the red sea fan, which is rare on these coasts. They appear almost black the deeper you dive, but a torch or flashlight will bring out their vibrant colour. They provide shelter for young fish and other organisms. This, together with the abundance of fish, reflects how unspoilt a dive location this is.

Sea fans are actually animals made up of many tiny individual polyps. Using small, feathery tentacles, the polyps feed by capturing tiny animal plankton that drift by in the current. In many areas, fishing trawlers used to snag and destroy many sea fans in their nets. Recovery takes years as they grow very slowly. Commercial fishing and trawling have been banned for over 50 years to protect the marine life here.

Cardinal fish and wrasse pick food scraps from the reef. Different species of scorpionfish are plentiful, glowing a lovely yellow and orange as you approach. Macro life is present here, including colourful nudibranchs, tubeworms and small invertebrates. This site is worth the visit.

ON DRY LAND
Sardinia is a walker's paradise, off the beaten track. Travellers are overwhelmed by its scenic diversity, ranging from rough, primeval landscapes to gentle, golden sand dunes. Towering mountains are a contrast to the turquoise sea; the Emerald Coast (Costa Smeralda) is famous for the beauty of its beaches, and is often visited by large yachts with VIPs spending their vacations there. The archaeological sites and Roman ruins in Goulogne are popular. For busy nightlife, go to Rotondo.

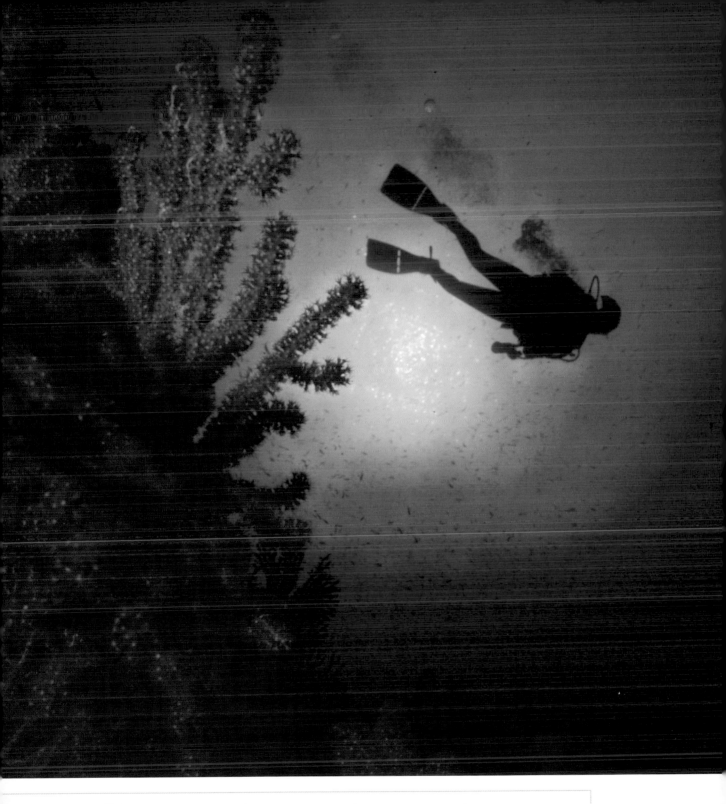

HOW DO I GET THERE

The Cannigione or Arzachena region is within easy reach of Olbia and Alghero airports.

LAVEZZI

Groupers' greeting

Corsica is the most mountainous and geographically diverse of all the Mediterranean islands. With its 1,000-kilometre coastline, the island attracts increasing numbers of French and foreign travellers to enjoy diving holidays. Although it is part of France, Corsica has a distinct personality of its own, both culturally and geographically.

maximum depth:
30m

minimum depth:
20m

access
The dive resort will take you by rib or hard boat on daily scheduled trips. There are many diving centres around the island, offering similar facilities to those found on the French mainland, although some hotels have their own facilities. Main centres are found at Bonifacio in the south and Porto-Vecchio in the south-east.

average visibility
14m–35m

water temperature
12°C–19°C

dive type
Reef/rocky outcrop

currents
Slight to medium

experience

in the area
In general, the west coast is rocky with stunning offshore reefs and spectacular walls. Corsica also has many diveable wrecks. One site dates back 200 years and there are a number from the Second World War off Calvi on the north-west coast.

WHAT WILL I SEE?

The island of Corsica lies within the French Cetacea Sanctuary, which boasts the highest concentrations of whales and dolphins in the Mediterranean. Marine life includes spiny lobster, bream, moray eel, scorpionfish, cuttlefish, octopus and grouper. Coral, tubeworms, starfish, sea slugs and anemones can also be seen. This area is good for rockfish; smaller than their scorpionfish cousins, they have a lovely red hue and big eyes.

On land, Corsica's rock formations are attractive and dramatic, and the same can be said of its underwater rocks. At first sight, there are clear waters and a barren area of rock and boulders; on closer inspection, there is much more than this to see.

Bonifacio in the south gives access to Lavezzi, a site known for its friendly groupers. Here, the dusky groupers are the main attraction and most divers pick this spot especially to visit them.

THE DIVES

A knowledgeable dive guide is required to find this place. Huge plates of rock and boulders create this haven for the groupers. To reach them, you must descend down an anchor line to about 30m, so your time and air supply is limited and must be monitored. Shoals of bream pass

by–many different species of bream and snapper can be seen here. Look out for rays, you usually need to see them on the move to spot them. As you cross over massive boulders it might seem as if you have made a wasted trip until, on cue, the large groupers emerge from behind rocks to greet you. Good conservation practice prevents divers feeding them but some of the older groupers remember a time when eggs and crackers were in plentiful supply, so by giving your buoyancy jacket pocket a tug, you will bring them closer. They are a regal site with their body mass and large eyes. Light levels diminish slightly and the groupers seem to add to the eerie atmosphere. They will hang around you long enough for you to get close and photograph them. Because your dive time is limited, by the time the groupers lose interest it is time for you to ascend. The deeper sections provide a stronghold for black sea fans, and octopus hide cleverly in small crevices in the rock. If you are patient enough, their curiosity will entice them out to inspect you. Rainbow wrasse and painted comber weave around the rocks, foraging for scraps.

There is no opportunity to ascend along a reef slowly, as these rock slabs are flat. When you are ready to surface, simply admire the clarity of the water and the fish life around you as you make your way straight up the anchor line for a safety stop in the blue.

ON DRY LAND
Corsica has a fascinating history. Napoleon was born in Ajaccio, where there are museums and statues dedicated to him, and Nelson lost his eye at Calvi. In addition to its historical interest and rugged beauty, Corsica has many sandy beaches and offers a wide range of water sports. Yachts pass through the area frequently, to enjoy its good sailing and excellent views.

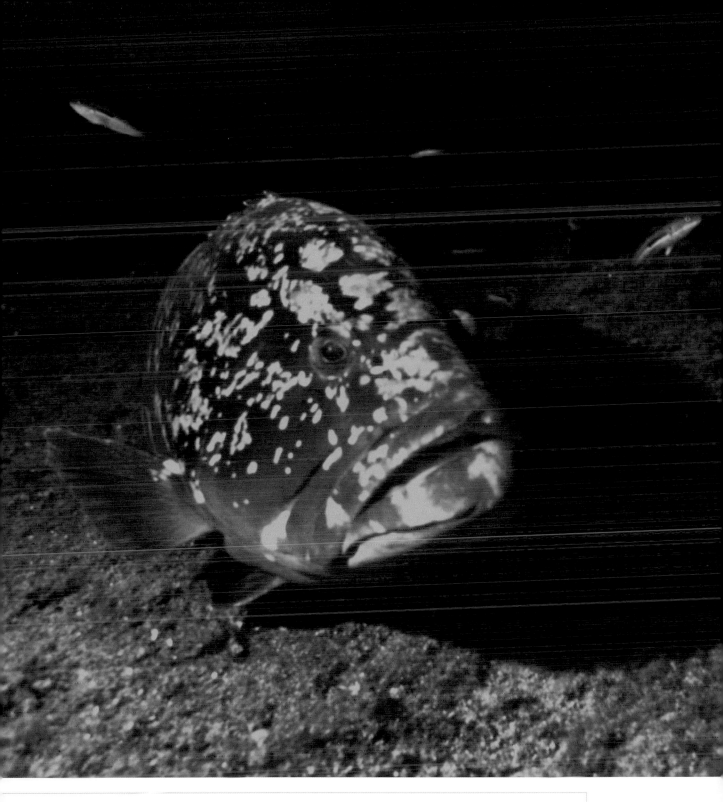

HOW DO I GET THERE

A number of airlines fly to Bastia (France's fifth busiest airport) from London Gatwick and many European airports. There are also airports at Figari and Ajaccio in the south. Travel to Corsica by ferry from France (Marseille and Nice) and Italy. The car ferries are fast and comfortable. Transfer to the resort by car.

TUNNELS OF THE MEDA PETITA

Spanish attractions

The Medas Isles are located off the north-eastern Mediterranean coast of Spain, approximately 1.6km offshore from the resort town of L'Estartit. Meda Petita, the second largest island, is actually relatively small and narrow in places.

maximum depth:
20m

minimum depth:
6m

access
The islands are reached by boat from L'Estartit, Costa Brava. They are less than a mile out of the harbour so trips can be made back and forth throughout the day. Many ribs and hard boats operate out of the harbour. Check the chosen operator is actually licensed to take dive parties out to the Medas Isles.

average visibility
5m–15m

water temperature
14°C–21°C

dive type
Reef and caves

currents
Slight

experience
**

in the area
Medallot
La Vaca
Pedra de Deu
Tasco Petit

WHAT WILL I SEE?

The waters around these islands were made into a national marine reserve in 1983.

Cooler than other more tropical locations, the water is clear and many species can be spotted moving on the rocks or swimming in the blue. Although the visibility can be good, extensive rainfall sweeps a lot of mud into the water around L'Estartit and the Medas islands suffer extensively when this happens. Ray's are common and large grouper roam the area. Mediterranean rockfish and moray eels hang around the rock spaces, looking inconspicuous against the brown stone face. Pretty corals also grow here, including a forest of gorgonian sea fans, glowing red in the sunlight or torch beam. Black and white spotted sea cows rest on colourful blanket sponges, their external lungs and small horns clearly visible. Other small nudibranchs hang from the weed. Shrimp, cuttlefish and many types of flatfish float about on the sandy seabed.

THE DIVES

The local soft limestone rock has eroded over the years to form many tunnels, archways and complete cave systems. The most spectacular tunnel goes through Meda Petita from one side of the island to the other.

These small caves bring interest to the dive and can be enjoyable to enter with a torch to look for bottom dwellers and devilfish. Weird anemones grow on the stone cave floor, their wispy grey feelers giving them a supernatural feel as they waft in the atmosphere, filter feeding then shrinking back into the holes in the cave floor as a diver approaches.

Each cave is unique and interesting, with wide entrance and exits. The quiet eeriness experienced inside the cave is broken by the pretty yellows, oranges and reds of the sunburst anemones and cup corals that coat the walls.

Look carefully behind the rocks and boulders and you have a good chance of finding conger eels and crayfish. Continue the dive to enjoy overhangs and caves. Rainbow wrasses whizz about, and often follow divers in the hope they will smash an urchin to reveal its tender insides, a tasty meal. Bright red starfish seem abandoned, lying on the huge flat rock face as if randomly dropped there.

The entrance to the tunnel through the island is at around 6m. This impressive underwater passage is around 50m long. Only enter it if you feel comfortable with an enclosed space, although it actually feels quite spacious as light is clearly visible at any point in the tunnel. The light forces its way through small windows, some perfectly circular, vertical chimneys pushing their way to the island above. This creates a cathedral feel and is well worth the experience. The tunnel becomes more spacious as it reaches the exit, which has several ways out.

When you pop out the other side, there are more underwater cliffs and overhangs to amuse you, festooned with oranges and yellow sponges and anemones. On the south side of the entrance is a rock ledge, attached to which, strangely, you will find a small bronze statue of a dolphin. This has obviously been placed there specially but the history behind it is a mystery. The cavern is called Dofi, which means dolphin, so that's a clue!

The Med is still very much alive.

ON DRY LAND
L'Estartit is a major tourist resort and just south is Lorette de Mar on the Costa Brava, which has plenty of night life. Barcelona is also quite close for a trip into a major city.

Historically, pirates used the Medas islands as a base for their attacks along the coast. From the Middle Ages until the end of the 19th century, the islands held military and strategic importance. The park protects and conserves many flora and fauna; walker and bird watchers would enjoy this environment. The largest island is topped by a lighthouse, and a handful of people can stay on the island at a time.

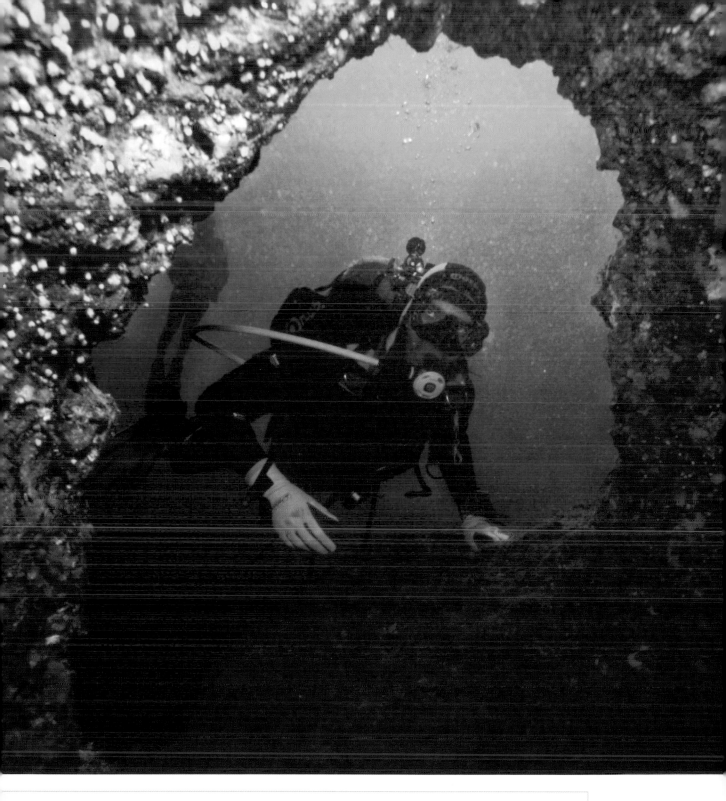

HOW DO I GET THERE

Charter flights go to Gerona. Cheap car hire is available to drive the 50km to the resort. Europeans often choose to take their own vehicle, and with the European motorway system now running unbroken from Calais to within 30km of L'Estartit, the journey from the Channel can be accomplished in 10 to 12 hours.

HALF MOON POINT, BAIKAL LAKE

Explore the wonders of the oldest lake on earth

This amazing and exceptionally clear lake is home to more endemic species than any other lake on Earth. Baikal is also the world's deepest lake, plunging to more than a mile in some areas.

Russia

Lake Baikal

China

Mongolia

maximum depth:
50m plus depending on qualification

minimum depth:
6m

access
*The city of Irkutsk is 60km from Baikal. Dives are organised via the village of Listvyanka. Local dive centres organise camping accommodation on the shores of the lake. Access by liveaboard or day boat.
Lake Baikal is chilly all year round, and the entire lake is frozen over for more than five months out of the year.*

average visibility
10m–60m

water temperature
*1°C–12°C
(Warmer July to September)*

dive type
Freshwater lake, ice diving – drysuit required

currents
None

experience

in the area
The lake has many dive sites to explore, with no other sites in the area as the lake is surrounded by land. Lake Tanganyika is the second oldest lake in the world, located in Zambia

WHAT WILL I SEE?

Estimated at 25 million years old, every inch of this lake is immensely rich, and it is home to around 1,550 species of animals and 1,085 species of plants.

Its occupants seem to live a long time too, as the plentiful sturgeon fish in Baikal are said to live up to 50-60 years. Fish seem unwary of divers, or perhaps they are just sluggish in the cold water.

The lake's remarkable clarity is partially attributed to its massive population of a small crayfish, Baikal epishura, which eats algae and other particles in the water that would otherwise serve to lower visibility. Apparently, these tiny crustaceans (and we are talking micro at approximately 1.5mm long) filter 10 to 15 times the amount of water that flows into the lake. They do this job along with the help of other crustaceans, keeping the lake clean and clear.

Lake Baikal is also home to one of the world's few freshwater seal species, the nerpa. Silvery-grey in tone, these seals have similar characteristics to their salty cousins and are mostly lazy on land and gentle and elegant underwater. Their different genetic make-up helps them survive in this deep, freshwater lake habitat; they have four pints of blood more than any other seal, giving them the ability to go without fresh air for 70 minutes. This enables them to carry out long, deep swims, up to 300m below the water's surface. During winter, the lake ices over, hiding their dens. These are carved from snow and ice, and the seals access them from under the ice.

THE DIVES

At Half Moon Point, boats anchor on a large shelf on the southern side of a canyon. There are several huge boulders and white sand on the shelf, which at its shallowest is 3–6m. This slopes down to a steep terrace wall that increases to around 70m, so choose your depth and enjoy the clarity of the water. A diver feels dwarfed amongst the gigantic underwater mountain ranges.

When you first arrive at the lake, a dense fog shrouds it in a grey veil and the winds are icy cold. As the sun emerges, particularly during its warmest in autumn, you feel its time to put on a drysuit and get in the water.

It's hard to believe how incredible it is under the surface. The boulders and rock walls are smothered with lettuce and other green algae; rubbing the algae causes clouds of green to vaporise. Further green hues emanate from the sponges, some of them jutting out with branches, joining others nearby to form a reef-like structure. This provides a great habitat for the cleaning crustaceans and other small marine life.

This site is typical of any around the lake, where 20–30m from the shore a small slope leads to a shallow ledge then falls away to reveal a steep wall. The vertical wall just drops into the abyss, frequently broken up by canyons. Look around to view windows revealing underwater caves and grottos.

ON DRY LAND Snow-related activities including skiing, dog-sledging and ice-fishing are available to book, as well as outdoor activities such as trekking, biking and kayaking. The area is steeped in tradition and history and, ringed by mountains, it seems like something out of a children's fable. This magical lake is surrounded by beautiful pine forests and here you may find the famous blue squirrel.

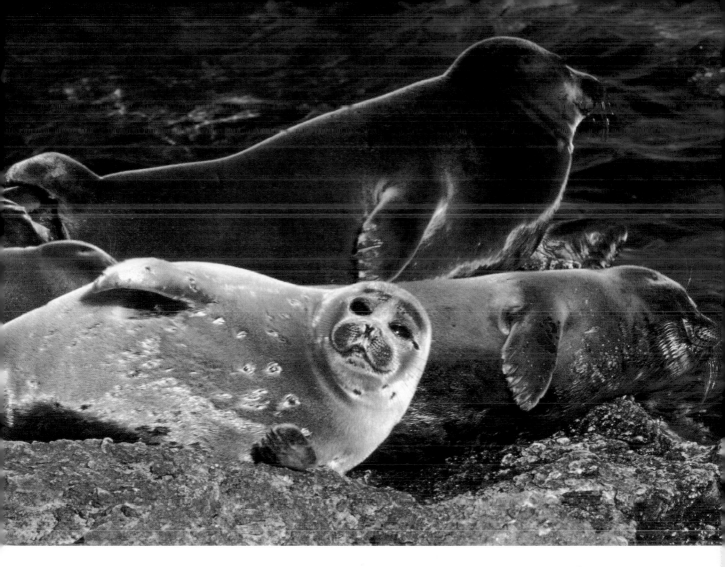

Follow the wall as it turns nearly 90 degrees and runs parallel to the shore. The wall smoothes out a little here and you can take time to admire the landscape.

Another canyon begins at 40m, with a central one ending at 54m. These canyons are formed by boulders of different sizes sitting on or close to each other, adding an extra dimension to the already varied and challenging dive.

Sponges are everywhere, with sculpins like the Mediterranean rockfish sitting on the soft coating as if it is a carpet provided for their comfort.

Surface slowly, watching the clouds through the surface; lie back and look through Snell's window.

Expect dive times to be short as a safety measure to protect your hands and faces from getting too cold.

This lake is more than 600km long. Its influx of sediment from rivers and streams is not making it any shallower. Scientists have studied the earth's tectonic plates here, which are causing a rift to deepen the lake still further. Baikal is the most beautiful place, and offers a great diversity of wildlife.

HOW DO I GET THERE

Fly to Irkutsk, Siberia's largest city.

SILFRA

Where continental plates meet and drift apart

The Silfra fissure in Thingvellir is a world-class dive. This awe-inspiring underwater landscape is definitely worth a visit.

maximum depth:
40m

minimum depth:
1m

access
Dive centres will pick you up from Reykjavik and transport you to the dive site for two dives. *Silfra is accessible all year around. The best time is between 1–15 July, to take advantage of 24-hour daylight. Although the lake is often frozen over Silfra never freezes, because of the constant current caused by the continuous flow through the underground wells.*

average visibility
60m–100m+

water temperature
2°C–4°C

dive type
Ice diving

currents
Slight

experience
*** and an ability to dive in a drysuit*

in the area
*Strýtan, a thermal chimney in Lake Eyjafjordur
El Grillo wreck*

WHAT WILL I SEE?

You will be astounded by the visibility you experience here, mainly as much of the water has come from melting glaciers, and travelled through the lava fields for many years before emerging through underground wells at the north end of Lake Thingvellir. Visibility has been reported at over 150m and described as looking through glass.

Silfra is actually the ravine between the Eurasian and the American continental plates – massive floating slabs of rock that effectively hold the continental plates apart. You will be diving down between the two tectonic plates.

Scientific research has suggested that the water emerging at Thingvellir has been on the move for more than 10,000 years. Unlike the nutrient-rich oceanic waters around Iceland, there are few organisms living in the water at Thingvellir. The one fish that is plentiful, and that you will certainly come across, is the Arctic trout.

THE DIVES

Pure and brilliant blue, the first thing you will notice is the water's hue, which will take your breath away.

Silfra caters for all divers' needs. The standard sport diver tour is to around 15–20m but deeper dives to 40m can be organised for experienced or technical divers. There are three sections to the dive: Silfra Hall, Silfra Cathedral and Silfra Lagoon. All three can be visited on one dive, but you may find the cold water demands a break between the dives to warm up.

The first part of the dive starts from a platform with steps leading down to the water. Meander through Silfra Hall, floating over the shallows that fall dramatically to a ravine. The cliff face then rises sharply and you feel you are crawling over shallow rocks to enter the next stage of the dive.

Drifting through the crack is a journey in itself, as a mild current caused by underwater wells carries you gently to your destination. During the dive, it feels as if you have been removed from the real world as eerie scenes unfold. The craggy, sharp edges of the tectonic plates seem to move, appearing to narrow and widen around you. This spectacular crack leads you to an area of gigantic rock formations on either side; this is the Silfra Cathedral. The rock formations are truly unique and the magnitude of the rock face, particularly in water of this clarity, appears gargantuan. Like an ancient pagan ceremonial site, the rocks look as if they were placed in position many years ago.

Towards the end of the fissure, it widens out into the final part of your dive, towards the open lake. Fin towards yet more stunning scenery as you enter an extremely beautiful blue lagoon, Silfra Lagoon.

Silfra is filled with spring water, and divers say the water is sweet to drink. This is a fantastic opportunity for diving; Arctic trout appear to fly around you like birds in the air and the clarity of the water is almost confusing.

Watch out for the algae on the stony walls and rock pinnacles. It forms a fine covering of organic sediment which, if touched or wafted by a fin, dissolves in the water to create a fog of green and spoil the visibility. The atmosphere is broken.

It is a fascinating fact that during this dive you are swimming between two continents, from Europe to America and back; one end of the dive site belongs to America, the other end to Europe.

As you surface, you realise you have visited an ancient and untouched part of the planet.

ON DRY LAND
Iceland is known for its unspoilt nature. Tourists have many options and places to visit here. Volcanoes and snow-capped peaks are all around, and trips to see the hot water springs and glaciers are organised regularly. For a wild evening out, try the local nightclubs, which are open till dawn in Reykjavik. White water rafting and snowmobile racing are on offer if you have not fulfilled your adrenaline rush through diving. You can also walk up to the Oxara Falls, where the river plunges over the walls of the valley before it meanders across the floor of the valley. Try the ice bar, or stay in the local ice hotel for accommodation with a difference.

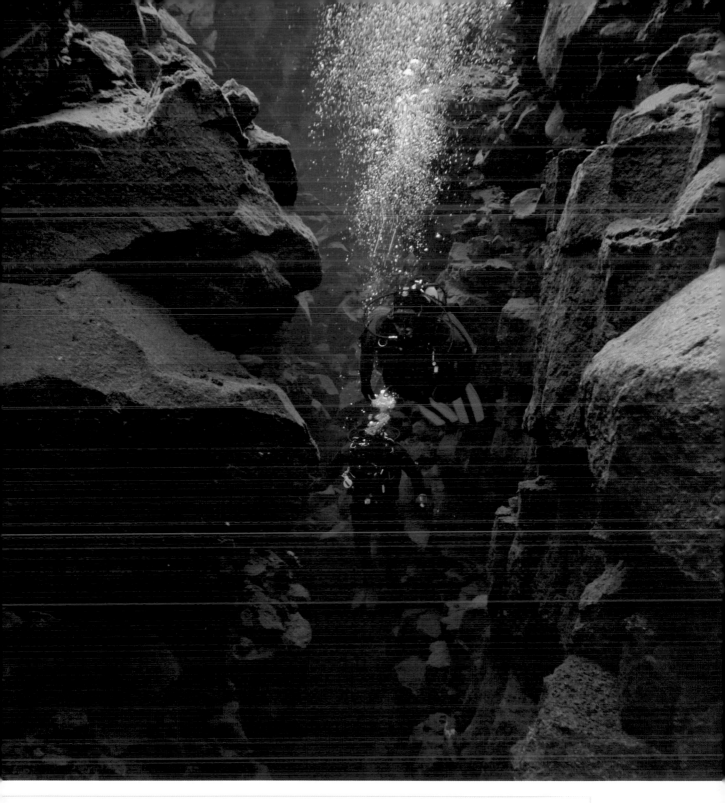

HOW DO I GET THERE
Iceland Express airlines run a daily service from Stansted Airport in Essex to Keflavik, which is about 50km from the capital, Reykjavik. From Reykjavik, it will take you under an hour to reach the national park. From Europe, it is possible to dive Silfra over a long weekend.

Italy

Greece

● **Blue Hole**

Mediterranean Sea

Libya

maximum depth:
50m

minimum depth:
6m

access
Gozo has many dedicated dive centres with daily trips to the Blue Hole. It can be accessed from shore but it is better by boat with surface cover.

average visibility
20m–40m

water temperature
13°C–20°C

dive type
Reef/cave

currents
Slight

experience

in the area
*San Dimitri Point
Cathedral Cave
Billingshurst Cave
Double Arches
Chimney*

THE BLUE HOLE

Diving on the edge of the world

An extraordinary dive that leaves you hanging in the blue like an astronaut in space. You swim through arches, over drop-offs and up chimneys. The Blue Hole is a truly memorable dive, which leaves a lasting impression.

WHAT WILL I SEE?

The Blue Hole is a divers' Mecca situated on the western edge of Gozo. Millions of years ago, nature carved a spectacular rock formation from limestone, creating a network of caves, arches and holes.

Schools of tuna, grouper and barracuda are often found hovering by the large boulders and rocks around a cave located within the Blue Hole at 15m. The hole is connected to another section through a short tunnel, or chimney. Here, much coral and marine life can be found including shoals of saddled bream, flying gurnards and rockfish. Octopus and cuttlefish hover around the rocks, seeking refuge.

Smaller creatures like nudibranch, shrimp and spotted sea cow seem dwarfed against the enormity of the Blue Hole's scenery. They, too, have their place here and it is worth stopping for a moment to appreciate them with a closer look.

THE DIVES

The Blue Hole is a stunning rock formation and probably the most popular dive site in Gozo. There are several ways to dive the Blue Hole. The most spectacular is a beautiful sharp drop-off straight into the Blue Hole. In essence, the hole is a collapsed cave that now allows divers to enter the sea and drop down to 16m before finding the cave's exit to the main sea. The colours and blues are truly mesmerising.

A fun and more varied way to dive this is to enter the water at the Inland Sea. It descends to the Blue Hole at 17m, leading into a large crevice and through to the open sea, taking in different scenery on the way. You may find it a long fin out over some large boulders but it is worth it to soak in the atmosphere. There is a good chance of seeing some large resident grouper here. Keep the reef on your left and carry on finning for about another five minutes.

The pool has an impressive underwater arch at around 8–15m, giving access to the open sea for divers and snorkellers. The archway has a flat top at 8m, almost square in shape, and covered in golden cup corals. Following the wall to the left, a diver will eventually come to the almost vertical fissure that starts at 25m and leads up and through the narrow passage all the way to the west side of the wall until you reach a depth of 6m. Visibility should be excellent, with a view of a solid blue hue glowing up from the deep. Look out for the Azure Window; a stop point to view more scenery, this window to the deep means you have reached the drop-off. It will seem a long way down, as the steep wall plummets to 60m.

The rocks and reef structure are covered in typical Mediterranean life, with sunset anemones, sponges and rainbow wrasse. You can swim up a chimney structure, formed by wind and wave action. The seabed is strewn with large boulders, with lobsters marching over them and starfish and sea urchins adding colour to the dark rocks.

When your dive is over and you ascend into the sunshine, you can walk back, but being picked up by boat is preferable. The chances are you may wish to dive the Blue Hole again as it is a quite unique dive.

ON DRY LAND
Malta is characterised by a series of low, flat-topped hills with terraced fields on their slopes. Its coastline has a rugged beauty, indented with natural and man-made harbours and bays.
Gozo's long history and its important position in the Mediterranean has left it with endless places to explore, covering the period from 5000BC to World War II and beyond.
You can also explore its natural landscape from the sea, viewing creeks, several sandy beaches and rocky coves. Sailing and other water sports are available on request.

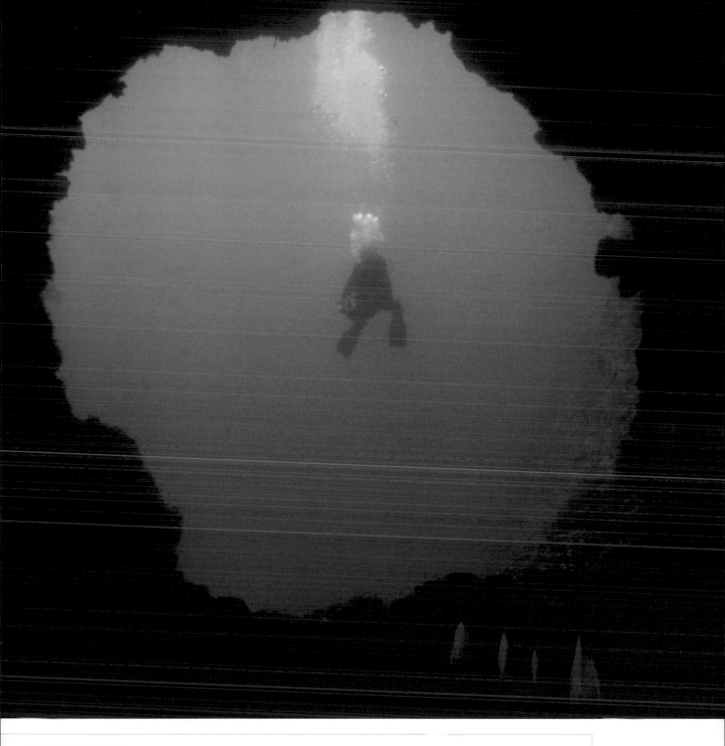

HOW DO I GET THERE

At just a couple of hours' flight from major European cities, the Maltese Islands are easily accessible for long weekend diving holidays as well. Gozo is visited by a regular ferry service operating out of the north-west corner of Malta known as Cirkewwa.

FARNSWORTH BANK

Purple haze on a picturesque pinnacle

About 35km off the coast of California is an archipelago of eight islands that offer some of the best temperate water diving in the world. One of these is Catalina Island, around which there are plenty of diving opportunities. The most famous is 3.2km off the west coast of the island, locally described as the 'backside', where there is a sea mount named Farnsworth Bank. It has an abundance of marine life and one of its special features is the purple hydrocoral, which adds a wonderful splash of colour to the reef. Hard corals are rarely found in cold waters but purple hydrocoral thrives here.

maximum depth:
60

minimum depth:
18

access
By day boat from Avalon, weather conditions allowing.

average visibility
Variable to 30m

water temperature
Averages 15°C (60°F)–21°C (70°F)

dive type
Sea mount in open water

currents
Moderate to strong

experience
**** to ***** with suitable temperate water experience and depth dependent*

in the area
There are a vast number of dive sites around the island, with the majority on the east side. Wrecks include the private luxury yacht Valient, which sank during the prohibition era and lies very near Avalon.

WHAT WILL I SEE?

Farnsworth Bank in fact consists of several sea mounts. They rise from the ocean floor some 75m below, the shallowest reaching to within 18m of the surface. The location means that they are exposed to the Pacific seas, which are not always in a 'pacific' mood. So getting there depends very much on the water conditions, which when rough can make them inaccessible for diving. Even when diving is possible the waters may be choppy, so good sea legs help. Dive boats from the main town of Avalon take some 45 minutes to reach the location. For those with the appropriate level of dive experience diving Farnsworth Bank is certainly worth the effort with its abundance of pelagic fishes and reef fishes, wonderful invertebrates, including the beautiful purple hydrocoral, and the possibility of encountering sea lions.

THE DIVES

One of the advantages of the exposed location is that amazing visibility can be found here, reaching over 30m in the best conditions. You may find marked changes in visibility and water temperature due to thermoclines, and currents can be strong. As a result of extensive

sport fishing, mature game fish are depleted. However, don't let that put you off as the dive location has gained its reputation for what it does have to offer.

As you descend to the top of the mount you will immediately see the colourful vista created by the purple hydrocoral and the red gorgonians. There is plenty of invertebrate life to search out, strawberry and pink anemones, yellow zoanthids and metridium anemones among the cnideria. Look out for the molluscs such as abalone, scallops, keyhole limpets and lots of egg cowrie shells. Octopus can be found here, hidden within the nooks and crannies. Colourful nudibranchs are another shell-less mollusc that are always in demand by the macro photographer. Spiny crayfish are common and you will no doubt come across old abandoned fishermen's creels. There are starfish and featherstars as well as several species of sea cucumber slowly manoeuvring their way across the seabed.

Against this backdrop there are plenty of fish to seek out. Some are easier to find than others. Large schools of blacksmith and jack mackerel and senorita in their thousands. Californian barracuda are an impressive sight, as are the bat and torpedo rays as they drift

ON DRY LAND
Catalina Island is some 33km long by 13km wide and divided by a narrow isthmus. It has a population of around 3,000 and is known to have

had human habitation for around 7,000 years. Avalon is at the southern end of the island and has all the facilities you need, such as restaurants, hotels and

shops. There is no car hire on the island but plenty of taxis and buses are available and you will see golf carts and bikes being used around town.

The interior is unspoilt and you can see buffalo roaming as they have been introduced onto the island from the mainland. These massive beasts are a joy to

see, surviving all the ravages of their past.

There are well marked trails on the island for exploration on foot. 15 species of plants are found here and there

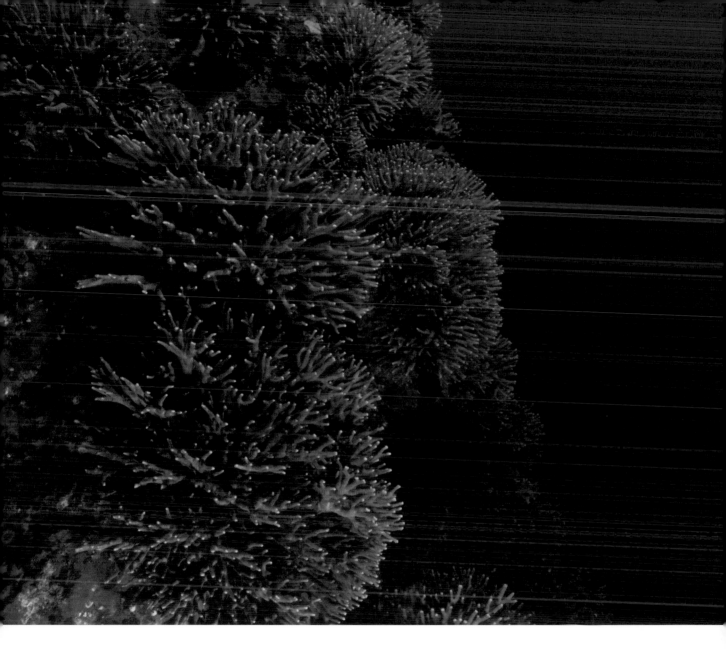

effortlessly across the reef. Blue sharks may also make an appearance. This long and slender predator is a most attractive shark, with its upper body of indigo blue, its bright blue sides and white underbelly.

Other fish are abundant also; large sea bass, perch, calico bass, blacksmiths, painted greenling, yellowtails and California sheepheads. Also, we mustn't forget the wonderful garibaldi, which is synonymous with the giant kelp forests found elsewhere around Catalina Island but they are also found here on Farnsworth Bank.

From the top of the bank you drop-off to a steep wall and if the visibility is clear you can sometimes see the ocean floor below you. So if you feel adventurous, pack your drysuit (preferred) and head for California and Catalina Island.

are many animals, some of which are endemic to Catalina.

HOW DO I GET THERE
Los Angeles International Airport (LAX) California. The main town of Catalina Island, Avalon is reached from the mainland ports of Long Beach and San Pedro.

Canada

Vancouver Island

Pacific Ocean

United States

maximum depth:
34m

minimum depth:
8m

access
Charter dive boat.

average visibility
*3m–15m (Best vis-
ibility during calm
weather and most
likely in summer and
autumn months)*

water temperature
4°C–30°C

dive type
*Temperate rocky
reef dive*

currents
*0–7 knots plus. Cur-
rents in the area are
extremely strong and
dangerous so care-
fully organised slack
water planning is
essential.*

experience
**** to ***** Temper-
ate water experience
necessary*

in the area
*GB Church Wreck
Mackenzie DDE261
Wreck
Clover Point
Ogden Point
Spindrift
Saxe Point
Spring Bay
Telegraph Bay
Plus many dive sites
too numerous to
name around the rest
of Vancouver Island.*

RACE ROCKS

With the racing current comes a wealth of marine life

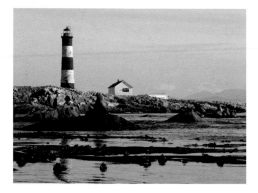

When a dive location is praised by the likes of Jacques Cousteau and David Doubilet, it would be a brave person to say otherwise. Vancouver Island has that honour and divers who brave cold water diving will find that it lives up to such exalted praise and surpasses it.

WHAT WILL I SEE?

The city of Victoria is the capital of Vancouver Island and is located at its southern end. About 17km south-west of Victoria, Race Rocks jut from the sea, a black and white lighthouse sitting atop, guarding the entrance to the Strait of Juan de Fuca. This is probably the best known dive location in the Victoria area and probably one of the best cold water dive sites in the world.

The nutrient rich waters from the Strait of Georgia and the Strait of Juan de Fuca meet here. Fast flowing currents in the area can reach seven knots or more, ensure an amazing diversity of marine life, especially invertebrates. You may encounter harbour seals,

elephant seals and California and Steller sea lions, which is an unforgettable experience. There is also an abundance of fish in the area, so a dive here will definitely be worth all the effort you put in to reach the dive site. For the sea lions, it is necessary to dive during the winter months but, as the water temperature changes only a couple of degrees between winter and summer, and as it is very much dry suit territory, this should not put you off. Occasionally, the visibility can also be better in the winter months.

In 1980, the Province of British Columbia designated Race Rocks as an ecological reserve.

ON DRY LAND
The Capital Regional District of Victoria is home to around 750,000 people, almost half the population of Vancouver. Victoria has

all the facilities you would expect from a capital city; plenty of hotels, shops and restaurants, as well as interesting and historic places to visit. A network of

walking, hiking and biking routes takes you through the many parks in the city. There are plenty of activities apart from diving, such as boating, yachting, wind-

surfing, fishing, kayaking, golf, rock climbing, in fact something to suit all tastes. In the countryside there is a rich diversity of landscapes to explore, from the Douglas

fir forests near the coast to the rockier areas on higher ground. Whale watching cruises are available and Orcas may also be seen in the area. The rocks and cliffs are

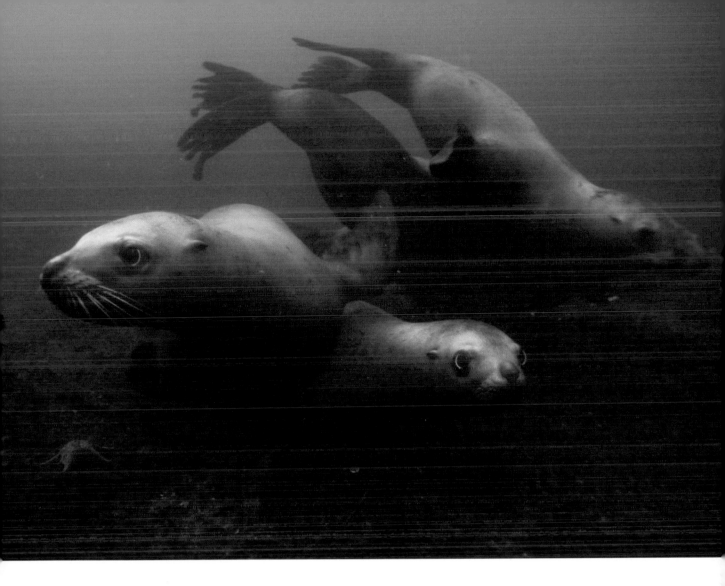

THE DIVES

Being offshore, you dive Race Rocks by charter boat. Race Rocks is a series of small islands, reefs, walls and pinnacles, which means that to do it justice you need to plan to repeat dive there to experience its many aspects. In the shallower areas, the forests of bull kelp provide shelter for many species such as rockfish, sea urchins, abalones, Puget Sound king crabs and nudibranchs.

Below the kelp, the invertebrate filter feeders get rich pickings from the nutrient rich waters and the strong tidal currents. Areas of rock are carpeted by barnacles and there are lots of tunicates, sea stars and basket stars. Urchins dominate the flat rocky surfaces, while the walls are covered with life. These include beautiful plumose anemones, dahlia anemones, dead man's fingers, purple hydrocorals, hydroids and sponges, all bringing a wonderful tableau of colour.

There are plenty of fish, such as ling cod, cabezons and greenlings. You may come across remains of ships wrecked here, which have come to disaster on these rocks. Many divers come here for the encounters with seals and sea lions. The California and Steller sea lions congregate in large numbers from September and there are several hundred harbour seals in residence all year round.

a delight for bird watchers as there are many nesting colonies such as gulls, cormorants, guillemots and oystercatchers. These are also the places to see the seals and sea lions while they are resting, as they share the rocks with the birds. You may also see river otters near the shore, and sometimes harbour porpoises.

HOW DO I GET THERE

International flights to Victoria International Airport, which is 22km north of Victoria. There are many dive charter operators in the region who can guide you on booking a dive trip and on transport options from the airport.

NORTHERN ARCH

Rays of light and flights of rays

The towering natural structure of this arch, which looks insignificant from the surface, is a spectacular sight. The walls are decorated in many colours created by sponges, bryozoans and jewel anemones, and fish are everywhere. Welcome to the wonderful world of temperate diving.

Pacific Ocean

Australia

Poor Knights Islands

Tasman Sea

maximum depth:
60m

minimum depth:
5m

access
Charter boat from Tutukaka Harbour, 30 kilometres north of Whangarei. Diving can be booked through the local resort. Dives are a 30–minute journey by local dive boat.

average visibility
15–30m, occasionally exceeding 46m in winter months (May to September)

water temperature
14°C–24°C

dive type
Wall dive, deep dive, cave dive

currents
Light to strong

experience
*** to ***** Depth dependant

in the area
Throughout the Poor Knights Islands, there are plenty of dive sites to choose from. In the area to the north-east of Tawhiti Rahi Island, the following sites are recommended:
Wild Beast Point
Cream Gardens
Haku Point
Dark Forest
Air Bubble Cave

WHAT WILL I SEE?

The Poor Knights Islands are situated 24km off the east coast of New Zealand's North Island, near the town of Tutukaka, about 200km north of Auckland. There are two main islands, Tawhiti Rahi and Aorangi, as well as many smaller islands.

The east coast of North Island receives currents from the warm waters of the Coral Sea. This means that both temperate and tropical species are found here. The importance of this location was confirmed in 1981 when the Poor Knights Islands were made a marine reserve.

THE DIVES

Once underwater, the insignificant arch above the water opens into a spectacular cavern. Large schools of demoiselles, pink and blue mao mao, snappers, butterfly perch and trevally can fill your vision. If you descend to the bottom of the arch at about 44m, you may encounter kingfish, leatherjackets, morwongs, wrasse, golden snappers, mado, porae and pigfish. Occasionally, long finned boarfish and splendid perch may be seen.

Dive the site between December and March and you may get a special treat, as short tailed rays congregate here to mate and breed. It is not uncommon for these to gather in numbers over 100; it is a truly awesome

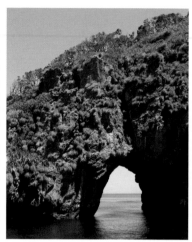

experience to swim amongst them as they gently ride the currents.

At the mouth of the cavern, the bottom drops away to the north from 44m over large boulders down to the sandy bottom at around 60m+. For the suitably qualified, you may way want to venture down to this area, which is less frequently dived. If you swim out of the arch to the south, you will reach the sandy bottom at around 45m after which the seabed slopes gently away. When the dancing rays of the sun penetrate the water they add to the beauty of this dive.

You may be rewarded with a spectacular show from the pelagics in midwater. Continue with a slow ascent up the wall to the north of the arch to inspect in detail the invertebrates that decorate the walls. Soft corals, sponges, bryozoans, hydroids and anemones all add colour to the scene. Nudibranchs graze the bryozoans. Pink and white jewel anemones create swathes of colour and are a magnet for macro photography. Moray eels and crayfish may be seen peering out from the safety of their fissures in the rock.

Jacques Cousteau once described Poor Knights Islands as one of the top 10 dive sites in the world and few would argue with that. Northern Rock is among the best of the best to be found there.

ON DRY LAND
New Zealand is famous for its breathtaking scenery. There are many ways to take in the country, from organised tours to hiking. Auckland is the largest city in New Zealand and tourist arrangements are available to suit every taste. You may wish to trek through rainforest, picnic on a volcano, visit a vineyard or just laze on a beach. In the forests of the Waitakere and Hunua ranges, there are birds and trees that are unique to the island. Boat trips for spotting dolphins (and occasionally migrating whales) are available, and kayaking and snorkelling can also be arranged. Auckland, as would be expected from a major city, provides restaurants serving many international styles, excellent shopping facilities and entertainment.

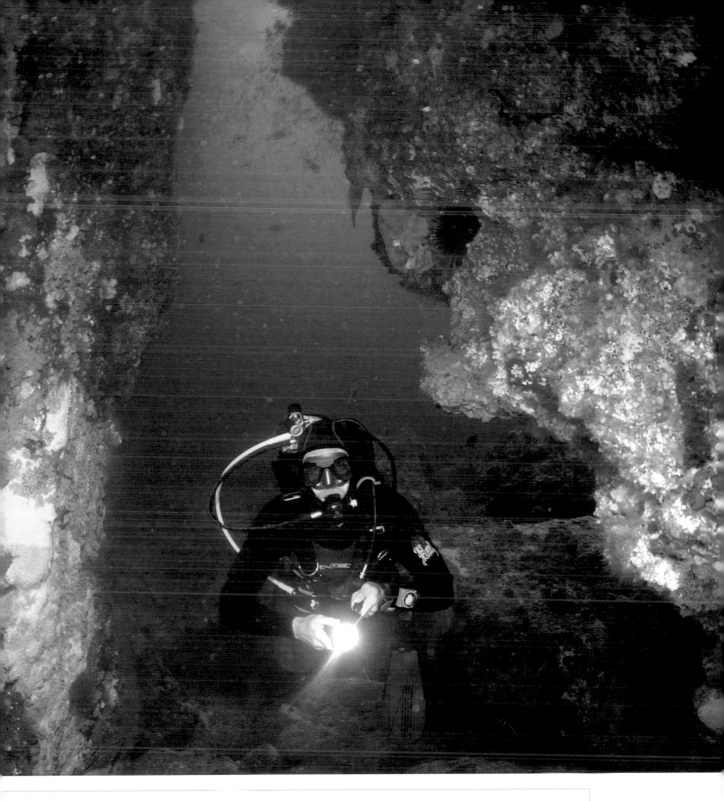

HOW DO I GET THERE

International flights to Auckland or Hamilton International Airports. Bus, coach, taxi and car hire services available to reach Tutukaka Harbour.

Australia

Indian Ocean

Tasmania

Fortescue Bay

maximum depth:
25m

minimum depth:
10m

access
There are no dive resorts on location; the closest resort is 16km away, an hour's drive from Hobart. Book before you arrive. The dive site can be accessed by shore dive from the beach or pier, or a short boat trip that takes minutes to get to the site. Dive operators also leave from Pirates Bay, with a 15–20-minute boat ride. Be aware this is a national park and fees will apply.

average visibility
10m–40m

water temperature
18°C–29°C

dive type
Reef

currents
Slight

experience

in the area
*Giant Kelp Forests
Cathedral Caves
Horseshoe Cave,
Waterfall Bay
Hippolyte Rock
Bruny Island Kelp
Forests
The Iron Pot
Tinderbox
Crayfish Point
Blackmans Bay
Princess Wharf*

FORTESCUE BAY KELP FOREST

Rainforests of the sea

Beneath dramatic island scenery of jagged mountains and cliffs lies another world. Enter the graceful and wondrous world of the kelp forest.

WHAT WILL I SEE?

Kelp trees tower up from 30m like a magnificent underwater forest in which many creatures dwell. Among the prolific life here, you can find much that is unusual, including boarfish, gopher rockfish, albalone and the scary-looking wolf eel. Wrasse, crayfish and short-finned pike are very common.

Kelp requires a special habitat to live, the water to be rich in nutrients, clear and cool with moderate water movement. Like trees, a kelp forest also needs plenty of sunlight to grow.

Sea otters roll in the kelp as a secure mooring, where they float in their overnight beds, being rocked to sleep by the rolling waves. Urchins are a threat to kelp as they eat the base of the plant, causing the rest to float away, and the sea otter helps prevent this deforestation with its good appetite for an urchin meal.

The ocean floor provides a soft sandy home for tube anemones, skate and banded stingarees. Surrounding the plants and animals are a wealth of microbes, including bacteria, single celled algae and worms. While small in size, they are vital to keeping the kelp ecosystem healthy.

THE DIVES

The darkness beneath the kelp is like a giant canopy, with hues of light shimmering through the branches and falling on the rocky floor where lobsters and crabs patrol the area for scraps of food.

This dive is an intense vertical drop off with undercut rock faces. Anemones and sea stars form a blanket on the walls beneath the surface cliff face. Purples, reds and oranges brighten the scenery.

Every tier of the kelp forest reveals something special. Jellyfish float between the stalks, drifting towards the surface sunlight. High in the canopy, sea snails, cuttlefish and finned fish move through the leafy domain in search of a snack.

As you descend down the tree trunks, king crabs with huge claws roam the branches. Kelp forms dense canopies up to 35m above the seabed. As you descend still further, explore the crevices and boulders where you will find abalone and spiny urchins hiding. During the night they will come out to feed on tiny algae they scrape off the rock. Shoals of jack mackerel weave in and out of the kelp stalks, sometimes taking you by surprise.

The forest floor is littered with rocks; bright orange garibaldi fish tend to make their nests here, picking off unwanted algae and chasing intruders away. They have even been known to carry away unsuspecting small hermit crabs that pass too close to their nests.

You may see a rare bigbelly seahorse or a cute cowfish. The weedy sea dragon is a speciality here and, although not as rare as its leafy sea dragon cousin, is a pleasure to find. It is hard to spot a weedy sea dragon as it mimics a piece of floating torn off kelp.

Looking up towards the surface will provide you with a different dimension to tropical reefs in other locations. You are likely to see sea snails and nudibranchs slowly climbing up the kelp's long leaves. Brightly coloured sea stars and soft spined urchins make their home amongst the kelp fronds.

The atmosphere created by a kelp forest is incredible. Few other dive experiences come close to diving in giant kelp forests and it is one that every diver who comes to Tasmania should try to do.

ON DRY LAND
Located at the south-eastern part of Tasmania and cradled between Mount Wellington and the Derwent River, Hobart is an historic town with so much to offer. At Fortescue Bay, abseiling, rock climbing, hang gliding and bush walking are popular. There are many hiking trails along the cliffs, offering spectacular views of the coastline. The paths will also take you through heath and woodland.

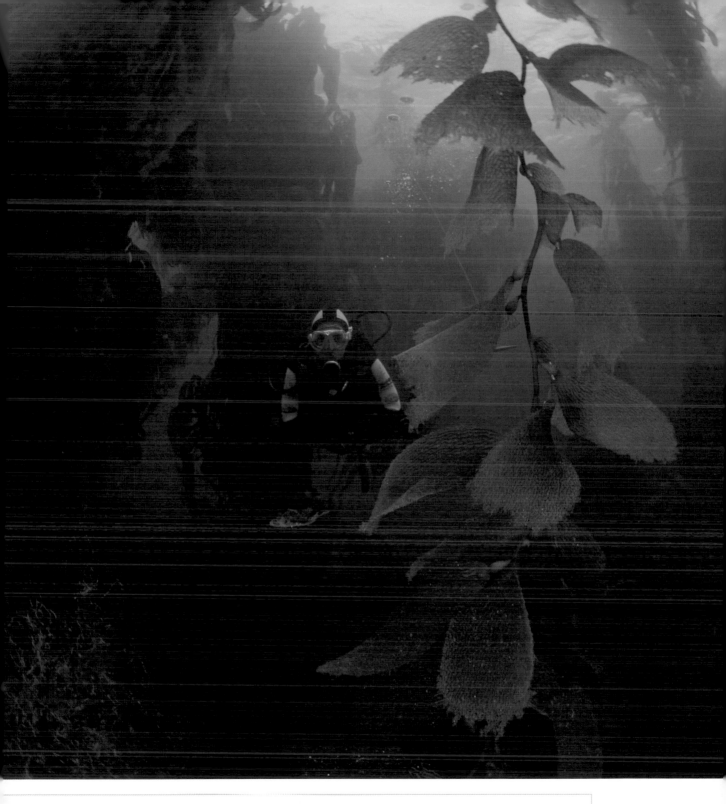

HOW DO I GET THERE

Fly to Tasmania's famous capital. Hobart, via major international airports. Public transport or car hire to the Tasman National Park, located on the Tasman and Forestier Peninsulas in south-eastern Tasmania. From Hobart, take the A3 to Sorell and then the Arthur Highway (A9) to Port Arthur. The park has several main access roads.

SGARBHSTAC SUBMARINE ARCH

The ultimate arch dive

St Kilda is a World Heritage Site renowned for its wild scenery. Its great sea cliffs are the tallest in the British Isles, the highest reaching 372m above sea level, and are home to some 700,000 breeding seabirds. This archipelago lies 65km beyond the Outer Hebrides and is the remains of a great volcanic complex that formed more than 60 million years ago. Isolated from the mainland, the waters can be crystal clear and blue with visibility exceeding 40m.

maximum depth:
50m

minimum depth:
0m

access
Charter boat from Oban, Scotland, between May and August.

average visibility
10m–40m

water temperature
9°C–13°C

dive type
Wall/cave tunnel

currents
Nil to strong

experience
**** to *****

in the area
There are many dive sites around the islands of St Kilda, around Hirta, Dun, Soay, Levenish, Boreray, Stac An Armin, Stac Lee and Am Plaistair. They are too numerous to name them here but the charter company will be able to guide you to the best sites. On the journey out to St Kilda, it is normal to dive in the Inner Hebrides, where there are again many dive sites.

WHAT WILL I SEE?

Getting to St Kilda is not for the faint hearted and cannot be guaranteed. The weather patterns can change rapidly, with wind speeds frequently at force 3 with wind speeds frequently at Force 6 and reach gale and they reach gale force at times. There are four main islands in St Kilda, the biggest being Hirta. Village Bay on the south-east side of Hirta is where the people of St Kilda lived until 1930 when they evacuated the island. Their remarkable story is well recorded. Boats that journey to St Kilda find shelter in Village Bay but weather forecasts have to be closely monitored as, should winds turn to an easterly direction and increase, it becomes necessary to head for the inner isles.

So why would you want to take the gamble that you might be able to reach the islands of St Kilda? Well, the sight of the great sea cliffs rising sheer out of the water is spectacular. Sea birds are everywhere; fulmers, gulls, puffins, guillemots, shags, gannets and many more make this a dream location for bird watchers. The cliffs continue underwater to great depths, providing dramatic underwater seascapes, and there are many dive sites around the islands and the sea stacks. As well as the magnificent underwater vistas

there are remarkable colours, in particular the spectacular walls covered with jewel anemones. The water is so clear the kelp forests go down beyond 20m, so most dives will be fairly deep to get below the kelp.

With so many unique dive sites to choose from, there is still one that stands head and shoulders above the rest for sheer excitement, and that is the arch at Sgarbhstac that rises from the sea just off the south-west of the island of Boreray. The dive here will take your breath away.

THE DIVES

The dive boat will take you close to the sheer stack wall, normally at the north face. Once in the water, you drop down below the kelp forest and onward until at about 30m you reach the top of the gaping arch. As you approach the arch, you will see the sheer walls that drop down 50m to the bottom. You enter the arch below 30m and begin your swim through. It can be an intimidating feeling as you commit yourself to a 30m swim through the arch that cuts clear through the stack.

As you drop deeper and head through the arch, the walls are covered with anemones, sponges and hydroids. If the visibility is more limited or there is a lot of plankton in the water, this can make the swim

ON DRY LAND
There is a hard landing stage at Village Bay and you can explore the remains of the village, parts of which have now been restored by the

National Trust of Scotland. One of the restored cottages is now a museum, its exhibits giving an outline of the history of the people who once lived on the island.

The remains of the earlier settlers' black houses and cleits, where they stored their staple food of seabirds, can still be seen. The old chapel and schoolhouse

have also been restored and the village's graveyard remains as a reminder of its past occupants. Buildings also remain from the more recent occupants,

the military. These are now used by the National Trust and include a shop. A famous reminder of the military presence is the Puffin Inn, which was

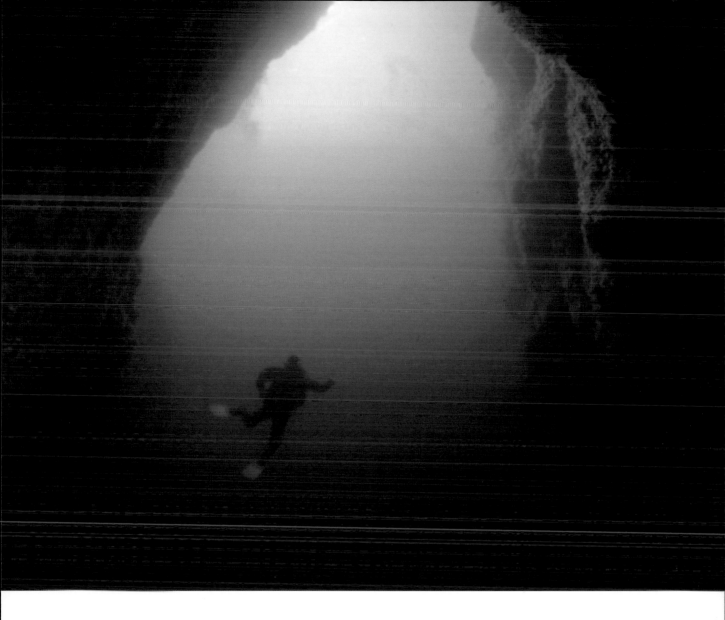

through even more heart pounding. Above you, divers' air may create a mirror effect where it gets trapped at the roof of the arch. Eventually, you begin to reach the other side of the arch and the effect of the light filtered through the water makes this a highlight of the dive. Suddenly, the arched exit glistens in the filtered light before you, indicating that you are reaching the other side and there is clear water above. Once you are through the stack, you keep right to avoid the risk of being washed off the rock, and gradually ascend.

You may find grey seals in the area if you are lucky and they may even accompany you through the arch. Before you enter the arch, dive bombing birds may make an appearance.

This dive site has earned its reputation as one of the great dive experiences in the world for those who take the trouble to visit these hauntingly beautiful Atlantic islands.

always a welcome retreat for visitors who were made welcome by the military. However, at the time of writing this may not be open to visitors.

Recommended reading for any visitor is *The Life and Death of St Kilda* by Tom Steel, which tells the story of St Kilda and its history.

HOW DO I GET THERE

International flights or flights from other UK airports to Glasgow, and train, bus or car to Oban on the

west coast of Scotland. A limited number of charter boats are suitably equipped to make the journey to St Kilda. No charter company will guarantee reaching St

Kilda as it depends on the weather.

United States

Eureka oil rig

Orange County

Pacific Ocean

Gulf of California

EUREKA OIL RIG

Prepare for the most unusual dive of your life

You will be amazed at what you encounter under Eureka, one of these offshore working rigs.

maximum depth:
36m

minimum depth:
15m

access
A 50-minute boat ride from San Pedro and Long Beach, California. Three dives are generally done in one day, with breakfast and lunch served on the boat. The third dive can also be done on a local wreck in the San Pedro Bay. Boats go out for the day so are well equipped with cooking facilities, showers, heads and beds. Only a couple of operators have permission to dive here. Upon boarding, ID and a bag search is conducted for security measures.

average visibility
10m–30m

water temperature
10°C–19°C

dive type
Wreck dive

currents
Medium to very strong

experience

in the area
*Ellen Oil Rig
Ely Oil Rig
San Pedro Bay
Laguna Beach
Crystal Cove/Reef Point
Seal Rock
Dead Man's Reef
Crescent Bay
Shaw's Cove
Fisherman's Cove
Diver's Cove
Heisler Park/Picnic Beach
Main Beach
Sleepy Hollow*

WHAT WILL I SEE?

Many wrecks are described as artificial reefs, creating a haven for marine life that might not otherwise have congregated there. Divers would not generally think of diving under an offshore oil rig, but in California you can do just that.

Under restricted permission, divers can visit these remarkable structures. Metal pillars built for industry are festooned with coral growth, in turn creating a great ecosystem.

Above the water's surface, the oil rig appears ominous, a rusty eyesore on the ocean. Underwater, the view changes dramatically. Mussels, scallops and sea stars cling to the steel latticework, turning platform legs and crossbeams into a kaleidoscope of pink, green and orange sea life. Fish rarely found on natural reefs congregate in the shadows of these structures. Bright orange garibaldi fish are California's signature fish and they seem to be the guardians of the rigs.

Dense schools of sardines thrive here, moving in one great mass, almost blocking the light from above from view. Mola mola and sheepshead fish may also be seen here. Oil rigs offer the perfect refuge for a large number of rockfish. The metal sections and bars of the rigs limit fishing activity around them, enabling fish to thrive in safety, a breeding ground and nursery for several species.

Exciting encounters may include sea lions, and blue sharks have been seen here. Possible sightings from your dive boat during surface intervals include large pods of dolphins and finback whales.

THE DIVES

Located off of Huntington Beach in southern California, the three working oil rigs (Ellen, Elly and Eureka) have become host to a very interesting collection of marine life.

Oil Platform Eureka is a huge structure. The depth is unending at 210m, so your dive plan needs to be strict so you stick to an agreed diving depth.

Approaching the rusty commercial oil rig, you start to doubt your chosen dive destination as the huge metal platform comes into view. As the boat draws closer, you start to see the attraction; lower levels of the rig have several lazy sea lions sunning themselves or lolling around in the water.

In such an exposed position, the surface sometimes surges and currents can be strong. Dive boats are not allowed to tie up or anchor, so divers are dropped off to drift to the rig.

The underwater scenery is surprisingly striking, your views obscured by shoals of fish stacked far and wide. The vertical columns provide stunning scenery and enable easy navigation. Scallops and mussels smother the rig's structure, bulging out between orange and yellow sunset anemones. Barnacles, nudibranchs and many tiny creatures can be observed clinging to the growth on the metal legs of the rig.

Sardines and mackerel are plentiful, darting back and forth, their silver scales shimmering in the blue waters. Their behaviour may become quite erratic as they swim for their lives away from hungry mouths. Californian sea lions are common here and are another great reason to dive Eureka. They welcome visitors as something to investigate and observe. Their smooth, graceful movements are a privilege to watch as they duck and swerve around you.

Elusive giant black sea bass fish huddle together around the metal structure, with a background of brittle stars, strawberry anemones and scallops.

ON DRY LAND
Tucked away between LA and San Diego, this is close to the original Disneyland resort. Orange County offers miles of beautiful beaches, and Huntington Beach is a surfing beach town where you can find a surfing walk of fame and museums.

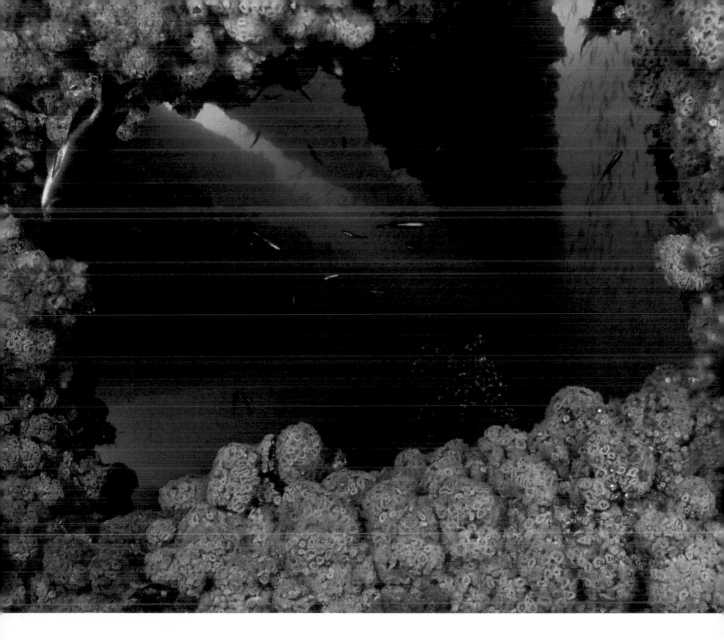

Like a metal maze, you see a beautiful reed and coral garden, bursting with life. You forget you are diving on an oil rig, and any doubts about your strange holiday destination disappear. Looking up from the depths, the silhouetted structure creates atmosphere.

An eyesore on the sea, perhaps by returning life by providing this artificial reef it softens the blow. Talks of decommissioning rigs to allow sport diving on them are underway in many parts of the world. Whatever your view, this is certainly a dive with a difference.

HOW DO I GET THERE

Fly to John Wayne Airport, Orange County via California. California has regular flights from all major inter-national cities.

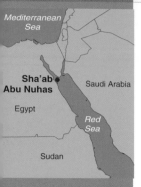

Mediterranean Sea

Sha'ab Abu Nuhas

Egypt

Saudi Arabia

Red Sea

Sudan

maximum depth:
27m

minimum depth:
20m

access
Liveaboard (from Sharm El Sheikh or Hurghada) is the only means of diving this location. The boat needs to have a rib or tender to take divers to the dive sites as the main boat can then moor in the shelter of the reef.

average visibility
25m–30m

water temperature
Winter 20°C
Summer 28°C

dive type
Liveaboard

currents
Can be strong around spring tides

experience
*** to **** depending on wreck and area dived*

in the area
Bluff Point
Siyul Kebira
Umm Usk
Siyul Saghira
Blind Reef

WRECKS – SHA'AB ABU NUHAS SS CARNATIC

One dive site, four world-class wrecks

Sha'ab Abu Nuhas lies off the main shipping lane of the Strait of Gubal at the southern end of the Gulf of Suez, and has four major wrecks lined up along its northern edge. Remnants of many other wrecks that have foundered on this notorious reef litter the area and wreckage is also found atop the reef. There has been considerable confusion surrounding some of these wrecks over the years, with different names attributed to them. Interestingly it is the newer wrecks that cause the most confusion with the oldest, SS Carnatic, well recorded.

WHAT WILL I SEE? *SS CARNATIC*

The SS Carnatic was a P&O passenger mail ship, which sailed between Bombay and Suez in the days before the Suez Canal. At 1.30am on 12 September 1869 she hit the reef and, although seriously damaged, did not sink immediately. The weather was good and a decision was made for passengers and crew to stay on board while arrangements were made to evacuate the ship at a leisurely pace. For the next day and night, no evacuation took place and disaster struck when the ship broke its back and sank with the loss of 27 lives.

Salvage operations after the sinking recovered, among other things, 32,000 gold sovereigns. However, as there were said to be 40,000 gold sovereigns on the wreck, the remainder may still be there, albeit well hidden among the wreckage.

ON DRY LAND
Both Sharm el Sheikh and Hurghada have now developed into major tourist locations and diversified from just diving. Facilities include horse riding, golf and many water sports such as windsurfing, sailing, deep sea fishing, and snorkelling. From Sharm el Sheikh you can take a trip to the impressive St Catherine's Monastery. Flights from both locations can take you to visit the pyramids or Luxor and the Valley of the Kings. Both locations have plenty of nightlife with clubs, restaurants, bars and shops. There is also a large range of hotels and resorts in and around both locations, enabling you to choose whether to stay in lively or more relaxed surroundings.

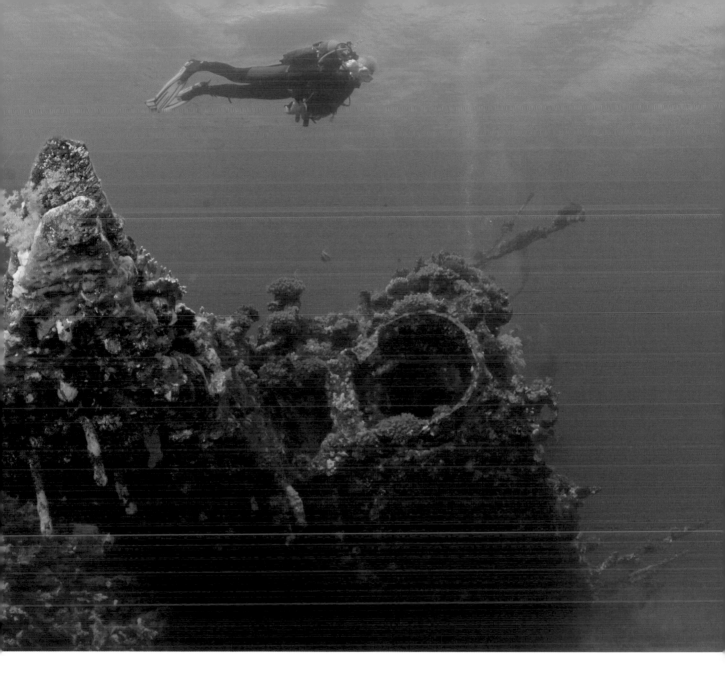

THE DIVES

She lies on her port side in 27m with a minimum depth of 20m and her grace and beauty can still be seen clearly, with her streamlined bows and graceful lines. The central section is very broken up where she broke her back. The wooden deck has long disappeared, leaving the skeletal hull that enables the bow and stern sections to be easily entered. The stern is still very much intact with its rudder and propeller. The wreck is garlanded with corals and soft corals and teems with fish life, including large shoals of glassfish, which ebb and flow like quicksilver.

HOW DO I GET THERE

Scheduled flights to Cairo, Egypt from most parts of the world connect with domestic flights to Sharm el Sheikh or Hurghada on the Red Sea coast. Flights from some locations may be available directly to Hurghada. Specialist packages direct to these resorts may offer a better deal.

Mediterranean
Sea

Sha'ab
Abu Nuhas

Saudi Arabia

Egypt

Red
Sea

Sudan

maximum depth:
24m

minimum depth:
4m

WRECKS – SHA'AB ABU NUHAS GIANNIS D

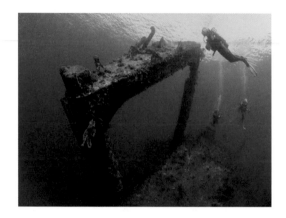

WHAT WILL I SEE? *GIANNIS D*

The Giannis D was a Greek cargo vessel, carrying a cargo of timber. She sailed from Croatia heading for Jeddah via the Suez Canal and ran aground at 4am on 19 April 1983. A huge hole was torn in her side and she listed to port. It took two weeks for her finally to sink and settle on the reef. She was built in Japan and was originally named the Shoyo Maru. In 1975 she was sold and renamed the Markus. In 1980 she was sold again to a Greek company and renamed Giannis D.

THE DIVES

Giannis D lies in 24m of water on her port side. The bow and stern sections are intact, with the central section very broken up. The stern section includes the superstructure and wheelhouse with masts reaching almost to the surface. The superstructure can easily be entered and it is also possible to enter the stern section and work up through the wreck but careful diving practices are advised as it is necessary to retrace the route and leave by the same point. The bow section also allows access and the for'ard mast reaches out across the seabed. The Giannis D is a very photogenic wreck with its imposing superstructure. Corals and soft corals are well established and there is a wealth of fish life including, of course, large shoals of glassfish. You can expect to find scorpionfish and lionfish, spadefish, anthiases, parrotfish, butterflyfish, moray eels and much more. Dolphins have been seen around the wreck on occasions.

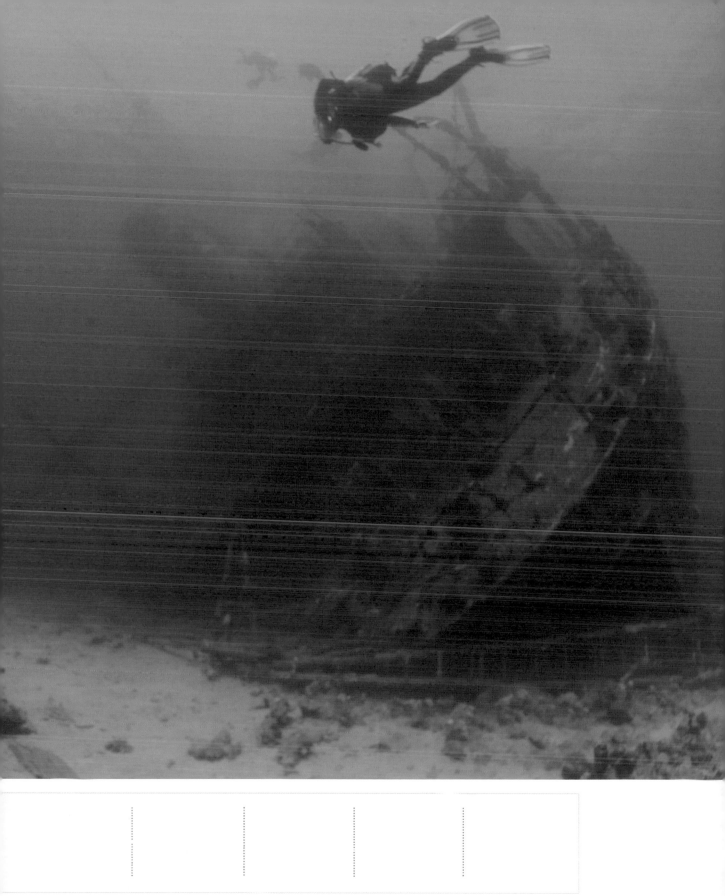

Mediterranean Sea

Sha'ab Abu Nuhas

Egypt

Saudi Arabia

Red Sea

Sudan

WRECKS – SHA'AB ABU NUHAS KIMON M

maximum depth:
27m

minimum depth:
10m

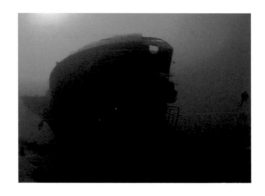

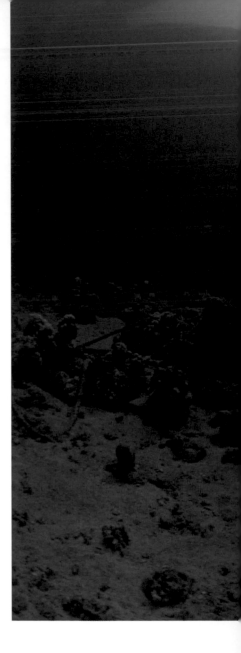

WHAT WILL I SEE? *KIMON M*

Kimon M was a general cargo vessel built in Hamm in Germany in 1952. Being of a similar size and age to another wreck on the reef, the Chrisoula K, she was, at one time thought to be the Chrisoula K. She left the Turkish port of Iskenderun in December 1978, heading for Bombay with 4,500 tons of lentils on board. Having navigated through the upper reaches of the Strait of Gubal, the captain left the control of the ship to one of

his officers. Once again, Shaab abu Nuhas lay in wait for the ship to run full speed into the reef. Fortunately, a passing ship picked up the distress call and no lives were lost. She was stranded on the top of the reef for several days, allowing some salvage operations to take place. However, a large part of it was abandoned due to seawater contamination. Kimon M eventually dropped into deeper water on her starboard side with the bow section completely broken up.

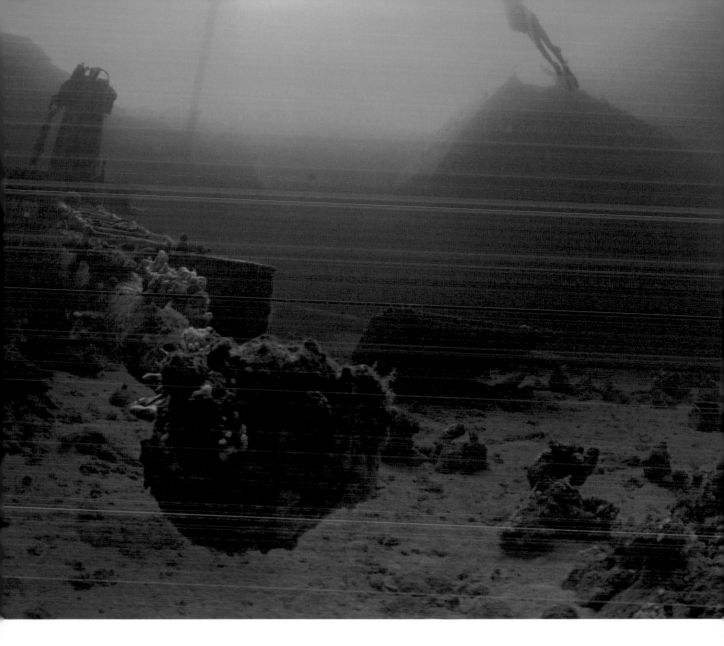

THE DIVES

With the bow section completely broken away, it is easy to enter No 2 hold and the engine room to the rear of that. There is also a large hole, which was later cut into the hold to remove a large part of the engines, and this allows easy access at that point. You can swim along the gangways past the superstructure and the ship's railings and bollards and enter the accommodation blocks, the cargo holds and the bridge. The stern sits proud on her starboard side with its rudder and propeller intact. The same profusion of marine life will be found as that on the other wrecks on this most dangerous reef. Kimon M is another exciting dive with something for divers of all standards from novice to advanced.

Mediterranean
Sea

Sha'ab
Abu Nuhas

Saudi Arabia

Egypt

Red
Sea

Sudan

maximum depth:
27m

minimum depth:
4m

WRECKS – SHA'AB ABU NUHAS CHRISOULA K

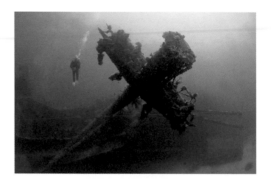

WHAT WILL I SEE? *CHRISOULA K*

The Chrisoula K was a Greek registered cargo vessel that was at one time confused with the Olden, because part of its original name, Dora Oldendorf, could still be identified on the hull. The Olden is in fact about 22km due east in over 1,000 metres of water! Once again, the story of its sinking tells of the mistaken view that the wider reaches of the Strait of Gubal meant that danger had passed. The captain handed over control of the ship and she hit the reef on 31 August 1981. She was carrying Italian tiles to Jeddah and for many years she was known as 'The Tile Wreck'.

Now lying at the stern end in 26m, the for'ard part of the wreck is just below the surface. The bows used to rise out of the water until the sea and the weather gradually broke them up.

THE DIVES

Once again, the wreck offers diving for a range of experience. The main section of the wreck sits upright on the reef, while the stern is broken off and lies on its starboard side. Entry to the hold that contains the tiles is easy, and you will normally find lionfish standing guard over the cargo. In the stern section, experienced divers may want to penetrate the engine room. However, there are many areas on the wreck that are easier to access. The rudder and propeller is intact and raised off the reef by the stern's settlement on its starboard side. The two masts are broken off and reach out to starboard across the seabed. The corals and soft corals are well established and once again plenty of marine life inhabits the wreck.

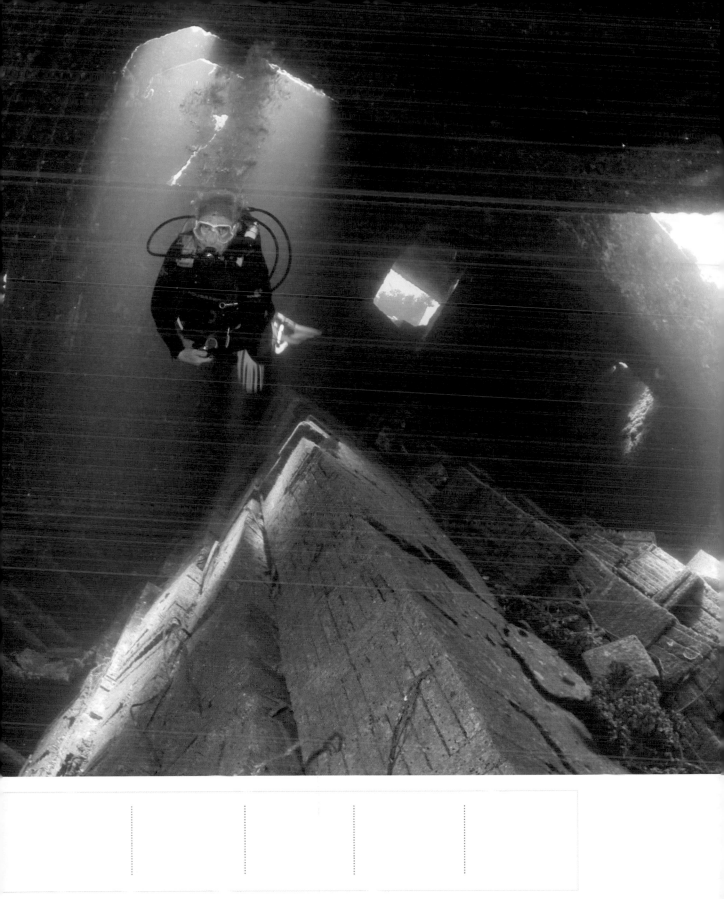

SS THISTLEGORM

Touch history by exploring this acclaimed World War II wreck legend

The Thistlegorm was discovered by Jacques Cousteau in 1956. Situated on the outer wall of an immense reef known as Sha'ab Ali on the western coast of Sinai, it is one of the most popular wrecks in the Red Sea and has been voted one of the top ten dives in the world. Her wreckage has transformed the underwater landscape, and this historic monument to the past is bursting with marine life.

maximum depth to seabed:
32m to the seabed and locomotive

minimum depth to wreck:
12m to the bridge; 15m to the deck
Wreck size: *131m long*

access
The best way to dive on the Thistlegorm is by liveaboard and it is a key dive on a Northern Red Sea Wreck Itinerary. It can be also be accessed from Sharm el Sheikh, El Gouna resort or Hurghada by special arrangement on a day boat, but be prepared for a 4am start as it takes about four hours to reach the wreck site.

average visibility
25m–30m

water temperature
Winter 20°C
Summer 28°C

dive type
Wreck dive

currents
Can be strong around spring tides, but there is no current in the holds

experience

in the area
Shag Rock
Ras Muhammad
Bluff Point
Yellowfish Reef
Sha'ab Abu Nuhas

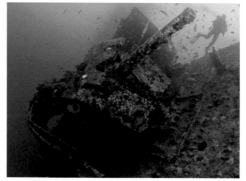

WHAT WILL I SEE?

This wreck is mostly intact and is unusual in that its military cargo, including two locomotives, now rests on the seabed, railway coal and water tenders still upright on the wreck. Schooling barracuda, blacktip sharks and tuna are often seen cruising around the wreck.

The Thistlegorm is always a joy to dive, day or night. Her rails above decks are covered in multicoloured soft corals and, if there is a current running, take time to look through the holds. It appeals to wreck divers, marine enthusiasts and photographers alike.

A British vessel, her role during World War II was to deliver stock to the British Army. On her final journey she was destined for North Africa, loaded with steam locomotives, motorbikes, trucks and various artillery. As the Mediterranean was closed to allied shipping, she was forced to make a 19,000km detour around South Africa in order to reach British-held Alexandria via the Suez Canal. Stopping off in Capetown, South Africa, she steamed north into the Red Sea, mooring in the calm zone alongside Sha'ab Ali to await orders to move up the canal. At 2am on 6 October 1941, a bomb dropped by a German Heinkel He 111 plane blew her into two sections.

The way marine life has made this wreck its home, finding camouflage here from predators, is amazing. Scorpionfish, crocodilefish and even the tiniest nudibranchs seek refuge here. To really appreciate the enormity of the wreck and the delights it has to offer, several dives are required. At night, the wreck takes on a different persona and feels slightly sinister. Groupers emerge from the shadows, moray eels come out of their safe holes in the wreckage and swim freely. Lionfish follow each diver's torch beam to catch small bait, and soft corals unfold and feed on the surrounding plankton.

On each dive, there is always something new to see.

THE DIVES

The front section sits upright on a sandy seabed at a maximum depth of 32m. The bow section remains on an even keel and the stern lies heavily to port.

The greatest damage to the ship is behind the bridge superstructure, where the bomb's explosion tore into the hull. Here the holds are well opened up and can be easily accessed on two levels with head room and clear exits.

Military trucks, trailers, motorbikes, aeroplane wings, ammunition and even military boots are on display in the holds, as if in a museum. In the aft hold, cases of

ON DRY LAND
Desert tours and camel rides are available from most resorts. From Sharm el Sheikh you can fly into Cairo to see the pyramids or take a coach trip to St Catherine's Monastery at the foot of Mount Sinai. A late-night climb up Mount Sinai is recommended, reaching the summit by dawn to see the sunrise. There are a couple of stables offering excursions on horseback along the beach or into the desert. From Hurghada you can fly to Luxor, the old capital of Egypt. See the great temple of Karnak and the spectacular tombs of Valley of the Kings or visit the Valley of the Queens where 80 tombs are located. Camel rides, jeep trips and Bedouin excursions are also available.

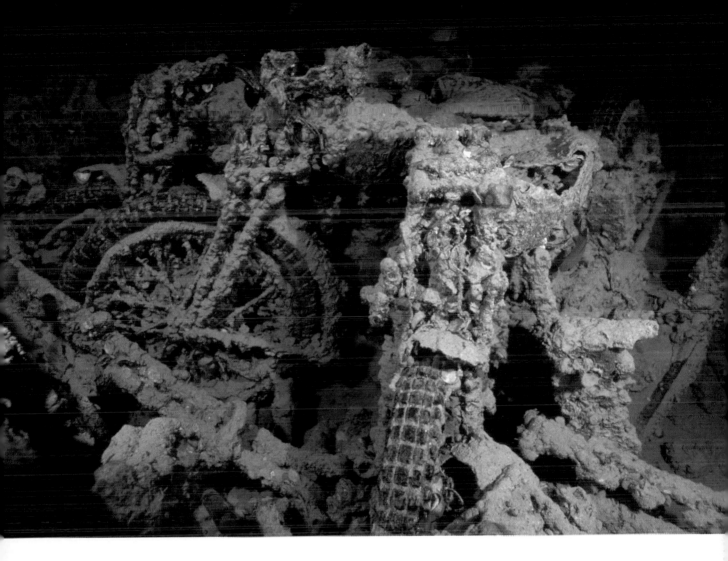

naval shells remain stacked in their original wooden packing cases, as they were in 1941. The Thistlegorm is often referred to as 'the motorbike wreck' as there are BSA motorbikes lined up in the hold. It is a great sight and no diver can resist squeezing a motorbike tyre to satisfy themselves it is inflated.

At the bow, the anchor chain and winches have provided a good ground for both soft and hard corals to grow, transforming the grey of the wreckage to colour and providing a home for the smaller creatures. Swim out from the bow and look back at the wreck to admire the scale.

An obligatory view of the propeller at the stern shows that it and the rudder are in one piece. The two deck-mounted guns are still in place and are best viewed from below where they make excellent silhouettes against the distant surface.

The Thistlegorm is protected by HEPCA (Hurghada Environmental Protection and Conservation Association), which in 2008 provided a system of moorings around the wreck to prevent boats from tying onto her as many had been doing, potentially causing damage. Holes have also been drilled in the ship to allow divers' bubbles to escape from the hold.

HOW DO I GET THERE

Scheduled flights to Cairo, Egypt from most parts of the world connect with domestic flights to Sharm el Sheikh or Hurghada on the Red Sea coast but specialised packages direct to these holiday resorts are usually a better deal and include hotel vouchers. From beyond Europe and the Middle East, it may be cheapest to fly to Europe and pick up a package deal from there.

Pacific Ocean

●Chuuk
Lagoon

Papua
New Guinea

Australia

FUJIKAWA MARU WRECK

Operation hailstone's aftermath

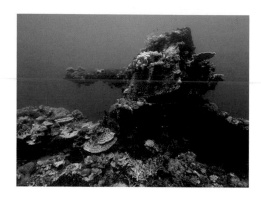

maximum depth:
34m

minimum depth:
5m

access
Either by day boat or from liveaboards that are a useful alternative for reaching the more distant wrecks.

average visibility
24m – 30m

water temperature
Approximately 27°C plus, all year round.

dive type
Wreck dive

currents
Nil to light

experience
*** to **** Appropriate technical skills for deep penetration*

in the area
*Other wrecks in the area include:
Yamagiri Maru,
Shinkoku Maru
Hoyo Maru
Kansho Maru
Kiyozumi Maru
Fumizuki (Destroyer)
Sankisan Maru
Nippo Maru
Hoki Maru
Amagisan Maru
Fujisan Maru
Shotan Maru*

There are also excellent reef dives, including Shark Island with its resident blacktip and grey reef sharks. As most divers concentrate solely on the wrecks, trips to the outer reefs will give you an opportunity to dive reefs that are seldom dived.

On 17 and 18 February 1944, US aircraft flew relentless sorties over Chuuk Lagoon to destroy the advance base of the Japanese Navy. At the end of the two days of action – known as Operation Hailstone – three Japanese light cruisers, six destroyers, three other warships and more than 30 merchant ships had been sunk. More than 250 Japanese aircraft were lost, while US losses amounted to 25 aircraft.

WHAT WILL I SEE?

Chuuk is one of the largest atolls in the Pacific. It is made up of 14 major islands and some 200 smaller islands and islets, encircled by stunning coral reefs covering a vast area. All of it is set in well sheltered, vibrant blue waters with visibility that can exceed 30m. In total, the islands cover 127 square kilometres and the population is only around 60,000, 75% of whom live on the main islands of Weno, Tonoes, Uman and Fefan.

Chuuk Lagoon is undoubtedly one of the greatest wreck dive sites in the world, if not the best. The wrecks have become home to myriad forms of marine life, meaning that all the wrecks are wonderful diving experiences. Its important place in the history of World War II also makes it a fascinating and thought-provoking place for history buffs.

The Fujikawa Maru is the most popular of the wrecks. She was built as a passenger/cargo carrier and was launched in 1938. Subsequently taken over by the Japanese navy, she was converted into an aircraft transporter. During the American assault, she was hit amidships by an air-launched torpedo and sunk; she now lies upright in 34m of water.

ON DRY LAND
Most hotels, restaurants and diver operators are on Weno. Chuuk is a place to chill out and relax. There is no pulsating nightlife, but there are wonderful sightseeing opportunities. You can visit the outer islands by boat or small aircraft. Not much has changed over the last 100 years and the people live their timeless existence as they have always done, with fishing as the islanders' major lifeblood. There are few accessible beaches, as would be expected, due to the volcanic nature of the islands.

There is evidence of the island's colonial history, particularly of the wartime period; there are caves containing guns and an old naval base, called Little Tokyo.

THE DIVES

Fujikawa is a large wreck, 132m in length and with a beam of 18m. To get the most from this wreck needs repeat dives, as there is so much to see. The main mast rises to about 5m from the surface like a huge, coral encrusted cross. Descending to 15m, you can enter the bridge area, which takes you into the main superstructure. A large, communal tiled bath is still in place.

You can descend from there to the deck at 18m. The bow gun is still in place, encrusted like much of the ship in coral and sponges. The stern gun also remains. The soft corals, sea fans and sea anemones turn this wreck into a vibrant, man-made reef.

A major attraction of the wreck is the inspection of the holds. Here you will find an amazing assortment of war materials, including five Zero fighter aircraft as well as torpedoes, propellers, bullets and artillery shells. You will also come across personal belongings and assorted accoutrements of everyday life aboard the ship, such as gas masks, mess kits, machine guns, bottles, crockery, beer bottles, shoes, uniforms, ceramic electrical parts and papers. It is forbidden to touch or remove anything from this or the other wrecks.

It is worth noting that this wreck makes an excellent night dive.

HOW DO I GET THERE

Flights to the international airport at Weno, the island capital. This is also where the main seaport is situated.

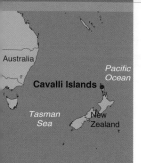

Australia

Cavalli Islands

Pacific Ocean

Tasman Sea

New Zealand

RAINBOW WARRIOR

The ship of peace

This ship once protested for peace. Now she has found another purpose and a new lease of life in the stunning Cavalli Islands, where she lies blanketed in a colourful abundance of life, attracting thousands of exploring divers each year.

max depth:
28m

min depth:
12m

access
The Rainbow Warrior is located at the Cavalli Islands to the North of the Bay of Islands in Northern New Zealand. It only takes about ten minutes to get to the wreck from Matauri Bay.

average visibility
10m–30m

water temperature
10°C–22°C

dive type
Wreck

currents
Slight

experience

in the area
*Nukutunga
HMNZS Tui
HMNZS Waikato
Matai Bay Pinnacle
Taheke Reef
Poor Knights
Auckland
Wellington
South Island
Marlborough Sounds
Stewart Island*

WHAT WILL I SEE?

The Rainbow Warrior was Greenpeace's flagship. She sank in Auckland Harbour on 10 July 1985. This was no tragic accident but a deliberate act by French secret service agents, instructed by France to put a stop to the Greenpeace protest against nuclear testing on the Murruroa Atoll.

It is therefore fitting that Greenpeace gifted the Warrior to the sea. She has blossomed as a fantastic artificial reef in the Cavalli Islands, a refuge for the very marine life Greenpeace were trying to protect.

Colourful anemones stuffed full of clownfish and anemone fish can regularly be seen, as well as schools of John Dory, snapper and kingfish.

The Rainbow Warrior is now home to many. Cardinalfish, leatherjackets, scorpionfish and brightly coloured nudibranchs are just some of the sea life to have found a home in her. It is said that inquisitive triggerfish were checking out the wreck within 30 minutes of her final sinking; perhaps they are the ship's guardians, as triggerfish are very territorial and protect their nests aggressively. If a triggerfish strikes, usually at a diver's fins, it is worth remembering to swim directly away from it rather than trying to ascend, as a triggerfish's territory stretches up to the surface.

THE DIVES

As you follow the mooring line down, the wreck starts to appear, looming out at you. The Rainbow Warrior is now an underwater garden. Tube sponges can be found growing around the bow section in pretty pink

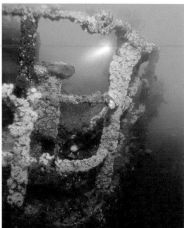

and purple colours. Orange finger sponges are another common sight, along with the resident huge snapper and scorpionfish. A thick covering of kelp provides food for invertebrates to munch on; small fish such as damsel pick at the kelp.

When the visibility is good, you should be able to see the whole stern section and of the ship as much of soon you descend the line. The bright colours of jewel anemones coat the stern and light up the new reef; this looks wonderful as far down as 20m. It is hard to make out the mine damage, where two holes were blown in her.

At 40m long, she is a good size to navigate all around and inside within one dive. Her bow rails are stunning, providing a picturesque backdrop for the entire wreck. They are still complete, and are festooned with anemones and soft corals. The blast hole in the keel is just about visible on the starboard side. It is possible to fully penetrate the wreck, and you can find your way to the galley. Carry on further in to the upper rooms, where swirling schools of cardinalfish may be found. The bowsprit is worth a visit, from which to swim away and look back at the Rainbow Warrior. Full of colour and coated in anemones, the nameplate is still visible, emphasising that the boat lives on.

Tiny, bright jewel anemones coat the hull, strings of kelp trail from the cargo hold and, peering into the gloom through the gaping hole that sunk the ship, you can see immense schools of 'bigeye' and huge snappers that have taken refuge.

Hidden between and underneath planks on the side decks, there are crayfish, morays and octopus. On the

ON DRY LAND
The Cavalli Islands lie off the coast of Matauri Bay. The main island, Motukawanui, is a nature reserve with a walking track. You can get to the Cavalli islands from here by chartering a boat, sailing or paddling a kayak. Idyllic beaches and secluded bays and coves await you, with a spa on the island to cater for your every needs. Nearby, Whangaroa has a beautiful coastline and bustling ship-building industry. Its history goes back to Maori settlement. Matauri Bay offers a short climb up the headland for fantastic views over the Cavalli Islands. Family activities and shopping is available here.

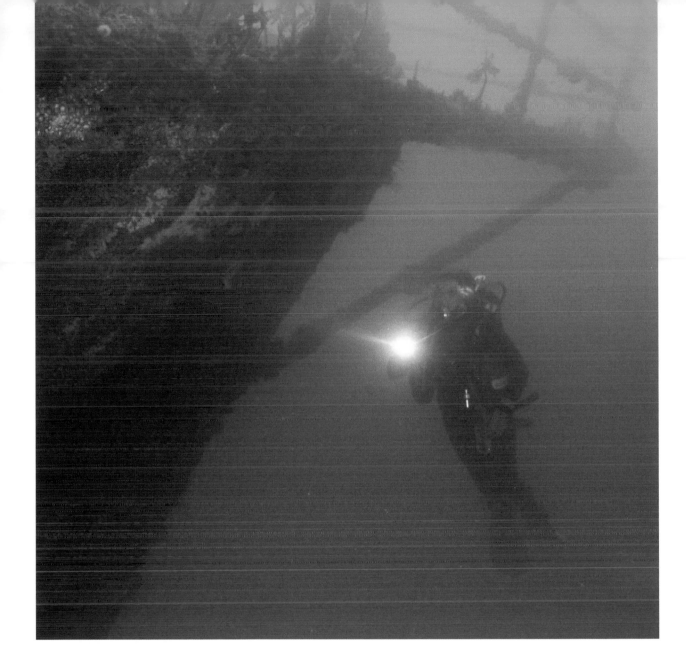

main deck there are swim throughs, again allowing you to swim into the wreck and get amongst the schooling fish.

The wreck is beautifully preserved and is nicely forming an artificial reef with lots of colourful anemones and other creatures. Triplefins and blennies dart about on sponges, hiding behind a piece of coral if you approach.

On your ascent, hang in the water at around 3–6m and look out for a cormorant doing a spot of fishing. If you think a weird looking fish is shooting past you, it might be this waterbird with its sleek swimming style, on the hunt for a fish.

Greenpeace gained worldwide publicity and sympathy over the whole affair. It helped create media interest in the organisation, which is now world famous as is this wreck, which makes quite a statement.

HOW DO I GET THERE

International airports fly via Dubai, LA, Singapore or Australia to Auckland, NZ. Auckland to Matauri Bay takes around 5 hours by road.

Greece

Turkey

Cyprus

Zenobia

Mediterranean Sea

Israel

Egypt

maximum depth:
43m

minimum depth:
16m

access
Many resort boats operate on a daily basis, going out a couple of times a day. Day boats will take around 15 minutes to transport you to the dive site from the harbour. Many resorts operate out of this area.

average visibility
15m–25m

water temperature
Summer: average 25°C
Winter: average 15°C

dive type
Wreck dive

currents
No tides or currents

experience

in the area
The wreck of the World War I river gunboat HMS Cricket. Other sites include scenic reefs, rocks, caves and caverns. Macro life is good, with sponges, anemones and cup corals etc colonising the many overhangs in the reef.

THE ZENOBIA

Gift of life

Cyprus offers good diving, virtually all year round. Its highlight is the wreck of the Zenobia ferry, considered to be one of the world's best wreck dives. Zenobia means gift of life, and this wreck is home to a host of marine life, providing an artificial reef.

WHAT WILL I SEE?

This Swedish roll-on, roll-off, 12,000 ton ferry was fully loaded when she sank on her maiden voyage to Cyprus on 7 June 1980. She now lies on her port side at 42m, a short distance from Larnaca's fishing harbour.

The Zenobia had over one hundred articulated lorries on board when she went down and many of them can still be seen along the holds and rear decks of the wreck. Also to be seen are many species of fish and marine life, amongst them grouper, wrasse and cardinal fish.

There is still intrigue over the Zenobia's sinking. It was discovered that there was a problem with the computerized pumping system that controlled the amount of sea water taken into her ballast tanks. Attempts to fix the problem failed, and she tilted over to her port side, slowly sinking. All her crew left the vessel safely.

THE DIVES

You can dive around the superstructure of the ship; a tour around the whole wreck to the rear propellers will give you a feel for her size and completeness. If you are able to spend a few days here, you can dive the ship in sections and fully explore this wreck.

There are a couple of car decks, which are very interesting. Start at the upper car deck, through the open decking at the rear of the superstructure. All the trucks inside have slid to the port side. It is surreal to see parking instructions on the wall and vehicles still hanging from the deck. It is possible to swim right

through and exit through a small door at the far end. You can drop over the starboard rail to view the outer cargo; below the deck, lorries are scattered on the seabed.

Penetration to the middle car deck should be carried out with care. This part of the dive is for experienced divers with a guide, as it is dark and the entry and exit points are tight. The enclosed deck looks really impressive with rays of natural light sifting though the gloom. The trucks here have a variety of cargos, and there is a single car.

The engine room is accessible, but room is cramped and it is deep and dark (40m). B deck takes you through an open door at the front of the superstructure at 25m. Here you will find the restaurant area and bar, a large room that spans the width of the ship. Depths here range between 16m and 38m.

Cyprus waters are very clear, but at times. Visibility can often be affected, by the algae growth that has been encouraged on the wreck over many years. Inside the wreck, loose algae and plankton hang in the water, reducing the clarity and adding to the feeling of time gone by.

Feather stars cling to many areas of the wreck, including in the holds, filtering the passing silty waters and struggling to see light.

Adding to the atmosphere, jacks whizz around the wreck and small spaces are crammed with glassfish. As you tour the wreck, you may turn around to see shoals of fish following you.

ON DRY LAND The Mediterranean island of Cyprus enjoys a near perfect climate with sunshine and warm temperatures most days. Steeped in history with a rich cultural heritage, Cyprus has an immense choice of ancient monuments and archaeological sites. Larnaca is one of the oldest inhabited cities in the world. There are many places to visit including the famous Lazarus church, the Turkish fort and the mosque of Hala Sultan Tekke. Or you could explore the historic quarter, with its narrow streets and charming buildings. Salt Lake to the west of the town attracts migrant flamingos from December to March, gathering in the centre of the lake in a blaze of pink.

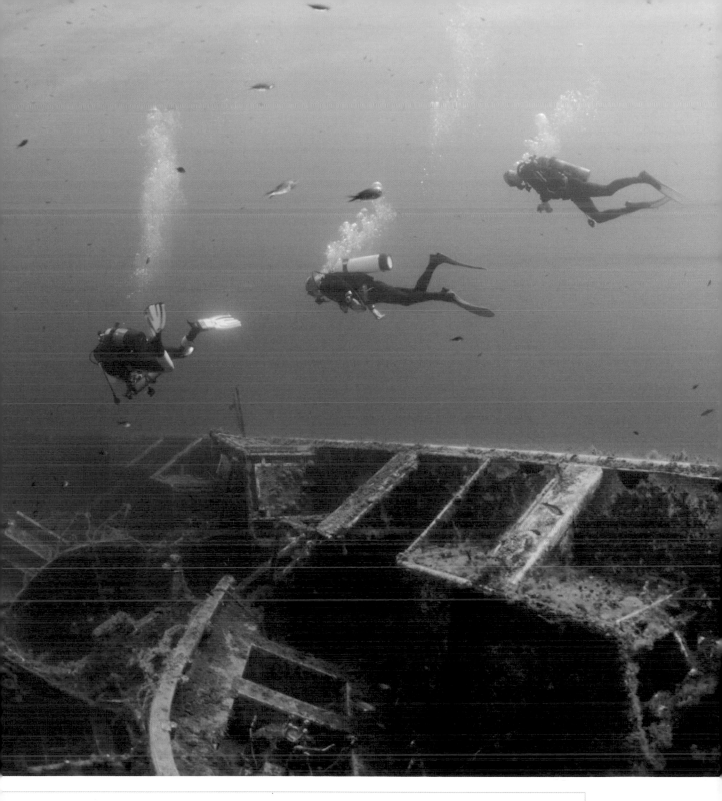

HOW DO I GET THERE
Cypriot Airways have regular scheduled flights into Larnaca from many parts of Europe. It is also accessible from Greece or Turkey if you hire a car.

THE BRUMMER WRECK

A dive into maritime history

Few places resonate with the history of Britain's naval heritage as much as Scapa Flow in Scotland's Orkney Islands. In 1916, this natural anchorage saw the fight between the British and German fleets at the Battle of Jutland. In 1939, the Royal Oak was sunk by a German U-Boat here, with the loss of 800 lives. But Scapa Flow is probably most famous as the place where the German High Seas Fleet was scuttled after the end of World War I.

maximum depth:
30m

minimum depth:
24m

access
You can arrange liveaboard dive boats or day boats.

average visibility
10m–20m

water temperature
8°C (46°F)–18°C (64°F) Dry suits recommended

dive type
Wreck Dive

currents
0-strong. Slackwater dependent

experience
**** to ***** depending on depth, conditions and whether wreck is entered*

in the area
Apart from the other six remaining German wrecks, there are many vessels that were used as block ships to prevent access by enemy vessels. These provide plenty of other dive sites and offer a wide range of shallow dives. Diving is not allowed on the Royal Oak, which is a war grave.

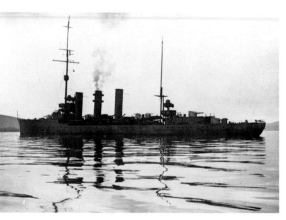

WHAT WILL I SEE?

For many divers, the waters of Scapa Flow are the holy grail of wreck diving. The German High Seas Fleet scuttled there on 21 June 1919 consisted of 72 ships that had been held in Scapa Flow by the Allies following the Armistice of 11 November 1918. Fearing that the peace negotiations would break down and hostilities would recommence, Rear Admiral Ludwig von Reuter took the decision to scuttle the fleet to avoid it falling into the hands of the enemy. In all, 400,000 tons of shipping was sunk, representing the largest ever loss of shipping in one day.

Over time, all but seven of these wrecks have been recovered for scrap. Those that remain are magnets for wreck divers. The one we have chosen to include is the German Light Cruiser, Brummer, thought by many to be the best dive in Scapa Flow. Its main armament consisted of four 5.9-inch guns and it had a top speed of 28 knots. It is located on the east side of Cava in 30m of water. The wreck itself is 140m in length.

There are plenty of dive facilities and diving is of major economic importance to the area. Local knowledge is essential when diving Scapa Flow, due to the tides and weather patterns. It is also important to make use of the local dive guide's skill and expertise on how to get the best out of the wrecks; the sheer size of these vessels means you can easily spend the whole dive on a wall of barnacle-covered steel.

THE DIVES

The Brummer lies on her starboard side and the results of salvage work can be seen around the engine room. Age, too, is having an effect on the wreck but she is still an awesome spectacle. You reach the top of the wreck in about 24m and from there you are on an adventure of discovery as the vastness of the wreck means there is much to see. The gun turrets emphasise the power of these ships and there is plenty to explore, from the mess deck and lift shafts to the engine room. It is satisfying to find so many portholes still intact due to the respect and protection given to these wrecks. Resting on the sandy bottom is the mainmast with its crow's nest.

Marine life is abundant, with shoals of fish, dead man's fingers in great profusion, plumose and dahlia anemones, starfish, brittle stars, and velvet swimming crabs. Don't be surprised, either, if you find yourself being watched by inquisitive seals, which are sometimes seen.

A single dive would only scratch the surface and you will need repeat dives to really get familiar with its sheer scale.

ON DRY LAND
There are many archaeological sites, including stone circles, burial tombs and neolithic villages such as Skara Brae. In Kirkwall, St Magnus Cathedral dates from the 12th century. Tours can be arranged and car hire and taxi services are available, as well as cycle hire for the more energetic. The scenery is stunning, with land and seascapes, lochs, hills and beaches. As well as diving, there are many water sports such as surfing, sailing, windsurfing, kite surfing, kayaking and fishing. Being Scotland, it goes without saying that golf facilities are available, with the three main golf courses at Stromness, Kirkwall and South Ronaldsay. The abundance of bird species and marine wildlife is great for nature lovers and photography, and wildlife tours can be arranged. All forms

of accommodation are available, including hotels, guest houses, bed and breakfast, self catering accommodation, camping, caravans and hostels.

HOW DO I GET THERE

International flights to British airports. Flights from Inverness, Edinburgh, Glasgow and Aberdeen to Kirkwall, Orkney Islands. Ferry services are available to Orkney, from Scrabster to Stromness and from Aberdeen to Kirkwall. Stromness is the most practical, as most of the dive boats sail from there. You can travel by road but it is slow going. You can also take a train to Thurso and then a bus to Scrabster or Aberdeen.

HISPANIA WRECK

Dive into a profusion of orange

Although the Hispania a fairly shallow dive, the wreck has remained fairly intact considering the conditions it has faced since it sank in 1954. The strong currents are ideal for the invertebrates that simply cover every inch of the wreck.

Atlantic Ocean
North Sea
Hispania
Ireland
United Kingdom

maximum depth:
32m

minimum depth:
15m to the shallowest part of the deck

access
Via dive boat from Oban, Lochanline or Tobermory.

average visibility
Between 5m and 10m but these can be exceeded at both ends depending on weather conditions.

water temperature
January to March: 4°C
July to September: 14°C Dry suits are recommended.

dive type
Wreck dive

currents
Can be strong, and timing to dive during slack water is recommended. This is between one and two hours before high or low water in Oban, varying from spring to neap tides.

experience
** to *** depending on depth, conditions and whether wreck is entered.

in the area
Other wrecks in the area include Breda, Rondo, Shuna and Thesis. There are many other dive sites in the area. Probably the best known one near the Hispania is Calve Island, which is east of Tobermory harbour.

WHAT WILL I SEE?

The 1337-ton Hispania was a Swedish steamship carrying a cargo of steel, asbestos and rubber sheeting from Liverpool to Varberg. When a storm threatened, the captain took the vessel into the waters of the inner isles of Scotland for shelter. Although it's true that these waters can provide shelter, visibility can be poor in bad weather and it was this that led the Hispania to strike the rock known as Sgeir More in the Isle of Mull. The crew of 21 launched their lifeboats and survived, but according to legend the captain was last seen on the bridge, saluting as the ship went down.

The wreck is in an upright position and the decks and engine room are penetrable. Like many wrecks, Hispania is an artificial reef which has become festooned with anemones and other invertebrates over time, the masses of plumose anemones providing a predominantly orange colour to feast your eyes on.

THE DIVES

The 70m wreck now lies with its bow pointing towards the shore in about 24m of water and the stern in 32m. She is upright but with a list to starboard. The mast has now fallen away to starboard and lies across the wreck.

The bridge can be explored and you can swim along the companionways and penetrate the holds and upper part of the engine room of the wreck, although this should be done with care because of the aging condition of the wreck. Penetrating further down into the engine room is much more risky, due to debris. You will find a profusion of fish such as wrasses on the wreck and the annelid worms are particularly photogenic as they spread their tentacles into the current to pick up passing plankton.

If you go all the way down to the stern you will find the steering gear and, below the stern, the rudder and propeller. The stern accommodations can be easily explored on the way back up the wreck, as with their roofs now gone, they are open to the elements. Be careful with any penetration of the wreck as it is very silty inside and visibility can easily become greatly reduced.

Good timing for diving the Hispania is essential to ensure that you dive during slack water. Dive planning with skippers who have local knowledge is therefore advised. Average visibility is between 5m and 10m although this can vary considerably depending on weather conditions.

The Hispania certainly is a world-class wreck dive.

ON DRY LAND
The Western Isles of Scotland have some wonderful scenery and depending where you base yourself, you will find endless opportunities to visit the towns and countryside. Oban is a major port and has many restaurants and other facilities. There is plenty of accommodation from bed and breakfast facilities to hotels. Tobermory is probably one of the most attractive coastal ports and villages in Scotland and the main village on Mull. The picture postcard view of the main street's brightly painted buildings is very well known. Shops, hotels and other accommodation are available here. The surrounding area is wooded hills. Lochaline is a small village overlooking the Sound of Mull and is a very quiet and peaceful place without the lively character of Oban.

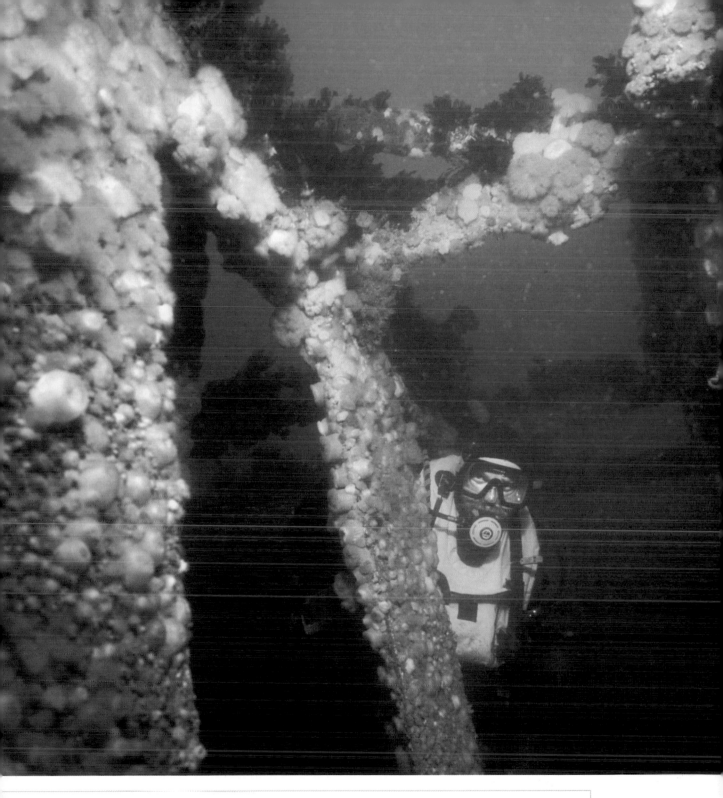

HOW DO I GET THERE

Flights to Glasgow,
Aberdeen and Edinburgh
airports. Train, bus services
and hire car to Oban, which
is the most usual mainland
location for diving the area
although it is quite a long
run to the Hispania unless
you are taking a liveaboard.
You can also take a ferry to
Tobermory, which is much
nearer and where there are
dive organisations. There
are also dive facilities at
Lochaline, which is at the
southern end of Mull.

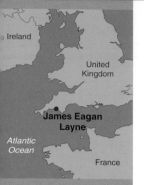

JAMES EGAN LAYNE

Britain at its best

This attractive shipwreck is festooned with coral life and is a great example of an excellent UK dive, holding more than its fair share of marine diversity. A fine example of a British wreck.

maximum depth:
25m

minimum depth:
11m

access
From Queen Annes Battery and Mountbatten dive centre, there are plenty of boat skippers to book through. Day boats and ribs frequent the site regularly from Plymouth. Bear in mind that, as it is in the UK, the dive will not be guided so you will need a buddy and suitable dive experience in the UK.

average visibility
4m–20m

water temperature
6°–19°C

dive type
Wreck

currents
Medium to strong; dive at slack water

experience
**** Divers should be used to diving in British water using a delayed SMB*

in the area
*HMS Scylla
Persier
Rosehill
Eddystone
Lighthouse
Handsdeep*

WHAT WILL I SEE?

The James Egan Layne was a casualty of war, hit by a torpedo on 21 March 1945. Filled with cargo, she took on water and sank to a depth of around 25m.

It is now an important breeding ground for cuttlefish and squid, and their eggs lie around the wreck during breeding season, in bunches like grapes.

Nudibranchs such as the candy striped flat worm and seahare may be found on many areas of the wreck, and ross coral and small sea fans grow here. There can be quite a current running at times, and this encourages food particles to flow past, feeding the organisms that grow so well here and giving the James Egan Layne its characteristics.

There are corkwing and ballan wrasse all round the bow section, which is completely separated from the main body of the wreck. Massive shoals of Pollack and bib can generally be seen around the wreck, with the occasional rare John Dory. Tompot Blennies have made their homes in the crevices and old pipes, with the odd conger or two if you look really hard. Sea bass, squid and even sunfish have been recorded here.

THE DIVES

The ship's loss is UK divers' gain and she sits upright on the seabed awaiting her underwater visitors when the weather is kind. Though much of her superstructure and masts have been swept away by winter storms, what remains brings inspiration to marine biologists, divers and underwater photographers alike.

She is absolutely smothered in soft corals and anemones, including dahlia anemones, Devonshire cup

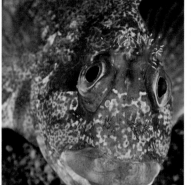

coral and the odd snakelock anemone with an accompanying small spider crab foraging in the tentacles.

Locomotive wheels on the wreck provide an interesting setting and are now full of life. The wheels are stacked as if ready for use but time has laid algae and coral growth on them and they are an interesting part of the hold. Her cargo included trucks, bikes and cars, which have since been removed and brought to the surface.

Fan coral grows on the plates at 18m. It is a joy to dive through this wreck as there are numerous entry and exit points, leaving it easy to penetrate and navigate around. You will find the hold packed with bass and pouting. Swim through the ribs, now exposed as the cargo hold bulkheads have eroded. This remaining structure provides an enchanting atmosphere, the dingy interior contrasting with the brighter hues outside. Rays of light can penetrate down to the ship.

It seems there isn't an inch of space free of the coral and sponges that grow on every part of the wreck's curious angles and shapes.

The port side of the James Egan Layne astounds; here, its steel has replaced rock in what looks like a natural reef. The current washing over this section has enabled many white and orange large plumose anemones and dead man's fingers to smother her.

The stern section is about 50m off the port side from the rubble area at the rear of the main section. Cross over the bare sand to view this section, as it's so pretty.

The bow section can really be treated as a separate dive and, although smaller, it makes up for it with the amount of marine life that covers it.

ON DRY LAND
The town of Plymouth is a historical and interesting city to visit. The South Hams of South Devon is an area of exceptional beauty and contrast, with river estuaries, rolling hills and thatched cottages surrounding the lovely old towns of Dartmouth, Totnes, Kingsbridge, Salcombe, Modbury and Ivybridge, and the pretty villages that abound. Historic shipwreck museums, aquariums and seal sanctuaries are open most days throughout the year. Famous gardens and houses are also available for visiting.

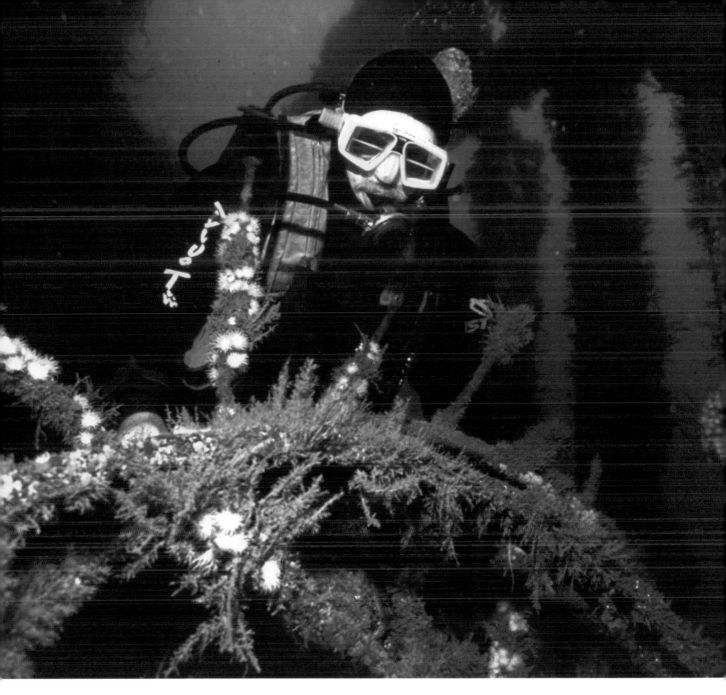

For British residents, diving the James Egan Layne is great at different times of the year, watching lumpsucker and cuttlefish in early spring, and you may spot basking sharks in summer. In late summer and early autumn, there is improved visibility, warmer water and summer coral blooms, showing off the wreck.

While carrying out your safety stop, you may see a barrel jellyfish, moving surprisingly quickly through the water with its massive pulsating motion, the largest of the UK jellyfish.

The wreck is buoyed and divers venture out to her regularly. Go and enjoy a British dive.

HOW DO I GET THERE

Via Exeter airport, or from Newquay, drive or get the train to Plymouth.

UMBRIA WRECK
The wreck with big bang potential

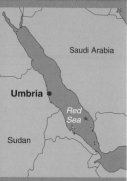

Saudi Arabia

Umbria

Red Sea

Sudan

maximum depth:
38

minimum depth:
18

access
Liveaboard dive boat.

average visibility
20m–30m plus

water temperature
Winter: 24°C
Summer: 28°C

dive type
Liveaboard

currents
Slight to moderate

experience
*** to *****
Advanced for deep wreck penetration.

in the area
From Port Sudan, the Umbria is normally the first dive site on a trip to dive the reefs of the northern Sudanese Red Sea, such as Sanganeb, Sha'ab Rumi and further north to Abington Reef and beyond. Alternatively, you can include the Umbria in a trip that travels down to the Suakin Peninsula, which also offers amazing diving in areas that are much less frequently dived due to their remoteness.

What gives a wreck dive an added dimension is the story behind it, and the Umbria is no exception. Its sinking takes us back to World War II. The Italian cargo ship was carrying bombs and explosives and was bound for Massaua, an Italian military base in the Red Sea. Anticipating Italy entering the war, British warships forced the Umbria into the bay of Port Sudan. At midnight on 10 June 1940, Italy declared war on the side of the Germans and to avoid the ship falling into British hands the crew scuttled her.

WHAT WILL I SEE?

The wreck is in depths ranging from 18m at the stern to 38m at the bow and leans at an angle of 45 degrees to port. She was first dived by Hans Hass in 1949 and at that time the masts were clearly visible above the water. Now only the starboard lifeboat davits can be seen at the surface. At 155m in length and 18m wide, she is still pretty much intact, although the bridge area near the surface has suffered damage and the masts and funnel have broken away. In addition to the abundant marine life, exploring the cargo is also fascinating and thought provoking. She sank with some 360,000 bombs on board and 60 boxes of detonators and incendiary

devices. After the war, bomb disposal experts estimated that in the event of an explosion a large part of Port Sudan would be destroyed. The cargo also includes bags of cement and three Fiat 1100 Lunghe motor vehicles, all of which are accessible to explore.

THE DIVES

Entry to areas like the bridge is straightforward, but some of the deeper recesses of the wreck, such as the crew accommodation, the galley, engine room and boiler room, should only be attempted with proper planning and experience. At the bow, the anchor chains still pass through the huge windlasses as they did when she

ON DRY LAND
In Port Sudan it is possible to arrange visits to markets in the town and escorted trips to the ruins of Suakin Harbour, founded in 600AD.

About 43km from Port Sudan is Marsa Fijab, a natural harbour where many birds shelter and nest, including ospreys, little egrets, kites and spoonbills. There is also

Marsa Inkelfal, a sheltered coastal area that offers the opportunity to walk and take in the desert vistas and the white beaches that contrast with the blue waters.

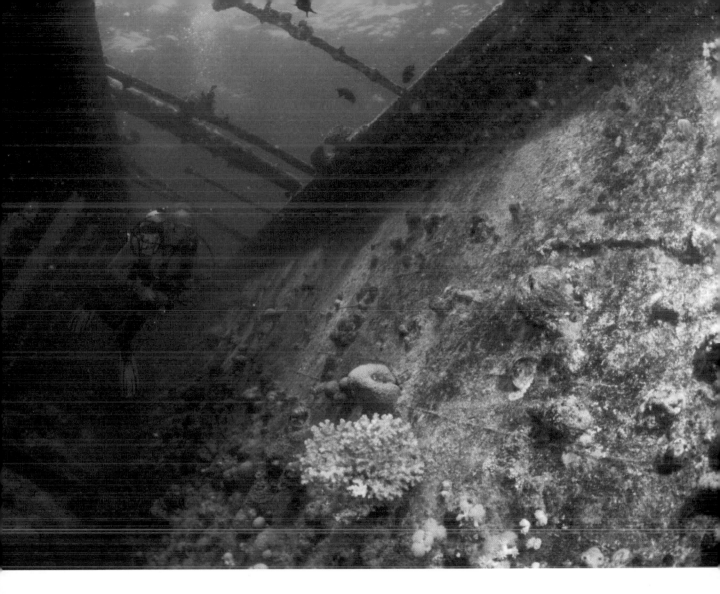

sank while at anchor. There are three holds, which can easily be entered from the forward deck. Aerial bombs, detonators, aircraft tyres, cables and storage containers are all there in No 1 hold. In No 3 hold are the bags of cement and above them the Fiat motor cars.

Moving aft to the central section, the bridge and accommodation area is shallow and easy to explore. Deeper penetration is possible into the wreck, including the engine room, if carefully planned.

The port and starboard companionways offer an easy swim through to the rear of the ship with cabins that can be explored on the way. Behind the central structure are two more holds and these contain most of the 360,000

bombs, still neatly stacked. The stern section soars proudly from the seabed with the starboard propeller an imposing sight, and the large rudder is also in place.

Much of the wreck is emblazoned with hard and soft corals and not surprisingly this artificial reef is now home to a large assortment of fishes such as large groupers, triggerfish, shoals of yellow snappers, lionfish, butterflyfish and angelfish.

Hans Hass described the Umbria as 'the best shipwreck in the world'. That was many years ago and many more wrecks have been discovered since then but we certainly would not argue that she is still among the best wreck dives in the world.

HOW DO I GET THERE

Flights via Cairo with connecting flights to Port Sudan. A liveaboard dive boat needs to be organised in advance and there are a growing number of dive boats operating out of Port Sudan.

Alternatively, it is possible to fly via Cairo to Marsa Alam in Egypt and connect with a liveaboard in Egypt, which can navigate south into Sudan. However, it should be noted that the Sudanese Government do sometimes change the rules so careful planning is necessary. I have never found any difficulty travelling to Sudan, but you need to be ready for the bureaucracy.

SS ROSE CASTLE WRECK

A metal tombstone, memorial anemones and soft corals, this wreck is a memorial to the 28 crew members who lost their lives when she was sunk by German U-boat U-518.

On 2 November 1942, U-518 entered the bay on her maiden voyage and torpedoed the English-built ore carrier SS Rose Castle. The U-boat then turned its attention to the Free French steamship PLM-27, which sank almost immediately with the loss of 12 lives.

maximum depth:
40m

minimum depth:
29m

access
Resorts in the area provide specialist dive facilities and expertise to dive wrecks in the area.

average visibility
10–25m

water temperature
0°C–17°C depending on time of year and depth.

dive type
Wreck dive

currents
Non-existent to minimal

experience
*** to ***** Normal season April to October, although winter diving is available, including diving under ice in local lakes and inlets.

in the area
The remains of three Conception Harbour whalers lie in 8m of waters and can be reached by shore dives. At certain times in spring, it may also be possible to dive the icebergs that have drifted down from Greenland. Summer brings the arrival of vast shoals of deep sea caplin fish, which come into shallow waters to spawn and attract humpback whales, belugas and, if you are lucky, narwhals. To dive with these is an amazing experience and can be arranged through the local dive resorts. Numerous shore dive sites are available in the area.

WHAT WILL I SEE?

In addition to SS Rose Castle wreck and PLM-27, two wrecks lie in Conception Bay off Bell Island, all sunk by German U-boats in 1942. The British Steamship SS Saganaga was sunk by U-513 on 5 September 1942 with the loss of 29 lives. Within minutes, this was followed by the sinking of the ore carrier SS Lord Strathcona. No lives were lost, as the crew had already manned the lifeboats following the sinking of the Saganaga. Although a sad reminder of the trials of war, these wrecks are a fitting reminder of the fortitude of the crews who helped keep the allies supplied with the means to conduct World War II. The four wrecks range from 30m to 45m. The SS Rose Castle is the deepest but most spectacular of these and an exciting dive for advanced divers.

THE DIVES

Many eastern seaboard wrecks were blown up to prevent them being a hazard to shipping. The SS Rose Castle did not suffer this fate and is in excellent condition, sitting majestically upright on the seabed. This is a huge wreck, with a length of 138m. You descend to the intact masts, which are absolutely covered in anemones, and to the

main deck where you can inspect the Marconi radio room with some of the equipment still intact.

About 30m off the stern of the wreck, in 48m of water, lie the remains of the German torpedo that sent the Rose Castle to the bottom. Wolf fish have taken up residence in its broken remains, which are also covered in plumose anemones and other invertebrates. There are many points of entry into the wreck itself, including rooms at the bow and stern end, where some of the crew's personal effects can still be found. Massive cargo holds can also be inspected. For the really adventurous and those with the experience it is possible to get into the engine room, avoiding the nets near the entrance which are covered in soft corals and plumose anemones.

At the stern, the 4.7" stern gun is still in place and the whole of the wreck is ablaze with soft corals and anemones, making this one of the most hauntingly beautiful wrecks, with visibility usually exceeding 15m. This is deep diving with possibilities of wreck penetration, however, so relevant ability and experience is essential. The dive organisations in the area are very much set up to ensure safety is maintained.

ON DRY LAND
The city of St John's offers many areas of interest. It is a lively town with many restaurants, pubs and sights. The extraction of ore was

the reason boats such as the SS Rose Castle sailed to the area, and you can visit the old Bell Island ore mines and museum. The city's many other historic sites include

Fort Amherst and Quidi Vidi, a local fishing village. Conception Bay South is a park area offering many activities, such as hiking, picnic areas, swimming, boat tours

and whale watching, as well as diving trips. Sea kayaking is available in the Long Harbour Fjord.
On a tour of the Avalon Peninsula, you will find

beautiful scenery, cute towns and great beaches. There are national parks with moose and bear, as well as a variety of bird life such as eagles and puffins.

HOW DO I GET THERE

Flights to St John's International Airport, St John's Newfoundland, which is nearest to the area; or Gander (three-hour journey) or Deer Lake (seven-hour journey).

Ferry services from Nova Scotia, Quebec or Labrador. Resorts in the area provide expert services to dive these wrecks.

Atlantic Ocean

Puerto
Rico

Caribbean Sea

Drago's Bay

Venezuela

maximum depth:
m (52m)

minimum depth:
m (30m)

access
*Diving on the Bianca
C is possible by
day boat; local dive
centres arrange trips
daily. Dive companies
operate out of Grand
Anse beach, near the
capital St George.
Boats will take you to
the site within 10-15
minutes. Grenada
can be dived all
year round, as it is
not in the hurricane
belt. Major rainfall
occurs from July to
November.*

average visibility
10m–30m

water temperature
26°C–29°C

dive type
Wreck dive

currents
Medium to strong

experience

in the area
*Most of the dive sites
are within 15 minutes
of the Grand Anse
Beach.
Flamingo Bay
Happy Hill
Moliniere Reef
Whibble Reef*

BIANCA C

Caribbean's largest diveable wreck

An exploration of the past.

WHAT WILL I SEE?

At dawn on Sunday 22 October 1961, the order had just been given for the Bianca C to set sail when a terrific explosion destroyed the engine room. This was followed by a raging fire of such intensity it began to engulf the entire ship.

There were 673 passengers and crew on board, and a rescue operation saved all the passengers and many of the crew. The survivors were looked after as guests of the people of Grenada before two ships arrived to take them home to Europe.

Meanwhile, the ship slowly began to sink at the harbour entrance, blocking the passage of other ships. She was unceremoniously towed away until the line broke and she slipped quietly below the surface around midday on 24 October, stern first, into some fifty metres of water. The Bianca C remains there today, in a great location between two deep parallel reefs. Most of the vessel is upright, with the rear sections twisted over and lying on the starboard side.

As far as the eye can see, the wreckage is covered in life.

THE DIVES

Expect a free descent to the Bianca C decks at around 33m, as Grenada authorities do not like this wreck buoyed. It is a great free-fall glide through the blue, with the chance of seeing a passing eagle ray.

There are a few open sections and rooms to enter on the deck, but bear in mind that this is an old wreck and there are plenty of things to see without having to penetrate the wreck itself. Most divers cannot resist the urge to swim in the pool sunk in the mid-ship deck area. Recently, one side of the pool collapsed but you can still swim right into it, and into the cargo hold as

well. Moving forward, the top of the bow is at 27m and the foremast is still standing, now draped with a tapestry of coral and circled by barracudas. There are plenty of deck features to explore, such as the steps to the upper promenade, and you can get a real sense of the ship as it once was.

The wreck is now quite broken up, but there is still plenty to explore. The central decking has rotted, exposing rib-like beams overgrown with elegant black coral trees, delicate hydroids and sponges. Lobsters lurk under the beams, where moray eels also hide, waiting for evening to arrive before they venture out from their protected dwelling. The anchor lies on the seabed with the winches visible.

Pass over the rail and view the hull from the outside: it's huge. Further along the deck, the once proud funnel has collapsed onto the topmost superstructure and here barracuda gather.

The foredeck is festooned with coral growth, a solemn flagpole marking the tip of the bow at 30m. The bows are awesome as they fall dramatically and vertically to the seabed below. From the bottom, you have an immense view of the Bianca C as it towers above you, encrusted with gorgonia, sponges and sea whips. Shoals of barracuda provide a splendid backdrop as you look up along the wreck to the surface.

Use the remaining dive time and air to explore the whibble reef; there are many whip corals, black tree corals and sponges. Small sand sharks, barracuda and larger grouper move between the wreck and the reefs. Schooling fish including bigger jacks are common and rainbow runner and palemeto will often swim in from deeper water to swirl around the shallower wreck sections.

ON DRY LAND
This beautiful island features more than 45 breathtaking beaches where you can enjoy sailing, whale and dolphin watching or deep sea fishing tours. There are guided island tours to explore its lush mountains, hike in the rainforest and view beautiful waterfalls. The highest point is Mount Saint Catherine, at 2,757 feet (840m). Trips to neighbouring islands, including Carriacou and Petit Martinique, are also possible.

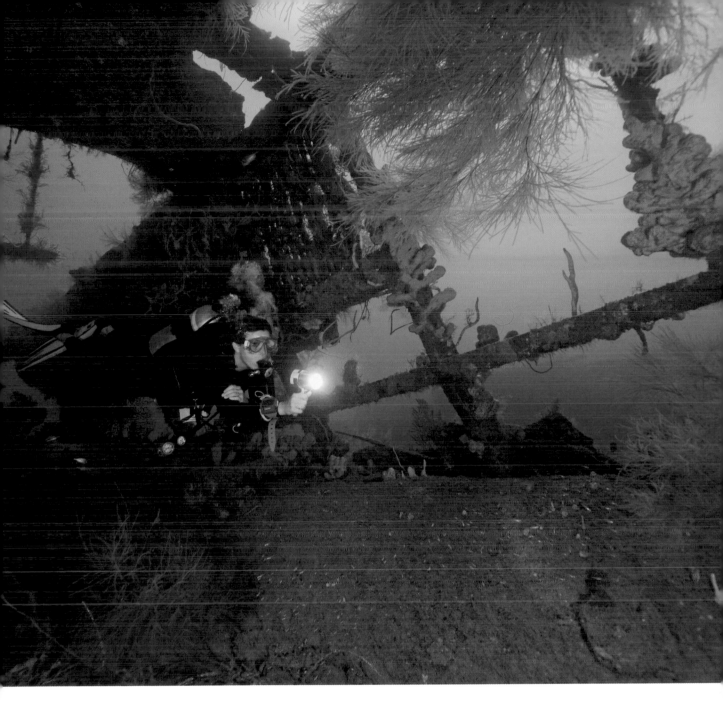

HOW DO I GET THERE?
Direct flights to the capital, St George's, from London, Europe and America. Inter-

nal flights from Tobago are also possible.

SS CRISTOBAL COLON

Relics of the past

Bermuda houses one of the world's largest collections of historic wrecks. The Cristobal Colon, at three decks high and 152m in length, is Bermuda's largest shipwreck.

maximum depth:
17m

minimum depth:
6m

access
Dive centres operate out of local resorts and take you by day boat or rib to the dive site. Wind direction and sea swells can sometimes deny access to certain dive sites, but since Bermuda is completely encircled by wrecks, there is always a calm side where wreck diving is good.

average visibility
15m–30m

water temperature
25°C–31°C

dive type
Wreck

currents
Slight to strong

experience
*

in the area
*Constellation
Montana
Lartington
Minnie Breslauer
Hermes
South West Breaker
Marie Celeste
Barracuda Reef
Pollackshields
Hangover Hole
Sandy Hole*

WHAT WILL I SEE?

Cristobal Colon offers hundreds of relics, among them boilers, steam turbines and propellers. She was a Spanish transatlantic luxury liner, built in 1923 and operating between New York and Central America. She was wrecked on 25 October 1936, when she crashed into a coral reef on her way to Vera Cruz. The island's North Rock light was out of order and channel navigation lights unfortunately misled its captain.

For some time, the wreck of the Cristobal Colon sat high on the reef only eight miles from the Royal Naval Dockyard. This allowed for the easy salvage of some of her fine furniture, paintings and fittings, which can still be found in many homes in Bermuda.

She was finally sunk during World War II when the Air Force used the wreck for bombing practice. This allowed her to rest underwater but sadly scattered the ship across the reef and surrounding sea floor.

A multitude of reef fish, wrasse and yellow tailed snappers cruise the wreck. In particular, large groupers are attracted to this wreck site. Soft and hard corals adorn the sun-drenched metalwork. Unusually the Cristobal Colon has rectangular portholes.

THE DIVES

This wreck is vast and the size of the engineering is phenomenal. The sea floor is cluttered with incredible machinery parts, amongst them eight massive coal burning boilers, two spare propellers and deck winches. Abandoned steel plates and coils of pipes explode

from the original wreck site. These represent just a part of a multitude of fragments from a once great ship. Just in case you forget you are in a tropical paradise, the wreck brings you back to the undersea life and you find yourself exploring less of the boat parts and more of the marine life. A field of sea fans grows all around her, with smaller creatures such as hawkfish and gobies clinging to their safe homes there.

The Cristobal Colon actually lies in two main sections divided by a reef. Your dive guide will need to show you the route from one area of the wreck across the reef to the remaining wreckage, to ensure you do not miss a thing.

Take time to go around and across all of the wreckage, as it stretches for over a thousand square feet, the ocean floor harbours yet more ship parts including propellers, engines and steam turbines. A bathtub sits alone on the sand; unexploded artillery shells litter the ocean floor. Coral and a large area of reef are interspersed with the metal, and this has become a haven for large groupers and a variety of reef fish. At the shallowest part of the reef, just a little distance from the wreck, an interesting cave can be accessed from the top of the reef.

In 1937, the funnel and mast of the Cristobal Colon were removed after Captain Stephensen of the Norwegian steamer Aristo mistook her for a ship in the channel and followed her onto the reef. Thanks to him, you have the added bonus of a second wreck lying nearby.

ON DRY LAND
You can get around by motor scooter, ferry, taxi, bus, horse and carriage, bicycle or on foot. A visit to Bermuda must include a day at one of the world famous pink sand beaches. Bermuda's culture and diversity will overwhelm you. There are many pristine gardens and 13 forts to explore, including the Royal Naval Dockyard and the historic town of St George.

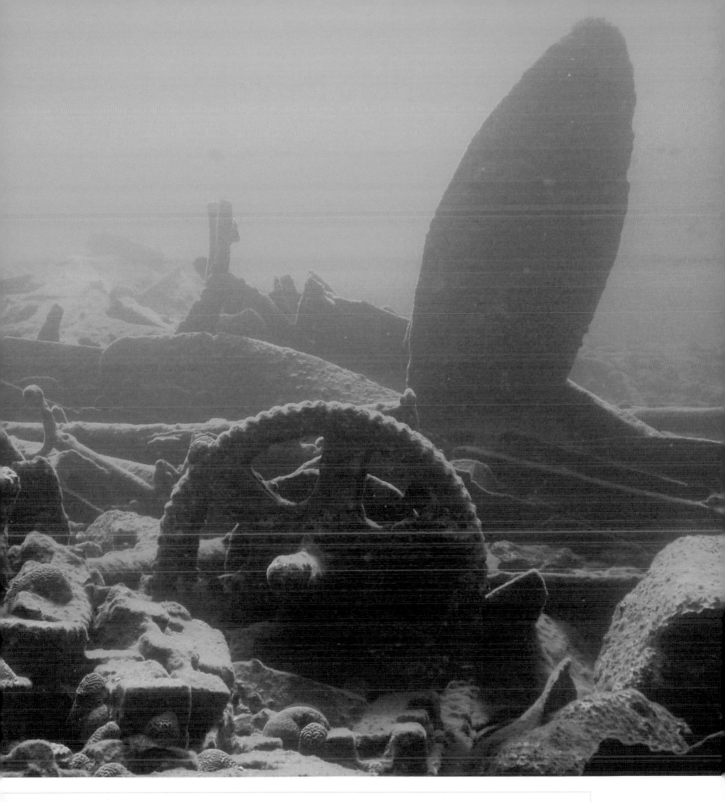

HOW DO I GET THERE

Direct flights to Bermuda take up to two-and-a-half hours from most cities in North America. You can access Bermuda from Atlanta, Boston, Charlotte NC, New York, Philadelphia and Washington DC, and Toronto is also served by direct flights. A British Airways flight from London Gatwick takes under seven hours.

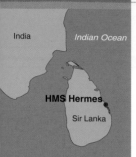

India

Indian Ocean

HMS Hermes

Sir Lanka

HMS HERMES

Sunk in action

HMS Hermes was the first purpose built aircraft carrier in the world. A British ship, she fought in World War II where she met her last days and returned to the sea for future generations to admire her wreck and hear her story.

maximum depth:
53m

minimum depth:
42m

access
The HMS Hermes must be dived by special arrangement. The wreck is situated only 12 km from the coast, and the journey can take 30-45 minutes depending on your boat. Boats will go out for the day and liveaboards are also available.
June to August is the best time to dive on the east coast.

average visibility
15m–40m

water temperature
26˚C–28˚C

dive type
Wreck diving

currents
Strong

experience

in the area
Boiler Wreck; sites around Katthankuddy, Kallar, Punnakudah and Pasikudah

WHAT WILL I SEE?

The wreck of the Hermes is located in the Indian Ocean off Batticaloa, Sri Lanka. Tasked with seeking out and destroying German submarines, the HMS Hermes was patrolling as far as the Indian Ocean as part of the Eastern Fleet. She was attacked by 70 Japanese bombers and hit forty times. Within 10 minutes, the carrier sank and split in two, with the loss of close to 300 lives.

British aircraft carrier HMS Hermes is one of the best known wrecks in the area. She has deteriorated over time and her remaining hull fragments are packed with abundant marine life that would not otherwise have been attracted to this particular spot. Considered to be one of the most exhilarating and thrilling sites to visit, she lies along the east coast.

THE DIVES

Divers who like wrecks often find HMS Hermes' military cargo of most interest. She carried five cannons, four anti aircraft guns and 12 aircraft. As you descend into the clear blue depths, there is time to gather your thoughts and reflect on the tragic story behind the sinking of the HMS Hermes. Down the anchor line, metres of blue water pass by and you may think there is not a lot of fish life around. Then a misty cloud appears beneath you as a massive shoal of blue lined snapper moves around the wreck. At around 30m, a large bulk looms out of the depth and it is a few more metres before you recognise the shape of a ship as the scenery is unveiled before you. There are countless yellowback fusiliers

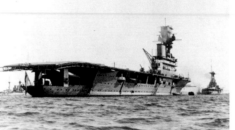

and longfin bannerfish to fill your peripheral view while you admire the wreck.

Despite the massive damage created by the Japanese bombers and the length of time the ship has been under the ocean, the wreck is largely intact and penetration is possible with care. The back section on the flight deck reveals the ship's hull, but it twists as you head towards the bow, being on its side and partly upright at the bow. This allows exploration into the lower holds where you will find many guns. Caches of unused anti aircraft shells lie stacked in the holds, waiting to defend the ship.

Mid-deck, several anti aircraft guns are still identifiable and intact, a true representation of war. Dogtooth tuna often settle into formation and may start swimming in large circles around them.

The first impression of the wreck is one of size and beauty. Light is dim at around 40m but the ship is covered in sea fans. The wispy forests of black coral envelop the ship. Encrusted with life, the HMS Hermes now seems enchanted. Giant sea fans and tall whip coral adorn her. Yellowback fusiliers gently meander around the wreck, undeterred by the divers who visit here. Large schools of barracuda, tuna and trevally are common, the barracuda layered up through the water providing a great silhouette against the pale glow of the sun many metres above. At the stern section, very large potato cod hang out; the gate keepers of the wreck.

Around the wreckage are many boulders. You may find longnose hawkfish hiding in the protection of a coral branch.

ON DRY LAND
Batticaloa occupies the central part of eastern Sri Lanka and covers a land area of approximately 2633km². Aside from beautiful beaches, Batticaloa's lagoon is famous for its 'singing fish'. Sri Lanka holds many exotic flora and fauna and is best known for its wildlife, including leopard, sloth bear and elephant.

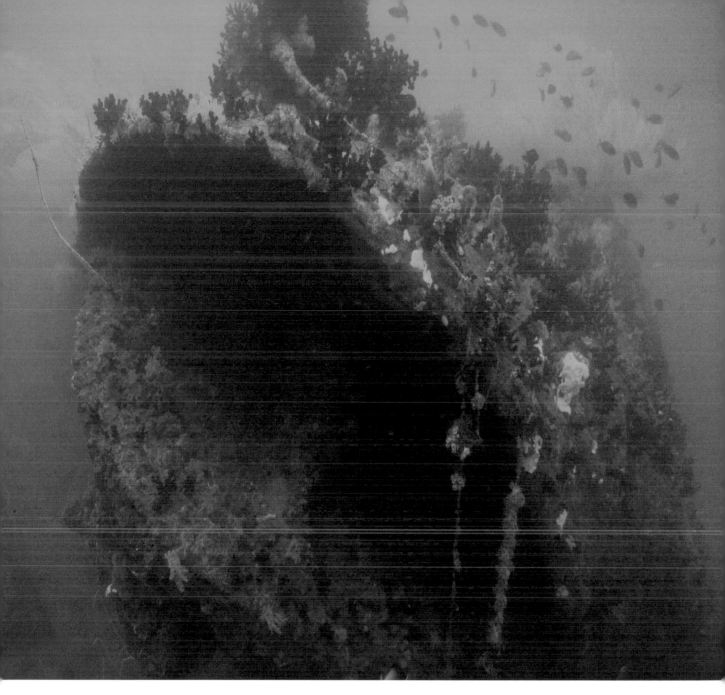

Sixty years on, you can still view the wreck's three propellers, large pipes, wires and many anchors stowed away.

You can make out the bridge and broken conning tower, lying in the sandy rubble at over 50m. There is a giant wheel that sits on the conning tower and looks very pretty and quite imposing, now covered in life.

Incredibly, divers have reported spotting a small whale swimming past on this dive but this is a rare sighting.

The HMS Hermes is world class and to be remembered with reverence as one of the largest undersea war graves in the world.

HOW DO I GET THERE

Sri Lanka's international airport, the Bandaranaike at Katunayake, is about 30km north of the capital, Colombo. Batticaloa is about 300km from Colombo and is a journey of up to eight hours.

USS NEW YORK

Dive a naval warhorse with a fascinating history

China

Subic Bay
Vietnam

Indian Ocean

Malaysia

maximum depth:
18m

minimum depth:
38m

access
Via dive boats, and it is only about 15 minutes from the beach. There are numerous dive operators in the Subic Bay area.

average visibility
5m–15m

water temperature
22°C December to March
28°C April to November

dive type
Wreck dive; advanced technical dive for any deep penetration of the wreck.

currents
Minor to none

experience
*** to ***** depending on degree of wreck penetration

in the area
There are some 30 wrecks and 30 reef sites in the area. The wrecks include:
El Capitan
Hellship – Oryoku Maru
The Oryoku Maru
Seian Maru
LST (Landing Ship, Tank)
Patrol Boat (Japanese)
San Quentin

Subic Bay may not be as well known as Coron or Truk, but it does not stand in their shadow. 25 Japanese ships were sunk here during World War II and there could be as many as 10 other large shipwrecks lying in the bay. It also has other historical wrecks, such as the 19th century San Quintin, a Spanish American War wreck. There is one wreck, however, that is in a class of its own when it comes to history, and that is the USS New York, which is the one we feature.

WHAT WILL I SEE?

Subic Bay is north of Manila and very picturesque with its beautiful beaches, mountains and lush rainforest. Its importance as a naval base goes back a long way, as Spanish colonizers developed one here in 1885. The USS New York was scuttled by the US Navy in 1941 due to the approach of the Japanese. She is located in 27m of water between Alaya Pier and the end of the runway. The armoured cruiser was launched in December 1891. She saw plenty of action during her illustrious career, including World War I when the US entered the war with the Pacific Patrol Force.

She was finally decommissioned in 1933 and moored in Subic Bay for the next eight years until she was scuttled in December 1941. In her final resting place, she is now a wonderful historic wreck and an artificial reef supporting a wealth of marine life.

THE DIVES

Although renamed on two occasions the wreck is still affectionately known as USS New York and she now rests

ON DRY LAND
Subic Bay has a marina and yacht club. There are hotels, restaurants, shopping arcades and food stores. Subic Bay boasts a casino and golf course. The beaches are great, and there are water sports such as jet skiing, parasailing and banana boating. You can visit places of historical interest dating from the Spanish to the Japanese occupations. Jungle treks are available, as well as visits to Olongapo City, Zambales and Bataan provinces and, of course, Manila.

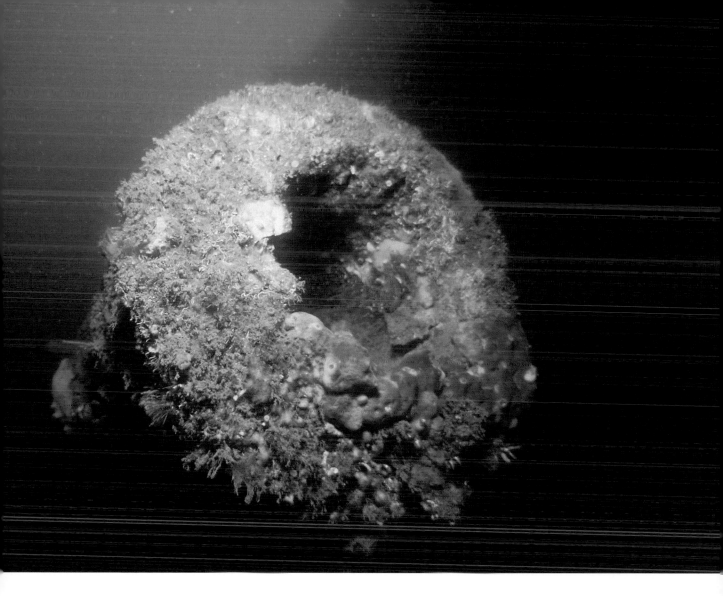

in 28m of water about 500m from the pier of Alava. She lies on her port side and is easily accessible, enabling the diver to explore some areas of the interior of the wreck, although good diving practice is essential if entering the wreck, especially if entering the inner areas where good technical diving skills are required. As she is buried in mud up to her centre line, depths of 34m can be reached within the wreck. You can explore the main deck with its turret guns still in place, although the bridge is no longer there. The gun deck is broken up and provides an easy access into the wreck through many gun ports. The berth deck is the accommodation area and is again accessible. The engine deck at the deepest point is largely unexplored and extra care needs to be taken if attempting to enter it. The four engines are still in place. There are two hatchways in the stern that allow easy penetration, and these take you to the stores, magazines and coal bunkers. The bulkheads were made of wood and have rotted away so manoeuvring through these areas is relatively easy.

There is a great abundance of marine life. You will find other fish in enormous numbers, including barracuda, jacks, lionfish, sweetlips, groupers and spotted rays. Occasionally, you may come across a lobster tucked away in a crevice. There are plenty of corals, gorgonian fans and sponges, as you would expect on a wreck that has rested here since 1941.

HOW DO I GET THERE

International flights to the international airport at Subic Bay or via Manila Airport. You can hire transport and drive from Manila to Subic, which can take 3 – 4 hours depending on traffic. Transfers can be arranged. Bus shuttle services are available.

Pacific
Ocean

Papua New
Guinea

**Kinugawa
Maru**

Australia

KINUGAWA MARU WRECK

Step off the shore onto a world-class wreck

The name Guadalcanal is synonymous with the savage fighting that took place during World War II with the loss of so many lives of soldiers, sailors and airmen. Beneath its clear waters lie the remains of many ships and aircraft caught up in that conflict.

maximum depth:
30m

minimum depth:
Surface

access
Access from the shore.

average visibility
Offshore 40m but run-off from land in some areas can reduce visibility

water temperature
Winter: 23°C
Summer: 28°C

dive type
Wreck dive

currents
Occasional currents but not excessive

experience
*** to ***

in the area
Wreck sites include Hirokawa Maru, the sister ship of the Kinugawa Maru, which is also a beach dive; Azumasan Maru, the Japanese cruiser submarine I–1; and USS John Penn. The USS Atlanta also lies here but is in 130m of water and would require technical diving arrangements. In addition to the wreck diving, there are some beautiful reefs around Tasivarongo Point and near Bonegi Beach as well as other dive sites around the coast.
If you are on a liveaboard or are able to arrange a multi-centre trip, there are many more dive sites and wrecks throughout the islands.

WHAT WILL I SEE?

Guadalcanal was under British control when in 1942 the Japanese invaded to create a forward air base as a staging post for further operations. In response, American forces and their Australian and New Zealand allies landed on Guadalcanal in August 1942, marking the start of a six-month campaign that was to become a turning point of the war in the Pacific. With control of the Guadalcanal airfield and aircraft from the aircraft carrier USS Enterprise, the Allies inflicted heavy casualties on the Japanese. Among the transport ships that were destroyed was the Kinugawa Maru.

The Solomon Islands consists of nearly 1,000 islands, with its capital Honiara located on the largest island of Guadalcanal. The chain consist of several large volcanic islands south-east of Papua New Guinea.

The Solomon Islands chain is the South Pacific's third largest archipelago. It comprises several large volcanic islands as well as outlying islands and atolls. The terrain on some of the islands, including Guadalcanal, is very mountainous and heavily forested, with fast-flowing rivers.

The Kinugawa Maru, sometimes known as Bonegi II, is very close to the shore to the north-east of Guadalcanal. Her bow is proud of the surface and very broken up. She is 132m long and her stern slopes down to about

30m. The shallow section makes it ideal for snorkelling as well as a most impressive dive. This is an incredible artificial reef, teeming with life.

THE DIVES

Entering from the shore, you will find that the shallow areas of the wreck consist only of scattered remains on the seabed, due to the effects of time and salvaging. However, these areas create an incredible artificial reef ablaze with beautiful soft corals and sea fans. Deeper down, the wreck is more three dimensional but it is skeletal, enabling good access. It is wonderful for photography, with the light streaming through. Everywhere, soft corals decorate the remains, including the guns and the gunner's seat, which still remain, as does live ammunition in the holds. The two propellers are long gone, having been salvaged in the 1960s, but the shafts and the rudder are still there. Nearby are giant black corals and large basket sponges.

Dense schools of silver fish are all around, and schools of barracuda and trevally swim above the wreck. Sea anemones provide sanctuary for the anemonefish, and large crocodilefish, leaf scorpionfish and stonefish are among the many species to be found on the wreck.

This is an easy wreck to dive and it is easy to access. For photographers in particular, it offers exceptional opportunities to play with light and shapes with wide angle lenses.

ON DRY LAND
Honiara came into being during the war and is a lively place with some good restaurants, a waterfront yacht club and a casino.

People are friendly and laid back, notwithstanding the violent history of the islands, where head-hunting and cannibalism were once practised. Evidence of this

can be found in the sacred skull shrines that remain as a reminder of those days. In Honiara, you can visit the National Museum and Cultural Centre, the National

Archives, the National Art Gallery, the Botanical Gardens, the thriving markets and Chinatown.
Outside of Honiara, there is a delightful fishing vil-

lage, excellent beaches and beach resorts, golf facilities and a handicraft centre at Betikama with displays of pottery, copper work and wood carvings, as well as a

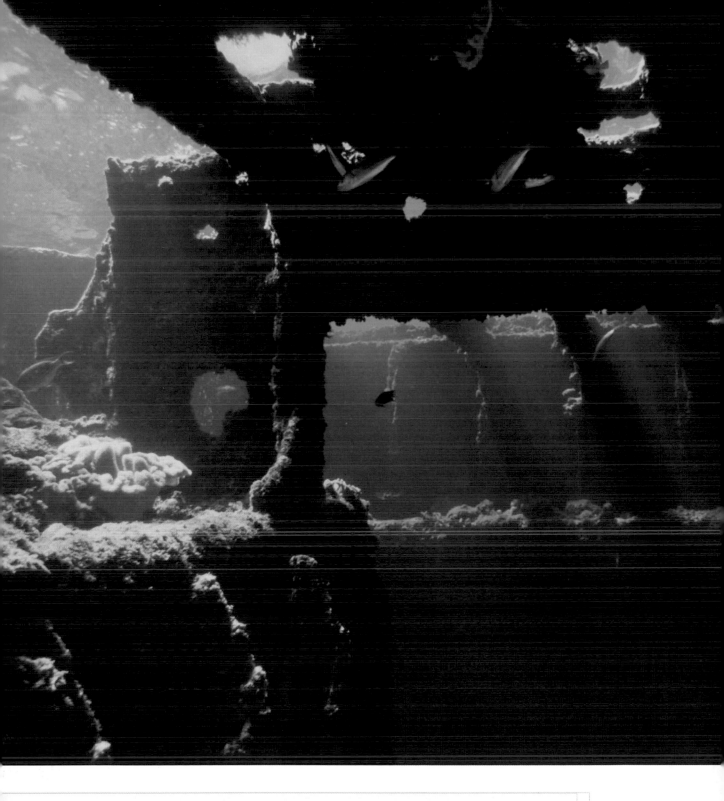

museum of wartime relics. The Mavasere Cultural Centre and Komuvaulu Village are centres associated with the Moro movement.

There are impressive water-falls that can be visited, such as Tenaru Falls, Matanikau Falls and Vihona Falls (the latter only accessible by helicopter).

There are many World War II battlefields, relics and memorials to visit, as well as the Vilu Village War Museum.

HOW DO I GET THERE

Flights go to the international airport on Guadalcanal, about 5km east of Honiara. Liveaboards are a good way to explore the islands but make sure they take in the itinerary that you want.

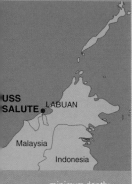

USS SALUTE

The Protector

A popular wreck diving locality in Malaysia, this small area saw significant battle action during WWII. The waters bear testimony to the tragedy that followed. The American wreck is a historical dive site, one of four wrecks that lie in close vicinity in this area.

minimum depth:
18 metres

maximum depth:
33 metres

average visibility
5–20m varies greatly dependent on the season (April–October best)

water temperature
25–27° C

dive type
Wreck dive

currents
slight

experience

in the area
*Cement Wreck
Australian Wreck
Blue Water Wreck*

WHAT WILL I SEE?

Known as the American Wreck, this is in fact the US Navy minesweeper USS Salute. Earning a commendation, she was a minesweeper during the war. A protector of lives, the ship sank on 8th June 1945, creating a haven for new life beneath the sea. The American wreck struck a mine and sank, taking nine men with it and leaving many wounded.

The blast caused the ship to buckle, twisting the bow and stern together making an almighty mess which could not be recovered. She sank at midnight in around 30m of water and now lies about 24km off the coast of Labuan on the Barat Banks.

This US Navy Minesweeper was built in Seattle, Washington in 1943. It was first put into service in Hawaii in 1944 escorting convoys between Pearl Harbour and several ports in the Far East before being assigned to action in Brunei Bay.

Now covered in marine life, sponges and soft coral envelope her. The park is protected by the local authority who ban anchoring and all forms of fishing in the waters around the park. This allows life to flourish and Labuan has become a popular diving destination in Malaysia.

THE DIVES

Built to protect anti-aircraft vessels and submarines, in the end the American wreck had no protection herself. The ship was hit hard by a mine which caused extensive damage. This is clearly visible when you dive on this wreck. The bow is folded back over the stern section,

providing an interesting shape as the bow appears to point backwards and stick out over the side of the wreck.

50m long and 10m wide, this onetime pride of the US Navy is now a fascinating wreck to dive. The marine life will dazzle you while the twisted metal of this jumbled wreck clearly reveals its violent end. Entry via a shot line to the shallowest part of the wreck is best, which is at about 18m. The water can sometimes appear a bit green, depending on the time of year you choose to dive. This can heighten the mystery of the wreck as you descend down the line and a ghostly image appears beneath you. The stern still looks ship shape and intact. Deck depth charge rails are visible and you can just see the tops of the propellers at 30m; the rest lies buried in the sand.

Divers can look in awe at still live ammunition, go under the forward section and carefully penetrate some areas here to find them. Care must be taken not to disturb or pick up anything. It lies untouched as a war grave honouring those who lost their lives on that fateful day. The US Navy has salvaged the depth charges but many other munitions still remain.

There are areas where you can swim through the wreckage, but take care as the ocean has taken its toll and some sections are now collapsing.

Cargo can be seen scattered around the sea bed such as wine bottles, cutlery and shoes. Fish life is evident all over the wreck.

Ships parts are still recognisable with many pipes and engine blocks on show, encrusted with clams, barnacles and spiny black urchins. A radar platform is

ON DRY LAND
Labuan waters encircle six idyllic islets surrounded by rich coral reefs. A romantic setting of long stretches of sandy beaches, jungle tracks and small rock pools. Bird watchers will have lots to see and many rare plants and butterflies flourish here. Other watersports are available including sailing and kayaking. A 20 minute boat ride from Labuan takes you to Menumbok, where you can spot Proboscis monkeys. Horse riding is also available here.

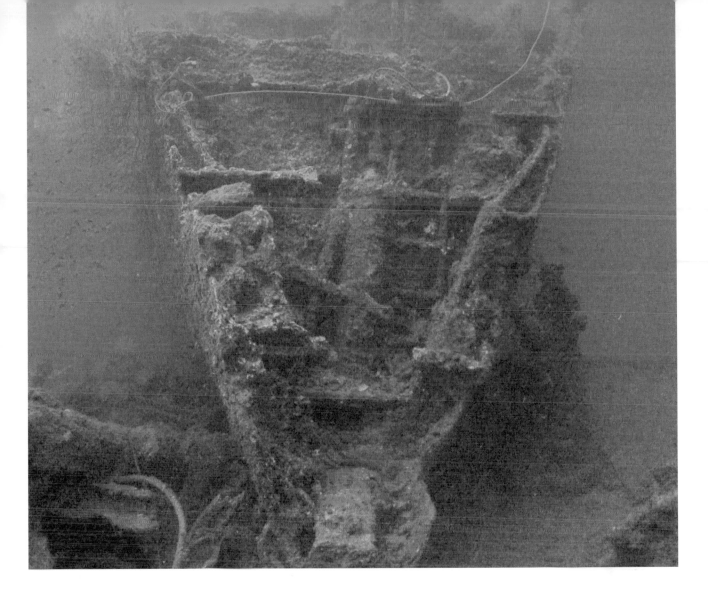

visible but is far from working order. Glassfish cram into every space available and lionfish float nearby waiting for a catch. Their poisonous fins spread elegantly as they swim around each other in formation. Sea snakes can be spotted here and usually are not bothered by a diver's presence. Much life swirls around the wreck including shoals of jack and snapper. Sightings of large sting ray and the less common marbled ray are also possible around the wreck on the sandy seabed.

The wreckage now provides protection for sea life against predators and the currents. A group of Barracuda, on the prowl for smaller fish to eat, hang around the wreck, smothering it.

Plans for the USS Salute to be salvaged in 2006 were abandoned after a number of divers raised objections and survivors and relatives were put in touch with the protesting divers. A memorial plaque was placed on the wreck honouring those who sacrificed their lives for their country. Please remember to respect the wreck as for many it remains a final resting place. The wreck continues to provide a haven for many fish and marine life.

The USS Salute provides an interesting and historical dive site for many divers to visit. Gather your thoughts and return to the surface, having explored some of Labuan's underwater paradise.

HOW DO I GET THERE

The main island of Labuan is located just 10 km off the north-west coast of Borneo, north of Brunei Bay, and faces the South China Sea. Labuan can be reached on daily flights direct from Kota Kinabalu, Miri and Kuala Lumpur, or alternatively, by high speed ferry from various ports in Sabah, Sarawak and Brunei Darussalam. It takes around 30-45 minutes to the site from the marina by speed boat. The wreck lies south-west of Rusukan Kecil Island, about 24 km from Labuan.

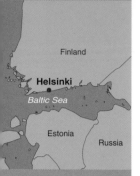

Finland

Helsinki

Baltic Sea

Estonia

Russia

KRONPRINS GUSTAV ADOLF
Historic underwater park

Declared a maritime historical underwater park in the year 2000, the wreck site of the Kronprins Gustav Adolf off the coast of Helsinki is the first Finnish park of its kind and has been excavated as a significant heritage site. The Gustav Adolf is a modest but significant dive site. The Baltic Sea and Helsinki's vital position hold great maritime significance for Sweden, Britain and Russia.

maximum depth:
20m

minimum depth:
18m

access
Daily boat trips from the harbour to the wreck. Park permission and payment is required through the tour operator. Buoys are provided at the park to prevent damage by anchoring, and the boat must be moored to the buoy whilst divers are in the water. The park is closed with winds exceeding 8m/s in order to secure safe diving. The wreck is situated in a shipping lane in the open sea, where even light winds can cause rough seas.

average visibility
2–12m

water temperature
4°C–18°C

dive type
Wreck

currents
Slight to none

experience
★★★

in the area
A group of islands in the Baltic spans the gap between Stockholm and Helsinki; these are the Åland Islands. The Åland archipelago in the Baltic has one of the highest densities of shipwrecks in the world, with more than 500 known wrecks. Among them are: Hindenburg Helge Alice Skiftet Balder

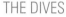

WHAT WILL I SEE?

Underwater parks have been used in different parts of the world to preserve the final habitats of wrecks as museums. This aims to promote maritime historical inheritance, and protects the wrecks from looters.

The Gustav Adolf is a Swedish wreck that was sunk in 1788, apparently having been captured by the Russians. She lay undiscovered at 18–20m until 1995, when the Finnish Naval Research Centre found this unusual wreck on the southern side of what is now known as Gustav Adolf's Shoal. Divers verified the find as a large wooden warship; based on further fieldwork, it was discovered that it was in fact the wreck of the Kronprins Gustav Adolf. No nameplates, emblems of the Crown or ship's bells were found on her; they may have been destroyed or stolen when the Russians emptied the ship. In May 1998, two cannons were raised from the wreck and, together with many volunteer divers, the Finnish cultural foundation pulled together research and documentation to try and piece her history together.

Due to the low salt content of the Baltic Sea, there is no woodworm to decay the ship's timbers, so this wreck is remarkably intact.

The UNESCO 2001 Convention for the Protection of the Underwater Cultural Heritage stipulates that, in the absence of any valid justification for intervention or recovery, sites should preferably be left where they were found. The increasing number of museums and tourist sites that combine a fascination with both the underwater environment and submerged cultural artefacts has given rise to a new form of tourism.

THE DIVES

Navigation around the wreck is easy and safe, even in low visibility. Descend on a fixed rope or shot line and use the guide rope that circles the entire wreck. Twelve boards with information about various parts and details of the wreckage have been placed in suitable locations around the wreck underwater for the visiting diver.

Much of the remains are scattered over a large area on the seabed. Lobsters and crabs seem to guard the area, protective of their home. The bottom of the hull is clearly recognisable, though the sides have fallen in. The remaining structure is still ship-shaped and the decking area is clear. Conger eels find plenty of places to seek refuge here. The rudder and two anchors can be seen, and have lots of European coral growth on them. The arms of the anchor are slightly bent, providing a means of identifying the wreck: this specific anchor shape is a typical feature of Scandinavian and Dutch anchors of the 18th century.

ON DRY LAND
Finland's landscapes are a glorious variation on the theme of forest and water, where the comforts of modern life are never far away. Yet each region has its distinct character, from the wilds of Lapland and the inspiring lakes of the east to the archipelagos of the south-west and the lively attractions of the capital, Helsinki.

Most fascinating is the cargo, estimated at around 70 cannon balls and several cannons. There are cannonball storage bins, of which those on the starboard side are better preserved. Typically, cannon balls from large warships were placed symmetrically amidships on both sides of the keel. Here, the port side is broken up; only small elevations are discernible under the crust. Next to the cannonball storage are the pumps and the main mast.

There are water barrel remains at the forepeak, on the lowest hold. Such cargo for a huge number of crew meant it was hard work lifting and stowing them. Here, cod and pollack stick together in gangs, perhaps wondering who is visiting their monument.

It is a privilege to be able to dive wrecks as old as the Kronprins Gustav Adolf, steeped in the history of a time that once was. Wartime battles fought ship-on-ship with cannons brought casualties and bloodshed. This wreck will remain preserved for a long time.

HOW DO I GET THERE

Helsinki-Vantaa international airport is the main arrival point for foreign visitors. Passengers wishing to travel beyond Helsinki have a choice of connecting flights.

SS PRESIDENT COOLIDGE

A whole dive programme, all in one gargantuan wreck

The chain of 83 tropical islands that make up Vanuatu are a true South West Pacific paradise. But during World War II, the shadow of war had fallen over it and it was a staging base for American troops gathering for the bloody assault on Guadalcanal. In the build-up to the event, an unfortunate incident led to the sinking of a leviathan of a ship, which is now the largest reasonably accessible wreck on the planet.

maximum depth:
60m

minimum depth:
18m

ooooo
The wreck is located close to Luganville. You can dive from the shore or by dive boat.

average visibility
15m–25m

water temperature
26°C)–30°C

dive type
Wreck dive

currents
Light to nil

experience
*** to ******
depending on depth and degree of penetration

in the area
Many other boat and shore dives available such as Million Dollar Point, Cindy's Reef, Fantastic, Chails Reef, Tutuba Point, Aquamarine Reef.
Other wreck dives include SS Tucker, Tui Tawate, M.V. Henry Bonneaud, Aore Plane, Sub Nets.
There is also a freshwater dive called Blue Holes.

WHAT WILL I SEE?

SS President Coolidge was launched in 1931 and was named after the 30th President of the United States, Calvin Coolidge. This was a truly luxurious passenger liner. She was 200m in length and the height of luxury, with a first class dining room, musicians' gallery, smoking lounge, library and two saltwater pools, one of which had an artificial sand beach. There was also a gymnasium, a playroom for children, a shopping arcade and other shopping facilities, as well as a play deck for such games as golf, tennis, squash and quoits. For many years she cruised between San Francisco, Japan, China, Hong Kong and Manila.

With the American entry into the war growing more likely, however, the US War Department began to use SS President Coolidge for US Army military purposes in 1941. Then came the attack on Pearl Harbour in December 1941, after which the liner was fully commissioned as a transport ship and was used to reinforce their garrisons in the Pacific. She was able to carry upwards of 5,000 troops by replacing her once luxurious opulence with more basic accommodation and facilities for the troops.

On 6 October 1942, SS President Coolidge set sail on her fateful voyage from San Francisco, heading for Espiritu Santo with 5,092 officers and troops. The harbour to the large military base on Espiritu Santo was well protected by mines. Japanese submarines were an ever-present threat and SS President Coolidge made for the safety of the harbour through the most obvious channel. Two

mines exploded in quick succession, one near the engine room and another near the stern. The captain steered the damaged vessel into shallow water, where it was beached. A short time afterwards, however, the ship slipped off the shore and ended up on her port side with her stern in 60m and her bow in 18m of water. Two people–a sailor and an army captain–lost their lives in the incident.

From this tragic and costly incident, we now have one of the most amazing wreck dives anywhere in the world, the wreck littered with all the accoutrements left behind by the troops and sailors on that fateful day.

THE DIVES

To call SS President Coolidge a dive site is a bit of a misnomer, as it is far too big to do it justice in just one dive. In fact, the diver operators in the area offer up to 20 different dives on the ship, with depths ranging from 20m to 60m and catering for everyone from novices to technical divers.

The stern is the deepest part of the wreck at 60m, with the rudder and prop shaft still intact. The outer areas of the wreck offer many soft and hard corals, as well as plenty of fish and invertebrates. As you swim along the promenade deck, you will see the ship's 3" gun as well as rifles, helmets, ammunition, bayonets, gas masks and other reminders of the wartime purpose of its last voyage.

There are two holds at the bow end of the ship, which contain plenty of military hardware such as howitzers, a massive truck, jeeps and tracked vehicles.

ON DRY LAND
Espiritu Santo is a lush tropical island with thick tropical rainforests and dazzling white beaches. The town of Luganville (population less | than 10,000) grew from the US presence during World War II when the military harbour was developed. Tours can be arranged, and you can hire trucks to | explore the island. Canoeing and cave exploring are available, while the Vathe National Park and rainforests are home to many bird species and beautiful | orchids.
Resorts and hotels cater for a wide range of budgets and activities.
The capital Port Vila on the main island of Efate is very | cosmopolitan, with duty free shopping facilities, restaurants and cafés, and a wide range of accommodation.

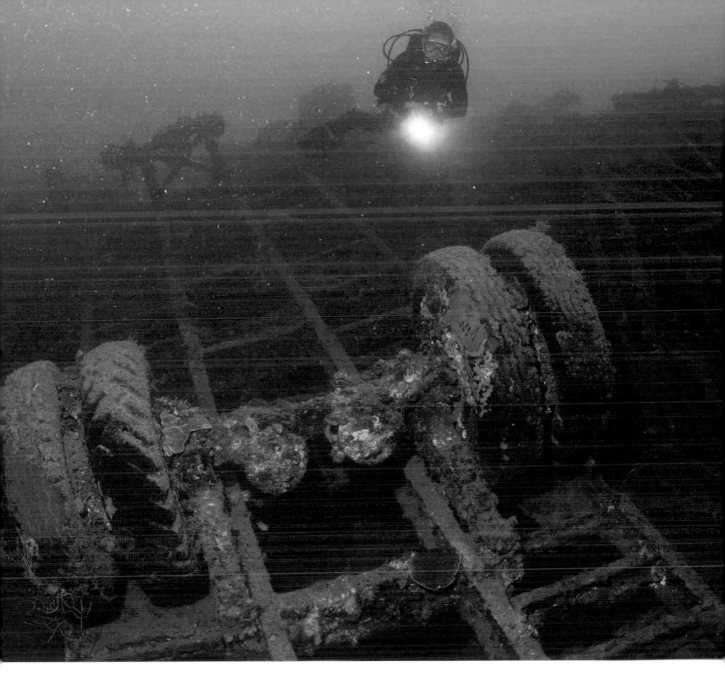

Everywhere you go, you will come across telling reminders of the ship's everyday activities, from the medical area, complete with supplies, to the personal effects of the Captain in his cabin and of the troops in their accommodation.

One of its most famous features is a ceramic figure known as The Lady and Her Unicorn. This involves a penetration dive down to 42m that takes you into the first class smoking lounge. At one end is an antique marble fireplace and above it a decorative panel depicting a lady and a unicorn. It is perhaps the most famous feature of the wreck and a reminder of its once opulent grandeur.

HOW DO I GET THERE
International flights to Port Vila with connecting flight to Espiritu Santo.

SS PROTEUS

Dive the 'Graveyard of the Atlantic'

The North Carolina Outer Banks richly deserves its graveyard epithet, as the wrecks in these waters are thought to number somewhere between well over a thousand and many thousands. About 200 wrecks are recorded and that in itself is enough to make this a wreck diver's paradise. Spoilt for choice, we have concentrated on the passenger freighter SS Proteus, which was built in 1900 and came to grief on 19 August 1918.

maximum depth:
38m

minimum depth:
29m

access
Via charterboats from Beaufort or Hatteras. The dive season starts in April and runs through to December.

average visibility
6m–30m

water temperature
12°C–25°C

dive type
Wreck dive

currents
Slight to strong. Dive planning through local charter operator essential.

experience
*** to *****
Depending on weather conditions and visibility.

in the area
Named wrecks include:
Aeolus
Ashkabad
Atlas
HMS Bedfordshire
Caribsea
Cassimar
City of Houston
Hardee's Reef
WE Hutton
Indra
Naeco
Normainia
Papoose
Theodore Parker
Schurz
Suloide
U-352
British Splendour
City of Atlanta
Dixie Arrow
and many more

WHAT WILL I SEE?

One look at a map of the coast of North Carolina will give an idea of why these waters are so dangerous to shipping. A long, thin string of islands (now connected by bridges) lies offshore, washed by the convergence of three currents creating swirling tides which make for difficult navigation.

Proteus was a high-class passenger steamer that regularly carried passengers and freight between New Orleans and New York. She was capable of carrying more than 200 passengers and crew, including 78 first class passengers. Sailing without navigational lights as a wartime precaution against enemy German submarines, she encountered poor visibility as she steamed off the Outer Banks. At about 2am, she was in collision with an oil tanker, the SS Cushing, which hit Proteus amidships, breaching her hull beneath the waterline. The order to abandon ship was given and all passengers and crew, bar one, were safely rescued by the Cushing, which was relatively undamaged.

She sank in 38m of water and has largely collapsed into herself from the battering of the seas. The stern rises highest above the seabed, which makes it the shallowest part of the dive at about 29m.

These are temperate waters and, although the Gulf Stream flows close by, the water temperature in winter is around a cool 12°C, there can be strong currents and occasional poor visibility. Therefore, this dive is suited to advanced divers with experience of temperate water

conditions. However, the main dive season is between May and October and visibility can be as much as 30m when conditions are right, with water temperatures at a more comfortable 25°C, so a dive trip to this world-renowned 'graveyard of the Atlantic' can be very rewarding indeed.

THE DIVES

The remains of this 118m long wreck now lie on the sandy bottom, well broken up and listing to port. In places, the starboard side reaches about 6m from the seabed. At the bow area, a large windlass can be seen. Working aft, you come to the three large boilers and a smaller auxiliary one, and a spare propeller. Although divers have found articles of china and silverware you are not likely to see these without digging. The stern rises 9m from the sandy bottom with a large bronze steering quadrant.

The engine lies on its side and is covered with marine growth. At the stern, the large, impressive, 5.5m four-bladed propeller and the rudder stand proud although partially buried in the sand. This is where you may be lucky enough to encounter ragged tooth sharks, which are known to gather here. Eels, stingrays, groupers and groups of cobia are among the fish found on the wreck. Occasionally, bull sharks, blue sharks and turtles are also seen.

The ship's 226 kilo bell was discovered near the bow after a violent storm in April 2004. This was raised and is on nearby Hatteras Island.

ON DRY LAND
This long, thin stretch of land, known fondly as the Crystal Coast, is a bustling vacation destination with its beach towns such as Atlantic Beach, Pine Knoll Shores, Indian Beach and Emerald Isle, with their beautiful beaches and many attractions. These include the North Carolina Aquarium and the Maritime Museum, which includes artefacts that are purportedly from Blackbeard's flagship. Historic sites include a Civil War fort in Macon State Park. Charter boats are available for tours and fishing, and there are plenty of activities such as kayaking, jet-skiing, sailboarding, surfing, parasailing and horseback riding, as well as forests and estuaries to visit. All levels of accommodation are available and there are many restaurants.

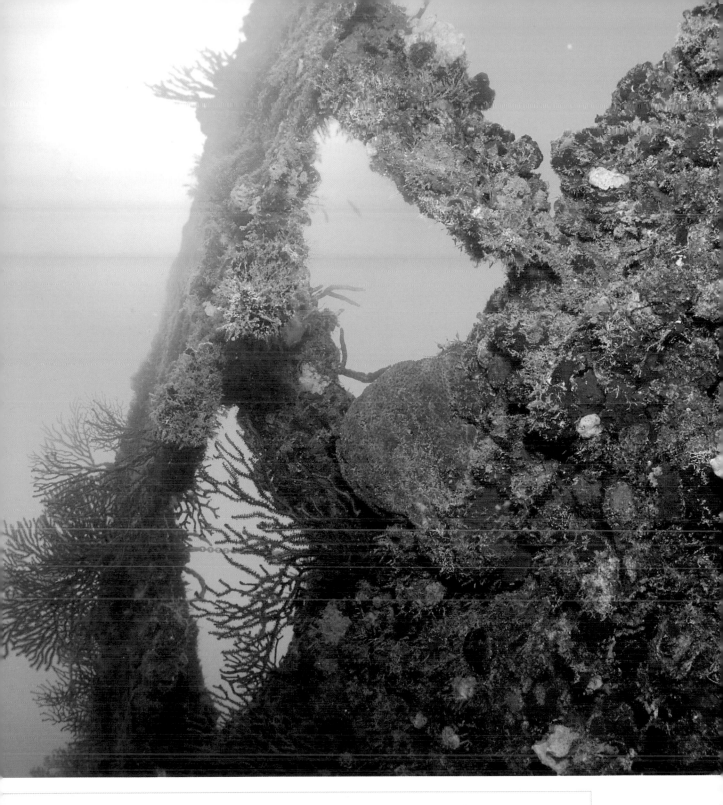

HOW DO I GET THERE
Flights to Raleigh-Duham International Airport and Wilmington International Airport. Regional airports include Craven Country and Albert Ellis in Jacksonville, both a 45-minute drive from North Carolina's Crystal Coast. Rental cars are available at all airports.

SS YONGALA

Reclaimed by the sea

The SS Yongala sank in 1911 with the loss of all on board, after sailing into the eye of a cyclone. She is located near Queensland on the northern side of Australia, on a void sandy seabed, bringing fresh life to the area. She lay undiscovered for more than half a century.

maximum depth:
30m

minimum depth:
16m

access
Day boats usually depart from Townsville, which can be a long trip of up to three hours; or from Alva Beach near Ayr, with a shorter trip of around 40 minutes. Many operators organise a weekend trip to take in the barrier reef and up to three dives on the Yongala wreck.

average visibility
15m–30m

water temperature
25°C (77°F)–31°C (88°F)

dive type
Wreck

currents
Slight to strong

experience

in the area
*The Great Barrier Reef
Wheeler reef
Keeper reef
There are many dive sites around Magnetic Island, particularly for the less experienced diver.*

WHAT WILL I SEE?

Encrusted in coral, the Yongola has now become a reef and provides a home to an incredible array of marine life. This historic wreck has lain here for almost a hundred years and is now protected. To prevent corrosion inside the wreck resulting from trapped air bubbles, divers are not allowed to penetrate it.

The Yongala is one of only five protected wrecks in Queensland and is said to attract somewhere in the region of 2,000 divers a year. Built in the shipyards of Newcastle-upon-Tyne in England, she was launched in Southampton and sailed to Australia in 1903. At the time of her sinking, the Yongala was scheduled to go out of service to be fitted with radio equipment, but unfortunately it was not yet on board to warn her crew of the impending danger posed by the approaching cyclone.

Now part of the sea, this large (109m) steel passenger and freight steamer looks like an overgrown garden. Bursting with soft corals, anemones and sponges, colours and shapes protrude from every area of the deck. Giant trevally and cobia hang around the wreck in gangs, causing a frenzy when they charge the smaller fish. Her funnels are a suitable nursery for the small fry.

THE DIVES

Lying in 30m of water on a sandy channel that would be barren of life were it not for the Yongola, the ship is the only solid structure to be found for miles around.

The wreck still holds together well, with clearly recognisable rudder and masts. Her name is still legible and portholes are on show. Many hydroids and sea fans cover her. The bow will be your first sight as you enter the water. The clear water shows you the top at 16m, the wreck sloping down to the deep. At 30m, between the stern and the seabed, hang giant groupers and potato cod. They appear to glare at you for intruding into their space.

Organised through a professional dive operator, the timing of the dive is important. The tides and currents sweeping through the channel can make the dive difficult and sometimes dangerous. If a dive gets cancelled because of windy or bumpy sea conditions, the Great Barrier Reef is a good second bet.

Yellowtailed snapper and orange lined sweetlips swim around the deck area. Barracuda, Napoleon wrasse, moray and a host of coral-related species gather in this sanctuary. You may see a turtle lazily munching on soft coral, tucking itself away from the current. This is a good sleeping place for them in the early morning and at night.

If there is a current running from the stern forward, you may get dropped at the rear of the wreck and dive the deep sections, drifting gently back towards the bow and slowly ascending to explore the remainder of the wreck.

Though you can no longer go inside the wreck, there are gaping holes into the cargo area so you can actually see inside the ship in places. You can observe toilets and even a cast iron bath without penetrating the ship. Olive sea snakes slither in the wreckage.

The big guys are particularly appealing, especially as they have become quite accustomed to visiting divers. As this is the only solid structure for miles and it sits in a sandy channel, it attracts all sorts of pelagics. You

ON DRY LAND
The rocky granite headlands and beautiful beaches make this a stunning location. Much of Magnetic Island is a protected National Park providing a haven for the native wildlife, like rock wallabies, possums and over 100 species of birdlife, and is home to Northern Australia's largest colony of koalas living in the wild.
Townsville offers the benefits of a great mixture of rainforest, sandy beaches, outback bush and big city life.

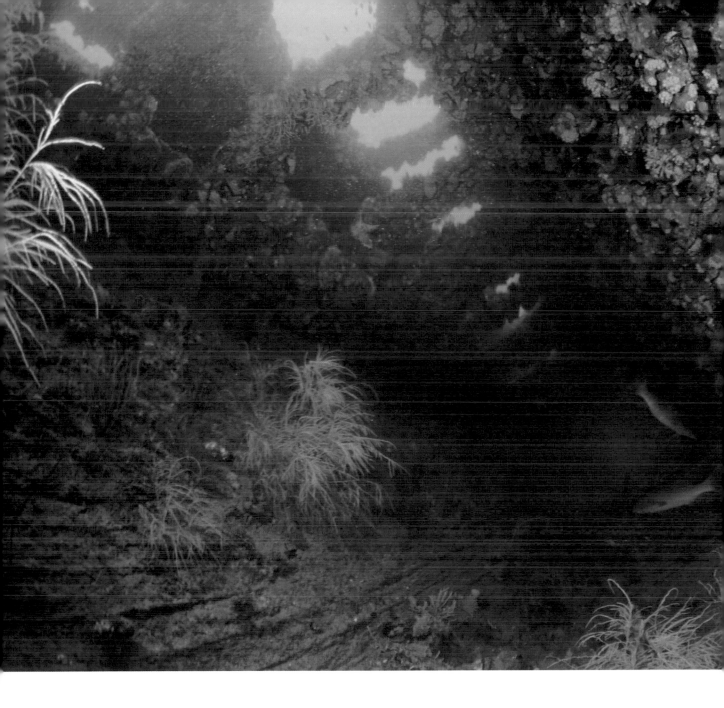

may encounter a bull or even a tiger shark. Massive bull rays and shovel nose rays hide in the sand around the bottom of the wreck. More exotic species, such as guitar shark and wobbegong, are a possible sight.

During July and September you may spot humpback whales from the boat. There seems no end to the variety and thrills from this dive.

HOW DO I GET THERE
Many airlines go to Australia via LA, Malaysia, Singapore and Dubai. Townsville is a short flight from Sydney, Brisbane or Cairns. By road, follow the Queensland coast from Brisbane all the way to Cairns. If you are staying on Magnetic Island, you need to get a ferry from Townsville.

USS SARATOGA

Goliath of the sea

The Saratoga presents an amazing opportunity to dive what was 60 years ago a state of the art naval vessel. At the time of her sinking, she was one of the biggest aircraft-carriers in the world.

Saratoga

Pacific Ocean

Australia

New Zealand

maximum depth:
58m

minimum depth:
12m

access
This can be restricted by the local Government, so full permits must be obtained. More easily accessed by liveaboard, but Bikini Atoll Divers operate an organised facility from their resort on the island. The seas are calmest between March and November, although it can rain in March and April.

average visibility
24m–46m

water temperature
*28°C–29°C
year round*

dive type
Wreck dive

currents
Medium to strong

experience

in the area
*The sunken fleet around the Marshall Islands also includes battleships, destroyers, submarines, cruisers and attack transports.
On Bikini Atoll there are nine ships to dive on. The Nagato was Admiral Yamamoto's*

WHAT WILL I SEE?

Bikini Atoll is located approximately 970km north-west of Majuro, the capital of the Marshall Island Group. The islands were part of a post-war nuclear testing ground, which has resulted in a vast, thought-provoking collection of war wrecks.

One of the wrecks, the USS Saratoga, was an incredible 270m aircraft carrier. It took two major explosions to sink it, the nuclear explosions so powerful they are rumoured to have vaporized three islands. She sank stern first, settling into 58m of water.

Launched on 7 April 1925, the Saratoga was a massive ship for her time and remains so today. She is 259m long at the waterline and almost 274m long at the flight deck. Completely loaded with fuel, munitions, aircraft and provisions, she weighed about 48,000 tons with a draft of 8.38m.

The marine life has been virtually untouched for over 40 years, and you will see a great profusion of sharks, tunas, marlins, rays, turtles and much more.

THE DIVES

Often the first dive is to the flight deck at 29m. From here, the bridge rises to around 12m, the shallowest point of the dive. The bridge is smothered with coral and surrounded by schooling jack and groups of batfish. From the deck it is still a further 25m to the bottom, where two aircraft lie. Large stingray often lie in the sand here.

Inside the hangar deck, it is incredible to see military Helldiver planes still intact, their wings folded away for storage. You can penetrate the area, but the rear flight deck is dented and the ceiling of the hangar deck has collapsed.

You can also enter the wreck carefully through the rear aircraft lift. The dented deck has created entry points on either side of the hangar, which you can swim through. You pass torpedoes, depth charges, racks of rockets and other tools of war. A dusting of light sneaks through from portholes above. Inside the wreck, the workshop areas are still complete with tools.

The dive has a spooky aura due to the wreck's enormous size and parts of the superstructure appear ghostlike, barely visible in the distance. Glassfish pack into every corner, moving together in a misty shoal in the deep. A military display awaits you, with anti-aircraft guns and heavy guns on the side of the ship; a huge double 5-inch gun sits in front of the bridge superstructure, showing that the ship meant business.

For an awesome view, swim out from the bow and look back–it is a truly impressive sight. The main anchor chain remains, the links flowing down to 55m.

There are plenty of large shoals of fish and smaller marine creatures nestling throughout the ship. This steel infrastructure has transformed into a magnificent artificial reef.

You need to plan for three or four dives on this incredibly huge wreck or you will only catch a glimpse of it.

ON DRY LAND
In addition to scuba diving, sports fishing and World War II historical attractions, there is not much here that you couldn't find on any other small Pacific Island. Alele Museum in Majuro showcases both the traditional and colonial history of the Marshalls. Some of Alele's features include authentic tools and artefacts, traditional canoe displays, original photos from the Joachim de Brum collection, a geological history model of the Marshall Islands, and numerous photos from the German, Japanese and US colonial eras.

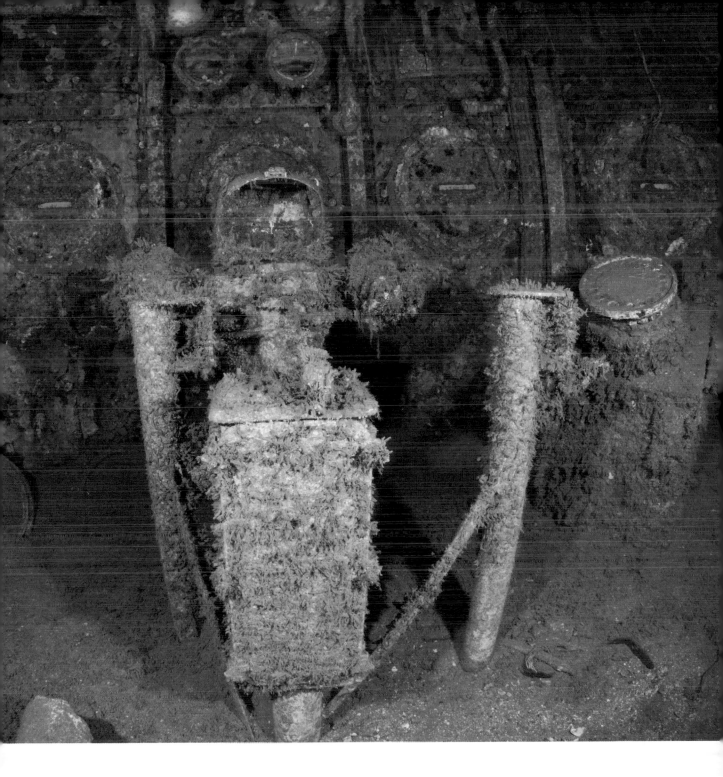

HOW DO I GET THERE
Continental Micronesia offers three weekly flights to and from Honolulu and Guam, while Air Marshall Islands offers three weekly flights to and from Fiji, in addition to its daily domestic flight schedule. Please note the government can suspend the links to the Marshall Islands from time to time.

RMS RHONE

The star struck wreck

The wreck of the Royal Mail Ship Rhone added to its fame when it was featured in the movie The Deep. Its fateful story is just as intriguing and it is one of the finest and most popular wrecks in the Caribbean.

Atlantic Ocean

SS Rhone

Caribbean Sea

Venezuela

maximum depth:
24m

minimum depth:
6m

access
By dive boat. There are numerous land-based dive operators in the British Virgin Islands and a livea-board itinerary is also available.

average visibility
18m–30m

water temperature
24°C–30°C

dive type
Wreck dive

currents
Can be strong. Local dive centre operators will advise.

experience
** to ****

in the area
Other dive sites in the area include:
The Aquarium
The Chimney
The Airplane Wreck
Alice's Wonderland
The Visibles
Painted Walls
Angel Reef

WHAT WILL I SEE?

Commissioned in 1865, the RMS Rhone was originally designed as a cargo carrier for the spice route. However, in 1866 she was refitted to a high standard with more than 300 passenger cabins, salons and dining rooms and became a cruising ship serving the West Indies. Over 94m in length, with both a steam engine and two sailing masts, she was fast and comfortable.

Her fateful last voyage was in 1867. On 29 October, many of her passengers had disembarked and she was replenishing stores for a return journey when storm clouds gathered. There were 145 people left on board, mostly crew but about 18 of them passengers, when the captain decided to take the Rhone out of the harbour to ride what he thought was a winter storm. This was a late hurricane, however, and when the full force of it hit, the captain was washed overboard and the ship was wrecked on the rocks at Black Rock Point on Salt Island. The hot boiler exploded as cold water hit it and the ship was split in two. Of those still on board, only about 21 members of the crew survived and one passenger.

The wreck lies today in two sections with the stern section in about 6m of water and the bow, which lies on its starboard side, in 24m. There are plenty of accessible swim through areas, particularly in the bow section, and time has turned her into a wonderful artificial reef.

THE DIVES

With parts of the wreck being so shallow, this makes a good dive to suit different levels of experience. In the clear waters, you can see the wreck from the surface

and the shallower parts are shallow enough for snorkelling. Being such a large wreck and split into two sections it deserves more than one dive to do it justice. The wreck is much broken up from the initial disaster and the years of pounding, and there are interesting artefacts to be seen. Other parts, particularly at the bow section, are more three dimensional, enabling divers to penetrate easily.

At the shallower stern section, the rudder and large four-bladed bronze propeller are partly embedded in the reef. Swim along the propeller shaft and this will take you to the gearbox. US Navy demolition teams blew up parts of the stern section in the 1950s but the twisted, broken remains are home to a wealth of marine life. In the past, plates, china, medicine bottles and other artefacts (as well as human remains) have been discovered, and even today can be uncovered when storms hit.

At the deepest section, the bowsprit can still be seen. The foremast and crow's nest are lying across the seabed and lifeboat davits stand proud. Intriguingly, two cannon lie amid the wreckage.

There are plenty of fish species, some 400 have been recorded, and these include morays, featured in The Deep film, and a huge species of grouper that grows to some 1.8m long. Sharks and rays may be seen. There are huge numbers, of squirrelfish, jacks, snappers and grunts, French angelfish, trumpetfish, butterflyfish and puffers. The wreck is decorated with corals and sponges, giving it a warm orange and yellow covering.

No dive trip to the British Virgin Islands would be complete without numerous dives on its most famous wreck.

ON DRY LAND
More than 60 islands make up the British Virgin Islands and there are plenty of activities apart from diving to enjoy, including sailing,

boating, hiking, surfing, parasailing, windsurfing, kayaking and fishing. There are wonderful beaches, relaxing spas, many parks where the natural treasures

can be seen, and tropical forests. There is a wide selection of accommodation to suit all budgets from campgrounds to spa resorts. A wide range of cuisine

is available, reflecting the diverse influences on the islands, including Spanish, East Indian, African, French, Dutch and English.
A visit to Salt Island will add

to your dive experience, as there is a small cemetery where some of the passengers and crew who died on the Rhone are buried.
If you want to get an idea

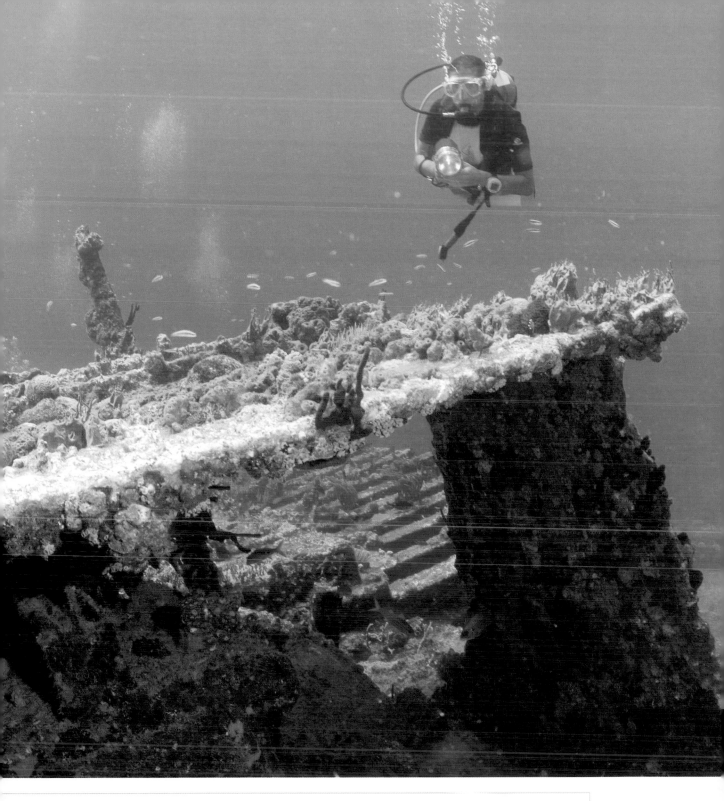

of the history, there are forts, museums and ruins, such as old copper mines, or visit one of the old sugar plantations.

HOW DO I GET THERE

Flights are via other Caribbean airports such as San Juan, Puerto Rico, St Thomas, Antigua, St Kitts and St Maarten. From there, connecting flights can take you to either Terrence B Lettsome Airport on Beef Island or a small airport on Virgin Gorda. Alternatively, ferries are available to reach the final destination.

Madagascar

South Africa Indian Ocean

Cathedral Aliwal Shoal

maximum depth:
27m

minimum depth:
5m

access
By well-equipped rigid hull inflatables.

average visibility
5m–30m

water temperature
19°C from July to October–24°C

dive type
Reef, sharks

currents
Unpredictable. Non-existent to strong. Follow the procedures set out by the experienced dive guides in the area.

experience
**** to *** ** dependent on weather and current*

in the area
Plenty of dive sites available along the whole stretch of Aliwal Shoal and wrecks of Nebo and MV Produce to the north of Aliwal Shoal. To the south of Aliwal Shoal and eight miles offshore is Protea Banks, another world famous shark diving site. Great white cage-diving is available in Gansbaai and Mosselbaai in the far south of South Africa.

CATHEDRAL

Close encounters with 'raggies'

Cathedral is an amphitheatre-like rock structure that attracts large numbers of ragged tooth sharks– 'raggies'– between June and November, when they come here to mate. This is a great opportunity to get up close and personal with the sharks, which, while they look threatening with their intimidating display of teeth, are not known as being aggressive. You have a good chance of close encounters as they can be very inquisitive and are likely to slowly drift near you to check you out.

WHAT WILL I SEE?

Aliwal Shoal has so much to offer for adventurous diving that it is difficult to choose just one site to highlight for shark diving. Cathedral is an excellent choice to focus on, however, as the ragged tooth shark is so impressive, reaching 3.6m when fully grown. Added to this is the awesome aspect of the Cathedral dive site, normally entered via a large arch, about 12m wide at the entrance to the craterous space.

Aliwal Shoal is about three miles (five kilometres) off the east coast of KwaZulu-Natal in South Africa. The depth of this fossilized sand dune varies from 6m to 27m. It is about three kilometres long and 300m wide, and offers a large number of dive sites in addition to Cathedral.

THE DIVES

The journey to the reef is by large, fast, rigid hull inflatable. Once you arrive at Aliwal Shoal, it is usual to spend the first part of the dive at Cathedral and then follow the reef to the north, gradually reaching shallower waters.

The period from June to November is when the raggies congregate in the area in large numbers, and this is also when visibility is likely to be at its best. Up to 60 of these sharks have been encountered on one

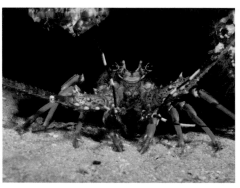

dive. Loggerhead turtles and ribbon tailed rays may also be encountered here.

The normal procedure is to settle down at the entrance to the area and watch the spectacle of the ragged tooth circling leisurely in the amphitheatre. At times, they may decide to come close to inspect you. They might also swim out into open water, when you will find them sweeping over your head. While you are there, take a close look at the sandy seabed; you could find some ragged teeth there. Raggies are able to regenerate their impressive display of teeth and sometimes lose them as a result of courtship biting.

Some of the other fish that you may encounter in the area of Cathedral are pink paperfish, pineapplefish and frogfish. If you do not spend the whole dive at Cathedral and want to take advantage of the opportunity to decompress into shallower water, the guide will determine which route to take depending on currents. A swim north along Outside Edge is a great way to continue the dive, and this will eventually take you into shallower areas at the Northern Pinnacles. These rock formations reach to 5m. On the way, you will pass Raggie Cave, another area where large numbers of raggies may be found.

ON DRY LAND
KwaZulu-Natal South Coast has plenty to entertain and is a well-developed tourist area. The beaches are beautiful and there are plenty of | activities such as golf, tennis, bowls, horse-riding and water sports. There are lots of opportunities for shopping in well-established shopping centres, and a wide choice | of restaurants. Some care is taken by the dive centres to arrange for visitors to travel around as a group, for safety reasons, and this is probably a wise precaution outside | the major centres such as Durban.
Further down the coast, the Wild Coast Sun Casino is a way of losing weight from your wallet. | Safaris can also be arranged to various game reserves.

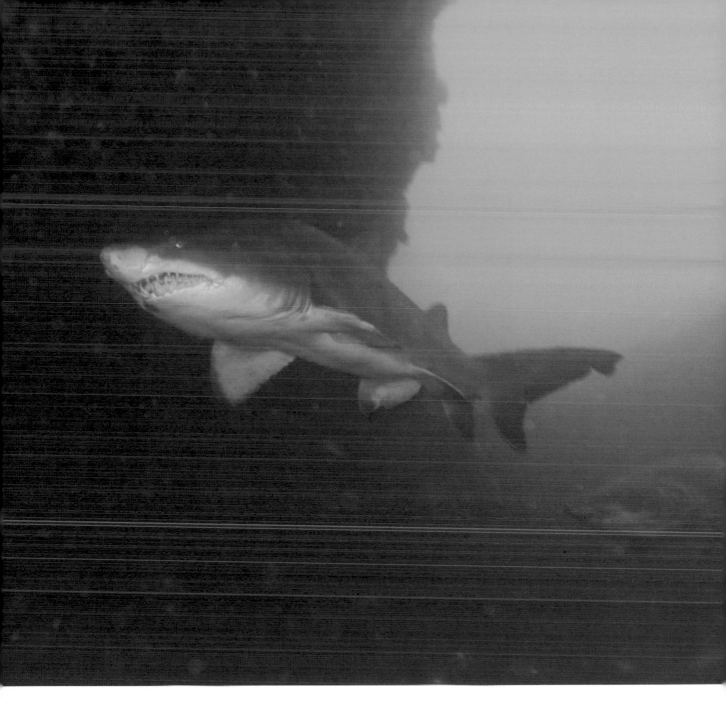

HOW TO GET THERE

International flights to Johannesburg then transfer to Durban. The nearest town, Umkomaas, is approximately 40 minutes drive from Durban airport. Pick ups and accommodation are normally arranged through the dive centre that is organising the diving.

AVATORU REEF
Sharks, up close and personal

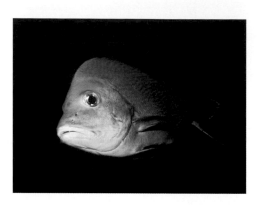

The islets that make up Rangiroa, which is part of the Tuamotu Islands, form a necklace around a lagoon that is 80km long and 24km wide. Formed from the remains of a giant volcano, it is the largest atoll in the region and the second largest in the world. With its huge number of islands in the vastness of the Pacific Ocean, French Polynesia awakens thoughts of Robinson Crusoe and remoteness. With beautiful beaches on both the ocean and the lagoon sides, Rangiroa really is a tropical paradise– with the added advantage of being an ideal place to dive with sharks.

Pacific Ocean

Australia

Rangiroa •

New Zealand

maximum depth:
22m

minimum depth:
16m

access
Dive centres use rigid hull inflatables and journey times to the site are just a few minutes from the launch site at Avatoru.

average visibility
12m–30m

water temperature
Winter: 26°C
Summer: 29°C

dive type
Reef dive, sharks

currents
Light to medium at the dive site, with dive times determined by dive guides. This is away from the Avatoru pass, which has extremely strong currents suitable for breathtaking drift dives.

experience
*** to ***

in the area
The Avatoru and Tiputa passes are great drift dives and there are numerous other dive sites in the area, such as Shark Cave, L'Eolienne, Hammerhead Plateau and The Aquarium.

WHAT WILL I SEE?

The strings of some 240 islets are separated by passes that run between the ocean and the lagoon. To the north-west of the atoll is an eight-mile stretch of land where most of the population and Rangiroa airport is situated. It also has two main villages, Avatoru to the north and Tiputa to the south. At the north and south passes, you have the opportunity to do exciting drift dives as the waters rush through, where you are likely to encounter sharks and rays, as well as schooling fish such as jacks and barracuda. In particular, silvertip sharks, some as long as 2.75m, can set your pulses racing and you may see a great hammerhead cruising with the schools of fish.

Avatoru Reef is an ideal dive to have close encounters with sharks. The experienced French dive guides are well experienced in setting up shark encounters and at Avatoru Reef they have an area where they set bait to bring in the sharks.

THE DIVES

The dive sites are approached by fast rigid hull inflatable, with Avatoru Reef a short journey from the launch point. At the dive site, divers settle in various areas around a central point in about 20m of water, where a 'bait basket' is set down to attract the sharks. After a while they scent the bait and start exploring. As the numbers build up and

ON DRY LAND
Fishing trips can be arranged, as well as lagoon excursions for snorkelling and kayaking. There are beach barbecues, visits to pearl farms (the rare black pearl is farmed here), and to Avatoru and Tiputa villages and various remote islets. Mopeds can be hired to explore the eight-mile stretch of island. The main hotel/resort is the five star Kia Ora Resort, offering low key but excellent amenities. There are numerous other options for accommodation, normally of the bungalow type. There are a limited number of other restaurant and bar facilities on the island, and shops and grocery stores. Rangiroa is not for people who want a wild nightlife, but is ideal place to get away from it all in a tropical paradise.

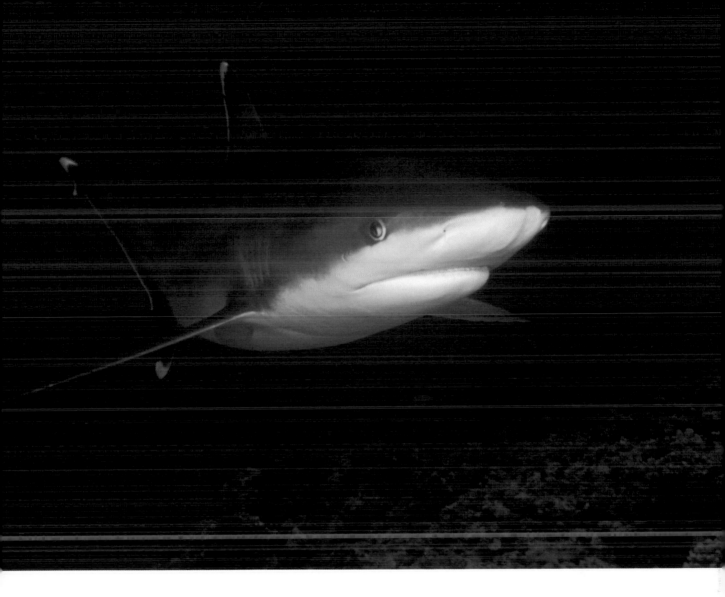

they get more and more excited you may find yourself being closely buzzed, but their main interest is the bait. Grey reef sharks, whitetips and blacktips will make up a lot of the numbers but if you're lucky, silvertips may join the group. There are seven species of shark found in the waters around Rangiroa, so you could also encounter lemon, silky, blackfin and nurse sharks. More rarely, tiger sharks may make an appearance.

Following the shark encounter, your dive profile is likely to take you along the reef where you will have an opportunity to take in the wide variety of marine life that makes this a world class dive location. The hard corals are home to plenty of fish, such as surgeonfish, triggerfish, soldierfish, parrotfish, tuna, threadfin butterflyfish, eels, Moorish idols, damselfish and snappers. There are large Napoleon wrasses and schools of jacks and barracudas. Turtles are likely to make an appearance and keep an eye out in the blue, where you may well see large Tursiops dolphins, manta rays and eagle rays.

Rangiroa can be dived all year round. The main manta ray season is September to October, and hammerheads are most abundant between January and February.

This sleepy tropical Polynesian paradise with its turquoise and jade green waters is a delight and the diving can be sensational.

HOW TO GET THERE

International flights to Faaa international airport in Papeete, Tahiti, and national flights that take about one hour to Rangiroa.

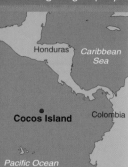

Honduras
Caribbean Sea

Cocos Island Colombia

Pacific Ocean

maximum depth:
46m

minimum depth:
25m

ⴑⴑⴑⴑⴑⴑ
Via liveaboard

average visibility
20m

water temperature
21°C (70°F)–29°C (85°F)

dive type
Seamount

currents
Strong

experience
***** to *** ***

in the area
Other named dive locations around the island are Dirty Rock, Submerged Rock, Sharkfin Rock, Dos Amigos Grande, Small Dos Amigos, Manuelita Outside, Manuelita Inside, Manta Ray Corner, Marble Ray Point, Wafer Bay, Chatham Bay.

BAJA ALCYONE

Dive into the wild domain of the hammerhead

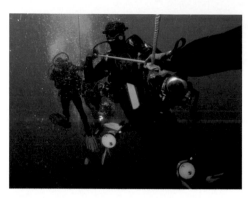

Cocos Island has many ways of enthralling visitors. It is the world's largest uninhabited island, blanketed by a rich rainforest with gushing waterfalls and many rare species of animal and plant, some indigenous to the island. Legend tells of hidden pirate treasure that has never been discovered. More recently, it proved to be the ideal location to film Jurassic Park. And underwater, off its towering cliffs, it is famed for being one of the best dive locations in the world for sharks, especially large schools of hammerheads.

WHAT WILL I SEE?

Cocos Island is more than 483 kilometres south-west of Costa Rica. It is reached by a journey of some 36 hours aboard one of the fast, well-equipped liveaboards from the Costa Rican port of Puntarenus. On arrival, you will participate in some of the most demanding dives that many divers have experienced. The sharks are attracted by strong currents so, for the best opportunity to encounter them, much of the diving is done in currents, none more so than the dive on the seamount of Baja Alcyone. The mother boat's tender takes divers to the sites. Extremely well organised diving has been established here, to ensure safety in this remote and testing location. On my trip, divers

were equipped with an extra-large orange dive sausage, a powerful storm whistle and a safety light. In addition, each diver was also supplied with a radio diver locator system to help locate them from more than five miles away, should they become separated from the group.

THE DIVES

The timing of the dive on Baja Alcyone is determined by a buoy that begins to break surface as the strong current reduces. The top of this seamount is 25m beneath the surface, and it falls to a sandy bottom at 46m. Dropping into the water–with the current still running at an impressive rate–you use the buoy line to

ON DRY LAND
San Jose has plenty to offer the tourist, as you would expect from a capital city–restaurants, hotels, parks, museums, shopping malls

and picturesque and historic buildings. There is a wide choice of hotels and guest houses to suit all needs. Costa Rica is a friendly, peaceful country. It has no

army and it has excellent educational and health standards. Outside the urban areas is a country that is incredibly rich in biodiversity. Over five per cent of all the

earth's species can be found in this small country. It has cloud forests, coastal jungles and volcanic peaks to explore, beautiful beaches, and a wealth of wildlife

reserves and national parks. The liveaboards that serve the area can obtain authority to land on Cocos Island for a brief exploration of the island.

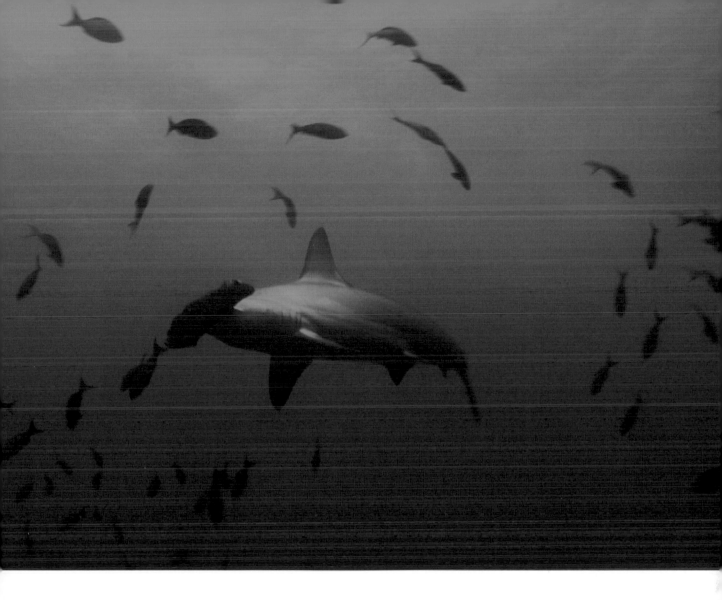

work your way down to the reef. On reaching the reef at about 25m, the dive group spreads out along the reef facing into the current. If you want your hands free to take photographs, you will need to hook yourself onto a rock and then wait, so a reef hook is a vital piece of equipment for underwater photographers.

Scalloped hammerheads are regularly seen on these dives, as well as marble rays, whitetip reef sharks and mantas. Dolphins and tuna may make an appearance, and whale sharks, marlin and sailfish have been also been spotted here.

If the current is strong, you will not explore the dive, but wait and watch. There are other dive sites in Cocos that will give you more time to concentrate on the rich diversity of other marine life, such as the red-lipped batfish, the impressive shoals of horse-eye jacks, snappers, pacific creolefish, feather bass, filefish, grouper, pufferfish and soldierfish.

When the dive comes to an end, the guide will give you a signal to release your hook from the rock and go with the current as a group, while you decompress and surface for the cover boat to pick you up.

Baja Alcyone deserves its place at the forefront of famous dive sites. It is just one of many sites around this enchanted island to keep you enthralled for an extended stay.

HOW DO I GET THERE

The most reliable route is an international flight to San José, Costa Rica from major US cities. It is recommended that you allow an extra night prior to sailing to Cocos, to take account of possible delays with connecting flights. The tour operator will arrange transfer to Puntarenas where you board the boat, which takes approximately two-and-a-half hours. Similarly, you are advised to book an extra night in San José on the return journey in case of unforeseen delays on the return boat trip.

DARWIN ARCH, DARWIN ISLAND
Whale sharks galore and much, much more

The Galapagos Islands were called Las Encantadas (The Bewitched Ones) by the Spaniard, Tomas Berlanga, who first discovered them in 1535. They were so named as they seemed to appear and disappear into the mist. Later, they were to become famous as the islands that helped Darwin to formulate his theory of evolution. The most northerly island in this archipelago is Darwin Island, which is one of the best dive sites in the world. And one of its many claims to fame is the regular appearance of whale sharks between June and November.

maximum depth:
40m

minimum depth:
5m

access
Liveaboard dive boat.

average visibility
10m–60m

water temperature
*December–April
24°C–27°C
May–November
22°C–24°C*

dive type
Blue water drift and rocky reef.

currents
Moderate to strong

experience
**** to *** ***

in the area
There are many dive sites apart from Darwin's Island, including Wolf Island in the north and others at Bartolome, Puerto Egas, Rabida, Santa Fe, Floreana and Gardner Bay.

WHAT WILL I SEE?

The Galapagos Islands lie almost 1,000km to the west of Ecuador, and diving the isles is done by liveaboard boats. There are 19 volcanic islands, of which the oldest is over four million years old and the youngest is still actively being formed. There are endless dive sites throughout the islands but the journey north to the most outreaching island of Darwin is an essential part of any itinerary. Darwin Island itself is 165m high with vertical walls rising straight out of the sea. It is uninhabited and no landing is allowed. To the east of the main island is a towering rock arch known as Darwin's Arch. This is not a dive for beginners as the conditions can be rough and currents strong and changing. However, for those who have the experience, this could well become one of your dream dive sites. Here you may find hammerhead, Galapagos and silky sharks, dolphins, schools of skipjack and yellowfin tuna, bigeye jacks and marbled rays. Tiger sharks, marlin and even killer whales are occasionally seen here. And then there is the amazing variety of smaller species to be found in abundance and the sea lions that may well make an appearance. But for many, one of the main purposes of visiting Darwin Island is the possibility of encountering the whale sharks that regularly visit this area between May and November, before the waters become warmer and they move on. It is not unusual to see four or more on a single dive.

THE DIVES

Part of the dive will normally involve going out into the blue water, and this is where you may encounter whale sharks as they slowly swim through. Patience can be rewarded at this part of the dive, as something special will usually appear. This could be a large school of hammerheads, silky or Galapagos sharks, dolphins or yellowfin tuna. Darwin's Arch is on a plateau at the east of the main island and you can choose your depth down to 40m with the water below you dropping into the abyssal depths. There are sandy areas where you may find hammerheads at a cleaner station where King Angelfish provide an essential service by removing parasites. Large shoals of mackerels, snappers and gringos can be found here and may be predated upon by tunas and jacks.

To the south-east, the drop-off is steep but made up of numerous rock-covered plateaus. In addition to the big stuff, there is plenty more to keep you enthralled on this dive site. Moray and spotted moray eels, shoals of goatfish, scorpionfish, eagle rays, hogfish, Moorish idols, parrotfish and trumpetfish are some of the sea life you are likely to encounter. Then there are the turtles. Another special treat is close encounters with sea lions. These can be very playful as they duck and dive around you.

The Galapagos Islands are a must for the adventurous diver, and Darwin's Arch deserves its reputation as their most famous dive site.

ON DRY LAND
Escorted landings on the islands of Galapagos, the main ones being Santa Fe Island, Espanola, Floreana Island, Santa Cruz Island, Rabida Island, Bartolome Island, North Seymour Island, San Cristobal and Genovesa, are a unique opportunity to see and photograph the diverse wildlife. All shore trips are escorted by naturalist guides ensure that visitors follow the rules to minimise visitor impact on the natural habitat. Stopovers in Quito and Guayaquil are a good opportunity to extend a visit to see what Ecuador can offer. Quito is a UNESCO World Heritage Site and retains much of its colonial past, with cobbled streets, churches and plazas. In the more modern parts of the town, you will find plenty of shopping opportunities and restaurants. Guayaquil is

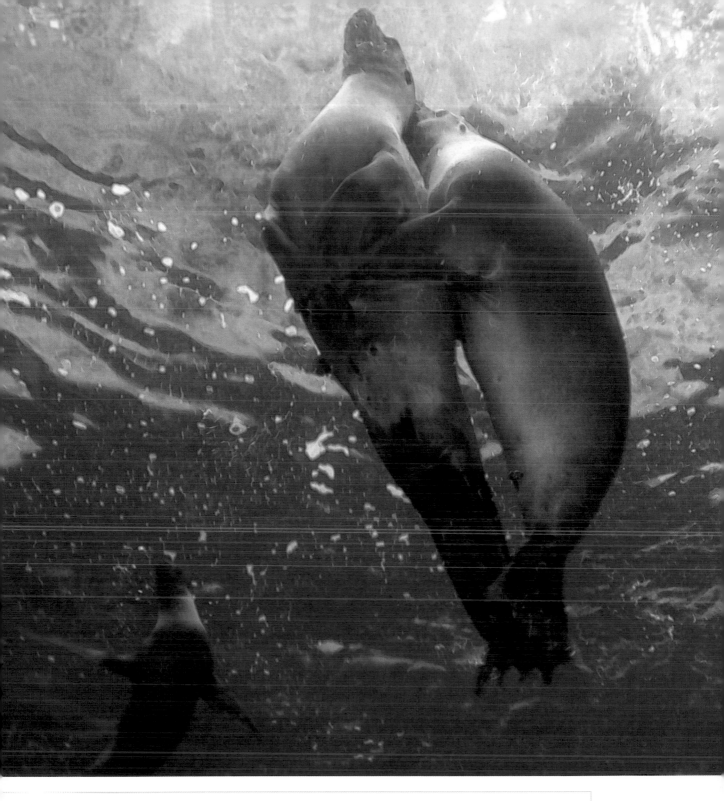

the main coastal town with its museums and botanical gardens, and Cuenta has plenty to offer the tourist with its churches, grand houses, squares and charm-ing cobbled streets. You can visit the market town of Otavalo, which boasts the largest open air market in South America. There is beautiful coun-tryside, rain forests, cloud forests, and national parks. You may wish to stay in one of the beautiful traditional haciendas or just visit for a meal.

HOW DO I GET THERE

International flights to either Quito or Guayaquil, Ecuador. From there, internal flights to Baltra or San Cristobal airport in Galapagos.

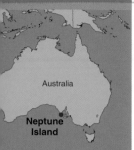

Australia

Neptune Island

Indian Ocean

NEPTUNE ISLANDS

Face to face with the greatest predators on earth

The Neptune Islands sit on a shelf south-east of Port Lincoln, South Australia. Sheer drop-offs provide cool, deep water that attracts seals and sea lion colonies. This in turn attracts their predator, the great white shark.

maximum depth:
17m

minimum depth:
3m

access
It's best to book a three or five day liveaboard to enjoy the area's diving and see the great white. Daily boat trips can be booked but be warned, the swell can make the trip of over two hours a little uncomfortable. February is the best month for regular sightings and generally from late May through to October. Embarkation is usually from Port Lincoln Marina.

average visibility
10m–15m

water temperature
14°C

dive type
Reef

currents
Slight

experience

in the area
Dive with Australian fur seals on Hopkins Island.

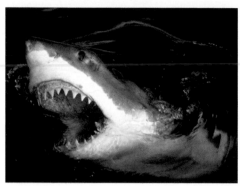

WHAT WILL I SEE?

Divers can experience getting close to a great white with scuba gear, but in the confines of a cage. The sharks are attracted to the boat by fish guts and blood, and the cage allows you to have a much closer view than you would ever hope or want to achieve out of the cage.

Though largely misunderstood, the great white shark is undoubtedly a fearsome predator. Their rows of large triangular teeth penetrate their prey and their eyes roll back in their sockets, adding to their scary image, although this is actually a defence mechanism to protect their eyes from flailing claws and teeth. This powerful creature can exert a biting pressure of three tonnes per square centimetre. They hear well and smell well, and their sight is good even in low light conditions.

Underwater footage for the movie 'Jaws' was shot here. This is one of the best great white dive destinations in the world.

THE DIVES

You will get a chance to practise getting in and out of the cage before the sharks turn up, as once the water is 'chummed' you do not want to get this wrong. It may feel a little strange at first, as you will not need your fins and the weight you carry will have to be different to be comfortable in the cage.

The cages will often be lowered 30m below the boat for divers to view the local marine life. There are huge spotted grouper and potato cod here, and huge stingrays on the seabed; enough to entertain you during a dive, but the purpose of this trip, is the rush of seeing the mighty great white shark. Occasionally, they can be found swimming around at these depths, although they are typically found nearer the surface.

Large quantities of specially prepared bait is used to attract the great whites. Be prepared for a possible long wait, but persevere and prepare for the adrenaline rush.

A sense of anticipation spreads around the boat as everyone looks out for the arrival of a shark. That classis view of the fin cutting through the water may send a chill down your spine. The magnificent creature arrives, gliding gracefully and purposefully through the water towards the bait ball and diver in the cage.

When the shark arrives, bait on a line is used to draw it close to the cage so that, with luck, you will be inches from the great white but protected by the cage. Its body is chunky and robust, with cold black eyes that show no emotion. Its jaws may well crunch at the cage itself, inches from you face. The hue of its skin may surprise you; it can be olive or brown rather than the expected grey. The white underside of the belly is an attractive feature. The shark's movement is stiff, directed solely by its tail fin. One sweep and it moves very quickly through the water.

The view is equally amazing from the boat, and the crew may ask you to help log the sightings for conservation purposes as this is an endangered species.

The fearsome predator, which could be as much as 5m in length, may circle the boat a few more time, gliding gently by, then melting away into the distance.

ON DRY LAND
Southern Australia is full of untamed natural habitats. The outback is close to the city, and guests can experience both with little inconvenience. South Neptune Island with its impressive lighthouse is worth a visit during your liveaboard trip. A wonderful variety of wildlife, including many birds, dolphins, fur seals and the rare Australian sea lion are commonly seen on this remote and scenic island.

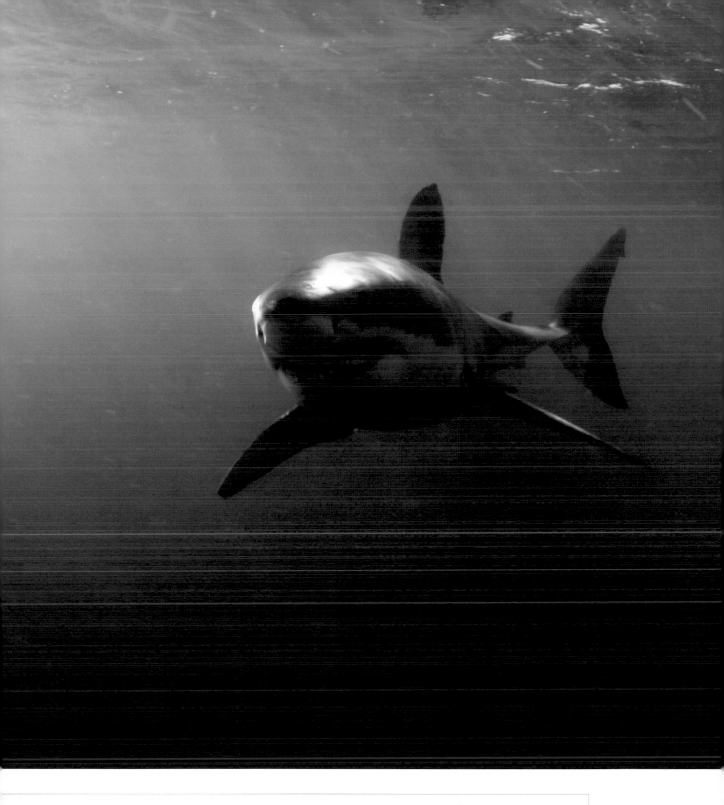

HOW DO I GET THERE
International flights via Dubai, Singapore or LA are most common. Fly to Adelaide, South Australia.

Transfer to Port Lincoln Airport, then it's a 29 minute car journey to the marina.

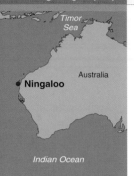

Timor
Sea

Ningaloo

Australia

Indian Ocean

NINGALOO REEF

Tales of Jonah

Once you've seen the gaping mouth of a whale shark, which seems wide enough to swallow a diver, the story of Jonah and the whale almost seems possible. Ningaloo is a popular migration point for whale sharks, and swimming with them is the experience of a lifetime.

maximum depth:
6m

minimum depth:
1m

access
Resort boats take you out on a daily basis. The reef is best accessed at Coral Bay or Exmouth on the north-west tip of Western Australia, north of Perth. Stay at Exmouth or Coral Bay and book your diving.

average visibility
10–20m depending on density of plankton

water temperature
24°C–28°C

dive type
Shallow dive or snorkel

currents
None to slight

experience
•

in the area
Gullivers
Blizzard Range
The Labyrinth
Helby Bank
Sponge Garden Drift

WHAT WILL I SEE?

Ningaloo Reef is Australia's largest fringing reef, lying close to shore. It is estimated that close to 300 whale sharks migrate to Ningaloo Reef every year between March and April. Their timely arrival coincides with coral spawnings–the sychronised release of millions of bright pink egg and sperm bundles.

The largest fish in the world, reaching an amazing 15m in length, these living submarines devour a rich buffet of plankton made up of the coral spawnings and small larvae which in turn feed on them.

Whale sharks attract other marine life, which accompanies it on its travels. This makes seeing an approaching fish even more exciting. Remoras hitch a ride with the whale shark, attaching themselves by their suckers and travelling vast distances with them. Shoals of baitfish and sergeant major fish trail around the whale shark's mouth, no doubt gaining food from this symbiotic relationship. Perhaps some of the shark's fellow travellers clean parasites from it in return.

The plankton also attracts other life in great quantities, with spotted eagle rays and up to 5,000 manta rays migrating through the reef.

Often staying until late May or early June, the sharks travel close to the surface and are a treat for swimmers, snorkelers and divers alike.

THE DIVES

The whale shark enjoys full protection in Australia, boats and divers must adhere to a special code of conduct. In an effort to help preserve and understand the shark population, the boat crew collects basic information

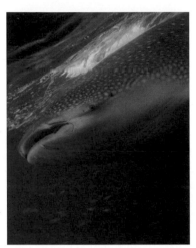

about them, such as their size, sex and location.

Snorkelling often provides you with a better chance of staying with the whale sharks, as they move at several knots and a scuba tank would restrict you. However, you may be lucky enough to see a whale shark during a normal dive.

You will be dropped quite a way ahead of the approaching shark, and are expected to keep to one side of it. This causes less disturbance to the fish and means it may stay a while. It seems the whale shark does not mind the presence of divers. When it has had enough it simply dives to a depth where it cannot be followed.

As the whale shark submerges, a waiting game begins and fingers are crossed that it will surface in the right area. Travelling about a metre below the surface, the whale can first be observed from the boat. Dappled sunlight reflects the interesting spotted pattern on the shark's back.

Excitement and imagination do not prepare you for the head view of the giant mouth as it approaches; it seems wide enough to engulf you. A tremendous sieve, nature's filtration system is designed for microscopic plant and animal larvae, not for swallowing large items whole.

The heavy ridge running down its back and wide flat head gives it a unique appearance. Nothing can compare to this animal, and witnessing it gives you an immense feeling that you are experiencing something special. Perhaps it is because the whale shark seems prehistoric or perhaps it is merely that this is an encounter that surpasses your expectations.

ON DRY LAND
Explore Dwellingup Forest. A series of organised walks highlights the forest ecology and aboriginal history, including a canopy walk through the tree tops. Western Australia has more than 75 national parks with walk and bike trails, taking in views of rivers, lakes, estuaries, wetlands and salt lakes.

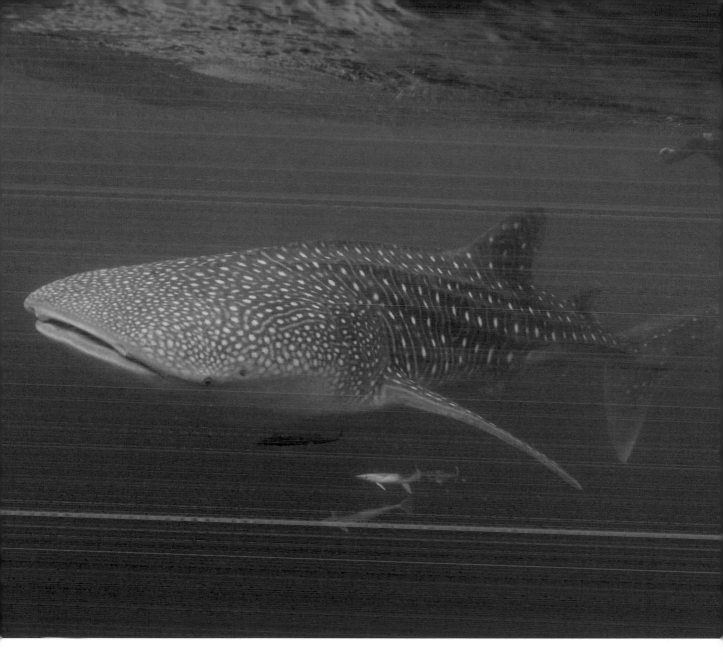

If the whale shark ignores you and seems to head straight for you, you may need to change course. This might seem especially pressing as you view the broad sweeps of the shark's tail fast approaching. As you move away and it passes by, you will be able to watch metres of fish pass before your eyes. The power and gentleness of such a large creature makes you feel safe in its presence.

You may get tired and dehydrated, and possibly delirious with the whole experience.

HOW DO I GET THERE

There are non-stop flights to Perth from Singapore, Dubai, Kuala Lumpur, Bangkok, Jakarta, Denpasar, Auckland, Johannesburg, Tokyo and Hong Kong. Internal flights from any airport within Australia to Learmouth, which is around 100km north of Coral Bay. A shuttle bus is available from the airport.

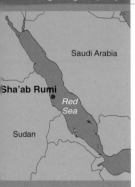

Saudi Arabia

Sha'ab Rumi

Red
Sea

Sudan

SHA'AB RUMI

Adrenaline rush

Sha'ab Rumi means Roman Reef. It lies a few kilometres north of Port Sudan, set in an isolated landscape where the sea supports a rich and varied world. As most of the reefs remain untouched, diving here is both a discovery and an adventure.

maximum depth:
30m–50m

minimum depth:
6m

access
Mostly by liveaboard from Port Sudan. Other options may be available from Marsa Alam, but check current rules with your travel agents.

average visibility
30m–40m

water temperature
24°C in winter and 28°C in summer

dive type
Reef and drift diving

currents
Light to variable

experience

in the area
*Sanganeb
Wingate Reef
Wreck of the Umbria
Angarosh*

WHAT WILL I SEE?

The Sudanese coast has coral mountains that shoot up from great depths through clear blue water to the surface, with a greater variety of corals than any other part of the Red Sea.

The never ending supply of reef and coral in these waters is astounding. Coral from the surface continues down to a plateau at around 25m, with currents and drop-offs to the depths below. From the deep grey oceanic reef, sharks emerge. First one, then many appear, some from behind you. Their sleek bodies glide through the water.

This site is well known for the presence of sharks. Schooling scalloped hammerhead sharks have been seen in deeper water here, but these sightings are less common than the oceanic grey sharks.

Many other unusual sights can be witnessed in this area of the Sudanese Red Sea; you can come across an unusual number of masked pufferfish in one big shoal and the same is true for red toothed triggerfish and unicornfish.

THE DIVES

You can start your dive directly descending to the plateau. To add to the thrill of seeing sharks so close to you in their natural environment, you can descend through the middle of a circling group. Around the plateau, a large shoal of big eye fish hangs in the current. Many jack and trevally dart about, and barracuda sit against the current. The area is buzzing with activity, but your attention will be fixed firmly on the sharks.

It is common on this site to view up to half a dozen sharks at a time. They pass close enough for you to

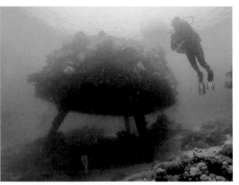

view them really close up; their smooth skin, their gills moving freely, with remora catching a ride and a few food scraps. The sharks patrol their patch, keeping a steady cold eye on their visitors. These large sharks are renowned predators and stand at the top of the aquatic food chain, their diet playing an important role in regulating the species below them. A shark can track large prey by following their low-pitch sounds, and they have two extra senses that allow them to sense electrical fields and vibrations in the water. Even the slightest movement in the water can trigger a shark's predatory instincts. They manoeuvre through the water deftly by adjusting the angle of their fins. They do.

Discarded shark cages take you back to the days when Jacques Cousteau visited in the early 1960s, watching and feeding the sharks from the safety of a cage; nowadays, sports divers no longer use cages from which to view sharks. At the long tongue of reef that points out into the ocean at the southern end of Sha'ab Rumi, one of the discarded cages lies at around 22m deep. Nearby, the famous Conshelf II holds the remains of Cousteau's underwater living experiments, during which five of his men lived underwater on the edge of the reef for three months. Only the garage for the submarine and the tool shed now remain; the Starfish house is no longer here.

As you continue the dive to shallower water, the reef will not disappoint you. Turtles are a common sight on most dives; hawksbill turtles feed on sponges and also on other invertebrates, such as comb jellies and jellyfish. Your choice of colourful marine life is everywhere; reef fish of every description. Leopard and snowflake moray

ON DRY LAND
Fly out of Sudan via Cairo and spend some time visiting the pyramids. Near Port Sudan, Marsa Inkelfal is a sheltered coastal area that offers the opportunity to walk and take in the desert vistas and white beaches that contrast with the blue waters.

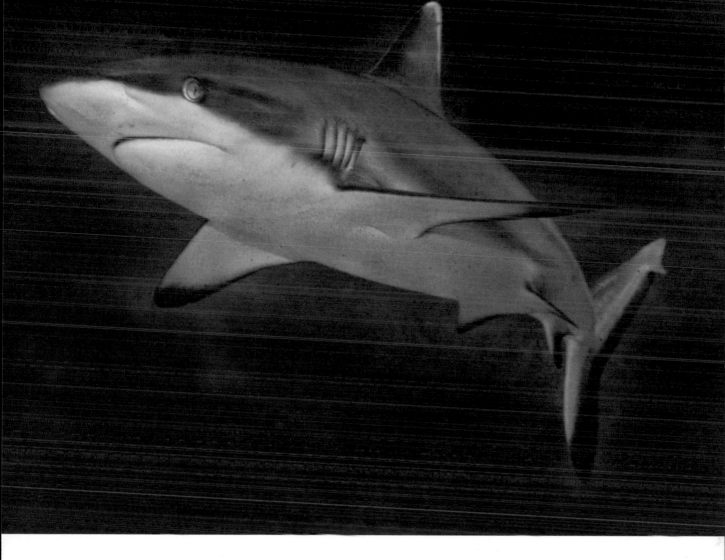

stick their heads out from the coral, cleaner shrimp eating scraps around their jaws. Go shallower still and macro life with gobies and nudibranchs are plentiful. Soft corals of all colours grow large and plentiful here and, together with the hard coral, form inlets or small caves in the reef. With the sun's rays filtering through the surface, this area is a photographer's delight.

HOW DO I GET THERE

Flights to Cairo and onward flights from Cairo to Port Sudan.

KOH BON ISLAND

Jurassic Park

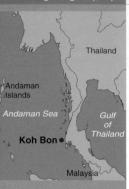

Limestone rock creates a Jurassic theme here, both on the surface and beneath. Huge, deep-water boulder formations create daring swim-throughs and provide dramatic back-drops to its vibrant coral gardens and reef slopes.

maximum depth:
35m

minimum depth:
12m

○○○○○○
Liveaboards can be booked for a week or four-day excursion, taking in many areas of the Similan and Surin Islands.

average visibility
10–15m

water temperature
29°C–30°C

dive type
Reef and drift diving

currents
Moderate to strong currents running mainly north to south

experience
**** Advanced dive due to irregular currents*

in the area
To the west of Koh Bon Island lies Koh Bon Pinnacle. This Thailand diving site lies in deep water (18m–40m) and is exposed; consequently, it is only possible to dive here in favourable conditions, and with experienced or advanced liveaboard divers. The west wall is steep and covered in small, yellow soft corals, and has a large cavern with a fish trap at its entrance. There is also a smaller pinnacle lying to the north.

WHAT WILL I SEE?

The nine islands of the Similans run roughly north to south, and Koh Bon Island lies an hour or so at the north of them. While it lacks the pristine white beaches of the other granite rock islands, it is one of the best places in Thailand to see manta rays and leopard sharks.

The leopard shark is an attractive, immediately recognisable shark, deriving its name from the distinctive markings of dark brown leopard-like spots set against a yellow-brown skin tone.

On this dive, the coral and fish life are not concentrated around a single reef as in many other sites; the area is vast, so expect a swim to enable you to see what the area has to offer.

THE DIVES

Koh Bon Island has a 33m-deep wall on its south side, facing a small cove, with a stepped ridge pointing west and down to over 40m.

You will feel dwarfed as you swim above the rocks and boulders, which provide an ample viewing gallery for shoals of yellow goatfish, palette and powderblue surgeonfish. Once you have absorbed the atmosphere and sense of space, use some dive time to get in amongst the life on the bottom. Look around boulders on the seabed for leopard sharks quietly resting, camouflaged by the grey stone.

Leopard sharks inhabit shallow inshore and offshore waters, near the bottom, and are often found close to coral reefs as they do not usually swim in open water. Believed to be nocturnal hunters, they spend most of the day lazily swimming and resting on the bottom, becoming active at night when they hunt for sleeping fish, molluscs and crustaceans.

At the far end of the reef is a flat area of stone known as Manta Point, it is a bit of a swim, but a good place to see marta rays.

Interspersed between boulders, narrow channels form pretty swim throughs, and fish life is funnelled through in the current. Make your way back up the mountainous terrain, keeping watch for a passing eagle ray or perhaps a blacktip shark.

Away from the boulders, there is a shallow reef area at around 12m–15m where you will see ledges of corals and layers of hard coral platelets. The staghorn coral is stacked high, providing good hiding places for octopus, moray eels and small fish. You will notice a good variety of pufferfish and clownfish in these waters, where they thrive.

The small cove of Koh Bon provides good grounds for a night dive. The reef is made up of pore corals, with shrimp gobies peering out of the holes and coral ledges. There are splendid decorator crabs, and you may spot red and white banded boxer shrimp. Look out for Spanish dancers, lobsters and other night dwellers.

ON DRY LAND
The islands' tropical rainforest consists mainly of large rubber trees and several species of palm, bamboo and vine. Seafaring gypsies used to live on the Similan islands, but they are now uninhabited except for the park rangers' office and the beautiful occasional residence of the Thai royal family. Apart from your surface interval, there is rarely a chance to set foot on the island. From a mainland location, day trips can be booked by speedboat to the famous James Bond Island and Phi Phi Island, both of which have appeared in Hollywood films. Rainforest tours are also available to see local wildlife, including elephants and monkeys.

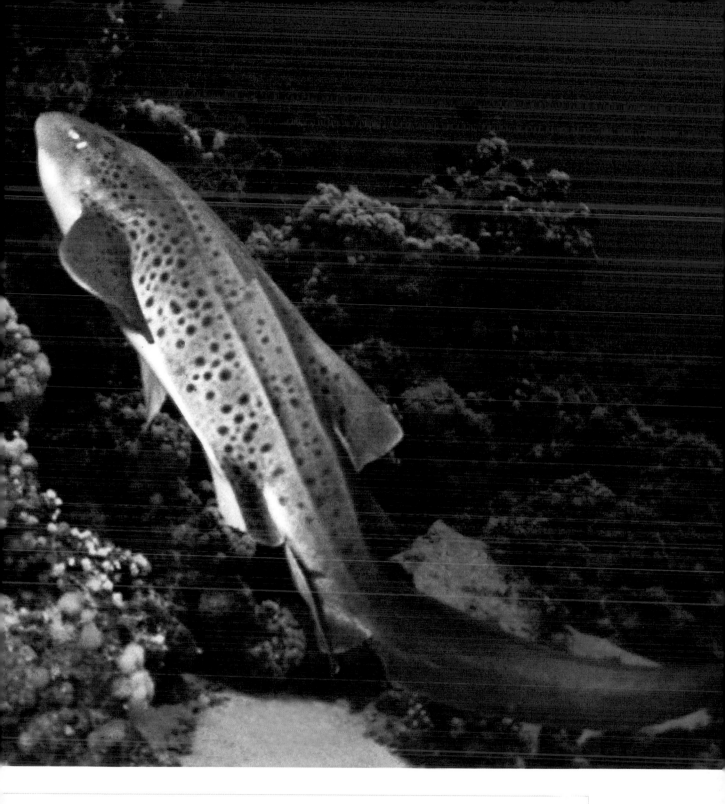

HOW DO I GET THERE
Fly via Singapore, Bangkok or Kuala Lumpar to Phuket, then transfer to a resort.

GARDEN EEL COVE AT NIGHT

Out of the darkness

Pacific Ocean

Honolulu

Garden Eel Cove

Hawaii

Garden Eel Cove has a special geology that makes it a perfect manta trap. Night dives are organised to provide an awesome close encounter with these creatures.

maximum depth:
18m

minimum depth:
23m

access
By day boat from your resort, which will take you north of Honokohau Harbour in 30 minutes.

average visibility
As far as your torch light reaches in the dark!

water temperature
25°C–28°C

dive type
Night dive

currents
Slight

experience

in the area
Suck'em Up
The Dome
Henry's Cave
Turtle Pinnacle
Kaiwi
Pipe Dreams

WHAT WILL I SEE?

The island of Hawaii is the youngest and largest of the archipelago that reaches 2250km to the north-west.

The Kona coast is home to more than 80 dive sites within a short boat ride of 15 to 20 minutes. Several more long distance sites are within an hour's ride. Lava tubes, pinnacles, and swim through arches characterize many of the sites. Large pelagics make Hawaii unique and exciting, with many endemic and rare creatures to be encountered.

The terrain is primarily black sand scattered with small and medium sized coral heads. Typical marine life found in this area includes garden eels, squirrelfish, goatfish, invertebrates, sleeping butterflyfish, moray eels and, most of all, giant manta rays.

The dragon moray eel is one of the rarest and most sought after eels in the world and has been seen in the reefs off Kona. The eels stay in their safe havens during the day, with their heads poking out, and at night can be seen free swimming. On Garden Eel Cove, garden eels gather by their thousands. These are actually Hawaiian garden eels, which feed on plankton and spend their lives buried in the sand. Other more local fish include the Hawaiian turkeyfish and teardrop butterflyfish.

Garden Eel Cove is a lovely dive site by day, but transforms into something unreal at night. This organised night dive offers the most amazing view of many manta rays.

THE DIVES

Your boat will place floodlights off the back boat to aid your vision and attract the mantas. The water looks

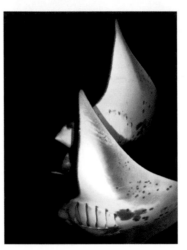

inky black and, from the surface, you cannot see what lurks beneath.

Descend into the darkness. The night becomes alive in the beam of your torch light. Many nocturnal creatures are now active; you may follow a hunting moray as it searches for its next meal. Watch as he attacks an unsuspecting tang, twisting his body in a knot and swallowing the fish. Shy, retreating shrimp, crabs, delicate nudibranchs and sleeping fish wrapped in their night cocoons are interesting distractions. It's a wonderful way to spend the evening and enjoy Kona's nightlife at its best. This is not what you have come for though, so find a good position on the shallow seabed and wait.

Just after dusk, zooplankton rise to the surface to feed; these in turn attracts the mantas. Before long, you will hopefully see the manta rays glide from nowhere towards you like huge bats, to feed on the microscopic plankton attracted to your light. Their 2–3m wings may almost touch your head as you watch in awe. They swoop in towards the divers, gently gliding by.

Divers' torches encourage the plankton to concentrate in the beam of light, enticing the manta rays to swim under, above and alongside the divers. The dive is so exciting, and is enhanced by the eeriness of the night.

The manta night dive is hard to describe effectively; each encounter with the giant manta rays is an exhilarating experience, which will never be forgotten.

ON DRY LAND
The Island of Hawaii is amazing, and the people are known for their friendly smiles. If you wish to keep to the water, plenty of activities are available including whale watching. Tours to the edge of the volcano are also organised. The hot lava is best viewed after dark, by walking to it for a mile or so across the older lava flows. You can safely get within a few feet of it. Spend the early part of the day doing a drive around Crater Rim Road in the national park, which will lead you to the crater rim to take a look over the edge. The wildlife here is great, and many of the national parks have nature trails.

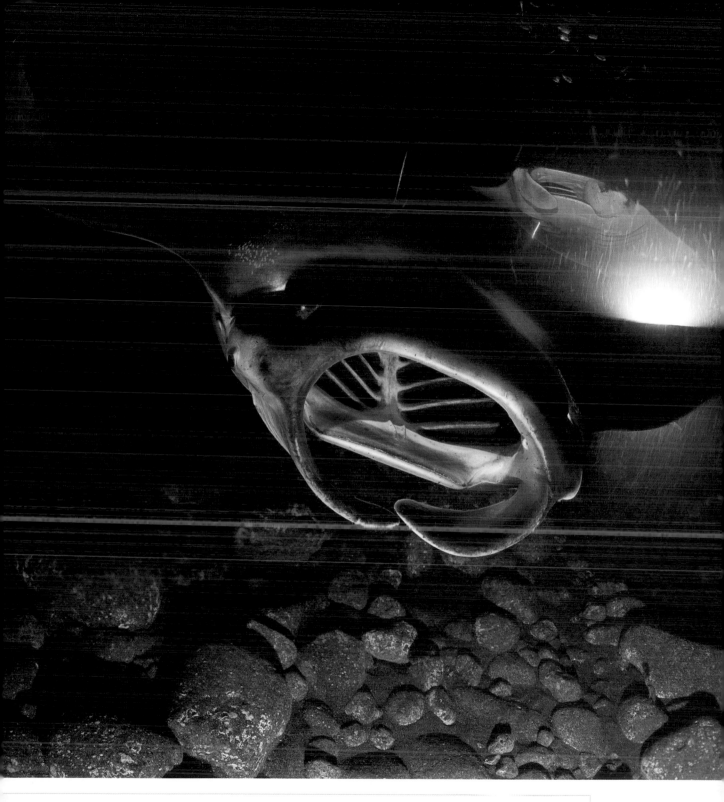

HOW DO I GET THERE

It's easy to get to Honolulu, as several airlines fly from many cities in the USA and the Orient. Hourly shuttles from there to Hawaii are available from two local airlines. Some airlines also fly international routes directly to Kona on the Big Island from the US, eliminating the shuttle.

United Kingdom

Manacles

North Atlantic Ocean

France

maximum depth:
6m

minimum depth:
1m

access
April-June around the Lizard, Cornwall. Specialist trips out of Porthkerris, Porthoulstock and Porthallow can be pre-booked.

average visibility
1m–5m

water temperature
6°C–12°C

dive type
Snorkel

currents
Slight

experience

in the area
*Penwin Reef
Vase Rock
Carmathern wreck
SS Mohegan
Raglan Reef*

THE MANACLES

Unforgettable encounters with gentle giants

Every year, the second largest fish in the sea visits this area. Seeing a Basking shark during a dive or snorkel is an experience never to be forgotten.

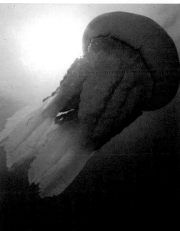

WHAT WILL I SEE?

At around 4,500kg, adult basking sharks can weigh more than an African elephant and can grow to a length of at least 10m–15m. Distributed in cool, temperate waters, they move into British coastal waters in spring and summer, and then seem to disappear during the winter months.

These gentle giants feed on plankton, filtered by thousands of small teeth called gill rakers. They efficiently remove minute floating plants and animals from the water, at a rate estimated to be as much as 9,000 litres of water an hour.

While this encounter may not have the heart-stopping thrill of being in the water with some of the more threatening sharks, you are unlikely to forget it.

Basking sharks get their name from swimming around in shallow water, seemingly basking in the sun.

Dive sites in this part of Cornwall can be very pretty, with jewel anenomes coating the rocks and sea fans forming reef beds. The area is very good for wrecks, because of the current.

The Gulf Stream brings warmer temperatures in the summer months and, once the plankton bloom has gone, visibility is excellent. Blue sharks have been known to visit this area, and dolphins too. John Dory, ballan and cuckoo wrasse, dogfish and cuttlefish can be seen on a regular basis, with conger eels hiding in the wrecks.

THE DIVES

This astonishing prehistoric creature, as big as a double decker bus, looks frightening. When you see its gigantic proportions from the boat, it's hard to believe you are about to get into the water with it. The thrill of being able to see it during a dive or snorkel is amazing.

The best approach is to lie motionless on the surface and wait.

Vigilance, patience and luck are required but it is worth the wait and persistence. The water will appear green and dark, as plankton makes the visibility very milky–you are looking out for a grey shape against a grey background.

The boat crew may warn you that the basker is close, perhaps a couple of metres straight ahead of you. First, you think you see a typical shark fin. Then you realise that there are actually three fins sticking out. This is the snout, first dorsal fin and tail projecting above the water.

Finally, emerging from the gloom of the low levels of light and the plankton surrounding you, this enormous and amazing beast appears. Its mouth opens, revealing a huge gaping space, vast enough to swallow you whole. Deep blue to charcoal grey, this giant feeding machine feeds methodically, needing vast amounts of plankton to fill its enormous stomach.

It glides through the sea with a smooth, graceful movement. Its mouth stays open as it hoovers up the suspended plankton. Every so often, it closes its mouth to swallow the soup.

Shafts of sunlight filter in between the huge gill slits and it approaches still closer; you can see every detail, its cold, uninquisitive eyes. Its size just blows you away. It passes by and you need to back off before its huge swishing tail gets too close.

Once you have lifted your jaw off the floor, you realise it's time to get back on the boat and try again.

ON DRY LAND
Cornwall is a beautiful area in south-west England with a huge variety of things to see and do. Taking a walk to enjoy the wild flowers and seabirds, with a stop for a cream tea, is recommended. The Eden project and the Lost Gardens of Heligan are popular tourist attractions.

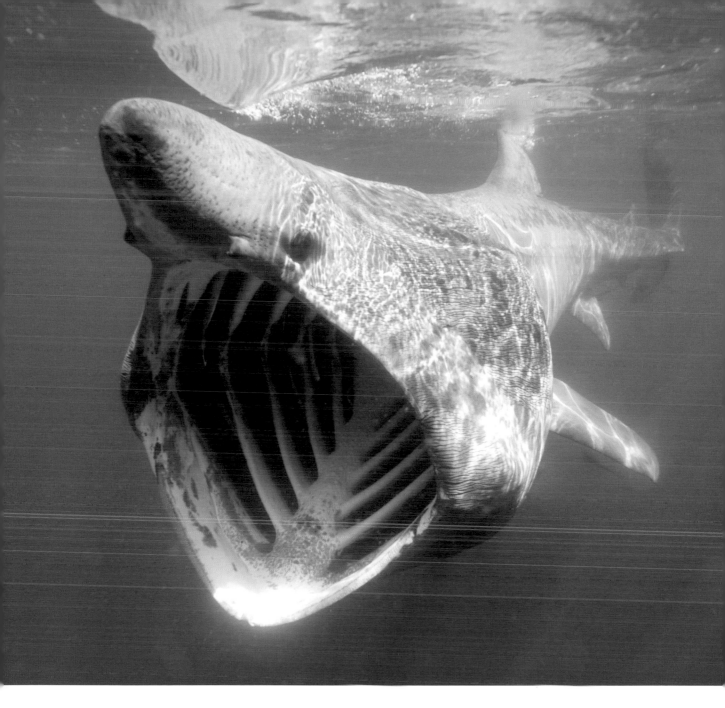

Often, you may float on the surface for some time with a sinking feeling that you have missed a great opportunity to see a shark. Then, out of the corner of your eye, something in the water changes, a grey moving mass travels beneath you and you look in awe at the basking shark passing by.

HOW DO I GET THERE

From the UK and Europe, fly to Newquay. International flights can be booked via London Airports. Hire a car or get a coach to Helston. St Keverne is about half an hour's drive from there.

India

Arabian Sea

Sri Lanka

Noonu ●

Indian Ocean

maximum depth:
35m

minimum depth:
5m

access
*More remote atolls
and dive sites are
only accessible by
liveaboard, booked
through a tour opera-
tor for a seven-day
dive trip. November
to April is the best
time, but diving is
accessible most of
the year.*

average visibility
10m–30m

water temperature
27°C–29°C

dive type
Reef and drift diving

currents
*Moderate to strong
currents*

experience
**** Advanced dive
due to irregular
currents*

in the area
*Dhekanan Faru
Orimas Thila
Many dive sites in
the Lhaviyani Atoll
Many dive sites in
the Noonu Atoll*

ORIMAS THILA

Dancing with mantas

Magically set upon enchanting crystal clear blue and turquoise waters, small verdant islands are fringed with palm trees. This is your first view of the islands from the seaplane on your way to Kuredu Island, and is spectacular.

WHAT WILL I SEE?

The Maldivian atolls were created as volcanoes sank beneath the sea, leaving craters above the waterline; coral reefs were formed and life engulfed them, bringing incredible richness and variety of life to the sea.

The currents of the Maldives are notorious for their strength. The exposure of the Maldives to the vast Indian Ocean ensures an immense body of water is constantly flowing across the plateau on which the atolls were formed. These conditions are perfect for manta ray and whale shark, and this is the location to see them.

Noonu Atoll only recently opened to tourism and there is still a wealth of dive sites to discover here. With most of the diving in Noonu Atoll conducted on coral pinnacles, or thilas, diving in this area offers some beautiful topography with caves and overhangs.

Eagle rays and various shark species are almost commonplace, and at certain times of year divers may be lucky enough to come across a whale shark.

THE DIVES

This ribbon of atolls creates a broken barrier across the prevailing ocean currents. These currents and local tides flush fresh water through the channels, locally known as kandus, carrying with them nutrients and plankton. This gives Maldives' diving a character all of its own and, for more experienced divers, means exhilarating drift dives.

Start from the northern end and work your way down the west side where there is a little wall. This is a good place to seek out ray, large grouper and shark hiding under the ledges of the wall. Large shoals of baitfish and

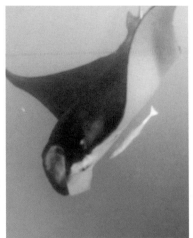

barracuda set the scene, and you may spot clown triggerfish, unicornfish and trevally.

The thila splits, with a sandy gap. A grey reef shark passes by, then more until several can be seen on the platform, congregating in massive groups on cleaning stations, hanging calmly and allowing brave little cleaner wrasse to enter their predatory mouths.

It is to the edge of this ridge that divers are drawn, as they peer into the blue looking for that first sight of a black and white wing that signals an approaching manta ray. Keep a little distance from the rays, and the chances are good that they'll circle and swoop around, feeding on the plankton. There are few sights more awe inspiring than mantas performing their graceful somersaults. Manta rays visit reefside cleaning stations to let cleaner wrasse remove small parasites from skin and gill cavities. Choreographed, as if they are putting on a show for their captive audience, the Manta Ray gather in perfect formation, flying over the cleaning station and hovering in turn for a good clean.

Watching them from a boat, you see what appears to be a huge moving rock, a ghostly figure sliding through the water. You put your head under the water and see the huge wing span as this amazing creature moves towards you.

Other attractions include remora and batfish, and the squirrelfish and hogfish that seem to pose in front of the camera. Spend time over the undulating coral platforms smothered with anenomes.

A great image to take away in your mind and recall on demand.

ON DRY LAND
The seaplane journey is a highlight, offering a great view of many of the Maldives' islands and atolls. Kuredu is the nearest island location for watersports and relaxation. Snorkelling, canoeing, sailing and wind-surfing are available. The beaches are breathtaking and accommodation excellent.

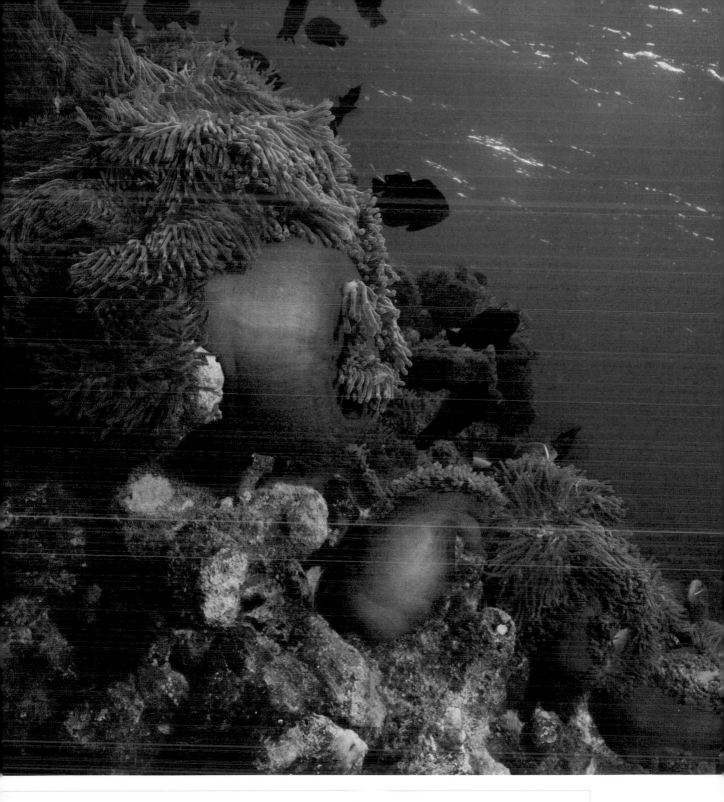

STINGRAY CITY

Voted the best four-metre dive in the world

According to local legend, stingrays first began to gather in this area of the Caymans decades ago, attracted by the discarded fish parts thrown overboard by fishermen returning from their daily fishing trips. Now, divers feed the stingray by hand with fresh squid provided by the resorts. Nowhere else in the world can such a rare and close encounter be experienced.

maximum depth:
4m

minimum depth:
2m

access
From George Town, it is a 45-minute drive to get on the boat. Stay at a local resort and you will be only five minutes away. Many resorts operate day boats to local sites. Diving here is easy, with access from day boats out of the harbour. These trips are well organised and regular, and even provide you with squid to hand-feed the rays.

average visibility
15m–40m

water temperature
24°C–28°C

dive type
Sandy bottom, some reef

currents
Light to none

experience

in the area
*Shore diving
Wrecks, sunk as artificial reefs
Bloody Bay Wall
Orange Canyon
Grouper Grotto
Snapper Hole
The Maze*

WHAT WILL I SEE?

The best diving in Grand Cayman is on the east side of the island. This is mainly due to currents bringing in nutrients from the open seas, allowing the marine sponges and coral to thrive. Many of the walls are stunning and start at around 10m–14m.

Stingray City is located in the shallow waters of the north-west corner of Grand Cayman's North Sound, just inside a natural channel that passes through the barrier reef.

Stingray City is world renowned for the interaction you can experience with stingray here; you can experience really close encounters and have them swimming all around you. Although they are free to come and go as they please, they have become totally accustomed to humans, and divers have been taking advantage of this wonderful adventure for some years. The dive guides attract the stingrays with food and they are happy to get a free meal. It is a highly policed conservation area–it needs to be, to prevent the rays being exploited.

THE DIVES

Stingray City is a sandbank that attracts many southern stingrays. You can sit on the seabed in less than 6m of water and watch the stingrays come to you. They seem to appreciate being fed lumps of squid, and are very used to human contact. This is a unique area to see the stingray as it is most uncommon to see so many of them together and behaving in this way. Stingrays are bottom-dwellers; they naturally like shallow, sandy seabeds like the one found in this channel, as this is where they find their food. They feed primarily on molluscs and crustaceans, for which they dig in the sand, and the occasional small fish. Rays are closely related to sharks, but are broader and more flattened cartilaginous fish. They have gill slits on the undersides, behind the mouth, rather than on the sides as is the case for sharks.

These rays appear friendly but be warned: they have a razor-sharp tail and their mandibles can scrape or sting as they enthusiastically grab squid titbits from a divers hand.

Joining the stingrays are yellowtail snappers, always eager to gulp up what the rays miss. Floating above the sand, keep a look out for other bottom-dwellers – flounders and other flatfish, hermit crabs and crayfish. There are some small patches of coral that provide protective nurseries for the tiny new fish.

This dive is best as your second or third. While it is a great thrill to be this close to the stingrays, the dive will be totally devoted to that one aim, but there is no coral reef or wreck to explore after your appetite has been satisfied. It should definitely be on your list of things to do whilst you are staying on Grand Cayman, and people come from all over the world to dive here.

ON DRY LAND
The beaches are lush and beautiful, and life in the Cayman Islands is relaxed. Trips to Cayman Brac and Little Cayman are available. Cayman Brac is 14 miles long and two miles wide, and has the most dramatic topography of the trio. Its majestic bluff rises west to east along the length of the island to 151.75 [query: metres or feet?] above Spot Bay. At Little Cayman is the 203-acre Booby Pond Nature Reserve, nesting ground for the Caribbean's largest population of red-footed boobies. On Grand Cayman, the capital George Town has a lively nightlife, and good retail therapy is also available.

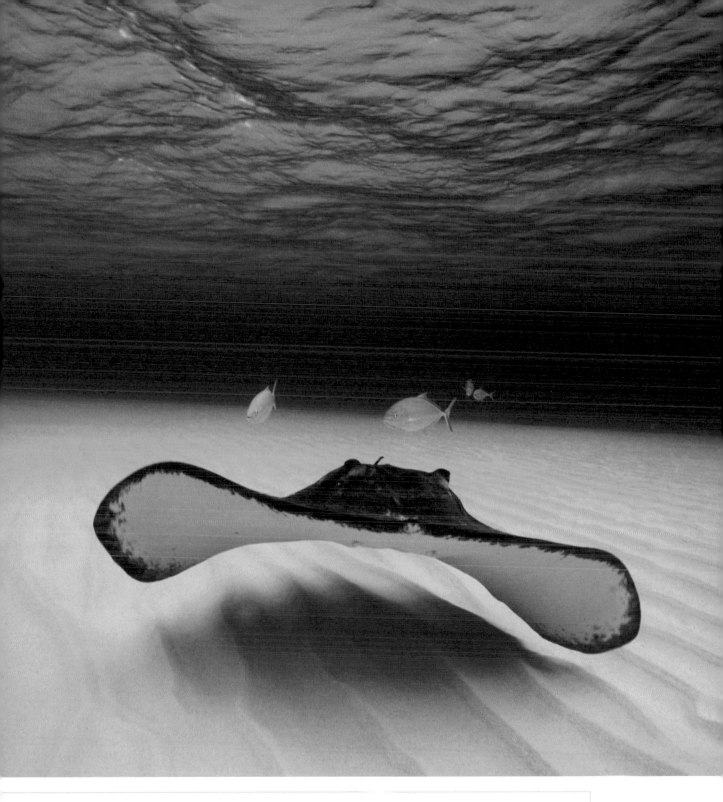

HOW DO I GET THERE

Direct flights to Grand Cayman are a mere 70 minutes from Miami International Airport. Short flights with

Cayman Airways island-hop to Cayman Brac or Little Cayman daily.

SHARK REEF

Unimaginable encounters with sharks

Shark Reef Marine Reserve is one of the few remaining places where one can regularly observe several species of shark at the same time. Here, you are guaranteed to see sharks.

Beqa Lagoon

Fiji

Pacific Ocean

Tonga

maximum depth:
35m

minimum depth:
5m

accoco
Accessed by day boat from Viti Levu and Beqa dive resorts; it is a 10-minute boat ride from Bequa. Liveaboard is a great option to access the many beautiful dive sites.

average visibility
10m–30m

water temperature
25°C–29°C

dive type
Cave dive

currents
None to slight

experience

in the area
Side Streets
Caesar's Rocks
Soft Coral Grotto
The Coral Gardens
Wreck of the TASU
No. 2

WHAT WILL I SEE?

You will witness several sharks during one dive. Blacktip and whitetip reef sharks, grey reef sharks and silvertip sharks are common. The gentle tawny nurse sharks and sicklefin lemon sharks often make an appearance, while the more aggressive bull sharks and tiger sharks are rarer occurrences, bringing with them a huge adrenaline rush.

The lagoon is actually the crater of an extinct volcano, and the 65km ring reef has formed on the lip of the old crater. Shark Reef is a rather ordinary hard coral reef just off the Viti Levu coast at Pacific Harbour, Fiji. This dive site also hosts many other marine creatures, and you can see humphead wrasse, red bass, surgeonfish, triggerfish, cod and many others.

What makes this place special is that the reef has been protected from fishing boats, and shark feeding has been taking place here for over a decade. Shark encounters of one kind or another are guaranteed.

You will be in close proximity to the sharks without the protection of a cage.

THE DIVES

On the fringes of Beqa Lagoon, Shark Reef Marine Reserve was created to study the resident shark population and aid in the long-term conservation of sharks worldwide. It is here, within the protection of the reserve, that the shark dive takes place.

This is generally arranged as a multi-level dive, and you can book two dives to ensure you see most of the shark species in the area. Typically, you start at 30m,

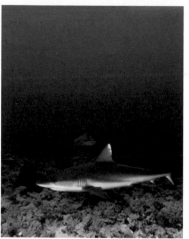

then ascend to a 15m ledge, then again to 5m as coached by your dive guide.

A coral rubble slope descends to 35m, creating an arena for the sharks' entrance. Fish scraps will be placed in the water, first attracting the mid layer food chain. You may see large schools of giant trevally, rainbow runners and red snappers all around, jostling for a bit of food. This frenzied action, plus the scent of the fish guts, in turn attracts the sharks.

Perhaps the confident grey reef sharks will be the first to approach, circling and assessing the situation, soon joined by whitetip and blacktip reef sharks moving in on the bait.

Light levels and visibility may appear quite low as the crescendo reaches it peak and fish and thrashing shark seem everywhere. It will blow your mind to see sharks at such close quarters. Divers are instructed to view the feed from behind a bank of coral rubble and safety is of utmost importance.

Typically, you stay here for about 15 minutes and are then led to a shallower ledge. As you ascend, looking up, you may see sleek silvertip sharks passing overhead. The dive then finishes on the shallow reef where you can view a pretty coral garden, but your mind will already be geared up for the next shark dive. After an hour's surface interval, you commence your second dive to a depth of around 15m.

The smaller reef sharks and nurse sharks are comfortable in the shallows and it is a great way to observe them at close quarters. The food bins are left in the water during your surface interval, giving the long

ON DRY LAND
Rainforest tours and an incredible journey through the canopy on zip lines. There are eight runs on the canopy tour, from the first

platform at 7m to the highest at 45m. White water rafting is another high-adrenaline activity on offer.

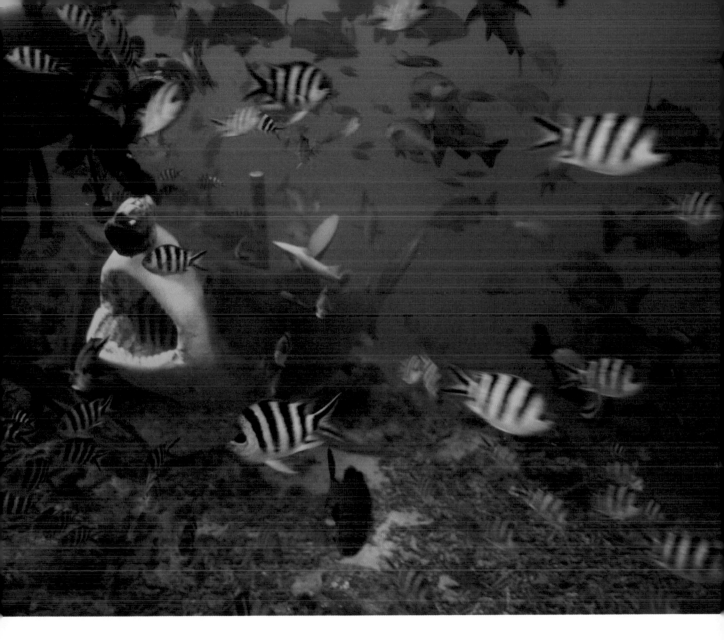

distance roamers, such as the tiger sharks, enough time to buzz the area. They soon decide it is worth coming in from the depths, giving up the safety of the blue water to swim into the reef for a much closer look. These large tiger sharks and impressive four metre bull sharks have a commanding presence in their own environment. Known as aggressive predators, you may see the tiger shark come up to the bait, its mouth wide open, and the bait disappear. The tiger shark has clear stripes down its body and is really quite beautiful. Its exudes power and confidence.

It will seem as if your dive comes to an end in no time at all, and you will be left with memories of diving in Viti Levu to treasure for a lifetime.

HOW DO I GET THERE

Fly from all international airports via LA, Singapore or New Zealand to Nadi airport in Fiji. The island of Viti Levu is two hours by road from Nadi.

Pacific Ocean

Australia **Rururu** ●

New Zealand

maximum depth:
Snorkelling

minimum depth:
Snorkelling

access
Small craft

average visibility
30m–60m

water temperature
July to October:
20°C–24°C

dive type
Snorkelling from small craft

currents
Light to moderate No problem for snorkelling, although conditions may be choppy.

experience
** to ***

in the area
Rururu is mostly famed for humpback whale encounters, but there is some scuba diving available at dive sites around the island. This sub-tropical region offers plenty of coral and tropical fish, as well as cold water species. Two centre options are a particularly good idea when visiting Rururu, to combine the whale encounters with shark diving at Rangiroa; or visit Faka-rava in the Tuamotu Islands of French Poly-nesia with its famed drift diving. Other combinations are with Bora Bora, well known for its manta rays, or the Marquesas Islands to the north where unique species such as melon-headed whales are found, as well as beautiful reefs and abundant marine life.

RURUTU

Swimming with humpbacks will take your breath away

Although diving is available on Rururu, strictly speaking you need to brush up on your snorkelling skills to experience the most exciting opportunity the island has to offer. The best way to get close to humpbacks is to snorkel. So get ready for the most exhilarating snorkelling you are ever likely to do. These gentle giants often do not come close when air cylinders are used, although some centres may be able to offer rebreathers to divers with the appropriate experience.

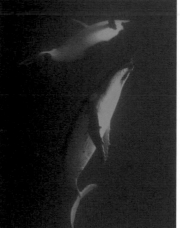

WHAT WILL I SEE?

Rururu lies 576km south-west of Tahiti in French Polynesia and is the most northerly of the Austral Islands. A small but beautiful island just over 10km long by less than 3km wide, it is on the migratory path of humpback whales when they travel from their feeding grounds in Antarctica to the warmer waters of Rururu to breed. With a lack of predators here, these shallow waters around Rururu afford ideal opportunities for the females to calf and nurse their young in preparation for their journey back to their feeding grounds in Antarctica. They are here between July and October each year.

THE DIVES

Patience is the order of the day. You may spend a lot of time on a small open boat in choppy waters, and the temperatures can be quite cool whilst waiting for the highly experienced guides to spot signs of a humpback. You might be lucky enough to see a bull humpback breaching, but normally it is the sign of a waterspout from an exhalation when they blow at the surface that reveals the location of a whale. When resting, they can stay on the bottom for about 30 minutes before returning to the surface to breath. If swimming, they may surface every five to eight minutes. Young calves can only hold their breath for about that period of time so they may surface with their mother or on their own.

Once a whale is spotted, the boat will position itself in front of the direction of travel of the humpback, and snorkellers will slip gently into the water to avoid heavy splashing so whales will not be spooked. On occasions, the whales will be inquisitive and that is the time when all the hard work will be rewarded, as there is nothing as exhilarating as having one of these leviathans, which can grow to a length of 18m and weigh up to 50 tons, swim up close and inspect you with an inquisitive eye.

When a calf is accompanying its mother, it will often be nestling under the mother's chin as calves tend to be less in control of their buoyancy. When resting on the bottom, calves will also nestle under their mother's body. The calves need to surface more frequently and they can often be fearless and inquisitive and come very close.

The calves are normally suckled and weaned for about five months to prepare them for the arduous cyclical journey to Antarctica.

A 3mm wetsuit is advised and this will create buoyancy for snorkelling. To get the best encounters, it is better to be able to duck dive with ease. Therefore, make sure the dive organisation you book with on the island agrees the use of weights, as they can be reluctant to provide them. With the right preparation, a trip to Rururu could well be an unforgettable experience.

ON DRY LAND
A tour of the islands can include visits to caves with stalagmites and stalactites, and traditional villages where basket weaving is a speciality.

The main village is Moerai. It has basic facilities such as a post office, gendarmerie, banks, stores, bakeries, snack bars and butcher's shop.

The island has a few beaches, and swimming and snorkelling are possible in certain areas. Other activities include horseback riding, hiking and island tours by four-wheel drive vehicle. Each January and July, there is a festival called Amoraa Ofai, when young men and women carry out shows of strength by lifting volcanic stones. This is accompanied by dancing and feasting.

HOW DO I GET THERE

International flights to Tahiti Faa'a International Airport, Papeete, Tahiti, and internal flights to Rurutu airport.

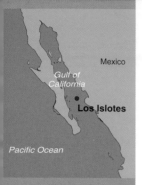

LOS ISLOTES

Ballerinas of the sea

Los Islotes is a rugged island made up of a protrusion of rocks rising sharply out of the Sea of Cortez off the tip of Espiritu Santa Island. This site is well known for the presence of sea lions. So graceful, like ballerinas, they flow through the water, enjoying their free living under the sea.

maximum depth:
30m

minimum depth:
3m

◖◖◖◖◖◖
Sea front hotels and marinas in La Paz have dive resorts with day boats to take you to each dive. Daily boat dives take you to over 25 dive sites, around 30 minutes to an hour away.

average visibility
The visibility is best from July to October when it is around 30m, but you can count on 15–25m in most diving places.

water temperature
21°C–29°C all year round. The water is coldest from November to March.

dive type
Reef diving/boulders

currents
Little

experience

in the area
Salvatierra Wreck (Ferry with a cargo of trucks, 19m)
Las Animas
El Bajo
El Corralito
Los Cabos diving

WHAT WILL I SEE?

The gnarled shapes of the guano-covered cliffs have hundreds of golden-coloured sea lions lazing on the rocks. These wild creatures have chosen Los Islotes as their rookery.

The shallow side of the island provides a nursery for young sea lions, who are protected by the adults. The male sea lions' bellowed barks of warning can be clearly heard underwater. Care and respect must be shown to these territorial males as they rush up to you and open their jaws to reveal rather large teeth. Male sea lions have robust bodies compared to the more slender females but are not aggressive; they are mostly interested in the temporary visitors to their world.

The females are curious too, and often creep past and look back, studying each diver. Juvenile sea lions are the most fun. They are playful and cheeky, and show little fear. They can often be seen scampering off with a diver's snorkel or mask, won as a trophy.

The Cortez Sea has a reputation for being one of the richest in the world in terms of number of species and size of populations.

THE DIVES

Los Islotes offers varied diving. It sits in a protected area so is a good place to visit whatever the weather.

The deeper side of the island offers a sloping rock face and is a good vantage point from which to see large

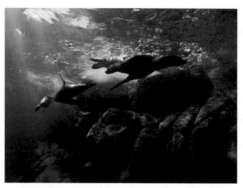

shoals of barracuda hanging in the current waiting for their next meal. Here, in the deeper areas around 20-30m, there are black sea fans and small sponges and sea squirts. Yellow tail jacks are also plentiful here, along with snappers and Mexican goatfish.

Swim around the side of the island to find interesting boulders that form shapes and gullies to swim through. On occasion a school of sea lions will rush past, providing divers with a surge of excitement. They appear to seek out divers' company here and, when the weather is calm and dive boats visit less accessible sites, the sea lions seem genuinely keen to greet visitors once again. The pups race around, turning somersaults and blowing bubbles in your face. You feel a tug at your fin and see it is a young sea lion, delighted to have found some amusing new playmates.

Most dives can be finished in the shallow areas, where you can stay at 4–6m for a long while, mesmerised by the frolicking sea lions. Here, the nursery seems barren, as the fish keep well away from the hungry mouths. King angelfish add some colour to the large rocks and boulders that form hiding places for the young sea lion pups.

La Paz offers excellent conditions for scuba diving. There are three beautiful islands in the gulf (San Jose, Espiritu Santo and Cerralvo) plus countless little islets.

ON DRY LAND
Perched on the south-east edge of the district of Baja Sur, the small colonial town of La Paz offers glorious landscapes and numerous bars and restaurants serving good seafood or spicy Mexican dishes. La Paz is an old city, notorious for pirates in the early 18th century. Desert surrounds the town, and tall mountains look on from the distance. For nature lovers, huge cacti and endemic plants and animals can be seen. Back on the water, resorts offer whale watching. Kayaking and other water sports are possible. Fishing, including Marlin and tuna, is popular.

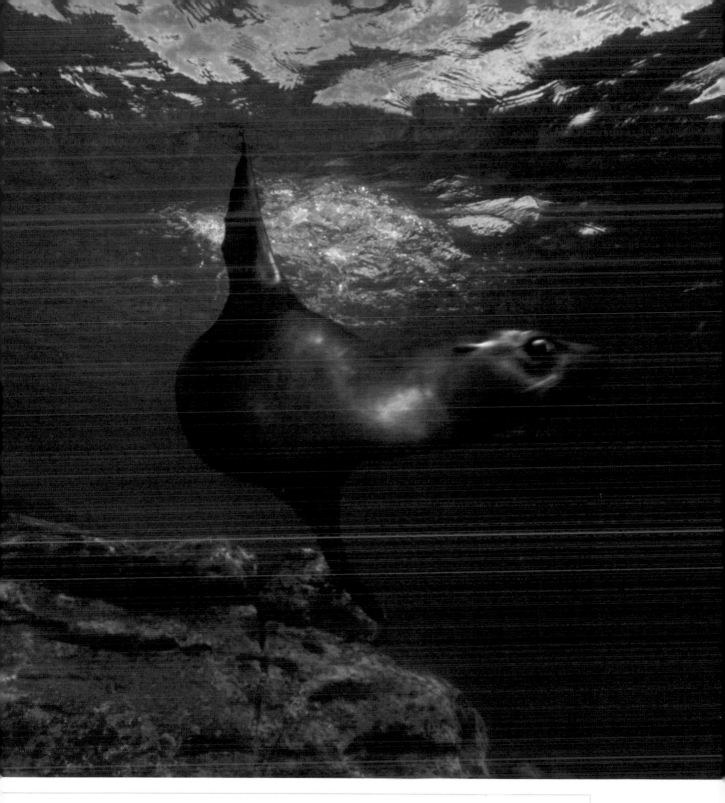

HOW DO I GET THERE
Via LA, fly to La Paz.

Coral Sea

Australia • **Hervey Bay**

Tasman
Sea

New Zealand

maximum depth:
6m

minimum depth:
1m

access
*A variety of vessels
offer whale watching
trips during the sea-
son, and visitors can
choose from dawn,
morning, afternoon or
full-day cruises.*

average visibility
15m–40m

water temperature
21°C–28°C

dive type
*Shallow dive or
snorkel*

currents
Slight

experience

in the area
*Cod Hole
Challenger Bay
Pixie Pinnacle
Many dive sites on
the nearby Great Bar-
rier Reef*

HERVEY BAY

Whale song

Hervey Bay is located in south-eastern Queensland, particularly between May and August.

WHAT WILL I SEE?

Hervey Bay, on the Fraser Coast, has become an important resting area for whales to relax and play with their newborn calves.

Approximately 5,000 Humpback whales migrate each season between Antarctica and the Great Barrier Reef. The Great Barrier Reef is the only destination within Australia that allows swimmers to dive and snorkel with these distinctive creatures.

Dwarf minke whales are sleek, despite their very thick blubber, and are the smallest of the baleen whales. Each whale in the pod has its own individual markings. Perhaps not commonly known, they have two blowholes and they use both to take air into their lungs.

Though close interaction with humpbacks are less likely than the dwarf minkes, the humpbacks will often put on a brilliant display you can watch from the boat. They create noise and disturbance on the water, with breaching, tail waving and pectoral fin slaps. The male humpback whale is well known for its complex underwater vocalisations, or whale songs, during the breeding season. Humpback whales have two large pectoral fins over 5m long, making them an unmistakable sight. They have adapted a unique hunting system where they work as a team, using their blowholes and moving in a coordinated way to create a barrier of bubbles to imprison schools of small fish. Taking turns, they dive into the net of bubbles and emerge with a mouthful of fish.

Dwarf minke whales are social creatures and are often seen travelling in pods. Communication between these whales comprises of a combination of grunts, moans and rasping sounds.

THE DIVES

The bay is sheltered and safe for the humpbacks and dwarf minkes to rest after their long migration. During this time, the whales swim very close to the shore, so it is a perfect opportunity to get close to them.

Dwarf minkes are renowned for their curiosity and approachability. When the whales are spotted near the boat, it's time to experience one of the ultimate snorkels, or dive. Some operators will only book excursions to swim with the whales without the use of tanks.

Dwarf minkes may be seen spy hopping, putting their whole head out of the water to look at the passengers on the boat. They may even follow the boat until the swimmers get into the water. The smallest of the baleen whales they may be but, at around 8m long and weighing up to 7 tonnes, it feels quite daunting to get in the water.

They are intelligent and curious mammals and may wonder who has entered their seas. Successful interactions are amazing and the boat will let you stay for up to an hour before moving on to another popular whale site. The classic view of the tail fluke upturned on a descent shows the lovely white underside of the humpback and it is worth being on the boat just to see the pearls of water running off its tail as it disappears into the depths and its underwater world.

These encounters, whilst never guaranteed, are frequent during the Australian winter months, and many whales are also sighted while the vessel is travelling. From early July until late September, the much larger humpback whales are also encountered, often giving breathtaking displays. They are known to be acrobatic and playful at times.

The largest pod seen numbered 28 whales, as reported in the local news, and the longest encounters can last for up to 10 hours.

ON DRY LAND
Queensland (capital Brisbane) is one of Australia's largest states. With a wonderful tropical climate, Queensland produces a wealth of fruits and vegetables and is home to a number of wineries. The state boasts amazing beaches and excellent access to the Great Barrier Reef. Hervey Bay is the gateway to Freser Island where you have the choice of scenic walks along uninterrupted white beaches and coloured sand cliffs, or refreshing dips in crystal clear freshwater lakes. Nearby is Maryborough with its glorious colonial architecture, museums and riverside dining. To keep the family happy, the state has five amusement parks.

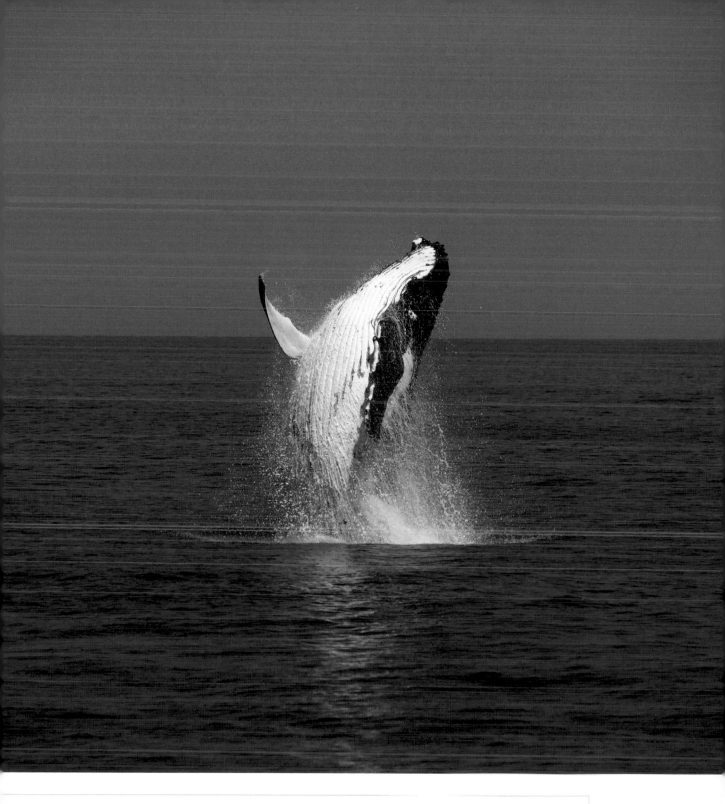

HOW DO I GET THERE

Fly to Brisbane via international airports in Dubai, Singapore, Malaysia, LA. Hervey Bay is only 3 hours north of Brisbane, You can drive there with a hire car or coaches operate several services each day through Maryborough to Hervey Bay. There are also internal flights available from Brisbane to Hervey Bay.

HUNGA ISLAND

Smitten with humpback whales

Whale-watching is a boom industry across the world, but Tonga is one of the very few places where you are allowed to swim with whales, the spectacular singing humpbacks.

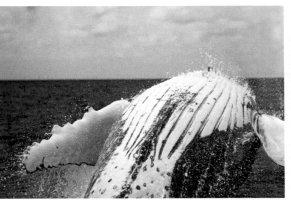

maximum depth:
3m

minimum depth:
0m

access
Your hotel resort coordinator will help you book on a snorkel excursion. Liveaboard dive trips will allow for this on your itinerary. Whale watching boats go out daily and can be booked. There are hurricanes in September and October, and the best time to visit is April-November.

average visibility
30m–40m

water temperature
24°C–26°C

dive type
Snorkel dive

currents
None

experience

in the area
King Neptune's Sea Fan Grotto
Mariner's Cave
Hunga Magic
The Clan McWilliam
Split Rock
Gorgonian Valley

WHAT WILL I SEE?

Tonga is a pleasant place for humpback whales to stop on their way to the Antartic, and provides them with warmer water and a safe place to mate and produce their young. There are more than 50 islands in the Tonga group so it is still very much a place that is to be discovered. Hunga Island is on the edge of a coral garden, with brilliant blue water surrounding shallow fringing reefs and high island peaks.

Beneath the water, dramatic coastal caves harbour whitetip sharks, lobsters and schooling fish. Tunnels and submerged ledges make for good diving, with deep magenta, pastel pink and sunny yellow soft corals seen throughout this dive. There are untouched hard corals, and soft coral gardens in a myriad of colours. You may encounter lots of large marine life, including humpback whales. You do have an option to do this dive and swim out to see the humpback whales but, although encounters are possible during a dive, it is easier to book a snorkel trip on an organised boat to increase your chance of seeing these whales close up.

These large creatures are an amazing sight. The humpbacks built up blubber up to 48cm thick by gorging on krill and small fish in the Antarctic, but they do not eat a thing during the six-week trip to Tonga, cruising at about five miles an hour.

THE DIVES

The boat motors out, looking for the familiar water spout, a fuzzy white column of water produced by an explosive exhalation after a humpback surfaces from a dive. Just seeing the whales' huge bulks gracefully cutting through the water from the surface is tremendous. Knowing you may soon be in the water beside them is unreal, and seeing them close to you is emotional and humbling.

Once spotted, the boat skipper and crew will track them; you may see them slap their huge tails against the water, creating a crescendo of sound. As you get closer the sound resonates and combines with whale song. Humpback songs are the most elaborate in the animal kingdom. They can reach an ear-shattering 185 decibels and carry through the ocean for more than 100km. The humpbacks have a seven-octave range and use rhythmic variations in their grunting, clicking and groaning songs that are astonishingly similar to human musical compositions. This is not done for entertainment but to attract a mate and communicate within the pod.

Wearing mask and snorkel, you will be instructed to slip into the sea and float silently, face down. You wait patiently, harbouring a dread that you might end up missing the experience, then the water appears to shake as a humpback whale weighing more than 30 tonnes gracefully into view through the water. Your vision is blocked by blubber as this magnificent beast sweeps by; for a moment, your eyes may appear to meet.

ON DRY LAND Sailing, fishing and other watersports are popular here. One of the most impressive sights in Tonga is provided by the Blow Holes, found along the coastline nine miles from Nuku'alofa. Waves send seawater spurting some 18m into the air through holes in the coral reef. Tongans call this stretch of coastline the Mapu 'a Vaea (the Chief's Whistle) because of the whistling sound made by the geyser-like spouts. Fruit bats and rare birds can be viewed around the island. The beaches are beautiful and easily accessible.

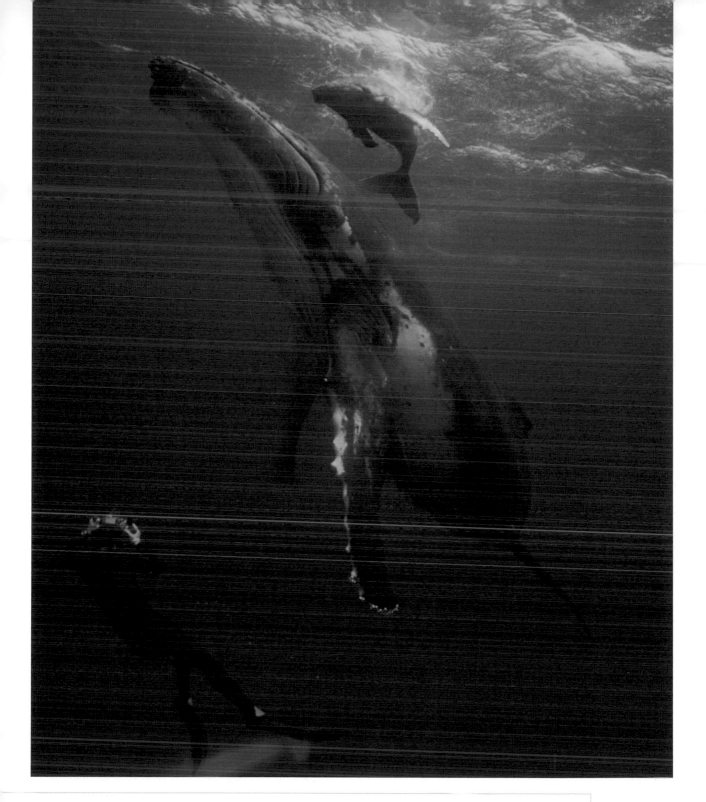

HOW DO I GET THERE

You can fly to Nukualofa in Tonga from most airports, via LA, Samoa, Manila, Auckland, Dubai and Singapore.

THE HOPPER
Enchanted by seals

The Farne Islands are home to a large colony of grey seals. This dive offers a scenic site to experience wonder and amusement as the seals grow confident with divers and play.

North Sea

The Hopper

Ireland

United Kingdom

maximum depth:
25m–30m

minimum depth:
3m

ooooo
Accommodation at Seahouses or Beadnell and booking on to a local day boat is advised. Summertime is best or when the new pups are weaned. Visibility can reduce dramatically in adverse weather conditions so watch the local weather forecast.

average visibility
8m –25m

water temperature
7°C–15°C

dive type
Reef

currents
Slight as long as they are tied to the slack water periods. Can be strong so good diving practices are important. Avoid spring flood tide.

experience
** * ***

in the area
*Knivestone
Whirl Rock
Northern Hares
Wrecks include a Danish steamer, a steam ship (St Andrea) and the Somali, a 6,809-tonne cargo ship.*

WHAT WILL I SEE?

The Farnes consist of a bunch of around 30 small islands and rocky outcrops in two main groups, separated by Staple Sound. The islands are protected, as they provide a critical breeding area for huge numbers of grey seals, puffins and other seabirds.

For the marine biology enthusiast, it is worth mentioning that there are light-bulb sea squirts, ross coral, and dahlia and jewel anemones, which can be appreciated if you know what you are looking for. Urchins and starfish cover the walls and ledges. Ballan wrasse and flatfish are plentiful, with the chance to see dogfish on the seabed. Spider crabs and lobsters are common here too.

The Hopper is a site populated by a seal colony. The seals are very used to encounters with divers and regularly come to investigate visitors. It is very common for mischievous young seals to nibble on a diver's fins. This is a scenic dive with three fantastic gullies, one of which runs some 30 metres into the island.

THE DIVES

The Hopper can be dived in most conditions except strong easterlies. The reef drops sheer from the surface to 20m; it then shelves to more than 98ft (30m) but, from here, strong currents may be encountered away from the reef. The scenery is dramatic, with steep walls and narrow canyons leading up and through into the small lagoon behind. They provide an added dimension to the dive and are interesting to explore. These rocks are

covered in plumose anemones and sponges called dead man's fingers, showing orange and cream colours.

The rough gravelly seabed has areas that are covered with hundreds of brittle stars, and octopus may be seen creeping over the carpet on its way to hunt. Macro life is abundant here too, with sea slugs and well-camouflaged sea hare to spot. Look around the cracks and crevices in the rock for a squat lobster, prawn and the fierce looking conger eel or rare wolf fish.

Fan worms look like pretty feather dusters emerging from their tubes, which are constructed from mucus and mud. Many species of starfish create a rainbow of colours to brighten up the dark rocks and seabed, including the purple sunstar and Bloody Henry.

The seals provide a fun, memorable distraction from the fish and macro life. They can be spotted first on the surface, lazing about on the rocks, looking lethargic and clumsy. Even as you approach the dive site in the RIB, you can hear them calling to each other. The way they transform into energetic, dynamic puppies once they slide into the water is amazing. Caves and steep drop-offs are the perfect places for nurseries and hiding places, allowing the seals security when you observe them in their own habitat.

The seals are cheeky and inquisitive; often the first sign they are around comes from a tug on your fins. These animals look cute and cuddly but are still wild and unpredictable. The younger seals are particularly curious

ON DRY LAND
A puffin colony and many seabirds make this area an attraction for bird lovers.

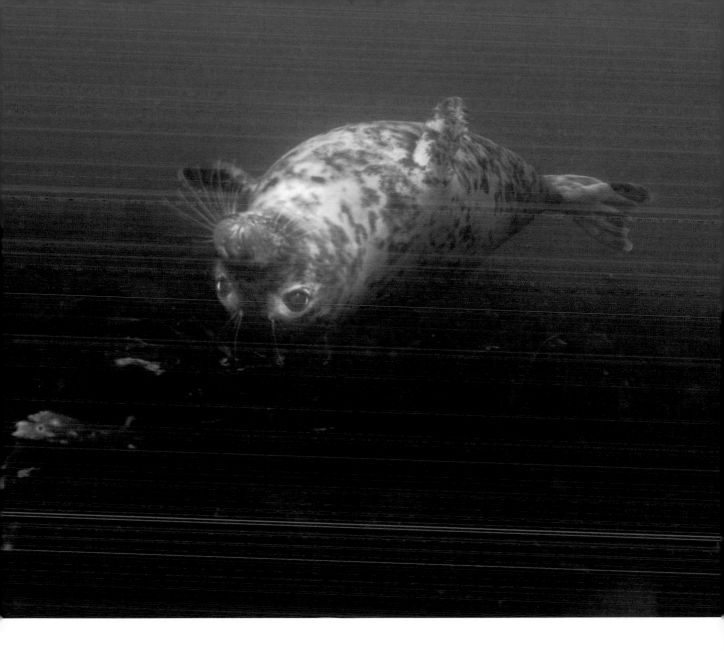

and gain confidence with a diver quickly if they are not chased. They appear to enjoy the physical contact with humans; maybe they believe we are strangely shaped seals. Divers may be welcomed into their environment enthusiastically when they are in a playful mood.

Many dives just with the seals can be enjoyed in the shallows, as most encounters are in the top six metres. You will be sure to surface with a huge grin and want to repeat the dive.

HOW DO I GET THERE

Fly to Newcastle, but driving is best from places in the UK. Based in Northumberland, Seahouses is well signposted from the A1 and Beadnell is about 2.5 miles (four kilometres) to the south.
Rigid inflatable boats (RIBs) can be launched from either Beadnell or Seahouses.

WHITE SAND RIDGE

Unique interaction with Caribbean dolphins

The air is still and the ocean surface is as smooth as glass. These shallow sandbanks are home to a resident school of Atlantic spotted dolphins.

United States
Atlantic Ocean
Grand Bahama
Cuba
Caribbean Sea

maximum depth:
12m

minimum depth:
3m

access
Good climate all year round. Boat access from the beach and jetty. Liveaboards from Florida can access these dive sites. Many dive companies advertise in the area and you can take your pick. Boats usually go out two or three times a day. You can dive or snorkel this site.

average visibility
10m–30m

water temperature
25°C–27°C)

dive type
Reef dive or snorkel

currents
Slight

experience

in the area
*North Memory Rock
Lily Bank
Fish Bowl
Cat Cay
Freeport
South Riding Rock*

WHAT WILL I SEE?

White Sand Ridge is a particular spot in the Bahamas which offers the unique chance to have close encounters with dolphins while diving or snorkelling.

Even as the boat approaches Little Bahama Bank, the dolphins come over to ride the bow wave and show off their acrobatics. Just seeing Spotted Dolphins on the surface in the wild results in an upbeat atmosphere and exhilaration among the passengers and crew.

The Bahamas are a beautifully formed string of islands straddling the Tropic of Cancer. White Sand Ridge is about 35 miles north of the port of West End.

Yellowfin tuna and amberjack can be observed hanging around with the dolphins–perhaps they feed off scraps disturbed by the dolphins as they eat from the seabed.

Small shipwrecks lie in the area, resting on the sandy bottom.

Underwater encounters with dolphins do occasionally happen throughout the Caribbean waters, but on a far less predictable and less intimate basis than here.

THE DIVES

There are many beautiful coral reefs and dive sites in the Bahamas. White Sand Ridge is where divers may encounter the largest numbers of dolphins, and they are often happy to interact with people.

The edge of the bank plummets into the deep blue waters of the Atlantic and the Gulf Stream. Here at the sandbank, the water's combination of temperature, salinity and density creates the perfect conditions for individual dolphins to stay in contact with each other

acoustically for miles around– the sandbank acts like an underwater phone line.

Under the surface, the dolphins excitedly rush up towards the divers and then they are gone. They return, moving around the divers more purposefully and slowly. Their movements are deliberate as they swim around you, one way and then the other, making you wonder who is observing whom. Their exceptional aquatic skills allow them to position themselves within inches of you, yet never allow you to touch them. The dolphins move off the sandbanks in the late afternoon to feed on squid in deeper waters.

Bring your patience with you, as there is no guarantee that the dolphins will appear and they may not turn up to your timetable. While you are waiting, there are other areas to explore. Study the sand, as many species of stingray can be found in the Bahamas. Look around for the dolphin's food source–crustaceans and flatfish hiding beneath the sand. The banks are home to many other forms of bottom-dwelling marine life such as lizardfish, razorfish, garden eels and shoaling reef fish.

Nearby lie the remains of the Spanish treasure ship Nuestra Señora de las Maravillas, which struck the bank in 1656; her heavy load and treasure have already been salvaged.

Matanilla Reef lies just off the bank, alongside a line of dense coral heads. Large colonies of elkhorn form a forest of branches and twigs that shelters an army of grunts and snappers. Brightly coloured nudibranchs crawl on the elkhorn, adding to the marine diversity. Colourful Christmas-tree worms embed themselves

ON DRY LAND
Trips are available to island-hop; there are 700 islands in the chain, 30 of which are inhabited. Wildlife habitats including pine forests and wetlands give the Bahamas a Robinson Crusoe feel. Other watersports are on offer including sailing, canoeing, windsurfing and kite surfing. Many James Bond films have been produced in the Bahamas, and wrecks have been purpose sunk to produce the underwater film set. They are worth a visit and a dive.

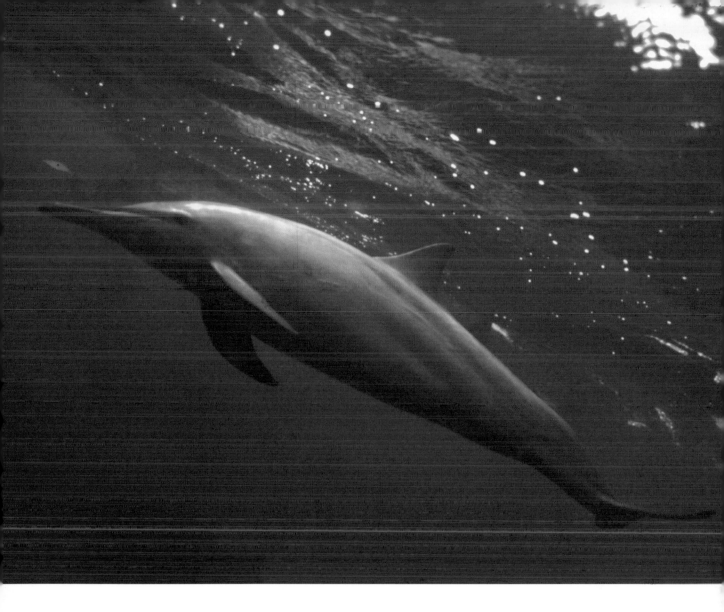

in the coral. If time and air allow, move towards the seaward side where the woods give way to deep ravines and cliffs with pinnacles. Here you may see a black grouper, unusually turned white, as translucent banded coral shrimps scurry over its body, picking off titbits. The grouper can change colour like this to indicate its wish to be cleaned. Its mouth open and gill plates splayed, this is an important appointment.

As you finish the dive and wait on the surface to be picked up by your boat, you can hear calls from the dolphins. They are never far away.

HOW DO I GET THERE

Flights via the US, typically Miami or Freeport. The main airport in Bermuda is Nassau.

SHA'AB SAMADAI

Dolphin Delights

This horseshoe shaped reef is one of the few places in the Red Sea where the chances of seeing and swimming with wild dolphins are high.

maximum depth:
18m

minimum depth:
3m

ʋʋʋʋʋʋ
Day boat from Marsa Alam or liveaboard.

average visibility
15m–30m

water temperature
26°C–28°C

dive type
Reef diving

currents
Mild to none

experience
*

in the area
Day boat diving out of Marsa Alam with many nice reefs. Liveaboards often continue south to dive Daedalus, Rocky Island and St Johns Reef.

WHAT WILL I SEE?

The massive, U-shaped coral reef has created a sheltered lagoon. The turquoise waters of this shallow pool attract several families of spinner dolphins who rest between their hunting expeditions. Over the years they have got used to the dive boats visiting and, when they are in the mood, they allow snorkellers to come quite near to them. Initially, you see a brief view as they whizz past but usually they return with slower and intentional movements towards you. Then a dolphin comes close and looks you in the eye; truly an unforgettable experience.

Wild dolphin encounters are always by chance, enhancing the anticipation of seeing one. A dolphin will choose whether you can join its world; it is not forced upon them.

THE DIVES

This protected lagoon offers pretty coral gardens and swim throughs or holes in the reef. You can enter it at around 3m and it deepens and narrows with twists and turns. When you pop out on the other side, you continue the dive around the coral heads.

On the outer reef wall, a group of ergs or small pinnacles stretches out from the end of the barrier, where turtles have been seen feeding on the soft coral. The largest erg is best seen again at night, when there is a good chance of seeing a Spanish dancer. Coral grouper, freckled hawkfish and many of the common Red Sea fish life can be seen here. In between the erg lie wide stretches of white sand, and here many animals can be spotted. Stonefish and devilfish lie still, blue

ON DRY LAND
Marsa Alam has some inland attractions, such as the Emerald Mines and the Temple of Seti I at Khanais. Several hotels have large golf courses. At El Quesir, there is a fortress; the Sultan Selim built the Quesir Fortress in Marsa Alam in the 16th century. This has been refurbished and a museum has been opened there.

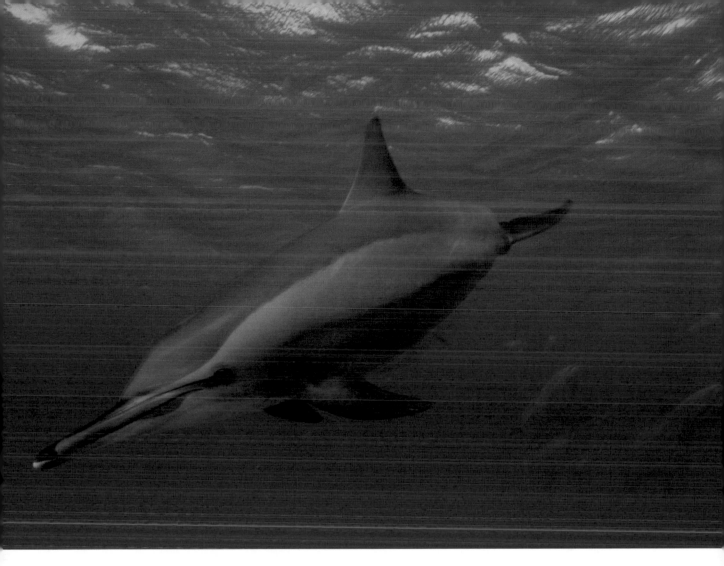

spotted stingray hide in the sand and well camouflaged crocodile fish lie in wait for their next meal. Many anemones and clownfish are scattered on the coral on the ergs, with one group in particular near the cut through, like a clownfish village. This reef even has a resident Napoleon wrasse.

Mild currents drift southwards on the outer side of the reef (west), which usually has the sun on it in the afternoon. The reef caves feel like a labyrinth; scorpionfish and morays hide here so keep a clear look out as you go through the more narrow sections. The light rays hit the sand, giving a feeling of being in a great cathedral.

During the dive, dolphin clicks and whistles are clearly audible, and you look all around in anticipation of a glimpse; then they come, full of energy and enthusiasm for life in the sea.

In the last five years, the Red Sea authorities have created exclusion zones to separate snorkellers from the main reef the dolphins feed and rest in. This allows the dolphins to choose who they interact with; visitors are clearly told they have a 50/50 chance of any close viewing.

Even as the boat motors away, dolphins can often be seen riding the bow, ducking and diving in the surf.

HOW DO I GET THERE
Flights to Marsa Alam from Europe, or transfer from Cairo, Sharm or Hurghada airports. You could travel by bus or get on a boat/liveaboard from Hurgharda.

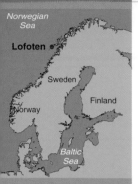

Norwegian
Sea

Lofoten ●

Sweden

Finland

Norway

Baltic
Sea

maximum depth:
1m

minimum depth:
0m

access
Day boats generally set off south and east from Kabelvag, heading deep into the Vestfjorden. Weekend trips start and end at Orca Basecamp. It takes around three hours to motor to the spot the orcas can be found. Orcas are most abundant in the Fjord from October to January. Day boats and ribs operate form the shore, and liveaboards are available for a weekend or a week's dive, including the orca snorkelling.

average visibility
10m–15m

water temperature
8°C–11°C

dive type
Snorkel, though some areas operate dives

currents
Strong, but no problem for surface snorkellers

experience

in the area
Shipwrecks in the area include:
Nordstjerna
Mira
Gallic Stream
Stella Orion
Fram
Hamburg
Ramoe
Rio

LOFOTEN
Swimming with killer whales

Being close to a pod of killer whales at close range, particularly swimming among these enormous animals, is one the most exciting experiences in the world.

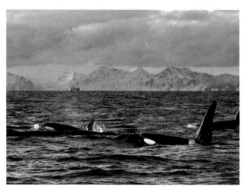

WHAT WILL I SEE?

There are approximately 600 whales in this area of Norway, following an important food source, herring. The killer whale is not strictly a whale at all, and is in fact the largest member of the dolphin family.

Coastal current pumps clear water from the Atlantic Ocean in between the Lofoten islands, bringing good visibility and a special selection of marine life.

In the currents and on the cliff walls, there are carpets of soft corals that filter these nutritious waters. Underwater cliffs and deep crevasses are surrounded by forests of giant kelp, looking like palm trees on a white sandy beach, the bed of white coral sand below making a great contrast.

Orcas remain in close-knit family pods and communicate using sound; each whale learns the different sounds within the pod.

THE DIVES

Rewards come to those who wait; you may be on the boat for five hours, motoring and searching for the whales, watching and hoping they will come.

Usually, the liveaboard or day boat will take you to the islands then transfer you to a rib or tender. It is possible to dive in order to see the orcas but the most successful sightings are from snorkelling.

Divers are loaded into the rib and the serious search continues. The intensity builds, as no one wants to miss the reason for being there. There is relief when the skipper points to a group of whales, circling and tail slapping. They are rounding up shoals of herring for

a feed and the smell of the sea hits your senses. As the signal is given to enter the water, the freezing cold hits your face and the water appears dark and menacing, with low visibility. Crowds of fish are in the way and it seems there are no killer whales, until the panic stricken herring shoal parts and an orca streaks past, a white flash moving below you.

The awesome pod is made up of adults and calves working together, completely absorbed and focused on the job in hand, hunting. You can follow them, but they quickly vanish into the depths. Deep into the fjord, you should be able to observe several pods of killer whales, often travelling fast and intent on finding herring. In this state, they are moving too fast. The best time is when their stomachs are full and they are less interested in food but curious about the divers.

Your expert guides will identify when the whales have been sighted in this state, and this is the best time to be with them. Again, you have to contain your excitement as you listen intently and wait for the moment of entry. The whales' majestic dorsal fins announce their arrival; you can hear the slap of the sea against the inflatable and the amazing sounds of the whales blowing through their blowholes. Their movement through the water is powerful and purposeful. As you once again hang in the water and wait, you may be lucky to see them swim below you, inverted in order to get the best view of the strange entrants to their world. They are curious and intent on investigating their visitors.

Light fades quickly here, and it is time to leave the killer whales.

ON DRY LAND
Sea eagle safaris are organised through the village or travel agent. In the centre of the charming old fishing village of Kabelvaag, you will find the Lofotdykk diving centre and quaint local accommodation. Some rock climbing can be enjoyed on the islands.

HOW DO I GET THERE
Flights from Europe and America to Lofoten via Oslo; take a ferry or drive from neighbouring countries It takes about three hours by air from Oslo to Lofoten.

WEST INDIAN MANATEES

Close encounters with mermaids

Time to leave behind your tanks and snorkel with a mermaid. It is believed that in ancient times mariners mistook manatees for mermaids, which, if nothing else, is evidence that they spent too long at sea!

Atlantic Ocean

Crystal River

Florida

Gulf of Mexico

Cuba

maximum depth:
3m

minimum depth:
0m

access
Via dive resort boats that will take you right to the manatee.

average visibility
3m–10m with better visibility in winter months

water temperature
23°C

dive type
Snorkelling with manatees

currents
None

experience
** to ***

in the area
Once you have finished snorkelling with the manatees, there are plenty of dive sites to choose from, such as Kings Springs with its cavern, Kings Bay with its caves, Rainbow Springs, Devil's Den and Blue Grotto. Snorkelling with manatees is also available at nearby Homosassa Springs.

WHAT WILL I SEE?

There is plenty of diving to be had in Crystal River but, for the manatees, only free swimming is allowed. This is an experience we could not leave out of this book, however, as these friendly, slow moving sea cows are a delight to get up close and personal with. The resorts in the area have set up strict regulations for these encounters and rightly so, as there was a time when many manatees were being injured or killed as a result of fast boats without propeller covers and lack of speed controls. Now, Crystal River is a safe haven for them all year round.

The migratory manatees normally arrive around October and leave around April when the food supply dwindles. Some 40 manatees now remain in Crystal River all year round, however, so you will have the opportunity to free swim with these cute creatures no matter what time of year you visit. The fresh water, spring-fed river remains at a constant temperature of 23°C. When the temperature in the Gulf of Mexico drops below that, hundreds of manatees make their way to Crystal River until the Gulf waters return to a suitable temperature for them.

Manatees can grow to 3m or more, and live for up to 60 years. They are herbivores and spend a lot of time feeding and resting. They eat aquatic plants and are known to consume up to 15% of their body weight

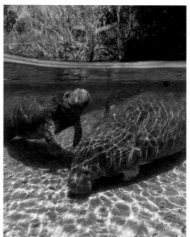

daily. They may rest just below the surface or submerged on the bottom, normally coming up to breathe every three to five minutes although they have been known to stay submerged for up to 20 minutes. On average, they swim at about 5–8kph although they have been known to reach speeds of 32kph for short bursts. Their closest relative is believed to be the elephant and they are thought to have evolved from a wading herbivore.

THE DIVES

A Federal Enforced Manatee Protection Program has been put in place to safeguard the future of these wonderful creatures. You will need to accept that your encounters with manatees will be closely managed affairs–it is thanks to this that the manatees' livelihood is well maintained, so it should be welcomed.

You will be taken by boat, normally with no more than 15 people. You will be given a briefing on the do's and don't's of snorkelling with the manatees and then slide into the warm, spring-fed waters to experience the encounter. You are only likely to be in about 3m of water so, whether you wallow on the surface or duck dive down, this is easy snorkelling.

Crystal River is the winter home of the largest concentration of manatees in North America and is deservedly world famous.

ON DRY LAND
Kayaking and canoe services are available in Crystal River, including guided kayak tours. There is a Crystal River wildlife refuge, which can be reached by kayak. Airboat rides are also available across the flats of the Crystal River or in the Gulf of Mexico. From these, you may see dolphins, alligators, eagles and much more, as well as manatees. Birdwatching can be rewarding around King's Bay, with over 200 species of birds found in the area. Homosassa Springs Wildlife State Park is nearby. Fishing tours are available and there are golf facilities in the area. There is also horseback riding and hiking, and plenty of tours to select from. There are plentiful dining options and hotels, as well as shopping and nightlife.

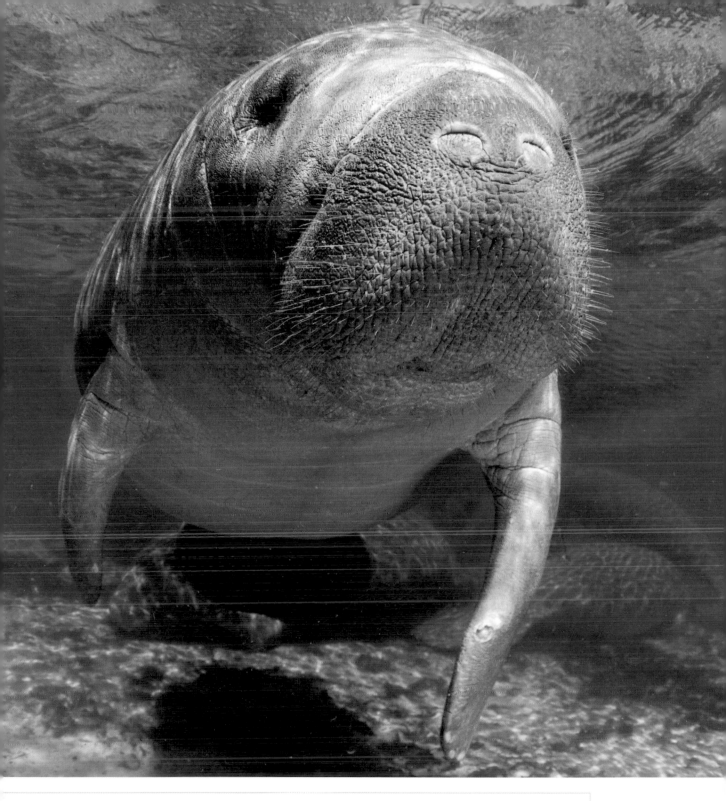

HOW DO I GET THERE

Fly to Orlando International Airport and drive to Crystal River (100 miles/160km)
Fly to Tampa International Airport and charter flight to Crystal River.
With tour organised trips, various forms of transportation can be arranged.
Car hire is readily available, and bus transfer services are available.

LAHA I
A psychedelic experience

With diving being such a popular sport these days, it may seem surprising that new finds are still being made, from previously undiscovered wrecks to new species of fauna. It is not so surprising, however, when you consider that the life that has survived and flourished in this hostile environment has done so by making amazing adaptations to protect itself. One of the most exciting recent discoveries has been a new species of frogfish, now formally named Histiophryne psychedelica. *Aptly named, this bizarre looking creature makes you wonder whether you have been slipped magic mushrooms with your last meal.*

maximum depth:
2m

minimum depth:
12m

access
Normally by boat from local dive centre. Liveaboards do operate in the area.

average visibility
15m–30m Variable due to local shipping activity etc.

water temperature
Average 29°C (86°F)

dive type
Muck dive

currents
Mild to strong. Local knowledge needed to plan dives.

experience
** to ***

in the area
Pulau Tiga No.2
Laha II
Ambon Wreck
Pintu Kota
Murdoch's Point
Batu Kapal
Tanjung Kilang No.9
Tanjung Hukurila No.10
Cape Paperu No.17
Molana No.19
Nusa Laut No.20
Hukurila Cave
Lehari

WHAT WILL I SEE?

The Moluccas (or Maluku) are also known as the Spice Islands and consist of a string of islands stretching between Sulawesi and Papua. Once the only place where spices such as nutmeg, mace, cinnamon and cloves were found, these islands were an important trading post. Ambon Island, the capital of Maluku, was the centre of the spice trade in the 17th century.

A narrow neck of land separates the two peninsulas, Leitimor and Hitoe, that make up Ambon Island. As a busy port and the hub for spice trading over many centuries, the island inherited many colourful cultures and religions, which generally live together in harmony. However, in the late 1990s, there were serious disturbances between Christians and Muslims. Before then, this had been a little known dive location and subsequently, diving dried up completely on the island. Today, the situation is peaceful again and diving operations have now re-established themselves.

It was already becoming famous as a world class muck diving area but its fame increased tenfold when a new species of frogfish was discovered and photographed there. One look at this amazing creature makes it absolutely obvious why it was given the Latin name *Histiophryne psychedelica*. It hit the headlines everywhere and is likely to make Ambon Island a magnet for muck diving enthusiasts and underwater photographers who want to record this rare and exotic creature.

THE DIVES

Like all muck diving sites, to the uninitiated first impressions can be deceptive. Laha I is typical, with its substrate of sand, rocky outcrops and muddy or grassy bottom, interspersed with the detritus of mankind. But abundant in this seemingly drab terrain are weird critters that have evolved over millennia to survive by adaptation. Darwin's theory really comes to life in muck diving sites, where animals blend into the terrain. However when you find them, which is often only possible with the help of a local guide experienced in spotting them, it is amazing how the full wonder of these creatures can be realised, with the help of flash photography.

Ambon is one of the great muck diving locations and some would say the best. Laha I lies in the bay between the north and south peninsulas, near the village of Laha, and centres on a working jetty used by fuel tankers and small fishing boats. From here, the reef drops away from 2m down to about 12m and continues to drop down to the depths from there. Organic matter from the fishing boats, currents, freshwater run-offs and upwellings all help to create the conditions where the muck diving critters flourish. In the black volcanic sand, the rocky coral outcrops and man made junk, such as old tyres and parts of filing cabinets, provide suitable hiding places for creatures.

On this shallow dive you will have plenty of time to explore and discover the reason that Laha I is a Mecca for muck divers. Lacy scorpionfish, stingerfish, wonderpus octopus, ghost pipefish, sea moths, flamboyant cuttlefish, and seahorses are just a few of the many species associated with muck diving. Of course, frogfish are also there in various guises and one in particular has really brought Ambon Island to the attention of underwater photographers of late.

ON DRY LAND Use local transport to get around the island, such as taxis, minibuses and hooded tricycles known as becaks. As the capital city, Ambon has many buildings of historical significance, although a lot of them were damaged during World War II. The island is volcanic in origin and mountainous with rainforest. Although Ambon experienced racial tension in recent years, this has now eased, meaning that dive resorts have begun to return. Before travelling to Ambon, however, you should seek guidance from your own authorities.

No doubt the recently identified *psychedelica* frogfish will attract many divers to see it. There is no guarantee that you will see one, of course, as they do not appear to order. Hopefully, however, the recent emergence and naming of the species will lead to this frogfish becoming a regular feature of diving this area; as far as is known at present, it is endemic to it. It is an amazingly beautiful creature with fleshy skin (frogfish are anglerfish, which do not have scales) and striking pink and white, yellowish brown or peach, zebra-like stripes, probably designed to mimic certain hard corals. Its face is flattened and, unlike most fish, its eyes face forward; this gives it the same type of depth perception as humans, which is a trait rarely seen in fish. Unlike many frogfish, it does not have a lure to attract prey.

If you are hooked on muck diving, this is a place you cannot afford to miss. There are also many other dive sites just a short boat ride away.

HOW DO I GET THERE

International flights to Jakarta, Bali, or Manado, and connecting flight to Ambon via Makassar

South
China
Sea

Hairball

Indonesia

Java Sea

Indian Ocean

maximum depth
30m

minimum depth
3m

access
Resorts in Lembeh Strait via Manado airport or liveaboards from Manado. Some liveaboards are now including Lembeh in their N.E Sulawesi itinerary.

average visibility
5–20m with greater visibility (20–30m) at the ends of the strait.

water temperature
July–November 26°C Rest of the year 28°C

dive type
Muck dive

currents
Variable. Can be quite strong as tides pass through the strait.

experience
** to *** normally due to tides.*

in the area
Approximately 30 recorded dive sites within the strait, all accessible from the resorts in the area or via liveaboard. Further afield there are many dive sites to the north of the strait around Bangka Island, Talis Island and Gangga Island, and on the northern tip of the mainland. In addition, on the western side of the mainland the islands of Runaket, Manadao Tua, Siladen, Mantehage and Nain provide a further abundance of dive sites.

HAIRBALL (I & II), LEMBEH STRAIT

Where muck diving was born

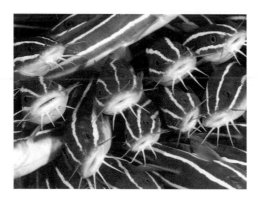

It is hard to imagine what induced the first divers to go underwater in the Lembeh Strait, which is the main shipping lane to the port of Bitung. The seabed is predominantly black volcanic sand, with some coral outcrops and the detritus of mankind littered about. But first impressions are deceptive. On closer inspection, you find some of the most exotic and outlandish creatures in the sea, evolved over millennia to survive in this habitat.

WHAT WILL I SEE?

The Lembeh Strait has a wide range of dive sites on both Sulawesi mainland and Lembeh Island. It is noted for being at the epicentre of marine diversity and is world renowned as a muck diving paradise. However, there are also areas of attractive reef systems, particularly on the Lembeh Island side of the strait.

Hairball (I and II) is very much a muck diving site, with black sand, algae and patches of sponge. Although these are ostensibly two dive sites they are on a continuous stretch of seabed and, with a long dive and enough air, it is easy to take in both of them.

THE DIVES

The depth varies from 30m to 3m and therefore offers ample opportunity to work up to the shallows slowly on a long, relaxing dive. You are likely to come across many different critters, including various species of frogfish, devilfish, snake eels, tiny cuttlefish and flamboyant cuttlefish, ambon scorpionfish, harlequin ghost pipefish, clouded moray eels, catfish, gurnards, mantis shrimps and dragonets. Giant helmet shell *(Cassis cornuta)* can also be found lumbering across the black sand. Growing up to 25 cm, these feed on echinoderms.

ON DRY LAND
There are plenty of things to do on land, which can be organised through travel organisations. These include a Minahasa Highland tour, a visit to Mount Mahawu or Mount Locon volcanos, a visit to Tangkoko Nature Reserve, home to the Black Crested Macaque, which is indigenous to North Sulawesi, and the Tarsier Spectrum, the world's smallest primate. White water rafting and horse riding trips are available, as well as a visit to the Kali Waterfall. You can also do a tour of Manado City, which has much to offer the tourist.

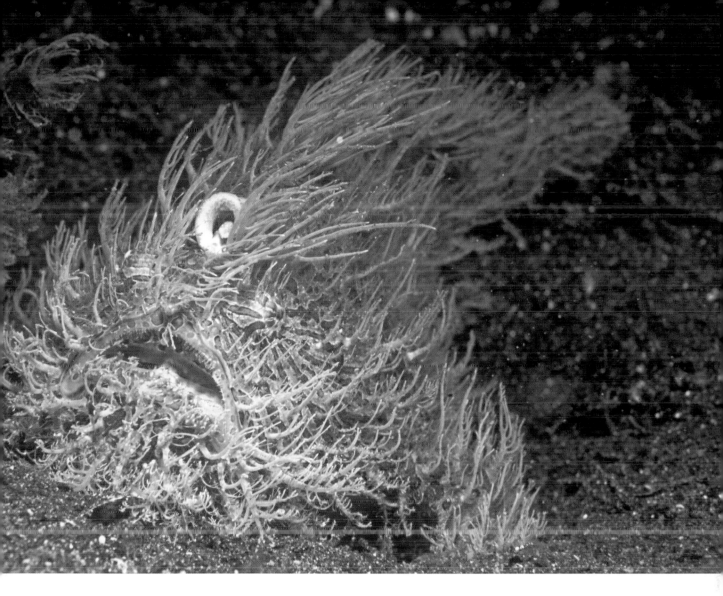

One of the most exciting critters to be found here is the hairy frogfish. Its modified pectoral fin is used as a lure to attract its prey, which is quickly devoured by the frogfish. Its evolution to such an exotic design becomes a little more understandable when one sees its terrain, which has growths of algae that look like underwater tumbleweed. The hairy frogfish could easily be mistaken for algae. Similarly, some species of pipefish look like leaves, and have no doubt evolved as a result of the fact that leaves invariably fall from the land into the sea, and looking like a leaf is a good way of protecting themselves against predators.

The ornate ghost pipefish will often be found hovering near feather starfish, where they can easily be confused with part of the feather starfish and go unnoticed.

Catfish may be found flowing like a wave across the seabed, taking turns to head the flow as they search for food. Gurnards may be seen, too, with their wonderful fan-like pectoral fins.

Sea anemones that have found a foothold in the black volcanic sand may have resident clownfish, as well as porcelain crabs and shrimps.

HOW DO I GET THERE

Flights to Manado, where local resorts collect their visitors and transport them to the resort.

South
China
Sea

Efratha

Indonesia

Java Sea

Indian Ocean

EFRATHA

Beauty and the beasties

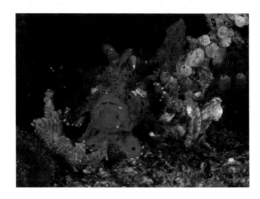

Just north of the Lembeh Strait is one of several dive sites that are well-kept secrets, because the local dive resort that discovered them does not include them on their maps. One of these is Efratha, which is an amazing site, offering beautiful corals, a drop-off to die for and wonderful exotic species.

maximum depth:
20m

minimum depth:
0m

access
Resorts on Gangga Island and in Lembeh Strait via Manado airport or liveaboards from Manado.

average visibility
20m–30m

water temperature
Approx 28°C all year

dive type
Reef dive

currents
Variable

experience
* to *** normally due to tides

in the area
Approximately 30+ dive sites around the islands of Bangka, Talisei and Gangga and on the north coast of mainland Sulawesi. These are easily accessible from the island resort on Gangga and can also be reached by liveaboard.
The islands of the Bunaken National Marine Park are a journey of about one hour to one-and-a-half hours to the south-east. Lembeh Strait is a similar distance to the south-west.

WHAT WILL I SEE?

The Lembeh Strait is world famous as a muck diving location but just to the north of it is a group of islands that offer all the diversity you would expect from this area as well as colourful reefs and great muck diving sites. The main ones are the islands of Bangka, Gangga and Talisei. Just to the south of these is a stretch of the North Sulawesi coast along which Efratha lies.

All of these dive sites are easily reached from Gangga Island and, at the time of writing, this has the only dive resort in the immediate vicinity.

THE DIVES

You normally start your dive at about 20m and there are areas of white sand interspersed with outcrops of coral. On beautiful red branching corals you may find cowries with mantles that match the colouration of the coral. Clams also display their colourful mantles and seemed quite insensitive to the presence of a diver, enabling photos to be taken showing the wonderful colourations of the living tissue. Many species of nudibranchs can be found on the sand and amongst the corals. Golden and Reticulated Damselfish are found in and around live

ON DRY LAND
Gangga Island has a local community and it is perfectly safe to stroll along the beach and through the village. The island is one

of an archipelago of small islands connecting Indonesia with the Philippines. The strait separating Gangga from the mainland links the Pacific Ocean with the Indian

Ocean.
The mainland is only about three miles (4.8 kilometres) from Gangga and there are plenty of things to do on land, which can be

organised through travel organisations. These include a Minahasa Highland tour, a visit to Mount Mahawu or Mount Locon volcanoes, and a visit to Tangkoko

Nature Reserve, home to the Black Crested Macaque, which is indigenous to North Sulawesi, and the Tarsier Spectrum, the world's smallest primate. White water

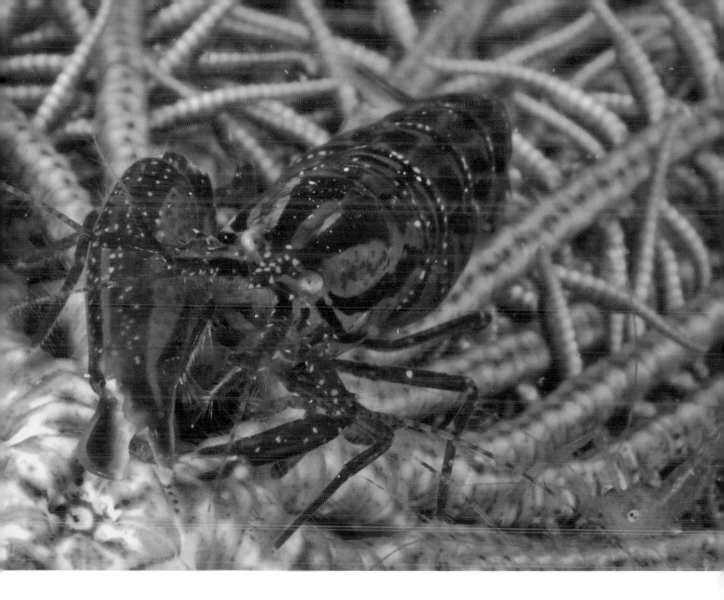

branching corals. A close inspection of bubble anemones will reveal various species of shrimp that live in symbiosis with the anemones, and maybe an orangutan crab. A careful inspection of crinoids may reveal crinoid shrimps, although these are normally found on the oral disc or on the lower part in contact with the substrate so it may require the help of the dive guide to see them.

There are plenty of fish such as the blacktipped grouper, trumpetfish, lionfish, scorpionfish and pipefish, as well as some lovely sea anemones on the seabed with their resident clownfish. Various species of frogfish may be seen.

The dive will take you to a sheer wall, rich with marine life including leaf fish, butterflyfish, spinecheeks, angelfish, trunkfish, and many more species that you would expect to find on such an unspoilt reef.

Another highlight of the dive is electric clam. Its name derives from what appear to be streaks of electricity flashing across its red mantle. This is in fact caused by phosphorescence and is an amazing light show in miniature.

Finishing the dive while swimming along the wall enables you to ascend slowly while discovering more and more species and enjoying the dive right to the end.

rafting and horse riding trips are available, as well as a visit to the Kali Waterfall. You can also do a tour of Manado City, which has much to offer the tourist.

HOW DO I GET THERE
There is one resort on Gangga, which discovered this dive and includes it in its itinerary. Gangga is reached by flying into Manado. From there, you are transported north to the coast, where a boat collects you and takes you the three miles to Gangga.

Some liveaboards are now including the area in their itineraries.

HOUSE REEF

Muck diving paradise for magical macro photography

Mabul has provided many divers with the best opportunity to dive the famous nearby island of Sipadan ever since dive resorts were removed from there. Mabul has its own unique marine environment, however, and is especially famed for its exotic macro marine life.

Philippine Sea
Philippines
Mabul
Celebes Sea
Indonesia

maximum depth:
30m

minimum depth:
5m

access
Shore dive or boat to particular part of the house reef. Liveaboard dive boats also visit the area.

average visibility
5–15m

water temperature
26°C–30°C

dive type
Muck dive

currents
Nil to light

experience
to**

in the area
There are many dive sites around Mabul, including Crocodile Avenue, Froggy Lair, Eel Garden, Ray Point, Lobster Wall, Ribbon Valley, Odrieland, Paradise, Old House Reef (1 and 2), Panglima Reef, Old Lobster Cave, New Lobster Cave, Stingray City and Second Wall Rocks. Offshore is Sea Venture, a converted oil rig a short distance from Mabul, and its vast underwater structure makes a great dive. In addition to the neighbouring island of Sipadan with its many dive sites, Kapalai Water Village is just a short hop from Mabul. the sunken remains of an island and there is therefore no land above the water. Mangrove dives are available at Semporna, which is some 30 minutes away by speedboat.

WHAT WILL I SEE?

This small, oval island is ringed by sandy beaches and surrounded by a 2 km² reef system, which is on the edge of the continental shelf. Surrounding the reef, the seabed slopes away to about 30m before dropping away to the deep. Most of the creatures you will find here are small bottom dwellers but many are unique and exotic, and some are very rare. Their evolutionary development has meant a lot of them have evolved to become weird and bizarre. An extensive water village has been developed over part of the reef; we have chosen this water village's house reef as most of the creatures can be found right on the doorstep.

Although Mabul is actually larger than its neighbouring island of Sipadan, it was less well known when divers were able to stay on Sipadan. Even then, a visit to Sipadan would not be complete with one or two trips across to the famous muck diving sites of Mabul, 25km to the north. Now the situation is reversed and diving on Mabul would not be complete without one or two visits to Sipadan when divers are staying on Mabul. What has not changed is the fact that Mabul is one of the best destinations for exotic macro life.

THE DIVES

Mabul ranks as one of the great dive sites for muck diving with the wonderful exotic critters that can be

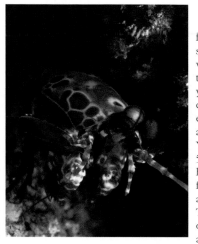

found there. As this dive can be done straight from the Mabul Water Village, which is located to the north-east of the island, you can repeat dive to your heart's content, including night dives. With its easy access, you may encounter a host of weird creatures as well as some less unusual ones. You can choose your depth, from 5m to 20m. Cuttlefish can be found here in great numbers, including flamboyant cuttlefish with their amazing display of colour changes. There is also a diverse variety of octopuses, including the blue-ringed and mimic octopus, squids, sea stars and boxer crabs.

Some of the wonders of the fish world seen here are giant, painted and clown frogfish, ghost pipefish, sea moths, sea horses and pygmy hawkfish, to name just a few. The goby alone may provide sightings of black sailfin, spikefin, fire and metallic shrimp gobies. There are morays, crocodile fish, triggerfish and scorpionfish. Shoals of catfish may be sighted rolling across the seabed like waves as they feed from the sand. This will be paradise for you if you like nudibranchs, as you will come across many different brightly coloured species.

You are unlikely to find the big stuff here: for that, you can take a short trip to Sipadan. The weird and wonderful world of muck diving is what makes Mabul famous, and deservedly so.

ON DRY LAND
The small island of Mabul is covered with palm trees and the indigenous inhabitants are made up of one of the many ethnic groups in Sabah, the Bajeu Laut tribe. The villagers live in close proximity to the resorts. You can stroll around the island and mingle with the local population, who are friendly and welcoming.

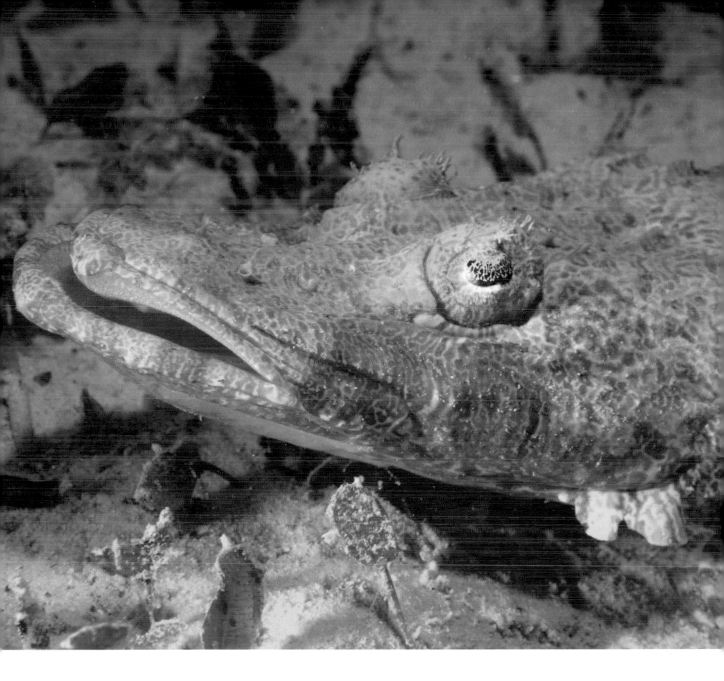

HOW DO I GET THERE

International flight to Kota Kinabalu, Sabah, Malaysia, and internal flight to Tawau. From there, dive centres organise for you to be collected and driven to Semporna, which takes about one hour. A fast resort boat will transfer you to Mabul Island in about 45 minutes.

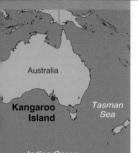

Australia

Kangaroo
Island

Tasman
Sea

Indian Ocean

maximum depth:
20m

minimum depth:
10m

access
Dive sites are 20
minutes by boat from
the island. Hard boats
go out for the day to
take in two or three
dives. The ideal way
to ensure you find
the rare leafy sea
dragon is to book a
liveaboard for two or
three days. Most div-
ing is done on the lee
side of the island, as
opposed to the side
facing Antarctica,
which is swept by
strong winds most of
the time.

average visibility
10m–40m

water temperature
17°C–24°C

dive type
Reef

currents
Slight

experience
**

in the area
Snapper Point
Backstair Passage
Penneshaw Jetty
Kangaroo Head
Nepean Bay
Western River Cove
Fides Shipwreck
Hanson Bay

KANGAROO ISLAND

Floating algae reveals a surprise

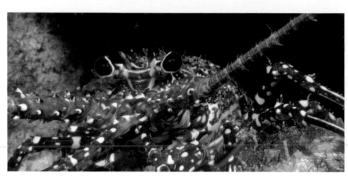

The north coast of Kangaroo Island has some of the most spectacular cliffs to be found around Australia's coastline. Underwater lives a special and elusive creature, the leafy sea dragon, which is endemic to the waters around Kangaroo Island.

WHAT WILL I SEE?

The waters off Kangaroo Island provide some of the best temperate water diving in Australia. Marine life is prolific and has a buzzing temperate water environment. Blue devil fish, harlequin fish, truncate coralfish and boarfish are a few of the more unusual fish found here.

Unique to the southern waters of Western Australia and South Australia, many divers travel great distances to see the elusive leafy sea dragon. Found amongst the inshore areas of sea grass, this is a very bizarre looking fish. On first encounter, it may be mistaken for a piece of drifting algae.

This rare and vulnerable relative of the sea horse is small, on average 30cm, with a long tube-like snout that sucks up larval fish, plankton and mysid shrimp.

Adult sea dragons are green to yellow-brown with thin, pale dark-edged bands. As with many species of sea horse, sea dragons are able to change colour depending on age, diet, location or even their stress level. New research has shown that leafy sea dragons have a highly sophisticated navigation system, venturing hundreds of metres from their base but returning precisely to the same spot.

A diverse variety of marine fish lives in these temperate seas and there are over 370 species, many of them unique to Southern Australia.

THE DIVES

As well as sea dragons and abundant species of fish, the north coast of Kangaroo Island is home to seals and dolphins. Australia also boasts some of the most prolific areas of soft coral, sponges and gorgonians found in temperate waters.

Descending to 20–24m, walls reveal Gorgonia corals, impressive red, orange and white sponges. Large schools of swallowtails dart too and fro, each reacting to its neighbour's movement, like a cohesive flying mass. Many crabs, including hermit crabs, and larger lobsters scurry away to their rocky homes. Divers are usually allowed to take the odd cray, lobster or abalone they find on a dive, adding to the fun of the trip.

This rocky reef has particularly abundant sponges, tubeworms and bivalve molluscs. Anemones, sea stars and urchins are scattered around the rocks, poking out from the colossal kelp and brown algae.

The leafy sea dragon is extremely difficult to find. Bunches of seaweed and algae sway with the water

ON DRY LAND
Kangaroo Island is a haven for wildlife including mammals, reptiles and birds. Its most famous attraction is Seal Bay Conservation Park

on the south coast, home to a colony of Australian sea lions. Visit Flinders Chase National Park to admire a spectacular rugged coastline, where acacias,

banksias and tea-trees grow right down to secluded beaches. Bird lovers may observe sea eagles and osprey. The undisturbed forest and grassland is home

to kangaroos, wallabies and the rarely seen platypus. Visitors can see many koalas too. An alternative day out is the Kelly Hill Conservation Park, an underground

labyrinth of limestone caverns and sinkholes. Here you can view incredible formations of stalagmites, stalactites and helictites.

movement, and odd bits break off and drift by. You will need to look more closely as one of the floating seaweed fronds may actually be a passing leafy sea dragon. Often hiding in clumps of seaweed, its shape blends into the fronds of the kelp, making it hard to spot. By using artificial light, you can really see what a beautiful and fascinating creature this is.

Many divers choose the breeding season to observe these creatures, particularly between August and March when the male sea dragon gives birth. The bright pink eggs become embedded in the cups of the brood patch, receiving oxygen via the cups' blood vessels. During each breeding season, male leafy sea dragons will hatch two batches of eggs.

HOW DO I GET THERE
International flights via Dubai, Singapore or LA are most common. Fly to Adelaide, South Australia

From there you can reach Kangaroo Island by ferry, from Glenelg to Kingscote, or from Cape Jervis to Penneshaw. A small twin engine

aircraft can be booked to the island itself.

Pacific Ocean

Papua New
Guinea

Milne Bay

Australia

Tasman
Sea

minimum depth:
8m

maximum depth:
40m

access
*Liveaboard is the
best way to explore
the reefs, but
Dinah's Beach is
accessible both by
boat and by shore.
October to December
generally enjoy
the best and most
consistent weather,
while strong, south-
easterly winds are
usually experienced
in January to March;
this is also the
cyclone season.*

average visibility
5–15m

water temperature
26°C–29°C

dive type
Reef

currents
Slight

experience

in the area
*Muscoota
Sullivan's Patches
Banana Bommie
Cobb's Cliff
Observation Point
Black Jack
Deacon's Reef
P38 Lightning
Samarai Wharf
Deka Deka Island*

DINAH'S BEACH

Marine life here is so unusual, much of it is new to science

*The tepid waters of Milne Bay, Papua New Guinea, are well known for the rare and unusual crit-
ters that it often yields to the observant diver. Its reef fish communities are also some of the richest
in the world.*

WHAT WILL I SEE?

Between the Coral Sea and the Solomon Sea. The seas surge back and forth, causing a frantic profusion of marine growth.

At the south-east corner of Papua New Guinea, Milne Bay has exceptionally high marine biodiversity. The island systems are a maze of reefs, which provides unending exploration and varied dives in a great variety of habitats.

An endless list of marine creatures awaits you. Seven species of clownfish and up to five species of lionfish may be seen. The flamboyant cuttlefish is a special little creature. It seems to have quite a dull appearance until a predator approaches, when it turns into an array of textures and colours. You will hopefully be lucky enough to come across black gobies, blue ribbon eel and lots more besides. The variety of marine life in Milne Bay is almost unbelievable. Crinoids or feather stars coat the coral, splaying their arms to the water; many species nestle in them or use them for camouflage, including the tiny crinoid shrimp, so hard to spot because it exactly matches the colour and design of its host. Many other rare and endemic species can be seen, such as the rare Merlet's scorpionfish.

THE DIVES

Dinah's Beach is a secluded beach with a small village. Steep limestone cliffs drop straight into the sea and magnificent walls of coral are on offer to the visiting diver.

This sandy beach hides delicate coral gardens, with sea grasses providing protection and breeding grounds for sea horses and rare species of garden eel. As the reefs grow right up to the shoreline, you can swim from the beach to start your dive.

First, you come to a shallow coral and algae reef with a resident anemone family of panda clownfish dancing around their anemone. Juvenile fish stick together in shoals, sweeping past in scared little droves.

The dark sand is a great area for muck diving and as it spreads out you can begin your exploration. It may appear that the reef is surrounded by uninteresting black coral sand but look carefully and you may discover critters such as ghost pipefish, leaf fish and filefish. Amongst the coral rubble and rotting tree trunks can be found other weird critters including cockatoo waspfish and frogfish. Several varieties of multicoloured nudibranchs can be seen slowly making their way to the next clump of coral to graze on. Flying gurnards extend their wings and glide over the seabed. Tunnels dug in the sand provide a safe place for green and red mantis shrimp. Snake eels appear as statues, with just their heads poking out above the sand, as they lie in wait for the appropriate menu to appear for supper.

Tiny coral islands protrude from the sand, giving opportunities to other reef dwellers. It may be possible to observe the mimic octopus, which has been recorded in only a few places in the world. Fairy basslets and sweepers hover over the layers of plate coral, and you will not be bored by the variety of scenery on offer here.

ON DRY LAND Papua New Guinea is part of a great arc of mountains stretching from Asia through Indonesia and into the South Pacific. This fascinating land is home to the largest area of intact rainforest outside of the Amazon. Visitors will discover a wealth of tropical scenery, from the jungle-clad mountains of the highlands to the sandy white beaches and atolls of the coastal and island provinces. The scenery is breathtaking, with volcanic mountains, dense tropical rainforest and large rivers. The rugged mountain terrain and deep cave systems offer adventure for walkers, cavers and climbers, and canoeing, kayaking and fishing are available on request.

Milne Bay offers a flourishing muck diving habitat and continues to surprise the discoverers of new and endemic species. Keep a sharp eye on the rubble and sand, as you never know what you might discover.

HOW DO I GET THERE

Port Moresby is the capital city of Papua New Guinea and the International Airport is here. Qantas and Air Nuigini both have daily flights from Australia to Port Moresby. There are weekly flights from Singapore, Manila, Hong Kong and Tokyo.

LORENZO'S DELIGHT

Critters galore

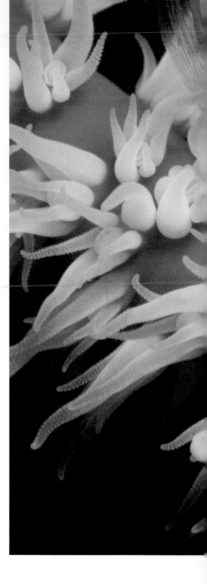

maximum depth:
80m

minimum depth:
3m

access
Access is from the resort, located on the island. Live-aboard dive boats occasionally visit the area.

average visibility
15–80m; July and August bring plankton blooms with lower visibility.

water temperature
30°C–26°C

dive type
Reef dive

currents
Currents are generally mild, but can be strong at times

Experience
*** to**** Depth dependent*

in the area
*The house reef is extensive with a great variety. Many visitors do a lot of their dives from the shore on the house reef.
Other sites include Inka's Palette, Mari Mabuk, Onamobaa Cavern, Table Coral City, Fans Garden, Pinki's Wall, Roma, Cornucopia, Baraccuda Point, Waiti's Ridge, Blade, Fan 38, The Cavern, Concita and Batfish Ridge. The wreck of a Japanese freighter is within easy reach of the resort.*

Situated off Sulawesi at the eastern end of the Indonesian Archipelago in the Banda Sea just south of the equator, Wakatobi falls within an area of the world that is the epicentre of marine diversity.

WHAT WILL I SEE?

Flying into Wakatobi just after the airstrip first opened was an amazing experience, as the bi-weekly flights would attract local residents from all over the island to see the 'big bird' land. They would crowd round the aircraft and watch in fascination as it dispatched the latest dive group. The 'flight control tower' and waiting lounge were simple bamboo framed huts and the locals would continue to gather there.

It is a short transfer by boat from Tomia Island, where the airstrip is located, to the dive site on Onemobaa Island where you arrive at a picture book location with golden sandy beaches, swaying palms and lush rainforest. From here, you have more than 40 named dive sites to explore, both from the shore house reef and around the area. The variety and quality of the diving is exceptional and it is difficult to pinpoint one location for the purpose of this book. However, we have chosen the one named after Lorenz Mader, who has been largely responsible for the preservation of this unique marine habitat – Lorenzo's Delight.

There are 10km of coral reef sponsored as a marine reserve, which has resulted in the underwater environment being kept in pristine condition, supported in no short measure by the Coral Reef Alliance and the Nature Conservancy.

There is plenty of variety in diving Wakatobi, from the incredibly scenic coral reef system to the weird and wonderful critters that have evolved in the region, including some unique species. Over 3,000 species of fish alone have been classified. Larger species

ON DRY LAND
Accommodation in the only resort on the island comes in a range of standards, from bungalows of varying refinements to beach villas. All are comfortable and the service and food in the resort is excellent. Spa facilities are available, with well-trained masseurs to untangle those knotted muscles. Village tours can be arranged, as well as treks to a volcano and rice fields. Surfing and rafting can also be arranged. Tours to Komodo Island and Rinca Island can be arranged to see the Komodo dragons.

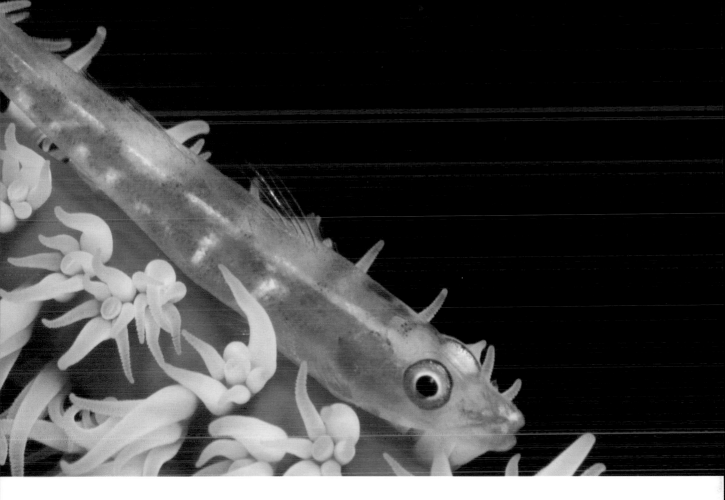

sometimes seen include whales, dolphins, sharks, rays and marlin.

As always in places where there are weird and wonderful critters that have evolved to blend into their underwater world, it is a good idea to stay with the dive guide who is invariably expert at finding the creatures for you.

THE DIVE

When you enter the water, the steep, sloping wall drops away to 80m. There is no need to go to this depth to get a taste of the wonders of this site, including forests of whip corals, large sponges, gorgonian sea fans, soft corals and schooling fish. Drop down to around 30m and work your way slowly up the wall. At around 18m, there is an overhang where huge sea fans share space with colourful soft corals.

Once you have taken in the overall spectacular vista, it is time to begin to search out the critters with the help of your guide. There are many to discover, such as leaf fish, frogfish, ornate ghost pipefish and many species of nudibranch.

The sloping wall takes you to just a few feet from the surface, giving you plenty of time to decompress as you enjoy the slow ascent, all the time discovering more interesting creatures and, maybe, photographing them.

HOW DO I GET THERE
International flights to Bali, Indonesia and then private charter plan to Wakatobi. From there, it is just a short drive and boat ride to Onemobaa Island organised through the dive resort.

Philippine Sea

Philippines

Lankayan

Celebes Sea

Indonesia

BIMBO ROCK

Master of disguise

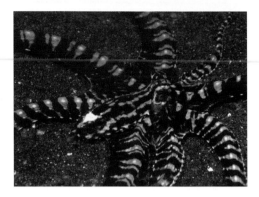

This small paradise island offers a fantastic variety of macro marine life and a wonderful muck diving arena. Stretches of white sandy beach and beautiful sunsets add to the island's charm.

maximum depth:
25m

minimum depth:
5m

access
Lankayan Island Dive Resort is the only resort on the island and no liveaboards visit the area. The dive resort organises daily dive trips and resort boats can take you to the sites within 20 minutes. Conditions are relatively stable and good for diving throughout the year.

average visibility
3–15m; visibility in the area can be impacted due to the finest of the white sand that is easily disturbed

water temperature
26°C

dive type
Reef and some drift diving

currents
Moderate

experience

in the area
Thirty dive sites, including Lankayan wreck, Mosquito wreck, Pier wreck, Bimbo Rock, East Ridge Ken's Rock, Lycia's Garden, South Rock, Malu Malu, Ray City, Froggie Fort, Fan Garden, Lost World, Mel's Rock.

WHAT WILL I SEE?

The corals at this site are excellent. There are large stretches of hard corals, as well as many soft corals.

With new protection from local fishermen, the larger marine creatures such as leopard shark, stingray and giant grouper have returned to the surrounding reefs. Rarities can also be seen, including sea horses, flying gurnards, flamboyant cuttlefish, jawfish, dragonets and sand divers.

This pristine reef also plays host to a variety of fish species, from small glassfish and harlequin ghost pipefish to painted frogfish. Nearby Pulau Selingan has a turtle sanctuary, so it is likely you will see a hawksbill or green turtle during your dive on Bimbo Rock.

THE DIVES

The reef is buoyed, so follow it down to view the beautiful staghorn and many other hard corals. As you fin along the reef, dwarf lionfish, white morays and nudibranchs can be seen, along with batfish and many other reef fish. Every twist and turn provides a showcase of activity.

Sometimes visibility is reduced due to the fine, silty sand in the area. Come off the reef and head for the sandy plain at around 20m; the thicker sand here offers better visibility and is good for marine critters. Amongst them, the flamboyant cuttlefish appear to have a dark dull complexion until a diver or potential threat

ON DRY LAND
Unpopulated and covered by rich vegetation, this is a great place to relax. The more adventurous can hike or trek up Mount Kota Kinabalu.

The orangutan sanctuary in Sepilot near Sandakan provides an opportunity to be a volunteer for the day, staying at a jungle lodge in Sepilok, which is next to the orangu-

tan sanctuary. Here you can see rehabilitated orangutans arrive from the open jungle to feed on bananas distributed by their human former carers. A few hours' cruise

up the river can give access to views of jungle animals such as proboscis monkeys, macaques, elephants and crocodiles.

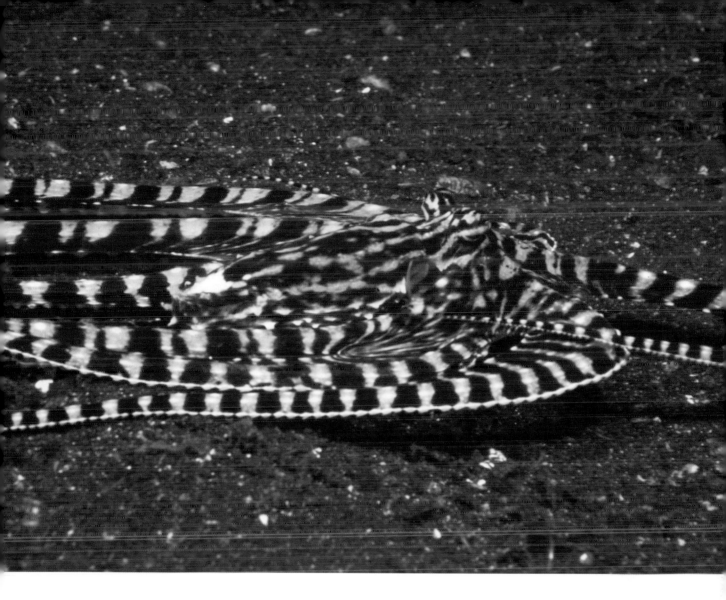

approaches, when this little cuttlefish puts on a lovely display of many colours to fool passers-by into thinking it may be dangerous or poisonous.

The intelligent mimic octopus is a great master of disguise. If you catch a glimpse of it, sit back and admire the display. This amazing, rare creature is able to copy the physical likeness and movement of more than 15 different species; it can pretend to be a sea snake, lionfish, flatfish, flounder or stingray, to name just a few. It accomplishes the disguise by contorting its body and arms, and changing colour. This animal is so intelligent that it is able to discern which dangerous sea creature to impersonate, in order to present the greatest apparent

threat to whatever predator is showing an interest.

Look at around 12–15m for the octopus; it is worth seeking help from a dive guide, as this is one of the few places in the world to spot them.

Flounders and flying gurnards also help keep the sandy area interesting. When you are ready for more reef, you can observe where muck diving and reef diving come together, with frog fish and ribbon eels in between. Gobis can be spotted on whip coral if you have the eye for it. Continue the remainder of the dive on the shallow reef and enjoy.

HOW DO I GET THERE

Flight to Kota Kinabalu via Singapore, then 50-minute flight departs to Sandakan daily at 10:10 and 16:15 hrs (return 13:35 and 19:40 hrs).

An alternative is to arrive from Sipadan; there are daily 40-minute flights from Tawau to Sandakan at 12:30 and 18:35 hrs (return 11:25 and 17:30 hrs).

Guests are collected at the airport and taken to the jetty for registration before being transferred to the island. The boat transfer takes between an hour and a half and two hours. To get a transfer on the same day, you need to take one of the earlier flights, otherwise you can stay overnight in Sandakan and get a transfer next morning.

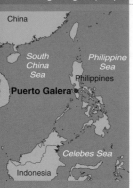

China

South
China
Sea

Philippine
Sea

Philippines

Puerto Galera

Celebes Sea

Indonesia

SINANDIGAN WALL

Slugs galore

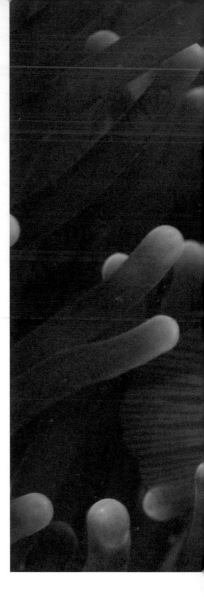

maximum depth:
40m

minimum depth:
10m

access
Dive boats (approx 10 minutes) from Puerto Galera dive resorts.

average visibility
20m–30m

water temperature
March–November:
25°C–30°C
December–February:
21°C–24°C

dive type
Reef dive

currents
Variable and can be strong

experience
*** to **** normally due to tides*

in the area
Approximately 40+ dive sites within easy reach of Puerto Galera on the northeast mainland and on the islands of San Antonio, Verde Island and Maricaban.

On the northern peninsula of the island of Mindoro in the Philippines, lying in the shelter of Varadero Bay, is Puerto Galera, an ideal base to access over 40 dive sites around the peninsula and on the nearby islands of San Antonio and Verde. The Spanish founded the settlement of Puerto Galera in 1572 to provide a safe haven for their galleons seeking refuge from storms and looking to replenish provisions. The name in English means Port of the Galleons.

WHAT WILL I SEE?

The area around Puerto Galera offers a great variety of dives, from impressive muck diving sites to coral reefs rich in marine life. This includes Verde Island, which is located in Verde Island Passage, which separates Mindoro from Luzon. There, you can experience exhilarating drift dives of up to 6 knots as the passage is flushed by the currents of the South China Sea.

The dive site we have chosen is Sinandigan Wall, north of Varadero Bay, which is particularly famous for the abundance of nudibranchs of many varieties. But it offers so much more, making it one of the great dive sites of the world.

THE DIVES

Sinandigan Wall is a dive full of beauty of extra special interest for nudibranch lovers, as it has an enormous diversity of the most colourful sea slugs. As the name suggests, you dive on a wall that starts at 10m and goes down vertically to 30m after which it slopes more gently down to 40m, with large rock formations providing plenty of areas to explore. As well as being famed as a site for nudibranchs, it has many other species to keep you absorbed throughout the dive.

The abundance of soft corals, sea fans, tree corals and sea squirts help provide colour, and there is an abundance of fish life including grouper, snapper, jack,

ON DRY LAND
Picturesque beaches offer a variety of watersports other than diving, and you can explore the mountainous interior of Mindoro Island,

enjoying short hikes or more adventurous ones such as the Tabinay-Talipanan trail, a two- to three-day walk through the forests offering spectacular views across

Verde Passage. Mountain biking is available, with established routes in the area. Four-wheel drive vehicles can also be hired. The Tukuran River Tour is a two-

to three-hour trek through rivers and rice fields and offers stunning scenery over the Mindoro countryside. Day trips are available to Tamaraw Falls, traditional

Mangyan villages, the capital of Mindoro, Calapan, or Lake Naujan, a freshwater lake with hot mineral springs. Puerto Galera is a busy little place with very friendly

tuna, barracuda, Moorish idol, lizardfish, zebra lionfish, stonefish, dwarf hawkfish, pufferfish, surgeonfish and frogfish. Pigmy seahorses are also found on the sea fans (Murcella sp.) they mimic so well, making them difficult to spot without the help of an experienced dive guide. Once found, they test your macro photography skills to the limit as they are only 1–2cm long and can be difficult to focus on and achieve a good composition. Clownfish are always irresistible to the underwater photographer and deep red bridled anemonefish are particularly attractive and can be found in their adopted sea anemones.

Among the invertebrates you may find banded sea snakes, cuttlefish, octopus, mantis shrimps, fan worms,

Christmas tree worms, featherstars and various sea squirts in blue, white and yellow, as well as large green species.

Keep your eye out towards the blue as sharks have been reported on this site, including thresher sharks.

This site well deserves repeated dives to absorb the wide variety of life from the small and exotic to the larger, colourful creatures, with the added feature of wonderful scenic views.

people and there are restaurants, bars, shops and nightclubs for partying until the early hours if desired. A visit to the local Excavation Museum will help you

appreciate the historical importance of Puerto Galera as part of a trade route from Asia, and contains many Chinese artefacts. South-west of Puerto Galera

can be found the Ponderosa Golf Club, which has a nine hole course. It is 600m above sea level and offers a great view of the harbour area and the Verde Passage.

HOW DO I GET THERE

Flights to Manila and then by road and boat from Batangas Pier across to Mindoro and by road again

to Puerto Galera. Dive resorts normally arrange all transport and the journey time is about three-and-a-half hours.

maximum depth:
20m

minimum depth:
6m

access
Sea front hotels and marinas in La Paz have dive resorts with day boats to take you to each dive. Daily boat dives take you to over 25 dive sites, around 30 minutes to an hour away.

average visibility
15m–25m, and up to around 30m from July to October

water temperature
21°C–29°C Coldest November to March

dive type
Reef diving/boulders

currents
Little

experience
*

in the area
*Salvatierra Wreck (Ferry with a cargo of trucks, 19m)
Las Animas
El Bajo
El Corralito
Los Cabos diving*

SAN DIEGO REEF

Enter a three dimensional world of dramatic shapes and colours

The Sea of Cortez circulates huge amounts of nutrient rich water, producing heavy plankton blooms that in turn attract a massive diversity of tropical and pelagic fish to these waters. Exotic species also have their place here, and this site brings a new view of the area with strange yet wonderful creatures.

WHAT WILL I SEE?

This site is set apart from the norm, as diving in la Paz is generally around sea mounts. This site proves that Baja has still more to offer, the sandy seabed encouraging different animals to become resident here.

Unusually large pufferfish and leopard grouper are frequently spotted on this reef, while it is less common in other parts.

Cortez angelfish, blackbar soldierfish and maybe an angel shark are frequent visitors. The jawfish enjoys the habitat for nest building, and this site can be dived specifically to find them.

Blue and yellow chromis add a touch of panache to the rocky reef; bumphead damselfish, longnose butterflyfish and the three banded butterflyfish add to the variety of smaller fish. Larger filefish and wahoo, often served up in the evening, cruise the waters.

Grunt of all variety and colours are here, including the special cortez grunt fish with its characteristic blue spot on each scale, and the burrito grunt, with its fleshy lips and large scales.

Plenty of starfish and urchins sit on the rocks and litter the seabed, while vibrant orange cup coral coats the reef walls.

THE DIVES

Walls covered with golden cup coral open to feed on planktonic animals drifting by in the current. As you descent a little deeper you will see anemone clumps playing host to decorator and sponge crabs. These sweet

little crabs camouflage themselves with algae and pieces of sponge on its back. Watch out for slowly moving algae or sponge and look closely to see if it is a crab on the run.

The walls give way to sand, with small clumps of coral or pinnacles to break up the flatness of the seabed. Long stretches of sand provide an unending habitat for many creatures. Thousands of garden eels poke their heads out of the sand, a community acting in unison.

Scorpionfish are often missed on the sandy bottom, but are more likely to be seen as you approach close to them and they turn a red colour, letting you know in no uncertain terms that they are poisonous. Bullseye stingray are a treat to find. Its odd shape and dark markings forming rings like a bullseye distinguish this ray from other more common stingrays. Its shape fools predators into thinking it is a different size and species.

This dive has another purpose: finding the lair of the jawfish. This plain, even slightly ugly fish is fascinating. It fastidiously tends to its nest, a long hole in the sand. As current and water movement continually pushes debris down the hole, the jawfish works hard to extricate the rubble and clean the area using its mouth. Shellfish and tigerprawns pick up scraps around the nest. When the female jawfish lays its eggs, it transfers the millions of tiny, precious eggs to its mouth to keep them warm and safe. If you find one like this, its open mouth will reveal many tiny eyes from the spawning eggs. It is worth spending time watching the jawfish at work.

ON DRY LAND
Perched on the south-east edge of the district of Baja Sur, the small colonial town of La Paz offers glorious landscapes and numerous bars and restaurants serving good seafood or spicy Mexican dishes. La Paz is an old city, notorious for pirates in the early 18th century. Desert surrounds the town, and tall mountains look on from the distance. For nature lovers, huge cacti and endemic plants and animals can be seen. Back on the water, resorts offer whale watching, and kayaking and other water sports are possible. Fishing, including Marlin and tuna, is popular. Boats offer trips out to see the grey whale and whale sharks that sometimes visit the area.

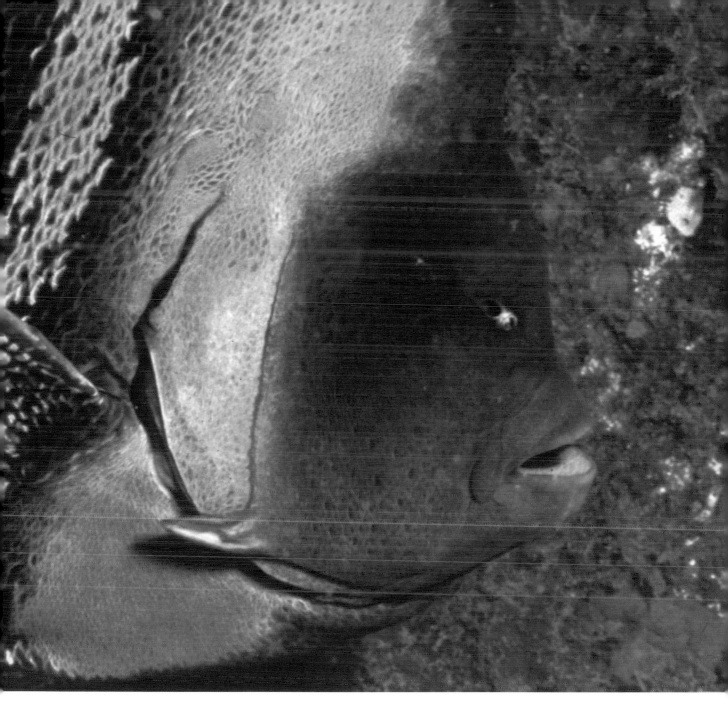

As you move away from the sand and back to the rocky wall, look out for the flatfish family; halibut, turbot, sand dabs and flounder. Schools of goatfish and mullet forage on the bottom, and large stingray hide just under the sand, keeping an eye out for food or predators.

This is also a great night dive. The best plan is to dive it in the daylight and, once you are sure of the layout, dive it again when the nocturnal marine life blossoms.

HOW DO I GET THERE

European and American flights via LA, fly to La Paz.

Philippines Sea

Philippines

Dumaquete

Celebes Sea

Indonesia

maximum depth:
20m

minimum depth:
0m

access
From resorts in the area of Dauin, north-east of Dumaquete City by dive boat.

average visibility
15m–30m

water temperature
December–March:
24°C
May–July:
28°C
At other times:
24–28°C

dive type
Beneath pier structure

currents
Nil to moderately variable

experience
** to *** normally, due to tides*

in the area
Some 30 dive sites in the immediate vicinity, including muck diving sites on Duain coast and excellent reef diving at Apo Island, Siquijor Island and Balicasag Island.

COCONUT MILL PIER
Made by man, decorated by nature

Any underwater man-made structures quickly become home to a wide variety of creatures, and this is especially so in the Indo-Australian archipelago, which is the epicentre of marine diversity. The Coconut Mill Pier at Dauine near Dumaquete in the Philippines (its official name is Ducomi Pier) is living proof of this, and is undoubtedly one of the greatest dives of its kind anywhere.

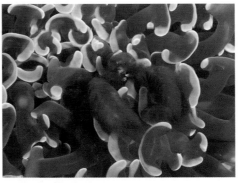

WHAT WILL I SEE?

Dumaquete is situated at the south-east corner of the island of Negros, which is part of the Visayas range. A 20-minute drive south from the town of Dumaquete will take you to an area of wonderful beaches, along which dive resorts are located. From this vantage point, you have access to some 30 dive sites on Dumaquete itself and on the nearby islands of Apo, Siquijor and Balicasag. These offer a wonderful variety of diving, from white sand muck diving sites at Dumaquete to beautiful reefs systems on the islands. However, it is the extensive working pier of Coconut Mill Pier that offers a unique and amazing dive experience.

THE DIVES

There are, in fact, two piers. The main pier, which has recently been extended, is still a working pier with large ships loading and unloading their cargo, primarily coconut products and rice. About 50m from the main pier are the remains of an earlier pier that is no longer in use. It is an easy swim between these structures so they can both be incorporated into one dive. However, this dive site fully deserves repeat dives and, if you are a photographer, you will want to explore the site with various lenses from macro to full frame fisheye as you will find wonderful opportunities for all of them.

The pier pillars are in 20m of water. The massive pillars rise from the seabed, festooned with colourful sponges and soft corals. These are most abundant on the old pier but the working pier is also gradually attracting the same abundance of marine life. Among the sponges and soft corals you will find all sorts of exotic creatures, which makes it irresistible to critter hunters.

The pillars themselves are wonderfully atmospheric against the dancing rays of the sun as they penetrate the depths. Add to this the abundance of shoals of fish sweeping to and fro, and you already have the makings of a unique dive site. But there is more. Start your dive at the seabed and you can begin with a muck diving entrée and then gradually work your way up and between the pillars, which means you will be fascinated by the variety of marine life until you eventually break surface at the end of the dive.

On the seabed and among the soft corals and sponges, you can find many varieties of fish including frogfish, juvenile batfish, harlequin ghost pipefish, pufferfish, shoaling catfish, cardinalfish, anemonefish, stonefish, moth fish, demon stingers, scorpionfish, devilfish, stargazers, cowfish and seahorses. Then there are the invertebrates including nudibranchs, orangutan crabs in sea anemones, tiny anemone shrimp on whip corals, cuttlefish, octopus, mantis shrimps and sea snakes. On.

Shoals of silver batfish and juvenile trevally sweep to and fro between the pier structure. Don't be surprised if you encounter a turtle passing through, or large barracuda.

ON DRY LAND
There are many activities for non-divers or those who wish to take a break from their diving. These include a visit to Dumaquete City with its many shops, restaurants and bars. There are three golf courses in the vicinity of Dumaquete and you can visit small villages with their local markets.

A tour through the countryside has much to offer, including rice paddy fields and coconut plantations. Beyond the agricultural areas, you can journey into the mountains where you see waterfalls such as Casaroro as well as lakes, such as Twin Lakes, which lie in old volcanic craters and are fed by warm springs.

A journey to the west of the island will take you to the sugar plantations. There are many hot springs to visit, and there are several caves that are accessible to

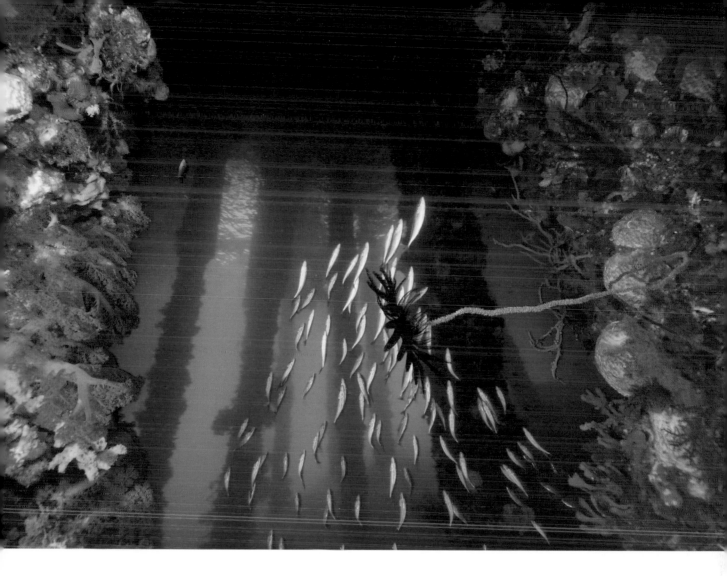

the public. Jungle treks can be arranged, including more adventurous ones higher up in the mountains.

HOW DO I GET THERE

International flights to Manila or Cebu. From Manila, you will need to take an internal flight to Dumaquete. From Cebu, dive resorts can arrange boat and vehicle transfers to Dumaquete.

WITCHES HUT

Hidden Gems

Bonaire's pristine reefs and diverse marine life are unique to the Caribbean. The waters around Bonaire are designated as an official marine park, keeping the environment untouched and unspoiled. As Captain Don said, 'Bonaire is to conservation as Greenwich is to time'.

maximum depth:
22m

minimum depth:
6m

access
Dive sites can be escorted or independent. Yellow boulders around the island are numbered to indicate the entry point for the dive. Shore diving gives easy access if you hire a jeep. Boat dives are organised by dive resorts.

average visibility
30m–50m

water temperature
25°C–28°C

dive type
Shore diving or by boat–reef and gentle drift diving. Offers year round diving.

currents
Gentle currents

experience
*

in the area
Wreck of the Hilmar Hooker
Vista Blue
Petries Pillar
Klein Bonaire dive sites reached by boat
Shore dives accessible by jeep
More than 80 dive sites have been marked, with the best reefs found within the protected leeward side of the island

WHAT WILL I SEE?

This popular destination has a wide variety of fish life, and ranks amongst the top four best diving destinations in the world.

Witches Hut is a lovely reef to dive and easy to navigate around. Pinnacles and coral heads form a pretty garden, lively with fish and marine life; tangs, filefish and parrotfish are out in force, grazing and foraging for food. Floating gently over a reef terrace, a diver can view dense soft corals, all inhabited by a dazzling spectrum of life. Yellow and orange sponges provide good camouflage for resident frogfish, and Witches Hut is a good place to spot them.

Harder to spot is the elusive seahorse, and it is worth diving with a guide to get used to finding them. This site is a well known home to several different types of seahorse.

The reefs are very well preserved, very diverse and support a truly amazing array of reef fish.

THE DIVES

Witches Hut gets its name from a dilapidated abandoned house that sits by the road. If you are accessing the dive site from the land, the hut is your destination, where you can park and get kitted up.

The reef starts right at the water's edge and shelves to a depth of around 15–20m. A gentle drift at the deeper sections of the reef will bring trumpetfish, parrotfish and shoals of grunt into view.

A variety of moral eels can be seen hiding in between the coral heads. Most of the dive is best spent shallower,

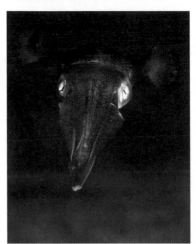

at around 10–12m, to search for a seahorse. Amongst the soft coral strands, these amazing creatures lie still and can easily be overlooked. The seahorse has an appeal for everyone and there is a real sense of achievement if you can spot one for yourself.

Keep a close eye on anything moving over a hard coral head; if it changes colour, it could be an octopus on the prowl. One puff of ink and it quickly disappears. Also look around the shallow areas of bare sand and warm blue water and you may spot a squid or two. The squid's strange, transparent look, along with its ability to change colour to suit its surroundings, can make it almost invisible. Its movement can sometimes give it a comical appearance, particularly if you find two together in a ritual courtship, as they seem to dance alongside each other.

The coral pinnacles provide a stable platform for crinoids, worms and animals that in turn live on them. Arrow crabs can be found hiding on sponges; feather stars cling to sponges or corals and unfurl their arms to feed on passing particles. Christmas tree worms bore into the live calcareous coral. They are very sensitive to disturbances and will rapidly retract into their burrows at a passing shadow, which can try the patience of an underwater photographer; they usually re-emerge minutes later.

The island's location in the south Caribbean gives it an arid climate with little rainfall. Consequently, the waters are exceptionally clear of silt, calm, and diveable all year round.

ON DRY LAND
On the northern tip of the island lies Washington National Park. Numerous indigenous plants, birds and animals thrive in this protected area. The southern tip of the island is dominated by salt flats; here, you can see the largest breeding colony of flamingos in the Caribbean region.

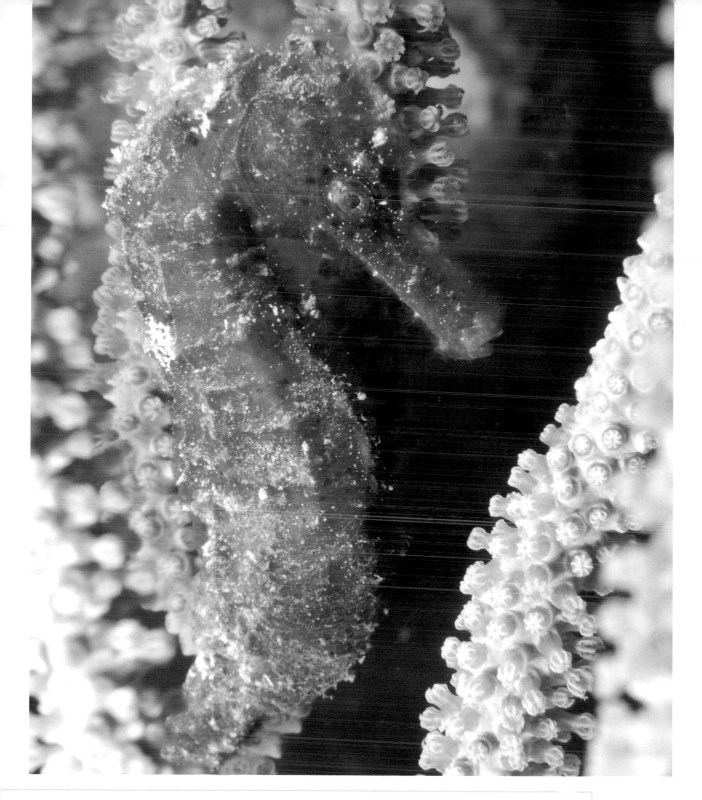

HOW DO I GET THERE

Connection to Bonaire's Flamingo International Airport is possible from several locations in the USA. From Europe, you can connect with KLM via Amsterdam.

RICHELIEU ROCK

All creatures great and small

Richelieu Rock is located in the Andaman Sea. This remote pinnacle provides good conditions to attract large pelagics.

maximum depth:
35m

minimum depth:
12m

access
By liveaboard from various locations around Phuket. Liveaboards can be booked for a week or a four-day excursion, taking in many areas of the Similan Islands. High season is January to March, and you can dive from November to March.

average visibility
10m

water temperature
29°C–30°C

dive type
Reef and drift diving

currents
Moderate to strong currents running mainly north to south

experience
**** Advanced dive due to irregular currents*

in the area
Rocky Island
Koh Bon Island
Tachai Pinnacle
Breakfast Bend

WHAT WILL I SEE?

Richelieu Rock lies north-east of Ko Tachai, close to the Burma's southern border. It is an isolated rocky outcrop marked by the top of the pinnacle a metre above sea level during low tide and disappearing under high tide.

Starting in the shape of a horseshoe, the pinnacle falls steeply to the sandy bottom at a maximum depth of 35m, gently sloping to the deep. The rest consists of sheer walls, groups of rocks and swim throughs.

Much of the diving landscape in this area is very rocky, with huge barren boulders broken up by coverings of coral and fans.

THE DIVES

When the rock is not visible, you descend in open water through schooling fish; fusilias, baby barracuda and sergeant major fish glinting against the sun's dappled rays, enhancing the glamour of this famous dive site.

Richelieu Rock attracts strong currents, bringing nutrients to feed the reef, fish and larger pelagics. It is a magnet for manta rays and whale sharks when the conditions are right.

At the other end of the scale, smaller, more exotic creatures also live here. Banded sea snake, fimbriated moray and double ended pipefish can be seen browsing the reef. The rare seahorse and ghost pipefish can be found in more sheltered areas. The ghost pipefish is so

named because of its excellent ability to look like the soft coral it hovers near and lives by. These amazing creatures can so easily be overlooked by a diver looking for more obvious things around them.

Anemones with colourful skirts of carpet the rocky platforms; many clown and anemone fish are endemic to this area, such as the eastern and pink anemone fish. These fish are very plucky and will defend their territory if you get too close, often delivering a nasty nip for one so small. Some of the anemones also harbour small anemone crabs, poking their heads out from between the tentacles. Other rare finds include the black ray partner goby, which darts about, venturing out of its hiding holes in the coral for short periods. The very shy comet longfin can also be seen here but is very elusive and will often swim into a crevice or rock if you approach. This fish is strikingly shaped and patterned, its white spots representing age, increasing and shrinking as time goes by.

A longish swim brings you to a glorious pinnacle rising from the seabed from around 18m to 6m. It looks like a display cabinet, elegant and perfectly placed with marine creatures on every shelf. The light reflects off the glassfish; sea fans and white soft coral add to the magic. It is worth spending a good part of the dive here; sheltered from the current, you can become totally absorbed in this scenery beneath the waves.

Spend the latter part of the dive above the reef at 10m and you can watch the bustling city life of fish. Juvenile

ON DRY LAND
Day trips can be booked to the famous James Bond or Phi Phi Island by speedboat. Rainforest tours are also available to see local wild-

life, including elephants and monkeys.

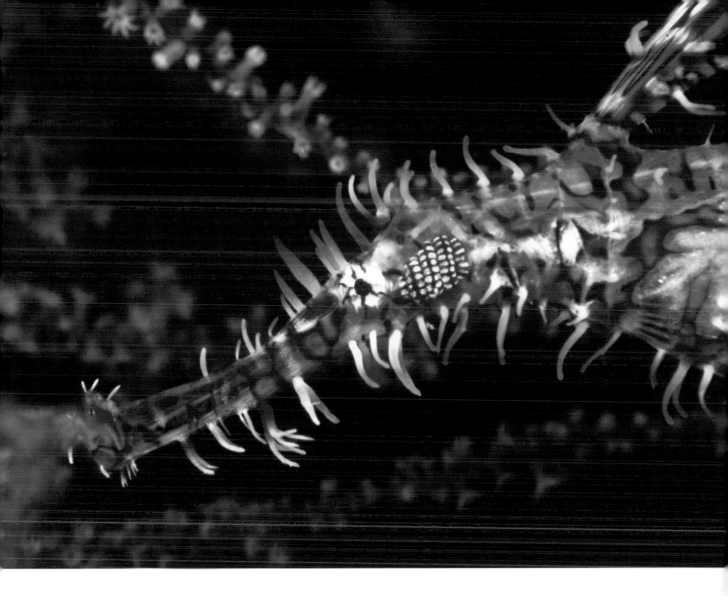

fish use this area as a nursery and shelter among the mass of corals. Butterflyfish typical of the area include the red tailed and Meyer's butterflyfish. Several types of colourful nudibranch can also be seen here.

During your surface interval in between dives, keep a look out to sea as it can be possible to spot minke whales and dolphins.

HOW DO I GET THERE

Fly via Singapore, Bangkok or Kuala Lumpar to Phuket, then transfer to a resort.

Picture credits (by page number)